ALBRECHT ALTDORFER
and the Origins of Landscape

ALBRECHT ALTDORFER

and the Origins of Landscape

CHRISTOPHER S. WOOD

REAKTION BOOKS

To my parents

Published by Reaktion Books Ltd
1–5 Midford Place, Tottenham Court Road
London W1P 9HH, UK

First published 1993

Designed by Ron Costley
Photoset by Rowland Phototypesetting Ltd
Bury St Edmunds, Suffolk
Printed and bound in Great Britain by
BAS Printers, Over Wallop, Hampshire

British Library Cataloguing in Publication Data
Wood, Christopher S.
Albrecht Altdorfer and the Origins of Landscape
I. Title
759.3
ISBN 0-948462-46-9

Contents

Acknowledgements, 7

1 Independent landscape, 9

Where landscape could appear
Landscape and text
Landscape as *parergon* or by-work

2 Frame and work, 66

The German artist's career
Subject and setting
The landscape study

3 The German forest, 128

Two-dimensional pleasures
Germania illustrata
Outdoor worship
Wanderer, traveller

4 Topography and fiction, 203

The topographical drawing
Style in Altdorfer's pen-and-ink landscapes

5 The published landscape, 234

Altdorfer's public
'Printed drawings'
Order and disorder

Notes, 283

Bibliography, 309

Checklist of Landscapes, 312

List of Illustrations, 314

Index, 320

Acknowledgements

This project was born exactly ten years ago when I first saw German art through the eyes of Konrad Oberhuber. His creative and ecstatic vision, and his evocations of the momentous first decades of the sixteenth century, have most powerfully influenced my own looking and thinking.

My dissertation was begun under Oberhuber, and completed under Henri Zerner and Joseph Leo Koerner. Koerner, a friend who fortuitously became an adviser as well, exerted a huge influence on this project throughout its preparation and then gave it a sharply pointed reading. I am massively in debt to his work both on Friedrich's landscapes and on authorial presence in German Renaissance painting. Henri Zerner has listened to and shaped my ideas for years, and he read the manuscript with great acuity. I have come to rely on his sensitivity in matters of graphic technique, format and function, and more generally on his warm support and superb judgement.

Among my other teachers I wish to thank especially Simon Schama, Hans Belting and Wolfgang Kemp. I am extremely grateful to Norman Bryson and to Creighton Gilbert for their close readings and helpful comments. Many teachers, colleagues and friends at Harvard, Yale and elsewhere offered dialogic provocation, good advice and wise correctives, in particular Maryan Ainsworth, Christopher Braider, Barbara Butts, Walter Cahn, Michael Cull, John Czaplicka, Derick Dreher, Lydia Goehr, Edward Goldberg, Philip Jacks, Geraldine Johnson, Benjamin Kaplan, Sarah Lawrence, Jean-Claude Lebensztejn, Katherine Crawford Luber, Kevin McLaughlin, Melissa Merritt, John Michael Montias, Alexander Nagel, Rod Nevitt, Pierre Nora, Steven Ozment, Peter Parshall, Mark Roskill, Robert Suckale, Irene Winter and Stephan Wolohojian. Finally, I wish to thank those curators and scholars abroad who offered assistance or encouragement: Szilvia Bodnár, Edwin Buijsen, Teresz Gerszi, Achim Hubel, Ulrike Jenni, Fritz Koreny, Matthias Mende, Friedrich Piel and Artur Rosenauer.

I wish to thank the Sheldon Traveling Fellowship (Harvard University), which funded study in Vienna and Paris, as well as the Department of Fine Arts. I am profoundly appreciative of the liberal support, the collegiality, and the other various amenities of the Society of Fellows, Harvard University. The contributions of my dear friends there to this book were mostly oblique; for the Society of Fellows was precisely a place *not* to talk about art history.

My wife Marina van Zuylen contributed to the project in a thousand different ways, and cared about it more intensely than anyone. All my work is unthinkable

without her companionship and fiery interventions. Our explorations of the darkest corners of Northern painting, side by side, and our mutual obsession with the blankness at the heart of the work of art, have in many ways framed our life together.

1

Independent landscape

The first independent landscapes in the history of European art were painted by Albrecht Altdorfer. These pictures describe mountain ranges and cliff-faces, skies stacked with clouds, rivers, stream-beds, roads, forts with turrets, church steeples, bridges, and many trees, both deciduous and evergreen. Tiny, anonymous figures appear in some of the landscapes. But most are entirely empty of living creatures, human and animal alike. These pictures tell no stories. They are physically detached from any possible explanatory context – the pages of a book, for example, or a decorative programme. They are complete pictures, finished and framed, which nevertheless make a powerful impression of incompleteness and silence.

These landscapes are small enough to hold in one hand. They were meant for private settings. Extremely few have survived: two were painted not directly on wood panel like ordinary narrative or devotional paintings, but on sheets of parchment glued to panel; three others were painted on paper. Altdorfer also made landscape drawings with pen and ink, and he published a series of nine landscape etchings. Altdorfer signed most of his landscapes with his initials. He dated one of the drawings 1511 and another 1524, and one of the paintings on paper 1522. In Altdorfer's time, drawings and small paintings were seldom signed or dated. A signed landscape, given its unorthodox content and ambiguous function, is doubly remarkable.

The *Landscape with Woodcutter* in Berlin, painted with translucent washes and opaque bodycolours on a sheet of paper 20.1 centimetres high and 13.6 wide, opens at ground level on a clearing surrounding an enormous tree (illus. 1). At the foot of this tree sits a figure, legs crossed, holding a knife, with an axe and a jug on the ground beside him. From the trunk of the tree, high above his head, hangs an oversized gabled shrine. Such a shrine might shelter an image of the Crucifixion or the Virgin; in this case we cannot say, for it is turned away from us. The low point of view and vertical format of this picture reveal little about the place. Is this a road that twists around the tree? Are we at the edge of a forest or at the edge of a settlement? The tree poses and gesticulates at the centre of the picture as if it were a human figure, splaying its branches into every corner. And yet it is truncated by the black border at the upper edge of the picture.

To this iconographic austerity corresponds a great simplicity of means. Many effects are achieved with few tools. The picture is imprecise, shambling, genial, candidly handmade. The branches of the tree sag under shocks of calligraphic foliage, combed out by the pen into dripping filaments. This pen-line emerges from under

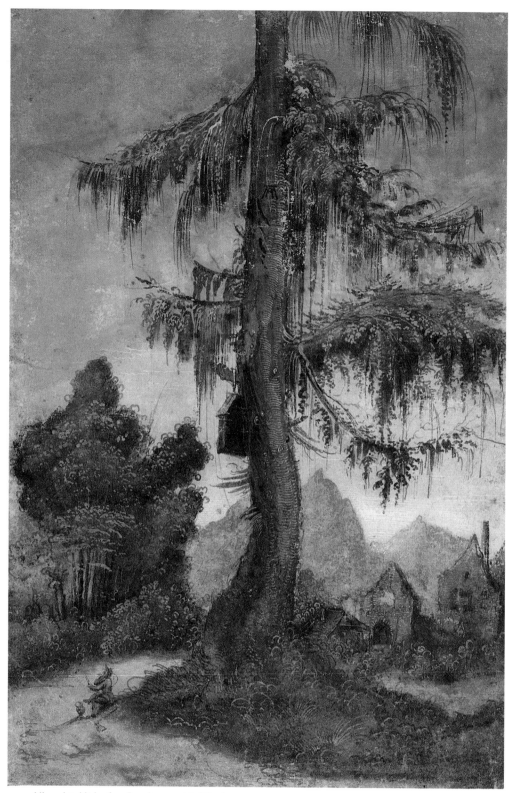

1 Albrecht Altdorfer, *Landscape with Woodcutter*, *c.* 1522, pen, watercolour and gouache on paper, 20.1 X 13.6. Kupferstichkabinett, Berlin.

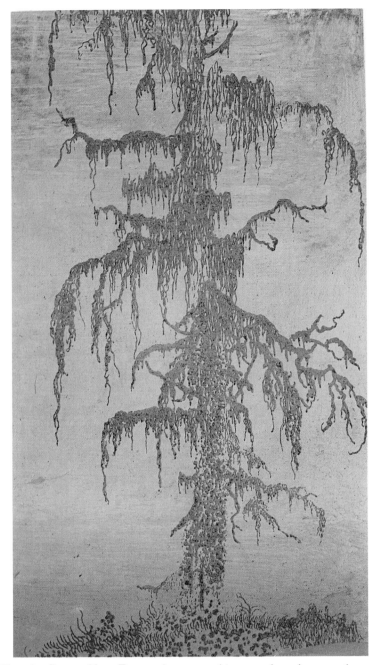

2 Hercules Segers, *Mossy Tree*, *c.* 1620–30, etching on coloured paper, 16.9 x 9.8.
Rijksprentenkabinet, Amsterdam.

layers of green or brown wash at the margins of the tree-trunk and the copse at the left, in licks and tight curls, legible traces of the movement of the artist's hand. Contours do not quite coincide with masses of colour. Behind the tree-trunk, a row of trees was outlined in pen, but never coloured in. The brittle buildings tilt to the right. The picture is touched by a slightly manic spirit of exaggeration, which makes the woodcutter's passivity and the silence of the place even more uncanny. These are rough-hewn and generous effects. A curtain of blue wash creates a breathy, sticky ether that fades into white near the profile of the mountains. The mountains – blue, like the sky – are overlaid with a ragged net of white streaks. Masses of leafage, by contrast, are made tangible by a speckling of bright green, so unreal that it conspicuously sits on the surface of the picture rather than in it. Paint adheres to paper like a sugary residue. All the picture's technical devices are disclosed, yet they look unrepeatable.

Such a picture as Altdorfer's *Landscape with Woodcutter* – as rich as a painting, as frank and gratuitous as a drawing – is not easily located either within an art-historical genealogy or within a cultural context. No Netherlandish or Italian artist of the early sixteenth century produced anything quite like it. Some German contemporaries and followers of Altdorfer did make independent landscapes. Wolf Huber of Passau, it appears, even established a kind of trade in landscape drawings. Altdorfer published some of his own ideas about landscape in his brittle, spidery etchings, and indeed through these etchings he exerted an impact that can be traced for several generations. But by and large this is not a success story. The independent landscape staked only the feeblest of claims to the surfaces of wood panels, which in southern Germany around 1500 were still largely the territory of Christian iconography. Nothing like Altdorfer's mute landscape paintings, with their elliptical idioms of foliage and atmosphere, would be seen again until the close of the sixteenth century, in the forest interiors of Flemish painters working in the wake of Pieter Bruegel: Jan Bruegel the Elder, Jacques Savery, Lucas van Valckenborch, Gillis van Coninxloo.[1] Not until the tree studies of Roelandt Savery, Hendrick Goltzius, and Jacques de Gheyn II did anyone again twist a trunk or attenuate a branch with such single-minded fantasy.[2] But the most apt comparisons of all are the moody etchings of Hercules Segers, an eccentric and still dimly perceived giant of early seventeenth-century Dutch landscape, pupil of Coninxloo and powerful inspiration to Rembrandt, working a full hundred years later than Altdorfer. Only a single impression survives of Segers's *Mossy Tree*, an etching on coloured paper of a nameless, spineless specimen that might have been plucked from a fantastic landscape, perhaps from one of Altdorfer's etchings (illus. 2).[3] Indeed, the affinity between Segers's prints and those of Altdorfer's earliest followers was remarked on as early as 1829 by J.G.A. Frenzel, the director of the print cabinet in Dresden.[4]

Altdorfer's independent landscapes, as strange and unprecedented as they were, left no discernible traces in contemporary written culture. They are mentioned in no letter, contract, testament or treatise. The earliest documentary reference to a landscape by Altdorfer dates from 1783; that picture has since disappeared. One of the

surviving landscapes can be traced back to a late seventeenth-century collector, but no further. Thus we do not even know who originally owned or looked at these pictures.

What does an empty landscape mean? Christian and profane subjects in late medieval painting were often staged in outdoor settings. Many pictures juxtaposed and compared earthly and heavenly realms, or civilization and wilderness. Many stories about saints revolved around spiritual relationships to animals or to wilderness. German artists, and Altdorfer in particular, addressed these themes also through rejuvenated pagan subjects, such as the satyr, or through autochthonous mythical characters, such as the forest-dwelling Wild Man. Literary humanists – many of whom kept company with artists – debated the historical origins of Germanic culture and its peculiar entanglement with the primeval forest. But none of these themes is simply illustrated by Altdorfer's landscapes. These pictures lack any argumentative or discursive structure. They make no move to articulate a theme. Instead, they look like the settings for missing stories.

Deprived of ordinary iconographic footholds, one might well wonder whether the early independent landscape is not simply an image of nature. But German pictures in this period, particularly small and portable pictures on paper or panel, had limited tasks: they told stories; they articulated doctrine; they focused and encouraged private devotion. To ask the landscape of the sixteenth century to be a picture 'about' nature in general is to impose a weighty burden on it. We would probably not think to do it had not some Romantics elevated the landscape into a paradigm of the modern work of art. Schiller, for example, expected the landscape painting or poem to convert inanimate nature into a symbol of human nature.[5] The difficulty of the early landscape is that it looks so much like a work of art.

Both Leonardo da Vinci and Albrecht Dürer, Altdorfer's older contemporaries, had something to say about nature. Nature for Dürer meant the physical world. This nature ought to curb the artist's impulse to invent and embellish, to pursue private tastes and inclinations. 'I consider nature as master and human fancy [*Wahn*] as a fallacy', wrote Dürer.[6] His erudite friend Willibald Pirckheimer, in a humanist 'catechism' of 1517, an unpublished and only recently discovered manuscript, numbered the 'striving for true wisdom' among the highest virtues: 'Observe and study nature', he advised; 'inquire into the hidden and powerful workings of the earth'.[7] Cognition of nature, in Pirckheimer's catechism, became an ethical duty. In his book on human proportions, published posthumously in 1528, Dürer warned that 'life in nature reveals the truth of these things'. Nature provided examples of beauty and correct proportions, and therefore the controlling principles of art: 'Therefore observe it diligently, go by it, and do not depart from nature according to your discretion [*dein Gutdünken*], imagining that you will find better on your own, for you will be led astray. For truly art is embedded in nature, and he who can extract it, has it.'[8] For Dürer, the study of nature was a discipline, and nature itself the foundation of an aesthetic of mimesis. 'The more exactly one equals nature [*der Natur gleichmacht*]', he stated in two different treatises, 'the better the picture looks'.[9] But Dürer never

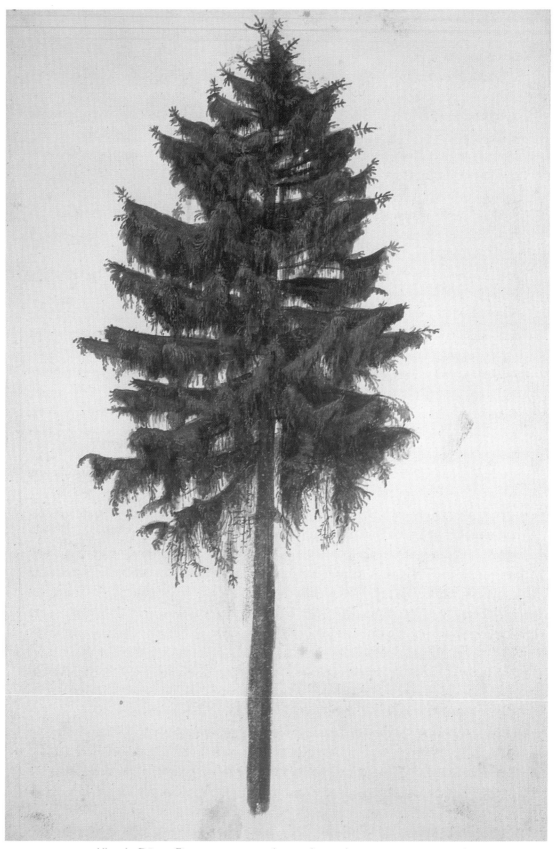

3 Albrecht Dürer, *Fir*, *c.* 1495, watercolour and gouache on paper, 29.5 x 19.6.
British Museum, London.

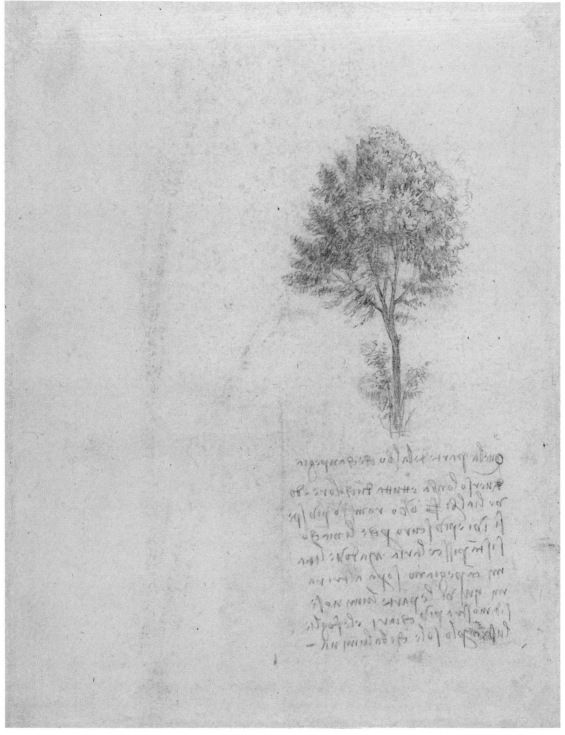

4 Leonardo da Vinci, *Tree Study*, *c.* 1498, red chalk on paper, 19.1 × 15.3.
Royal Library, Windsor Castle.

suggested that nature should become the basis for an independent landscape painting, and indeed he did not make any such objects. In his drawings he left first-hand accounts of his investigations into the morphologies of animals, plants and minerals. But these were private experiments and memoranda, not public works. His water-colour and silverpoint landscape views registered the impressions of a traveller. Dürer's eye was too hungry, and often he did not spend enough time on the paper to finish the drawing. Instead, a change of sky or a suddenly perceived riddle of foliage would distract him from the discipline of pictorial organization, and the work would never be concluded. Watercolours like the *Chestnut Tree* in Milan[10] or the *Pond in the Woods* in London (illus. 74) break off in the middle – appealingly, to our eyes. When Dürer ran out of patience, or light, he simply stopped adding layers of wash. Dürer was charmed by the random datum and the ephemeral impression. His *Fir Tree* in London, rootless, floats on perfectly blank paper (illus. 3).[11] Pedantry would have killed the tree, robbed the boughs of their spring and splay. Instead Dürer wielded the brush with a draughtsman's agitated hand. He animated the fir with a mass of short, wriggling strokes overlaid on a base of yellow and green washes; the strokes escape around the edges like fingertips. Such a transcription of a particular tree manifests neither the vagaries of personal inclination nor the stable certainties of intelligible nature. Dürer's watercolour studies, even if completed, were never offered to the world as pictures.

Leonardo, whose thinking was more involuted, escaped this impasse. Science or knowledge, for Leonardo, would reveal the principles and dynamic processes of nature – an ideal or 'divine' nature – while painting would accurately represent the visible data – the works of nature. But those principles of dynamic or generative creativity uncovered in nature could then serve as a model for the inventive and fictive capacities of the true artist. Knowledge of nature distinguished the artist not from the unreliable fantasist, as it did for Dürer, but from the merely reliable tran-scriber of the physical world. The painter who adjudicates among the data and recombines them in his work is 'like a second nature'.[12] Leonardo apostrophized the 'marvelous science of painting': 'You preserve alive the ephemeral beauties of mortals, which through you become more permanent than the works of nature.'[13] These thoughts anticipate the classic defences of poetry of the later sixteenth century, where fiction is prized over history precisely because fiction need not tell the truth. The painter, wrote Leonardo, can produce any landscape he pleases, for 'whatever exists in the universe through essence, presence, or imagination, he has it first in the mind and then in his hands'.[14] Such a landscape Leonardo might have painted! But he never did; that is, he never painted a mere landscape, one with a frame around it. Leonardo had new ideas about how to paint, not what to paint. He painted the same *kinds* of pictures that painters before him had: narratives, figure groups, portraits with landscape behind them. Leonardo's drawings of plants and geological phenomena are even less like complete pictures than Dürer's. A tree study at Windsor Castle, dating from *c.*1498, a tightly controlled spray of dusty red chalk, illustrates a manuscript preparatory to an eventual treatise on painting (illus. 4).[15] The specimen – a birch,

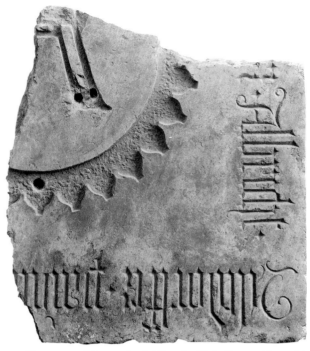

5 Fragment of the tomb of Albrecht Altdorfer, 1538, marble.
Stadtmuseum, Regensburg.

or a locust? – supplements a terse set of observations: 'The part of a tree which has shadow for background, is all of one tone, and wherever the trees or branches are thickest they will be darkest, because there are no little intervals of air.'[16]

Albrecht Altdorfer, on the other hand, left no nature studies at all. For most painters in this period, there was really no need to venture out under an open sky. Apart from a few drawings in pen and ink, Altdorfer's landscapes are indoor affairs. He was largely indifferent to the measurable or nameable attributes of the natural object. Sometimes, in the margins of his ordinary sacred paintings, Altdorfer described identifiable flora, for example plants with medicinal or symbolic significance.[17] But so many of his trees are monsters or fictive hybrids.[18] Moreover, he left no writings on nature or art; indeed, none on any topic at all. Nor is there any documentary or even circumstantial evidence that reveals what or whether Altdorfer thought about nature.

Altdorfer is known to us only through his works and through the silhouette of a public career. Like a number of other German and Italian artists of the period he managed to convert his talent into local social and political standing. He died in Regensburg on 12 February 1538, probably in his mid-fifties, at the crest of a highly visible and public career. His red marble tombstone in Regensburg's Augustinian church, where he was provost and trustee, was recovered by accident in 1840 during excavations. The inscription described him not as a painter, but as the 'honourable and wise Herr Albrecht Altdorfer, *Baumeister*' (illus. 5).[19] As the superintendent of municipal buildings he had overseen the construction of several commercial struc-

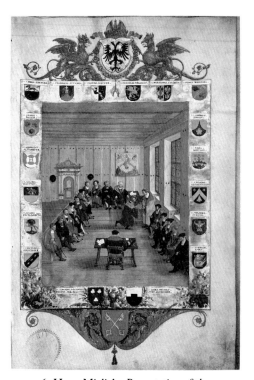

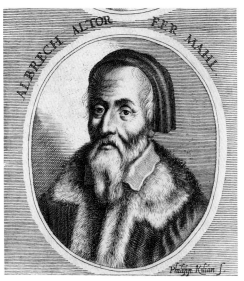

7 Philipp Kilian, *Portrait of Albrecht Altdorfer*, engraving after a drawing by Joachim von Sandrart, in Sandrart's *Teutsche Academie* (Nuremberg, 1675). Houghton Library, Harvard University, Cambridge, Mass.

6 Hans Mielich, *Presentation of the 'Freiheitsbuch' before the Assembly of the Inner Council*, 1536, miniature, from the *Freiheitsbuch*, 41 X 27.5. Stadtmuseum, Regensburg.

tures, perhaps even designed them; they all stand today. He also shored up the fortifications of the city. In his day Altdorfer was one of the outstanding political figures in Regensburg. He had sat in the Outer *Rat* or Council since 1517 and in the Inner Council since 1526, and had occupied various lesser public offices. In 1535 the city sent him as an emissary to King Ferdinand in Vienna. He owned three different homes, two of them at the same time, as well as vineyards outside the city.

What did Altdorfer look like? A portrait of an architect, formerly in Strasbourg but since destroyed, with an airy, capricious landscape behind him, was at one time judged to be a self-portrait by Altdorfer, or a portrait of him by a colleague.[20] But the only indisputable revelation of Altdorfer's person is a painting on parchment by his pupil Hans Mielich (illus. 6). This painting is found on the second page of the *Freiheitsbuch*, a kind of constitution of the city, dated 1536, and depicts the assembly of the Inner Council on the occasion of the presentation of this very book to the mayor.[21] Altdorfer is usually identified by his coat of arms, the fourth from the bottom on the left-hand side, as the figure in the black beret and fur-lined cloak. But in a chalk drawing by Joachim von Sandrart, the seventeenth-century academician and historian of German art, Altdorfer wears a forked beard.[22] Sandrart had the drawing engraved and published together with the biography of Altdorfer in his *Teutsche Akademie* of 1675 (illus. 7).[23] Both Sandrart's drawing and a contemporaneous engraving by Mathias van Somer evidently derive from a common source, perhaps an old painted portrait belonging to the city. Sandrart was in Regensburg in 1653 and 1654

and later painted an altar for the abbey of St Emmeram. Mathias van Somer worked in Regensburg from 1664 to 1668. Their versions of Altdorfer's head actually match a different councillor in Mielich's miniature – the third from the bottom on the left, the one gesturing with his hands.[24] Finally, a man holding a scroll and looking out of the background of a panel of Altdorfer's St Florian altarpiece, who had already struck some as a possible self-portrait, wears a similar forked beard.[25]

Altdorfer was not born to such status. Like Dürer, Lucas Cranach, Hans Burgkmair and Hans Holbein, Altdorfer was the son of an artist. Altdorfer won public attention not by undertaking huge and time-consuming public painting projects, as artists of his father's generation might have done. Nor did he attach himself to a princely court, as Cranach did, although, like Dürer, he did do occasional work for the Emperor and other potentates. He eventually made a giant painted altarpiece and many large devotional panels. But at the start Altdorfer made his name with intimate, modestly scaled works in unconventional media and with eccentric subject-matter. He painted small, clever, devotional panels; he made finished drawings of profane and historical subjects; he published his ideas in engravings, woodcuts and etchings. No contemporary reactions to Altdorfer's work are recorded. Yet we can infer that he appealed to a narrow and sophisticated audience with his esoteric subject-matter, his oblique treatment of traditional subjects, his visual wit, and his technical ingenuity and self-confidence. Most important, following Dürer's lead, he signed and dated his works. Altdorfer put vivid testimonials to his own talents, linked by a distinctive style and signature to his person, directly into the hands of individual amateurs and collectors. His monogram, which mimics Dürer's, was actually carved on the centre of his tombstone, no longer the mere corroboration of style, but an emblem in its own right.

By the end of his career Altdorfer was dividing his time between politics, architecture and a few prestigious painting projects. The small and intimate works, including the landscapes, played an ambiguous role in his career, just as they did in Dürer's. They were the foundation of his reputation, and they effectively preserved it, especially the small engravings with pagan or erotic subjects. Yet Altdorfer himself surely imagined they would, in the end, be overshadowed by his buildings and by his larger paintings. One of these late, public pictures is Altdorfer's grandest and most celebrated work, and indeed one of the most remarkable of all Renaissance paintings, the *Battle of Alexander* made for Wilhelm IV, the Wittelsbach Duke of Bavaria, in 1529 (illus. 8).[26] Over the next decade Wilhelm assembled a cycle of eight paintings of Antique heroes, all in vertical format; they hung in the Residenz in Munich together with a cycle of heroines in horizontal format. Wilhelm drafted all the outstanding Bavarian and Swabian painters of the day; Altdorfer and Hans Burgkmair were the first. The commission was so important to Altdorfer that he declined a term as mayor of Regensburg in order to complete it. The picture represents the victory of Alexander the Great over the Persian monarch Darius at Issus in Asia Minor in the year 334 BC, as recounted by the first-century historian Curtius Rufus. The texts inscribed on the floating tablet and in various banners lofted by the armies were very

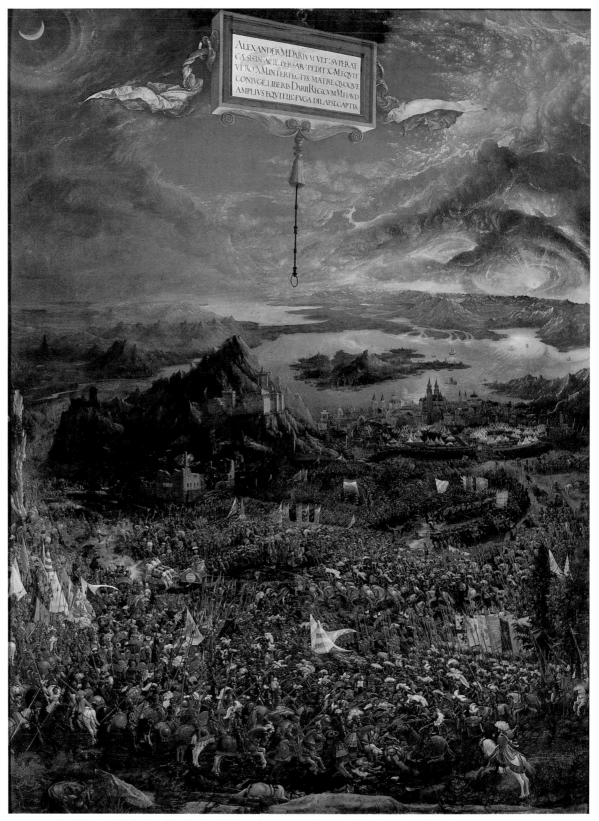

8 Albrecht Altdorfer, *The Battle of Alexander*, 1529, oil on panel, 158 x 120. Alte Pinakothek, Munich.

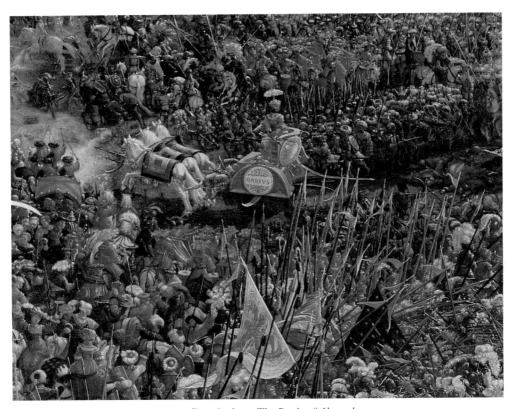

9, 10 Details from *The Battle of Alexander*.

likely composed by Aventinus, the Bavarian court historian, who was resident in Regensburg from 1528. The lower half of the picture describes Alexander's pursuit of Darius's chariot, slicing a path through a bristling, twitching carpet of soldiers. Darius throws a panicked glance backward, exactly as he does in the famous floor mosaic from the Casa del Fauno at Pompeii, which was not to see the light of day for another three hundred years (illus. 10). The upper half of the *Battle of Alexander* expands with unreal rapidity into an arcing panorama comprehending vast coiling tracts of globe and sky (illus. 9). It is as if the momentous collision of armies exploded outward into three dimensions, and was only then projected back onto a planar surface. For the picture represents an historical pivot, the expulsion of a force from the East, a muscular resistance to the left-to-right flow of history. The sun outshone the moon, just as the Imperial and allied army successfully repelled the Turks – massed under the sign of the Crescent – from the walls of Vienna in October 1529, the very year this picture was painted.

The *Battle of Alexander* is the foundation of Altdorfer's modern fame. As late as 1740 a German writer attributed the painting to Dürer.[27] But in 1800 Napoleon's Rhine Army carried it from Munich to Paris, and the work and its real author entered art history. In 1814 the victorious Prussian troops who commandeered Napoleon's residence at Saint-Cloud as their headquarters supposedly found it hanging in the Emperor's bathroom.[28] Napoleon must have discovered in Altdorfer the same sincere vigour that he savoured in his favourite poet, another 'northern Homer', the supposed primitive, Ossian. In the summer of 1804, the Romantic essayist and critic Friedrich Schlegel, one of thousands of post-war German pilgrims to the Louvre, saw the *Battle of Alexander* and marvelled. 'Should I call it a landscape, or a historical painting, or a battle piece?', Schlegel wondered. 'Indeed this is a world, a small world of a few feet; immeasurable, uncontrollable are the armies which flow against each other from all directions, and the view in the background leads to the infinite. It is the cosmic ocean. . . .' He ended by pronouncing the picture a 'small painted Iliad'.[29]

Schlegel's question introduces one of the recurrent themes of landscape painting in the West: the pretension to epic. Landscape painting magnifies outdoor setting at the expense of subject-matter. But as outdoor space expands, it offers itself again as the setting for still grander subjects. The far-flung spaces of the Roman ideal land-scapes of the seventeenth century, whose leading painters were Claude Lorrain and Nicolas Poussin, pulse with the aura of their mythological and historical subjects, no matter how minuscule those subjects appear. The rhythmic landscapes of Rubens portend vast narratives even when those narratives are physically absent. The give and take between the intimate and the epic landscape is encapsulated already in Altdorfer's career. Altdorfer's forest landscapes, such as the Berlin watercolour of the single tree, generate mood by relaxing temporal structures. They distil mood *from* narrative. Altdorfer's empty landscapes carried to a logical conclusion the pattern of extreme negligence towards narrative already manifested in a picture such as the *St George and the Dragon* in Munich, dated 1510, where man and monster are dwarfed by feathery bolsters of foliage (illus. 95). But even within Altdorfer's work, the peculiar

achievements of these pictures – their greenness, their textures – were constantly being absorbed back into epic, where they entered into restive tension with story and character. Landscape pressed itself into the foreground, literally or thematically, in all the largest and most imposing panels of his middle years: the lurid, nocturnal outdoor scenes from the Passion cycle of the St Florian altarpiece (illus. 50); the *Crucifixion* in Kassel, with figures like implacable totems before an immense, bulging panorama (illus. 11); the *Two St Johns* in Regensburg, rooted in the earth like fleshy fungi (illus. 12); the billowing, overgrown *Christ Taking Leave of His Mother* in London (illus. 13). The trifling, intimate, hand-held landscape can hardly stand comparison to such great-souled paintings as these. And yet, once planted within an epic, landscape could surreptitiously eat away at it from the inside, until the day when Schlegel could momentarily wonder whether the *Battle of Alexander* was actually a 'landscape'.

The purpose of this book is, in effect, to agree with Schlegel that it is not. In his true landscapes Altdorfer isolated certain pictorial qualities associated with the settings of narrative and made them the stuff of their own pictures. He prised landscape out of a merely supplementary relationship to subject-matter. This moment of isolation tends to get obscured when it is assumed that it was nature that furnished the principle of isolation. For a picture that retains nature while rejecting its antithesis, culture, can choose either to include or to exclude the human figure. The human figure need not disrupt nature; it can participate in and imitate natural processes, or it can share the painter's and the beholder's openness to nature. As a result, landscape in the West has been conspicuously tolerant of insect-like staffage or 'filler' figures, of embedded 'beholder' figures, and even of stories. In some cases the artefacts of culture themselves are assimilated to nature and thus granted safe passage within the landscape picture. Ruins or cemeteries in Ruisdael, for instance, or a watermill in Constable, are treated as if they were nature. In this tradition, therefore, it has not been strictly necessary to exclude subject-matter in order to win a reputation as a landscape painter.

Altdorfer's principle of exclusion was not the divide between nature and culture, but rather the divide between setting and subject. The emptiness of his landscapes is the hole once filled by the acting human figure. The clue is their verticality: these pictures derive structurally from small pictures with narrative and hagiographical subject-matter.

To recover a sense of the radicality and open-endedness of Altdorfer's invention, one needs to abandon any presumption of a pre-existent idea about nature, of a *Naturgefühl* or 'feeling for nature', or, indeed, of any primary experience of nature that his landscapes were meant to preserve. The idea of nature is so protean and problematic that a hypothesis about the origins of landscape that can afford to set it aside automatically becomes, by any standard of theoretical parsimony, highly attractive. But this is not so easy to do. Any interpretation of Altdorfer is burdened by the dense and prestigious later career of landscape painting. For many historians who were witnessing the closing phases of this career, landscape painting had come to compensate for the great dissociation of mind and nature which modernity seemed

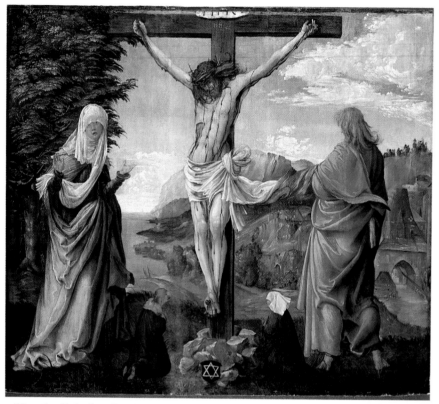

11 Albrecht Altdorfer, *Crucifixion with Virgin and St John*, c. 1515, oil on panel, 102 X 116.5.
Gemäldegalerie, Kassel.

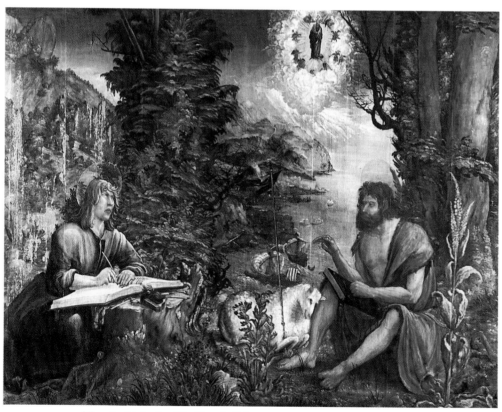

12 Albrecht Altdorfer, *The Two St Johns*, c. 1515, oil on panel, 173.2 X 233.6.
Stadtmuseum, Regensburg.

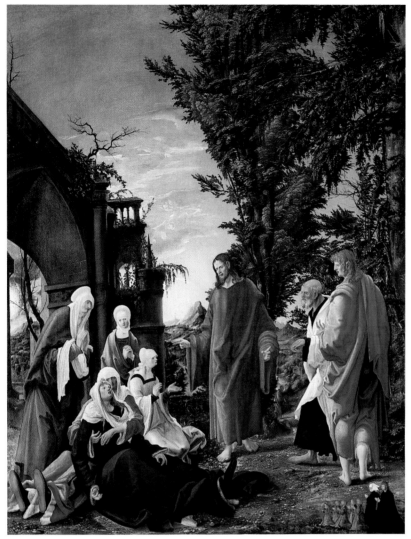

13 Albrecht Altdorfer, *Christ Taking Leave of His Mother*, 1520(?), oil on panel, 141 X 111.
National Gallery, London.

to suffer under. Landscape in the West was itself a symptom of modern loss, a cultural form that emerged only after humanity's primal relationship to nature had been disrupted by urbanism, commerce and technology. For when mankind still 'belonged' to nature in a simple way, nobody needed to paint a landscape. When poets, wrote Schiller, can no longer be the custodians of nature, 'and already in themselves experience the destructive influence of arbitrary and artificial forms, or have had to struggle against that influence, then they emerge as the *witnesses* and the *avengers* of nature. Either they *are* nature, or they will *seek* lost nature'. Landscape painting restored, momentarily, an original participation with nature, or even – in its greatest Romantic apotheoses – re-established contact with the lost sources of the spiritual. For Schiller, treading the fragile bridge between aesthetics and morality constructed by Kant in the *Critique of Judgement*, it was actually better to search for nature than to possess it. 'Nature makes [the poet] *one* with himself; art divides and

splits him in two; through the Ideal he returns to oneness. . . . The goal which man *strives after* through culture is infinitely preferable to that which he *arrives at* through nature.'[30] This potent model of cultural loss and redemption through art governed the Romantics' perception of their own situation. Moreover, it went on to pervade interpretations of the Renaissance. For a number of modern art historians, who came to see the Renaissance as a kind of prefiguration of the Romantic crisis, Altdorfer straddled a threshold of intellectual history. His works preserved a twilit image of a pre-modern animated cosmos, an organic totality infused with a divine spirit or linked by correspondence with a divine macrocosm.[31] There was indeed plenty of interest in such a cosmology in Altdorfer's time. Versions of pantheism, with ties to pagan cults, neo-Platonism and the occult, simmered in the writings of natural philosophers like Paracelsus, literary humanists like Conrad Celtis, and even radical Protestants. Altdorfer's landscapes have thus been understood as the belated epiphanies of a lost unified consciousness, talismans charged with authentic prelapsarian energy, perhaps demonic, perhaps simply pious and popular, or *völkisch*.

Sociological interpretations of the origins of landscape have been aimed directly against this sort of neo-Romanticism. Such interpretations dismiss the reunification with nature proposed by landscape painting as an aesthetic fiction. Art, in other words, should not deceive us into thinking we are actually making contact with nature; in pictures the culture merely constructs a nature. But materialist art history is often tinged with its own nostalgia, not for the pre-modern and pre-technological *art* of nature, but for a pre-bourgeois *life* of nature. Matthias Eberle, for example, following Schiller, Marx and Adorno, sees the Renaissance landscape as the expression of an urban or bourgeois consciousness of a new distance and detachment from the land. 'As long as nature stands in direct connection with human life', he explains, 'the connection between nature and human history does not need to be questioned'.[32] Landscape is the result of the subject's conversion of nature into an object. Eberle's own piety for nature remains intact. He accepts the reality of the original pre-modern oneness with nature, and thus laments the alienation that drove the painter to paint a landscape.

To dispel these various nostalgias for nature, one must preserve the critical insight that pictures themselves actually generate ideas about nature, and at the same time refrain from dismissing that 'secondary' image of nature as the phantasm of the aesthetic ideology. There is no use searching for nature either among the relics of a pristine and more authentic art, or in sensual and empirical life. Once the process of figuration is uncoupled from a prior natural object, one in fact loses confidence that nature will ever manifest itself anywhere but in that figure. Otto Benesch raised this possibility, an important complication of his own neo-Romantic argument about Altdorfer's cosmology, with the phrase *malerische Welteroberung* ('conquest of the world through painting'), which suggests the active part that picture-making took in the genesis of ideas about the cosmos. The phrase *All-Belebung des Bildorganismus* ('total enlivening of the picture-organism') in turn implies that the concept of the organic unity of the physical world was encouraged by the analogy with the pictorial

composition, with the formal coherence of the depicted landscape.[33] Equally, one could argue that the vigour and elusiveness of the artist's calligraphic style sharpened perceptions of the dynamic and the kinetic in the physical world. When Benesch, and following him Franz Winzinger, wrote that the early landscape transformed the beholder's religious piety into piety for nature, they implied that the rhetoric of the picture itself was capable of supplanting Christian iconography and installing a new subject.[34]

This hyperbole should not obscure the essential insight into the apriority of figuration that lies behind it. Ernst Gombrich, both in *Art and Illusion* and in his influential essay on Renaissance landscape, evoked with uncommon pungency the power of pictorial formulations to shape perceptions of real landscape.[35] The Venetian Lodovico Dolce attested to the overwhelming power of the image to displace the perception of the original, when he described a patch of landscape in a picture by Titian – adapting a commonplace of ancient writing on art – as so good that 'reality itself is not so real'.[36] More than a century later the French critic Roger de Piles observed that the bad habits of painters 'even affect their organs, so that their eyes see the objects of nature coloured as they are used to painting them'.[37] Verbal representations of landscape in the Renaissance, too, can hardly be trusted as simple registers of optical experience. Many apparently straightforward landscape descriptions were shaped by earlier literary treatments or by classical literary *topoi*. This has been amply demonstrated, for example, for the landscape descriptions of Aeneas Silvius Piccolomini (Pope Pius II), which figured so memorably in Jakob Burckhardt's account of the Renaissance 'Discovery of the World'.[38] Even Columbus's simple descriptions of the landscape of the New World, which Tzvetan Todorov read as testimony to an 'intransitive' admiration of beauty,[39] were moulded and constrained by an ideal of idyllic or paradisaical beauty.

The present study is aimed directly at this gap between the physical world and its image, between place and picture. In this respect it differs from some other accounts of the rise of landscape in the Renaissance, such as Otto Pächt's derivation of the Franco-Flemish calendar illustration out of the northern Italian nature study.[40] Altdorfer did not ground his landscapes in any fresh scrutiny of natural data. Instead, he worked from the frame inward. His landscapes began with strong gestures of style – flamboyant strokes of the pen, ostentatious inflammations of colour, extravagances of scale. This interpretation of the pictures will in turn begin with an historical account and localization of these gestures.

Svetlana Alpers in her extraordinary study of the visual culture of seventeenth-century Holland, *The Art of Describing*, showed how pictures *peculiarly* cast the world.[41] Any historical analysis of a pictorial culture, she argued, needs to be routed through an understanding of the special conditions of picture-making. The Northern, 'descriptive' painter in particular insisted on freedom from the expectations and exigencies of texts and their readers. Altdorfer certainly resisted texts, if anything even more so than Alpers's Dutch painters a century later. His work is equally poorly served by hermeneutic methods developed for the study of Italian narrative art. But

14 Albrecht Altdorfer, *Castle Landscape, c.* 1515, pen and pale red ink on parchment, from *The Prayer Book of the Emperor Maximilian*, size of page 27.7 X 19.3. Bibliothéque Municipale, Besançon.

Altdorfer was not a descriptive artist either. He did not seek meaning in the surfaces and textures of objects around him. Like many German painters he had another ambition: self-manifestation in the picture, through idiosyncratic line and generally through sharp-edged disregard of the criteria of optical verisimilitude. Michael Baxandall initiated one line of historical inquiry into the German 'florid style' in his *Limewood Sculptors of Renaissance Germany*.[42] Baxandall compared the sculptors' gratuitous elaboration of drapery lines to the preoccupation of the *Meistersinger* with melodic inventiveness and originality. The stylistic ambition, which almost literally 'flourished' in the decades immediately preceding the German Reformation, in the generation of Dürer and Altdorfer, cuts across the dichotomy of description and narration. It reveals another dimension of Northern art altogether. Description and narration are terms derived from Neoclassical literary theory.[43] Neither mode acknowledges, or has any particular use for, the so-called 'deictic' utterance, the utterance that calls attention to the circumstances of its own physical production. In linguistics, a deictic sign is a grammatical element (an adverb, a verb tense) which places the source of the utterance in some spatial or temporal relationship to the content of the utterance. A fictional character or a narrator engages in deixis by embedding information about the context of a statement within the very form of the statement.[44] Norman Bryson has complained that modern professional art history, uncritically acquiescent to received Christian and Neoclassical theories of the image, ignores the deictic reference.[45] Those theories, he argues, were excessively concerned with an image that simulated optical impressions of space. They legislated an efface-ment of the picture surface, and then set the fictive space to the task of narration. Bryson proposed, and has practiced, an alternative history of the somatic gesture preceding the picture: painting as a performing art, as it were. But Bryson overstated his grievance. It is true that art-historical scholarship has been excessively enthralled to the theologians and the rhetoricians. The paintings themselves, on the other hand, are not such assiduous propagandizers against the deictic interpretation. Nor has the best writing on Northern art been negligent. The ambitious German Renaissance artist deliberately packed his pictures with deictic markers. And no theorist was exhorting Altdorfer to abolish the material picture surface.

The project of distinguishing a Northern from a Mediterranean practice of painting provides one historiographical framework for this study. Another is the recently renewed recognition of the persistence and charisma, in late medieval and Renais-sance painting, of the icon. The Christian *imago*, the portrait of the sacred personage, was the institutional source and structural model of every independent painted panel. In a series of radically original inquiries into fourteenth- and fifteenth-century panel painting, Hans Belting has explicated the rhetoric of the early modern image as a set of responses to the prescribed and remembered functions of the Christian image. In an essay on Giovanni Bellini's *Pietà* in the Brera, for example, Belting shows how the medieval functional and formal categories *imago* and *historia* became the field for an overwrought professional rivalry among the outstanding painters of the late fif-teenth century.[46] Bellini and Mantegna were competing for the attention of the most

exacting northern Italian collectors. Belting recapitulates the successive fine-tunings of the pictorial categories: garrulous narrative was trimmed to an iconic core; the imperative and static image was then in turn reanimated in order to pull it back from iconicity. Out of this dialectic emerged a class of pictures whose consanguinities with the most ancient Christian images were at once more conspicuous and less binding than ever before.

A parallel track has been laid out by Joseph Leo Koerner in his work on Dürer's frontal *Self-portrait* in Munich.[47] Koerner shows how immemorial Christian concerns about the authenticity of sacred portraits framed that portrait, ceremoniously inscribed and dated 1500. Frontal portraits of Christ, in medieval tradition, all derived from an authentic original fabricated by direct physical contact with Christ's face. All such portraits shared in the prestige of the *acheiropoeton*, or the image made 'without hands', without the unreliable intervention of a human artist. Dürer thus commits a momentous double hubris: in the *Self-portrait* he places his own face, clear-eyed and bearded, in place of Christ's; and he competes with the perfection of divine fabrication by scrupulously concealing the trace of his own hand in the paint surface. Paint in this picture is a perfect match for the textures of hair, skin and fur; there is no visible remainder that can be attributed to 'style'. But this *tour de force* of self-concealment, which explicitly refers to the virtuosity of the Netherlandish pioneer of oil technique, Jan van Eyck, is itself the most spectacular possible boast and self-advertisement. Dürer submerges the trace of his brush hand; but then he raises his left hand – which is reversed in the mirror and thus looks like the right hand in the finished self-portrait – into the picture field, an emblem of the real subject of the portrait, the source of Dürer's fame, his performance.

The icon held the Christian beholder in a dialogue. It placed the beholder before the image of an other. The independent painted panel, descendant of the icon, became a principal venue for the Northern artist's presentation of self because it was the place where the beholder was most keenly and unavoidably aware of the artist's presence. That presence was always threatening to interrupt the dialogue between mortal and immortal. Thus the history and structure of the independent panel, and the theology of the Christian devotional image, become major contexts for Altdorfer's landscapes.

It is not difficult to situate Altdorfer within a contemporary discourse about the function and structure of the devotional image. He was living through the most tempestuous crisis of the Christian image since the eighth-century Byzantine iconoclasm. The utility and propriety of traditional religious imagery had become the subject of vituperative public debate in southern German cities. Like other German artists, Altdorfer was pressed into a political role. In 1519 and 1520 he supervised the production of devotional images commemorating a miracle performed by the Immaculate Virgin in Regensburg. The images became the focus and the fuel for a massive pilgrimage. Thousands worshipped and purchased Altdorfer's woodcuts and metal badges. The credulity and superstition of these pilgrims, and the fervid commerce of images, appalled many observers and helped to shift opinions in the direction

of Lutheran and Zwinglian reform. The first iconoclasm provoked by the Reform took place in Wittenberg in 1521; many similar episodes, orderly and violent, followed. And by the 1530s, long after the Marian pilgrimage had been discontinued, Altdorfer as a city councillor was actually encouraging the introduction of Lutheranism to Regensburg. Traditional Christian iconography was eventually either discredited or placed on the defensive in southern Germany. It was left to the secular works – pagan and historical subjects, portraits, so-called 'genre' painting, and landscape – to assert the innocence of painting.

The independent image was thus by no means to be taken for granted. The professional painter trying to pursue a career in this stormy climate had to secure his audience, and one way of doing this was to address that audience directly. Style – the heteroclite and unrepeatable mark – fixes the beholder's attention. The deictic trace implores the beholder to stay within the frame, to resist turning elsewhere for a narrative or a context that will justify the picture. This is essentially what Altdorfer was doing in his own time: authenticating the image with a rhetoric of personality that was only legible within the image. With his style he began to shift the project of self-presentation away from a sheer display of technical prowess towards a more complex manifestation of interpretative nuances: the capacity to make fictions, the assumption of a distinctive authorial tone. The act traced by style became an act of judgement as much as a physical stroke. But style still pointed back to a moment of execution, and the pointer has stuck to the work. Altdorfer's most aggressively stylish pictures, including the independent landscapes, have also proved unusually intractable to historical explanation. Iconography, format and function of a picture are more manifestly susceptible to external or material pressures. The artist's *characteristic* contribution to the picture, on the other hand, is irreducible and exempt from any possible causal explanation. Casting that contribution as a somatic gesture rather than as an intellectual design does not simplify matters. It is style that makes Altdorfer's landscapes so distinctive in tone and texture, so different from anything else around them, and indeed so different from one another. Most contextual interpretations – sociological, for example, or intellectual-historical – have quickly run up against their own limits.

This book will instead direct questions from within the history of German painting, and particularly from within Altdorfer's career. It begins by asking where landscape belonged physically and what formats and forms landscape took. It then asks what a picture was and how it could ever be self-sufficient; it tries to explain the structural and evolutionary relationships between independent landscape and pictures with subject-matter; it addresses the connection between the incipient category 'work of art' and a stable concept of the frame. All this 'philological' groundwork is laid out in the rest of this chapter and in the next. Chapter Three reads the paintings and watercolours as representations, carried out on more than one semantic level, of a native or regional landscape. The forest appears in these pictures simultaneously as a potential refuge from orthodox but idolatrous cult practices, and as the mythical setting of heathen idolatry. The landscapes themselves, finally, refer formally to older Christian images and thus complicate any claim that landscape as a genre may be

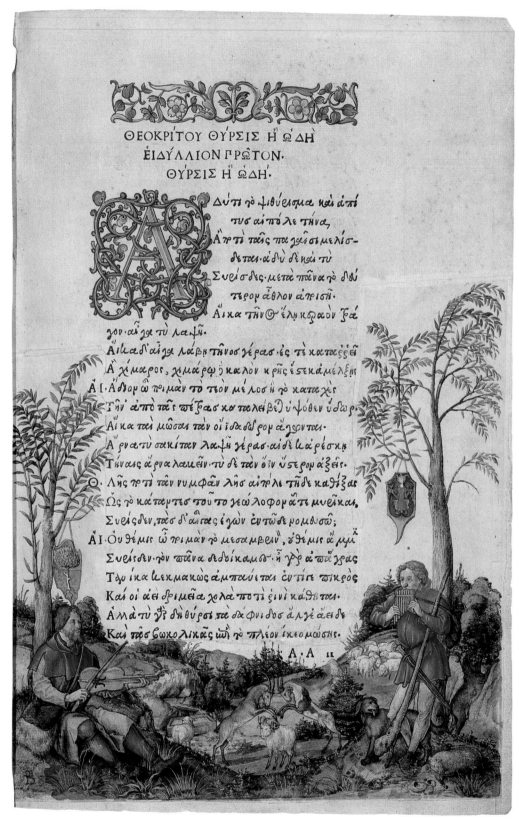

15 Albrecht Dürer, *Shepherds Making Music*, miniature on parchment, pasted into a
printed edition of Theocritus, Venice, *c.* 1495–6, size of printed page 31.1 x 20.2.
Ian Woodner Family Collection, New York.

making to doctrinal innocence. Chapter Four, on the pen-and-ink landscape drawings by Altdorfer and his colleague Huber, analyses the tension between the task of topographical description and the stylistic and fictional imagination. These drawings, but even more so the etchings discussed in chapter Five, mark the establishment of a secular culture of amateurism and collecting. Altdorfer's landscape etchings were mechanical reproductions of pen drawings. The trace of the artist's hand is visible but no longer present in the work. Moreover, the etchings reintroduced, through their horizontal format, an epic dimension to landscape. These etchings were the only real bridge linking Altdorfer's experiment to the next generation of German landscapists, and ultimately, through Bruegel, to the future of landscape.

Where landscape could appear

'Independent' is really a negative description: it tells us more about what Altdorfer's landscapes are not than about what they are. The independent landscape is, first of all, a complete picture not physically connected to any other picture. It is neither an element of a decorative scheme, such as the painted wall of a villa, nor part of an illuminated manuscript. It appears neither on the shutters of an altarpiece or a portrait, nor as the mere background of a narrative composition or a portrait. The independent landscape makes a clean break with the topological conventions of the dependent landscape. But it is not an unpredictable break: it follows already visible fault lines.

Landscapes in the late Middle Ages appeared above all on walls, either in tapestries or mural paintings. By the fifteenth century painters could confirm the antiquity of the practice by consulting Pliny's *Natural History*. The first-century Roman fresco painter Studius (or Ludius) had painted – in Lorenzo Ghiberti's paraphrase – 'land-scapes [*paesi*], seas, fishermen, boats, shores, greenery'.[48] But nearly all the works inspired by such texts have perished. An inventory of 1492, for example, reveals that the Medici owned some large Flemish *paesi* on canvas.[49] But tapestries, paintings on cloth, and domestic frescoes were particularly vulnerable to depredations of climate and shifts in taste. This is a chapter of the history of European art that will never be written.[50] Among the best surviving mural landscapes are the festive and hunting scenes at Runkelstein (Roncolo) near Bolzano, and the cycles of the months in the Torre Aquila at Trent, both dating from *c*.1400. The frescoes at Trent, visible through an illusionistic loggia, were commissioned by Bishop George of Lichtenstein, probably from a Bohemian painter (illus. 16).[51] Horizons are kept high to make room for as much earthly business as possible: mowing, raking, scythe-sharpening, fishing, love-making, all in the month of July. Hartmann Schedel, the learned author of the Nuremberg Chronicle, once described a series of murals he saw in a monastic library in Brandenburg in the 1460s.[52] A scene labelled 'Agriculture' looked like a Garden of Love; 'Hunting' was set in a dense grove; both scenes fell under the category of Mechanical Arts. The pretext of these long-lost frescoes was didactic, but the treatment, according to Schedel's *ekphrases*, was highly pictorial. Swiss and Alsatian tapestries, meanwhile, described the domestic and public misadventures of the sylvan

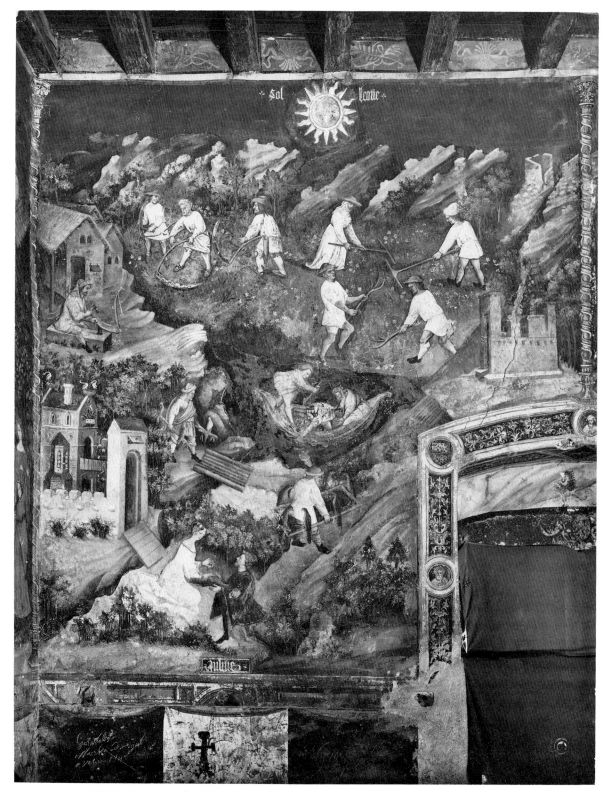

16 Bohemian master(?), *July*, *c.* 1400, fresco, Torre Aquila, Castello del Buonconsiglio, Trent.

17 English master, *On Water and its Ornaments*, woodcut, 15 x 15, from Bartholomeus Anglicus, *Die proprietatibus rerum*, London, 1495. Houghton Library, Harvard University, Cambridge, Mass.

Wild Man.[53] All these scenes retained some narrative or allegorical dimension. They described social types from opposite ends of the spectrum of wealth and elegance, and they described human activities, both work and leisure. Good painters did not disdain the decorative landscape. Vasari described the loggia that the Perugian Bernardino Pinturicchio painted for Pope Innocent VIII in the 1480s as *tutti di paesi . . . alla maniera de' Fiamminghi*, 'which, as something not customary until then, pleased very much.'[54] Some walls were simply decked with *trompe-l'oeil* foliage. Leonardo himself, in 1498, painted a pergola of tangled vines and branches on a vaulted ceiling in the Castello Sforzesco at Milan; on the wall he exposed a miraculous cross-section of rocky subsoil intercalated with roots and a hollow-eyed cadaver.[55]

Landscapes in illuminated manuscripts usually replicated the types and themes of the wall scenes. But others were truly empty. This extraordinary material has never been properly surveyed. Already in the 1320s the Parisian miniaturist Jean Pucelle had evacuated his spare, schematic landscapes on the calendar pages of a Book of Hours, illustrating the passage of the Seasons not by the cycle of human labours, but by the clothing of the earth itself.[56] A Bruges master, perhaps the Master of Mary of Burgundy, painted in a Book of Hours of around 1490 a series of rural landscapes with signs of the zodiac in the skies.[57] A rural landscape is painted on the first page of a fragmentary Prayer Book in the manner of Alexander Bening from the early 1490s.[58] The Prayer Book of James IV of Scotland in Vienna contains twelve half-page landscapes, again with zodiac signs, executed by a painter of the Ghent–Bruges school between 1503 and 1515.[59] Otto Pächt has traced at least some aspects of this sudden Franco-Flemish fascination with the earth's surface back to naturalistic northern Italian illustrations of herbals and bestiaries.[60]

35

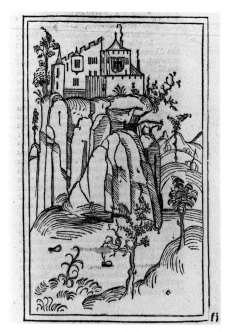
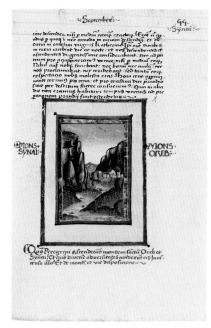

18 German master, *Castle Langenargen*, woodcut 18.8 x 11.9, from Thomas Lirer, *Chronik von allen Königen und Kaisern*, Ulm, 1486. Beinecke Rare Book Library, Yale University, New Haven.
19 German master, *Mounts Horeb and Sinai*, before 1508–9, miniature from a manuscript copy of Felix Fabri's *Evagatorium*, vol. 2, owned by Hartmann Schedel, 10.9 x 7.8. Bayerische Staatsbibliothek, Munich.

Manuscripts furnished various pretexts to paint empty landscapes. In Bartholomeus Anglicus's *De proprietatibus rerum* and other high-medieval encyclopaedias, the sections on materials and elements, birds, trees, the seas, the earth and the provinces of the world were frequently illustrated with schematic landscapes. Many of these were carried over into the illustrations of the earliest printed versions, like the woodcut from the section of Bartholomeus Anglicus on 'Water and its Ornaments' in an English edition of 1495 (illus. 17).[61] Herbals or medical handbooks also depicted depopulated places. A manuscript *Tacuinum sanitatis* in Liège, Lombard work of the late fourteenth century, offers a spare and empty landscape under the heading 'Snow and Ice', alongside the customary wheatfields and orchards.[62] In topographical treatises and travel descriptions, columns of text were increasingly interrupted by pictorial maps. The most spectacular were the woodcut urban panoramas in Bernhard von Breydenbach's *Peregrinatio in Terram Sanctam*, printed in Mainz in 1486, and in Schedel's Nuremberg Chronicle of 1493, with 1,809 woodcuts printed from 645 different blocks (illus. 36).[63] Some of the simplest topographical woodcuts were also the most picturesque, for instance the view of Castle Langenargen on the Gaisbühel, recently built, in Thomas Lirer's *Swabian Chronicle*, published in Ulm in 1486 (illus. 18).[64] Around 1508–9 Hartmann Schedel pasted a miniature painted in bright matt blues and greens into his manuscript copy of the pilgrimage report of the Dominican Felix Fabri. Framed with red bands and captioned in the margins by Schedel himself, the miniature portrays Mounts Horeb and Sinai in the Holy Land (illus. 19).[65]

36

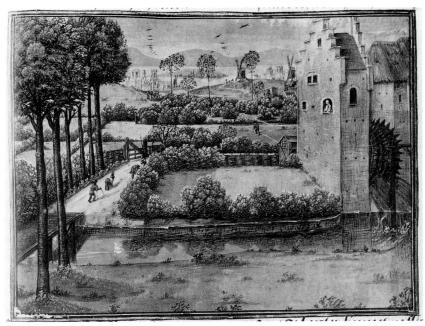

20 Flemish master, *Flemish Countryside*, c. 1470, 16 x 22, miniature from Cotton MS, British Library, London.

Otto Pächt called attention to a remarkable miniature landscape illustrating a topographical text produced in Bruges *c.*1470 (illus. 20).[66] The scene is nothing more than a vignette of ideal rural existence, complete with a cripple, a mounted knight, windmills and watermills, and a very thin, gabled building, all laid out along trim orthogonals. Detail does not imply specificity: the scene is no portrait of a real place, but is in fact an adaptation of a landscape setting from an earlier narrative illustration. The desire to construct appealing landscapes took root even in the most arid textual environments. As Walter Cahn has recently pointed out, there is no *a priori* obligation to sever the medieval descriptive or classificatory impulse from more affective, even if poorly articulated, attitudes towards the outdoors.[67]

Some illuminators seized any pretext to frame a landscape. An agrarian panorama painted in Regensburg in 1431, with trapezoidal fields and a heap of prismatic rocks, actually illustrates a moralistic text about larks (illus. 21).[68] Other book painters exploited the lower margin or *bas-de-page*. Innovations, in Pächt's phrase, often appeared first at the point of least resistance.[69] The *bas-de-page* opened up when miniaturists converted the lower edge of the frame, wound with schematic leaves or *rinceaux*, into a ground plane. Suddenly blank page signified space.[70] Jan van Eyck in the Turin Hours (early 1420s), stretched a Baptism of Christ into a cool river landscape along the bottom of a page.[71] Altdorfer, too, when asked by Emperor Maximilian to make marginal drawings for a printed Prayer Book, took advantage of the lower strip to draw a landscape – a spectral massif of turrets and crenellations on a rocky hill – in pale red ink (illus. 14).[72]

Occasionally, empty landscapes found their way into the marginal zones of altarpieces. They became part of the diverse apparatus that surrounded the painting at

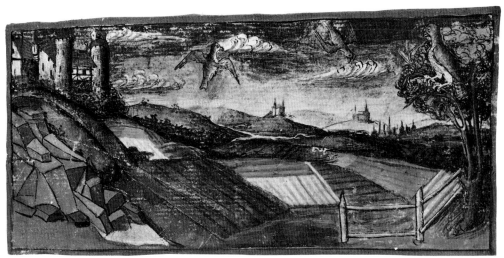

21 German master (Regensburg school), *Landscape with Larks*, *c.* 1430, miniature from manuscript of Hugo von Trimberg, *Die Renner*, size of page 40.8 x 28. University Library, Heidelberg.

the centre of the altarpiece. A long, low frieze of mountains serves as the predella or base to Lorenzo Lotto's Assumption altar in the cathedral at Asolo, dated 1506 (illus. 22).[73] The landscape measures 25 x 146 centimetres, and includes a chapel on a hill, a walled city with a citadel, and, on the lower edge, a row of still-lifes: two quails, a sprig of flowers supporting a butterfly, a crayfish and two partridges. The predella is treated as if it were part of the frame; for Gombrich this explained the simulation of *intarsia* or inlaid wood in the foreshortened terrain.[74] This appears to be the only uninhabited landscape in an Italian predella. A restoration report of 1822, however, suggested that the Asolo panel is actually a Baptism of Christ with its middle section removed, and that it originally belonged to another, wider, altar that was not by Lotto at all.[75]

Narrative scenes painted on predellas, like the sabotaged Baptism, were indeed often unified by landscape settings. Horizontal strips of landscape were frequently painted along the lower edge of the altar painting itself. Karel van Mander in 1604 described a work he knew by the fifteenth-century Dutch painter Albert van Ouwater: 'at the foot (*voet*) of the altar was a pleasant (*aerdigh*) landscape in which many pilgrims were painted. . .'.[76] The altar is lost, but the scene may have been a detached predella. A sixteenth-century chronicler reported a watercoloured Hell on the *voet* of the van Eycks' Ghent altarpiece; no one can agree whether this was a predella or an antependium, that is, a cloth or panel hanging from the altar table itself.[77] In a Sicilian–

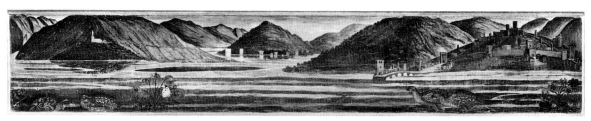

22 Lorenzo Lotto(?), Predella from *Assumption* altarpiece, 1506(?), oil on panel, 25 x 146. Cathedral, Asolo.

23 Albrecht Dürer, *Madonna and Child Above a Rocky Landscape, c.* 1515, woodcut, diameter 9.5, height 14.9. Museum of Fine Arts, Boston.

Venetian altarpiece of 1489, the *Madonna of the Rosary* in Messina by Antonello de Saliba, a landscape panel is physically inserted into the bottom of the main composition. This picture within a picture represents a city against a backdrop of mountains. The landscape, or the panel, is watched over by angels holding a propitiatory banderole, and is not spatially coordinated with the rest of the scene at all.[78]

'Internal' predellas – strips of landscape at the lower edge of an altar painting, inside the frame – often represented the earthly realm in contradistinction to a heavenly event hovering in the sky. Dürer used the device in his Landauer altarpiece of 1511, and Altdorfer in a panel now in Munich, a Madonna and Child among angelic music-makers borne on a cloud above a mountain landscape.[79] In Altdorfer's picture, the emblem of heaven's eclipse of the world is a fir-tree brutally truncated by the sacred cloud. Dürer around 1515 made a curious woodcut, perhaps an experiment, with a flinty, wedge-shaped landscape at the lower edge and a Madonna and Child suspended above in a circle (illus. 23).[80] Panofsky wondered whether the woodcut was not printed illicitly from two separate drawings by Dürer.[81] Many later collectors disliked the effect and cut the landscape away. Lorenzo Lotto himself introduced a clutch of Germanic thatch-roofed farm buildings into the base of the Assumption at Asolo, in the main panel just above the disputed predella. The strip of landscape with woodsmen in Lotto's *Sacra Conversazione* in Edinburgh, bizarrely, runs across the top of the composition.[82]

The backs of altarpieces and altar covers also became breeding grounds for unorthodox pictorial and iconographic themes. These surfaces were separately framed but still physically attached to the primary picture. The backs of many fifteenth-century German altars – for example the altar by Wolgemut, Dürer's teacher, at Zwickau in Saxony – are coated with mazy coils of painted foliage.[83] The reverse of the Uttenheim Altar of *c.*1470, south Tyrolean work close to Michael Pacher, combines foliage with a portrait of Christ as the Man of Sorrows, a devotional subject also found frequently on the backs of altars, as if taking refuge from the chaotic grid of the narrative sequences on the front.[84] Hans Memling painted two tall, bushy landscapes inhabited by cranes and a fox on the backs of a pair of panels representing saints, the wings of a lost small altarpiece.[85]

Around 1511, on the back of the wings of a triptych now in Palermo, the great Antwerp master Jan Gossaert painted a Paradise with Adam and Eve, a subject that could never take over the centre of an altarpiece.[86] It is as if the outside surface of the closed wings only half-belonged to the triptych as a whole, and incompletely shared its function; the outside enjoyed iconographic license and could thus represent a realm prior to and outside of sacred history. Altdorfer, too, painted a prelapsarian landscape: Adam and Eve in a feathery forest on the outside wings of a triptych, the 'regiments' of Bacchus and Mars on the insides. The central image of the triptych – the portrait of a humanist, or even a mythological subject, the core of a possible 'pagan altarpiece' – is lost.[87] Most remarkably of all, Gerard David of Bruges painted at some point in the 1510s two vertical forest landscapes on the outsides of the wings to a Nativity altarpiece (illus. 24).[88] In the left panel David depicted a cottage and an ass, in the right panel two oxen drinking at a pond. No one has been able to explain these landscapes. If this is Paradise, where is the first couple? Perhaps the wings represent the resting place of the Holy Family on the Flight into Egypt, the episode that immediately preceded the Nativity. The ass and the ox belonged to the conventional bucolic audience of the Nativity; sometimes they were differentiated as symbols of Old and New Testament, although not conspicuously in the Nativity behind these wings.[89] Perhaps David liked the effect of an empty, leafy space waiting at the end of an arched, sun-dappled, forest-like nave, as if he were inviting a beholder to enter a numinous grove. Esther Cleven has recently proposed that David, who habitually painted tall, billowing trees in the backgrounds and margins of his altars and devotional panels, was offering the landscapes as a kind of signature or trademark. The wings referred well-informed beholders to other pictures, including various versions of the Rest on the Flight, by David.[90]

Angelica Dülberg has recently assembled a huge repertory of eccentric subjects and motifs – still-lifes, emblems and devices, allegorical figures in landscapes – painted on the backs and on the covers of fifteenth- and sixteenth-century portraits.[91] A portrait by Memling in New York of a young woman standing at a window, for example, was attached to an upright landscape now in Rotterdam with a pair of horses and a monkey.[92] At least one of Lorenzo Lotto's small painted allegories was a portrait cover (see p. 51). A seventeenth-century inventory describes a lost work

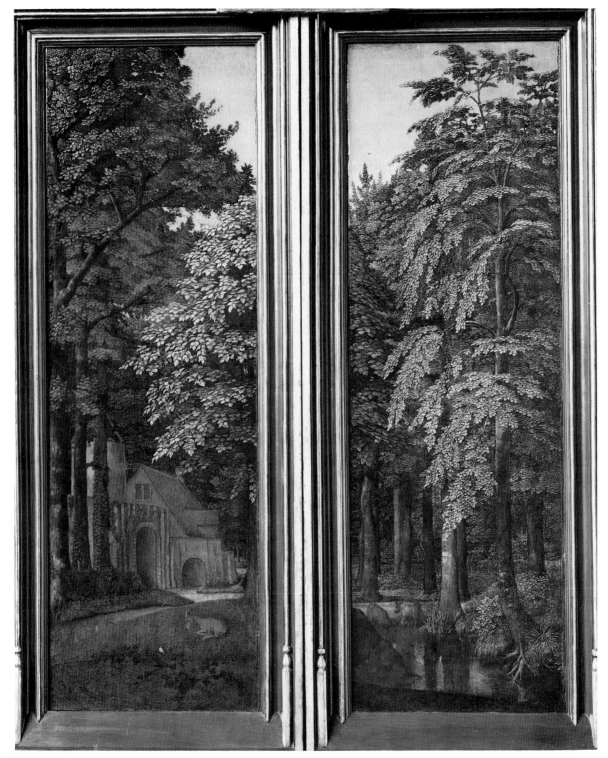

24 Gerard David, exterior wings of *Nativity* altarpiece, 1510s, oil on panel, 90 x 30.5.
Rijksmuseum, Amsterdam, on loan to the Mauritshuis, The Hague.

by Dürer with a 'landscape, a hunting-scene, lovely foliage' and two women holding the arms of the Pirckheimer and Rieter families, painted on parchment pasted on panel. The panel may originally have covered a portrait diptych of Willibald Pirckheimer and his wife Creszentia Rieter that was executed sometime between 1495 and 1500.[93] Portrait covers were places where iconography could run wild.

But most landscapes in this period simply appeared in the backgrounds of other paintings. The word *landscape* in Renaissance texts most frequently refers to an area within a panel painting, such as the background of a narrative composition or a portrait. Pinturicchio, for example, agreed in a contract of 1495 to paint 'in the empty part of the pictures – or more precisely on the ground behind the figures – landscapes and skies.'[94] An early altar contract from Haarlem stipulated that 'the first panel where the angel announces to the shepherds must have a landscape'.[95] Dürer referred routinely to the 'landscapes' in two sacred pictures in letters of 1508 and 1509 to his patron Jakob Heller.[96] A contract for an altarpiece in Überlingen on Lake Constance from 1518 specified that the *landschaften* in the scenes on the wings be painted in the 'best oil colours'.[97] In Leonardo's notebooks, *paese* refers to countryside itself as an object of imitation, but at least in one case means the landscape within the picture.[98] Dürer, too, according to Willibald Pirckheimer's afterword to the *Four Books on Human Proportion* (1528), had planned to write about landscape.[99]

Painting backgrounds was a specialized skill. Workshops collected model drawings of landscape motifs which were later copied into paintings. Nuremberg and Bamberg workshops in Altdorfer's time, for instance, preserved accurate drawings and water-colours of local buildings and skylines and inserted them in the backgrounds of altar paintings (see pp. 208–11 and illus. 69, 145–9). Italian amateurs of painting had long admired *paesi ponentini*: 'Western', or Flemish, landscapes.[100] The antiquarian Ciriaco d'Ancona saw a painting by Rogier van der Weyden in the 1450s and mar-velled at the 'blooming meadows, flowers, trees, and shady, leafy hills', as if Mother Nature herself had painted them.[101] Some Italian workshops employed Netherlandish specialists to paint landscape backgrounds. According to Vasari, Titian kept several 'Germans' (presumably Flemings) under his own roof, 'excellent painters of land-scapes and greenery'.[102] Flemish landscape backgrounds were so admired that some Florentine artists copied them directly into their own works. Botticelli enlarged the background of Jan van Eyck's *Stigmatization of St Francis*, a tiny devotional panel that survives in two versions, in Turin and Philadelphia, and adapted it to his *Adoration of the Magi* in London.[103] In the 1490s the Florentine Fra Bartolommeo copied a landscape from a Madonna and Child by Hans Memling (illus. 25), directly into his own Madonna and Child.[104] One Italian miniaturist actually detached Memling's landscape from its composition and presented it as a picture in its own right (illus. 26). The Flemish vignette, with half-timber watermill and a serpentine brook, becomes in the *Zibaldone* or 'commonplace book' of Buonaccorso Ghiberti (grandson of Lorenzo) an illustration to a discussion of the casting of bells. The copyist, probably Buonac-corso himself, merely subtracted Memling's swans and added a pair of smelting pots in the right foreground as the iconographical pretext.[105] The landscape backgrounds

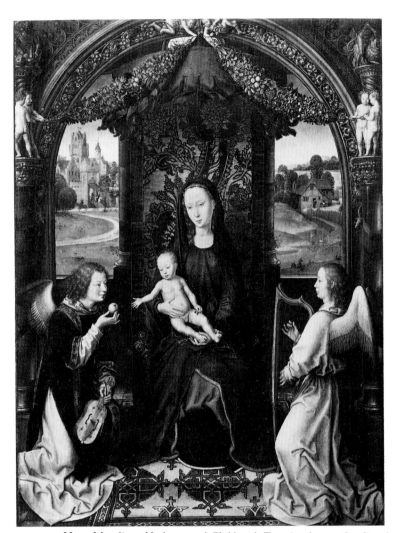

25 Hans Memling, *Madonna and Child with Two Angels*, c. 1480s(?), oil on panel, 57 x 42.
Uffizi, Florence.
26 Italian master, *Casting of Bells*, c. 1472–83, miniature, from the *zibaldone* of Buonaccorsi Ghiberti.
Biblioteca Nazionale, Florence.

of Dürer's engravings proved the richest lode of all. Marcantonio Raimondi, Cristofano Robetta, Nicoletto da Modena, Zoan Andrea, Giulio Campagnola and Giovanni Antonio da Brescia all transplanted trees and buildings from Dürer into their own engravings.[106] Even Vasari relished the 'most beautiful huts after the manner of German farms' in Dürer's *Prodigal Son* engraving.[107]

The next step for some Flemish painters was to let the setting dominate the picture, and indeed to make setting into the basis for the classification of the picture. Joachim Patenir of Antwerp, emboldened by the Italian taste for Northern rusticity, began as early as the 1510s to expand the backgrounds of his paintings out of all proportion. Patenir and many followers in Antwerp over the next decades painted horizontal panoramas of fantastic landscape seen from a bird's-eye view. A painting like the *Rest on the Flight* in Madrid technically still had subject-matter. But it violently reversed the

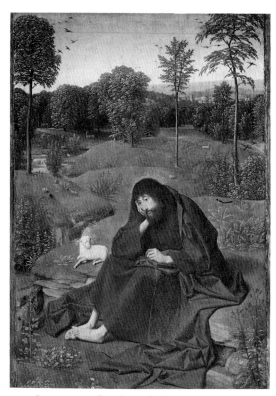

27 Geertgen tot Sint Jans, *St John the Baptist in the Wilderness*, *c.* 1475, oil on panel, 42 x 28. Gemäldegalerie, Berlin.

28 Joachim Patenir, *Rest on the Flight into Egypt*, oil on panel, 121 x 177. Museo del Prado, Madrid.

ordinary hierarchy of subject and setting (illus. 28).[108] Indeed, in at least one case –
the *Temptation of St Anthony*, also in Madrid – Patenir painted the landscape but left
the foreground figures to his friend Quentin Massys.[109] Patenir converted a workshop
speciality into a livelihood and a reputation. Dürer met Patenir in 1521 while travelling
in the Low Countries and referred to him in his journal as 'the good landscape
painter'.[110] Moreover, the Italian enthusiasts of Netherlandish painting did not hesi-
tate to describe pictures which still had recognizable subject-matter as landscapes.
The term was even extended to earlier pictures. The Venetian patrician and amateur
Marcantonio Michiel saw in 1521 an entire group of *tavolette de paesi* attributed to
Albert of Holland, presumably the early Dutch painter Ouwater.[111] These were not
independent landscapes by any means, not even panoramic landscapes with dimin-
ished subjects, but probably small devotional panels with notably green backgrounds,
much like the moody portrait of *St John the Baptist in the Wilderness* (illus. 27) by
Geertgen tot Sint Jans, a younger contemporary of Ouwater, also of Haarlem.[112]

Much innovation in the history of art involves excavating subjects and ideas from
hidden or marginal places and throwing them out onto a public surface, a prestigious
surface. Many of the painted proverbs of Hieronymus Bosch, for example, enjoyed
a clandestine prior existence in the margins of manuscripts or among the carved
misericords on the undersides of choir-stalls.[113] The mechanics of the relocation of
the landscape – the promotion of the landscape from the margin to the centre – will
be the subject of chapter Two. This promotion was accomplished first by assigning
the landscape a name, and thus an invisible and virtual frame, and then by sealing
it off from texts and other pictures with a physical frame.

Landscape and text

Max J. Friedländer, who in 1891 published the first book on Altdorfer, later wrote
that 'in the Netherlands we can, if put to it, trace the germination and efflorescence
of landscape as an historical process – at least we are impelled to make the attempt'.
But, he conceded, 'faced with south German art, the historian lays down his arms'.[114]
There are a number of reasons for this. Interpretation of the Netherlandish landscape
has been facilitated by its affinities with conventions of mapmaking.[115] Artists used
to make symbolic world maps by dividing a circle into three horizontal bands standing
for sea, land and sky. Pisanello, in the mid-fifteenth century, put such a shorthand
map on a bronze medal – once again, the verso of a portrait. The circle reduces the
vast globe, symbol of the worldly dominion of the sitter, Don Iñigo d'Avalos, to a
wavy sea, a strip of cities and pointed mountains, and a starry sky (illus. 29).[116] The
tiniest world map of all, another aerial-urban-aquatic abbreviation, appears in a
Dutch manuscript of 1431 (illus. 30).[117] This is a medallion painted on the imaginary
sarcophagus of Darius described in the vernacular legend of Alexander the Great.
The text reports that Apelles, no less, 'installed the round world' on this tomb, and
'made and engraved all the cities that were there, and all the rivers, and all the people
that lived there; and those languages that were spoken there, and the great water

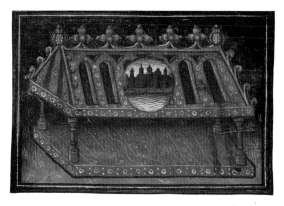

29 Antonio Pisanello, Portrait medal of Don Iñigo d'Avalos, verso with 'world map', *c.* 1448–9, bronze, diameter 7.7. British Museum, London.

30 Dutch master, *Tomb of Darius*, miniature from a manuscript *Historie des Bijbels*, Utrecht 1431. Bibliothèque Royale, Brussels.

inland; and also all the islands of the sea and what they are called'. On the manuscript page the medallion measures less than two centimetres across. The fifteenth-century Flemish panel painting would clear considerably more room for its microcosms.

Both the steady, earthbound eye of the urban topographer and the imaginary vantage-point of the pictorial map implied an intellectual grasp of terrain, the knowledge of the geographer or the cartographer. This was not a textual function; on the contrary, the topographical picture exploited a capacity of images that language could never rival. But it was a function textual culture could acknowledge. Literary humanists praised and justified painting as an instrument of knowledge: in 1336 a lettered Venetian referred to a cache of papers containing a picture or plan (*une figure*) of Florence by Giotto;[118] almost two centuries later Raphael undertook a monumental pictorial catalogue of Roman antiquities. The humanist Bartolommeo Fazio described in 1456 a 'circular representation of the world' painted by Jan van Eyck for Philip the Good, Duke of Burgundy, which was presented to King Alphonso of Aragon. In this work, 'more perfect than any of our age', one distinguishes 'not only places and the lie of continents, but also, by measurement, the distances between places'. The Eyckian *mappemonde* was probably a bird's-eye panorama of a slightly convex terrestrial surface, and may have been overlaid with Ptolemaic longitudinal and latitudinal coordinates.[119]

This is not to say that the Germans neglected cartography. Martin Behaim of Nuremberg constructed the very first globe – his *Erdapfel*, or 'earth-apple' – in 1491–2.[120] Dürer, in one of the drafts for the introduction to his treatise on painting, claimed that 'the measurement of the earth, the waters, and the stars has come to be understood through painting'.[121] Dürer may have encountered the thoughts of Leonardo, who had boasted in his own unpublished treatise that painting, 'by virtue of science, shows on a flat surface great stretches of country, with distant horizons'.[122] In 1515 Dürer published a woodcut projection of the globe and a pair of star charts for the imperial astronomer Johann Stabius.[123] Veit Stoss, the Nuremberg wood sculptor, showed his carved and painted *mappa*, possibly the earliest full-relief land-

scape model, to the calligrapher and art-historical chronicler Johann Neudörfer.[124] Literary culture paid tribute to this notational capacity by comparing its own verbal descriptions to pictures. Humanists in Dürer's and Altdorfer's time conventionally held up the panel painting as a paragonal format for descriptions of the universe, a more adequate medium for this task than language. Conrad Celtis, travelling scholar and poet laureate, compared Apuleius's cosmographical treatise *De mundo*, which he edited in 1497, to a small painting or sculpture: 'they learn, as it were from a small panel or sculpture of words, how and by whom this universe is put together and maintained in its form.'[125] Johann Cuspinian, the Viennese poet and physician, promised in his university lectures *c*.1506 on Hippocrates 'to describe, just as the painters do, the entire world on a small panel'.[126] Celtis, finally, in the dedication to the *Amores*, his geographical love poem published in Nuremberg in 1502, promised that 'our Germany and its four regions' would be visible 'as if painted on a small panel'.[127] In this case Celtis actually designed for his book, through the agency of Dürer's workshop, four woodcut panoramas based on astrological calendar scenes. The walled city at the centre of the woodcut introducing book Two – the account of Celtis's romance with 'Elsula' – is Regensburg itself (illus. 31).[128]

But, in general, the exemplary pictures to which the humanist formulas refer never existed. These passages belong to the general humanist justification of descriptive language under the Horatian motto *ut pictura poesis*. They sound like disingenuous apologies for a rhetorical topos (the *ekphrasis tou topou*, or description of place[129]) or a literary form (the cosmographical treatise) that, in fact, required no apology. They reflect either a general epistemological or pedagogical preference for the sensory over the intellectual, grounded in some version of Nominalism or anti-scholasticism,[130] or the more ancient preference for sight over the other senses, formulated by both Plato and Aristotle and invoked by Leonardo and Dürer in their writings on painting.[131]

The acknowledgement of a common purpose with textual culture helped legitimate the new Netherlandish landscapes of the 1510s and 1520s. It was, after all, not hostility toward subject-matter which distinguished these pictures, but rather the generosity toward terrain displayed by the horizontal format and the high horizon. Horizontality was an essential element of the novelty of the sixteenth-century Netherlandish landscape. Portable panel paintings were almost always vertical in format before 1520. Patenir's landscapes were among the first small horizontal panels of any sort. Horizontality was implied in the very word 'landscape', which at least in Italian (*paese*), German (*Landschaft*), and Dutch (*landschap*) meant terrain or countryside itself before it meant painted landscape. (English broke the pattern by absorbing the Dutch word in its secondary, pictorial meaning as early as the 1580s, and only later extending it to actual terrain.) Paracelsus, the sixteenth-century German physician and natural philosopher, used the word in this sense in his treatise on images: 'There are other kinds of chiromancy – a chiromancy of herbs, one of the leaves on trees, one of wood, one of rocks and mines, one of landscapes through their roads and water-courses.'[132] (Paracelsus, incidentally, called the specialist who is supposed to read the palm of landscape the *cosmographus*.) The horizontal format offered the

31 Workshop of Albrecht Dürer, *Elsula Alpina*, woodcut, from Conrad Celtis's *Quatuor Libri Amorum*, Nuremburg, 1502. Houghton Library, Harvard University, Cambridge, Mass.

landscape as a surface to be read. It encouraged discursive speculation about man's relationship to the surface of the earth, about the relationship between place and event, about the local and the universal, about time, travel and work. There was no obvious advantage in expunging subject-matter altogether, for the diminutive human figure, embedded in a magnified world, only multiplied and complicated meaning. The horizontal format permitted a smoother introduction of epic themes and grandiose moods into landscape. The Antwerp landscapes flowed directly into the main tradition of European landscape, through Bruegel to Rubens and beyond.

Most of Altdorfer's landscapes are vertical in format. They are hardly the *tabellae* that the humanist cosmographers had in mind. Because the horizons are narrow and low, the pictures are uninformative about terrain. Whereas the high horizon of the Netherlandish panoramic landscape implied a detached and omniscient narrator, Altdorfer's pictures not only imply but sometimes actually represent a real physical standpoint for the beholder of the scene. His points of view are more plausible and empirically more familiar than those of Patenir. This is the basic structure of most of Altdorfer's narrative paintings, prints and independent drawings, indeed even when they are horizontal in format. In narrative pictures, the rhetorical effect of the low point of view is obvious: the painter offers himself as eyewitness to an event and invites the beholder to share that privilege. It is not so clear, however, what purpose was served by a low angle on open terrain, or within an empty forest.

That emptiness is the absence of a narrative. Altdorfer's landscapes do not merely fail to tell a story: they are also empty of subject-matter itself, the raw material of narrative. They are narrative compositions from which subject-matter has been removed, or perhaps allowed to bleed into setting and dissipate. This statement needs to be elaborated, for 'subject-matter' is a literary term. Subject-matter is something subjected to a telling. Subject-matter is thus more or less equivalent to Aristotle's *logos* or argument, the primary imitation of action that serves as the raw material for plot or *mythos*.[133] Classical rhetorical theory acknowledged an equivalent hierarchy between *materia*, or raw material, and *res*, or conceptual content.[134] Medieval and Renaissance epic drew its plots from an unformed stock of characters and events it called 'matter', for example the 'matter of Britain' (the Arthurian legends) or the 'matter of Troy'. Spenser in the *Faerie Queene* (III. iv. 3) apostrophized: 'thee, O Queene, the matter of my song'; Milton used the same formula in *Paradise Lost* (III. 412–3): 'thy Name / Shall be the copious matter of my song'.

In fifteenth- and sixteenth-century German altarpiece contracts, the word *materi* refers to the subject-matter of narrative sequences and, by extension, to the pictures themselves: 'the *materi* of St Wolfgang', for example, in a contract with Michael Pacher from 1471, or the four carved *materie* on the wings mentioned in a contract with Veit Stoss from 1520.[135] Nearly all paintings had subject-matter. Dürer justified his art by pointing out, in a draft of his planned treatise on painting from 1513, that 'paintings are employed in the service of the Church, and by them the Passion of Christ and many other good images [*Ebenbild*] are shown'.[136] If the German painter

was to make a name for himself, he would have to achieve it as an effective expositor of narrative material. Thus it is hard to overstate the strangeness of the utter absence of subject-matter in Altdorfer's landscapes.

The independent landscape was derived from a particular kind of picture with subject-matter. Many of Altdorfer's landscapes shared their format, scale and medium with prints, drawings, watercolours and small painted panels. These pictures can sensibly be called narratives, although they did not all represent action. Some represented a single figure, usually a saint or other holy personage, identifiable as the protagonist of some familiar narrative by attributes and setting. Others represented figural types from pagan or secular culture without necessarily telling stories about them, for example satyrs or peasants. (This sort of subject-matter, however, seldom appeared on panels; it survived instead in more frail media, such as engravings.) But even pagan material, more often than not, was shaped into narrative, or at least the narrative qualities of such pictures were considered essential to them. Dürer, for example, in a letter to Pirckheimer of 1506, referred to Italian pictures with pagan subjects generically as *historien*.[137] The fundamental characteristics of such a picture were, first, that it was contained by a frame and shaped into a coherent and self-sufficient composition; second, that it was not merely an element in a larger decorative scheme; and third, that the composition rested on a distinction between subject-matter, embodied in the human figure, and setting, which included any adjacent attributes of the figure as well as its physical environment.

Close in structure to Altdorfer's landscapes, and perilously indifferent to the conventional equilibrium between subject and setting, were the pagan and pastoral cabinet pictures by contemporary Venetian painters. These works cluster around the person and aura of Giorgione. Some of these pictures broach themes from literary pastoral, either by adapting scriptural, hagiographical or classical subject-matter to pastoral formulas and moods, such as the *Landscape with SS Roch, George and Anthony Abbot* in London, possibly by Giorgione himself;[138] or by directly illustrating poems, such as Andrea Previtali's four panels illustrating an eclogue of Tebaldeo.[139] But others decline to tell stories. Giovanni Bellini's *Orpheus*[140] simply encloses a mythological personage in lush forest setting. Lorenzo Lotto's *Maiden's Dream* and *Allegory* in Washington are allegories with pagan overtones.[141] For its dense, feathery trees, the *Maiden's Dream* (illus. 32) of *c*.1505 tapped German prints, or perhaps even paintings. The woman's pose repeats figures by Dürer or the German–Italian engraver and painter Jacopo de' Barbari. Still other works celebrated secular pleasures by staging fictional concerts or love-making in the *locus amoenus*, for example the famous *Concert* in the Louvre,[142] or the Edinburgh *Three Ages of Man*[143] by Giorgione's prodigious pupil, Titian. Although the Venetian pictures never quite expelled the human figure, they exhibited an unprecedented defiance or indifference toward the ordinary functions of painting. The Venetian cabinet pictures flourished accordingly in marginal zones and spaces, adjacent to the primary contexts for painting. A lost series of eighteen Ovidian panels by Giorgione were evidently set into a wall, in a band running just below the ceiling.[144] Other panels were attached to furniture. Lotto's

32 Lorenzo Lotto, *A Maiden's Dream*, c. 1505, oil on panel, 43 X 34.
Samuel H. Kress Collection, National Gallery of Art, Washington DC.

Washington *Allegory* was the cover of a portrait of Bernardo de' Rossi, a humanis-tically-minded cleric.[145] The *Maiden's Dream* may, in turn, have belonged to a portrait of Rossi's sister Giovanna.[146] The dreamy and allusive moods of the Venetian cabinet picture easily spilled over into pen drawings and prints, first in the engravings of Giulio Campagnola, later in the woodcuts and drawings of Titian and Domenico Campagnola.

The intense debate about the meaning of the Venetian cabinet pictures gathers around a single painting by Giorgione, the *Tempest* (illus. 33) in the Accademia in Venice, a disquieting conjunction of nameless characters in a landscape.[147] A hal-bardier looks across a brook toward a semi-nude, nursing mother. A bolt of lightning illuminates a city and a geometrical pile of classical ruins. Many readings have been put forward, from Mars and Venus, to Adam and Eve, to Fortitude and Charity; none has prevailed. The figures look as if they might be involved in some drama, and the setting looks as if it might be invested with symbols. But nothing is quite clear; prior iconographic traditions are at once invoked and distorted.

The argument that Giorgione's *Tempest* was never meant to be 'read' was expounded most memorably by Lionello Venturi and Creighton Gilbert, and has taken on various formalist and anti-iconographical colourings.[148] The latest, and fiercest, assault on this position was launched by Salvatore Settis, who has denied

33 Giorgione, *The Tempest, c.* 1507, oil on canvas, 68 x 59.
Galleria dell'Accademia, Venice.

that any picture of the period could have dispensed with subject-matter.[149] Even landscape, for Settis, is subject-matter. This debate has been hobbled by imprecise terminology. Giorgione's *Tempest* is surely not devoid of subject-matter. That subject-matter is a minor and secular subject like gypsies or wild families, or pastoral, or even conceivably a minor mythological subject, and not a scriptural subject. But the raw material has not been shaped into a story. The durable appeal of the picture consists precisely in its incomplete and enigmatic presentation of subject-matter, and its simulation of more orthodox and informative pictures. In arguing that the picture represents Adam and Eve and therefore does have a subject, Settis defines 'subject' too narrowly: the picture does not need Adam and Eve to have subject-matter. Settis then defines subject much too broadly when he claims that a landscape, even when 'empty of symbols', is also a subject. By subject here he must mean 'content' in some general sense. A landscape might initiate a train of thought, for example, about the relationship between man and nature; so might the *Tempest*, or indeed any of the Venetian cabinet pictures. This train of thought would be facilitated by any Virgilian or Ovidian thematics, for in the poetry such questions are addressed explicitly and profoundly. But this kind of thematic meaning is not equivalent to subject-matter.

The Venetian painters cultivated semantic elusiveness, a certain fugitive quality more familiar from lyric poetry. Indeed, the pictures were often called *poesie*, and

some were directly inspired by poems. It is as if the pictures wished to retreat from the crass and earnest plenitude of expository or hortatory painting, back toward a state of deliberate incompleteness. The tempered glow of a sward of green or a lost contour replaced legibility. Indeterminacy of meaning was encoded at the level of the pictorial sign. Roland Barthes, in a suggestive discussion of semantic *bruit* or 'noise', once characterized all art as 'clean', that is, free of interference, functional to the last detail; this is what distinguishes it from life.[150] But then Barthes conceded that painting, unlike writing, could introduce artificial interference, as it were, as a code for indeterminacy. He was evidently thinking of painterly techniques such as the deliberate dissolution of outlines, smoky or fading boundaries between colour areas, or atmospheric perspective. Venetian brushwork and palette immediately warned beholders either to drop their iconographical antennae, or to keep them raised and savour the vain effort to clear up the muddle. The Florentine Vasari, only two generations later, was stumped by Giorgione's frescoes on the Fondaco dei Tedeschi, the German merchants' compound at the Rialto. Giorgione, he complained, had thought only of fashioning fanciful figures and displaying his art. Vasari found the frescoes unreadable. 'Nor, with all the inquiries that I have made, could I ever find anyone who did understand, or could explain them to me.'[151] But plenty of amateurs relished indeterminacy. Federigo Gonzaga in 1524 ordered from the Venetian painter Sebastiano del Piombo not 'sacred things', but rather 'some charming [*vaghe*] pictures, beautiful to look at'.[152]

Meaning of this sort emerges out of a deliberate detachment from subject-matter. Crucial to Giorgione's rhetoric of enigma was the overdevelopment of outdoor setting. Not only bits of narrative, but also allegories were often embedded in outdoor greenery. In Lorenzo Lotto's *Allegory* or in his *Maiden's Dream*, or in Piero di Cosimo's *Allegory* in Washington,[153] or in the grisaille verso of the portrait diptych of Alvise Contarini in New York,[154] with its shadowy, draped, river-bank figure, landscape amputates and frustrates ordinary trains of thought, dialectical links, and temporal vectors. Emblems and *imprese* are insulated by landscape, as if by a buffer zone protecting their fragile semantic mechanisms from the world outside. Marcantonio Michiel manifested his perception of such imbalances between setting and subject in his use of the word *paese*. In Michiel's notes on Venetian painting, *paese* can still refer to an element of the picture, for example in the description of the 'foreground landscape' in Giovanni Bellini's *St Francis Receiving the Stigmata*, now in the Frick Collection.[155] In other entries, however, the term *paese* becomes the primary identity of the picture: Giorgione's *tela del paese cun el nascimento de Paris* (landscape canvas with the Birth of Paris) or, again, the *molte tavolette de paesi* painted by Albert of Holland.[156] Most remarkable is Michiel's description in 1530 of Giorgione's *Tempest* as a '*paesetto* on canvas with a tempest, a gypsy woman and a soldier' (proving that if there ever was a story, it had been forgotten only twenty years after Giorgione's death!).[157] From this point on it becomes possible to describe a whole picture as 'a landscape'. Lodovico Dolce, for instance, referred in one of his dialogues to a *paese* by Titian illustrating the adventures of a nymph and several satyrs, which itself alludes

to an imaginary pastoral painting described by Jacopo Sannazaro in his hugely popular *Arcadia*. Dolce had in mind paintings such as the landscape frieze with a reclining shepherd in the Barnes Foundation in Merion, possibly a cassone panel, and possibly by Titian. Setting had come to dominate such pictures.[158]

And yet the Italians never permitted landscape to swallow up the human figure entirely. In the backgrounds of extremely sophisticated High Renaissance altar paintings, like Fra Bartolommeo's Carondolet altar in Besançon (*c.*1511), unnamed figures in hazy and portentous background landscapes contributed to a sense of meaningfulness without necessarily denoting anything in particular. Although diminished and garbled, subject-matter still exerted a gravitational pull on setting. There was no pressing reason to create a rigorously independent landscape.

Landscape as *parergon* or by-work

The Venetian paintings were able to uncouple the art of painting from storytelling and exposition because they offered something in exchange. The correlative of semantic indeterminacy was sensory delight. But views and foliage had been associated with pleasure since Antiquity, especially in domestic decorative painting. The main idea was that the harried beholder would seek refreshment or recreation in landscape. The representation of landscape was taken as a substitute for an experience of the out of doors.

Thus in Leon Battista Alberti's *Ten Books on Architecture*, written *c.*1450 and published in 1486, it is the beholder who delights in and is 'cheered beyond measure by the sight of paintings depicting the delightful countryside, harbours, fishing, hunting, swimming, the games of shepherds – flowers and verdure . . .'. Such painting is 'suitable for gardens, for it is the most pleasing of all'.[159] In his own treatise on painting, Leonardo da Vinci agreed that poetry made travel superfluous: 'What moves you, man, to abandon your home in town and leave relatives and friends, going to country places over mountains and up valleys, if not the natural beauty of the world . . . ?' Why not accept the poet's description and stay at home, avoid the heat and fatigue, escape illness? Better yet, let the painter put before your eyes the very landscapes 'where you have had pleasure beside some spring, [where] you can see yourself as a lover, with your beloved, in the flowered meadows, beneath the sweet shade of trees growing green'.[160] Erasmus, highly suspicious of profane painting, nevertheless condoned decorative landscape: 'If you are charmed by painting, what is more fitting to the Christian house than the acts of Christ, or the examples of the saints? And if it pleases you to mix these with pleasantries [*joci*], there are moral tales, there are the innumerable forms of trees, plants, flowers, and animals.'[161]

Recreation in this tradition stands as a *supplement* to work, in the sense made familiar from Derrida's *Of Grammatology* and other writings. The supplement for Derrida is an amphibious entity that presents itself as a superfluity, a gratuitous excess, and yet whose very existence reveals a deficiency or lack in the object it supplements. The supplemented object turns out to be knowable only through, and

in terms of, its supplement. Thus writing offers itself – misleadingly – as a 'mere' supplement to the spoken word; or art as a supplement to nature. The disclosure of the mutual dependency underlying the notional hierarchy of object and supplement is one of the central and most characteristic operations of Deconstruction. Recreation in Western pictorial culture, then, is meant to follow work and therefore stand outside it. It is, perhaps, a reward for work completed. But pleasure also prepares one to resume work by restoring or recreating the spirit. The danger is that the interlude of recreation will not only restore the labourer, but ultimately provide a superfluity of pleasure, and even replace work. It is easy to see how the pleasure taken in outdoor scenes, first in the mere representation of a venue associated with retreat and leisure, eventually in the painterly effects achieved in those representations, could generate both enthusiasm for, and resistance to, landscape painting in the Renaissance.

Landscape painting also stood as a supplement to the work of the *painter*. The most suggestive of all contemporary comments on Renaissance landscape is a remark about Dosso Dossi, the Ferrarese court painter, in a dialogue written by Bishop Paolo Giovio, a historian and art collector:

The elegant talent of Dosso of Ferrara is proven in his proper works, but most of all in those that are called *parerga*. For pursuing with pleasurable labour the delightful diversions of painting, he used to depict jagged rocks, green groves, the firm banks of traversing rivers, the flourishing work of the countryside, the joyful and fervid toil of the peasants, and also the distant prospects of land and sea, fleets, fowling, hunting, and all those sorts of things so agreeable to the eyes in an extravagant and festive manner.[162]

In this text of 1527 the painting of landscape is presented as a diversion for the painter, a respite from his proper tasks; or rather, it garnishes his labour with pleasure. Leonardo chided Botticelli precisely because he took landscape too lightly: the younger painter considered landscape a *cosa di brieve e semplice investigatione*, for would not a sponge thrown against the wall serve equally well as a studied composition? But random stains supplied only the invention. Botticelli painted miserable (*tristissimi*) landscapes because he neglected to apply himself to finish them.[163] Landscape is a *parergon* because it stands alongside both work (*labor*), and the work (*opus*). The same ambiguity is preserved in the obsolete English word *by-work*, which, according to the *Oxford English Dictionary*, means both 'work done by the way, in intervals of leisure', and 'an accessory and subsidiary work'. Thus the beholder's pleasure in looking at landscape overlaps the painter's pleasure in making it. The danger of pleasure, as Michelangelo supposedly observed in a famous passage from the *Dialogues* of the Portuguese painter Francisco da Hollanda, was permanent diversion from a primary task, namely the representation of the human figure: 'In Flanders they paint to attract the eye with things which please. . . . They paint draperies, masonry, green meadows, shady trees, rivers, bridges, and what they call landscapes [*paisagens*], and in addition many animated figures scattered here and there'. 'I criticize Flemish painting', the 'Michelangelo' character concluded, 'not because it is entirely bad, but because it tries to do too many different things.'[164] Attention was not only diverted, but strewn across the surface of the picture.

One model for the pleasure taken in private and recreational painting was the humanist ideal of retreat into contemplation and creative languor, and in particular of spiritual refreshment in a rustic haven. Although this dream was rooted in Virgil and Horace, the more immediate models for the humanist contemporaries of Giorgione and Altdorfer were Petrarch and the Florentine neo-Platonists. Conrad Celtis, in particular, cultivated the image of a *plein-air* poet.[165] The appeal of the retreat from society for the humanist was its paradoxical and patrician reversal of the ordinary hierarchy between productivity and leisure: work – creative work – becomes the fruit of play rather than the other way around. Work is ultimately transformed into an aspect of play. This reversal could only be carried out on the margins of civilization, and so the poet modelled himself after the shepherd. The new co-operation of poet and nature is illustrated by the marginal illumination that Dürer painted and pasted on the first page of the edition of Theocritus owned by his friend Pirckheimer (illus. 15).[166] Two shepherds, tranquil yet alert, make music in a crumpled, rocky valley. The illumination itself, not a proper work but an amicable offering, dances around and below the block of printed text, itself the product of the most sophisticated textual criticism, and one of the early monuments of Greek typography in the West.

Another model for the experience of early landscape painting – another alternative, that is, to the escapism described by Alberti – is provided by the figure of the antiquary. In his intellectual pleasure in the past the antiquary escapes the ordinary experience of time. The association of archaeology and epigraphy with recreation was made explicit in the celebrated excursion on Lake Garda undertaken in September 1464 by Andrea Mantegna, in company with the antiquaries Felice Feliciano and (possibly) Giovanni Marcanova.[167] The pleasure of ruins and inscriptions was indulged alongside, or outside of, everyday activity, embedded in a fantastic round of mock ceremonies and re-enactments. Indeed, Marcanova's antiquarian pursuits – whether he was actually on the boat with Mantegna at Lake Garda or not – were described by his eighteenth-century biographer as a *parergon* to his primary work.[168]

Yet another model was the pleasure taken in the comic, in the spectacle of mundane or even unworthy characters, 'men who are inferior but not altogether vicious', in the definition of Aristotle.[169] Domestic decorative landscape was a primary setting for this subject. Alberti had characterized his 'garden' painting as the type of painting 'depicting the life of the peasants', distinguishing it both from the type that 'portrays the great deeds of great men, worthy of memory', and from the type that 'describes the habits of private citizens'. These rustic characters were so low in station that in the eyes of the beholder the distinction between their work and their play was blurred. In Giovio's text, for example, the toils of the peasants are described as 'joyful and fervid' (*laetos fervidosque*). The hard comic possibilities of the situation were exploited especially in the North, where the peasant was brought ever closer to the surface of the landscape and yet made to look ever stranger. In Bruegel, who, in van Mander's words, 'delighted in observing the droll behaviour of the peasants, how they ate, drank, danced, capered, or made love', the boundary between profound

contempt and profound sympathy is imperceptible.[170] In early landscape painting, even subject-matter is divided against itself, divided between the serious and the frivolous, as if mirroring the division of the picture as a whole.

Landscape thus stood outside or alongside the proper work or task of painting, the business of treating subject-matter. The veiling of subject-matter by landscape, as in the Venetian *paesi*, or its expulsion, as in Altdorfer's landscapes, were exercises played out far from the primary and serious business of painting. For Alberti, the grandest painting, the representations of 'the great deeds of great men, worthy of memory', belonged in 'public buildings and the dwellings of the great'. Recreational landscape painting, on the other hand, was relegated to the gardens, presumably in the form of wall-painting on, or in, garden buildings.

The structural relationship between important and trivial painting is complicated when the two must share the same surface. This problem had been raised already by Pliny. Protogenes of Rhodes, the rival of Apelles, had 'added' to his wall-paintings at Athens small depictions of warships 'in what the painters call *parergia*'.[171] The *parergia* were either the margins of the fresco, or the background, or perhaps an additional field outside the scene altogether, an ornamental strip. The *parergia* came to mean both the areas of the picture susceptible to landscape, and the landscape motifs that appeared in those areas. This ambiguity is brought out in an *ekphrasis*, or description of a picture, from the *Hypnerotomachia Poliphili* by Francesco Colonna, the fantastic and learned prose romance of the late Quattrocento. The passage describes a frieze of mosaics on the inside of an arched gate, adorned 'with exquisite *parergi*, waters, fountains, mountains, hills, groves, animals'.[172]

The accessory landscape was both superfluous to the essential purpose of the picture, and an inextricable part of the picture. In a eulogy to the miniaturist Simon Marmion by a sixteenth-century French chronicler, supplementary details have become as indispensable as skill in drawing: 'He laboured over and ornamented all his works so well, as much by his ingenious and expert drawing as by his buildings and other accessories [*accessoires*], that one finds nothing incorrect or imperfect'.[173] Another clever miniaturist, possibly Simon Bening of Bruges, made a schematic image of the double face of landscape setting in an early sixteenth-century manuscript (illus. 34).[174] The scene inside the inner frame, St Christopher carrying the Christ child across the river, is complete; normally it would be surrounded by blank paper. But the painter has let the river flow under the frame and fill an outer frame. The hagiographical scene has been supplemented by a second margin of landscape setting, and it is still complete. This model of the relationship between subject and setting survived for some generations. The lexicographer Thomas Blount, who rated 'landskip' among those 'Hard Words ... as are now used in our refined English Tongue', spelled it out clearly in 1656: 'All that which in a Picture is not of the body or argument thereof is *Landskip, Parergon*, or by-work. As in the Table of our Saviour's passion, the picture of Christ upon the *Rood* . . . , the two theeves, the blessed Virgin *Mary*, and St. *John*, are the Argument. But the City *Jerusalem*, the Country about, the clouds, and the like, are *Landskip*.'[175]

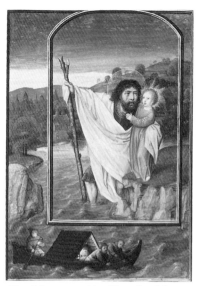

34 Flemish master (the Hortulus Master, or
Simon Bening?) *St Christopher, c.* 1524,
miniature, from *Hortulus animae.*
Österreichische Nationalbibliothek, Vienna.

All these tensions were strung across an invisible boundary between the work and
its by-work. There was no symmetry between work and accessory: one was subordi-
nate to the other. The unequal dependency kept subject and setting suspended in a
symbiosis. The *parergon* fluctuated between usefulness and uselessness. Some access-
ories were overdetermined: the landscape invested with didactic markers (the *paysage
moralisé*), the fragments of still-life that invoked theological principles (disguised
symbols). Other accessories were underdetermined: the recreational landscape. Many
parerga were both at the same time. In the Christian tradition, the deliberate upending
of the hierarchy of centre and margin generated real irony. The 'work' of a Christian
image was to assert the supremacy of the metaphysical over the terrestrial. Painting
had to preach spirit in the language of matter. This paradox fascinated especially
Northern painters during and after the Reformation. It surfaced in still-life painting,
for example in the gross and sumptuous market scenes of Pieter Aertsen, with sober
biblical episodes sequestered in the backgrounds; pictures that state the superiority
of sacred narrative to naked description, but perform the opposite.[176]

Altdorfer's landscapes are altogether different sorts of objects. They abolish the
boundary between subject and setting, as well as the hierarchy, by banishing subject
and funnelling setting toward the literal centre of the image. Once subject is gone,
it is no longer possible to characterize landscape as either overdetermined or
underdetermined. It no longer even makes sense to call it setting. For the primary
boundary is now the frontier between work and world. The symbol of this new
boundary is the frame.

Altdorfer's landscapes, in contrast to all the other artefacts we have been thinking
about, were independently mounted and framed and entirely portable. The only
possible Italian equivalents – framed images truly empty of subject – were the paint-

ings of Dosso Dossi. Paolo Giovio contrasted Dosso's *parerga* to his 'proper works' (*justis operibus*). There is, unfortunately, no precedent or corroborating document that would prove that here *parerga* refers to independent paintings.[177] It is conceivable that by Dosso's 'proper works' Giovio simply meant the subjects of his paintings, to which his rocks, rivers, peasants and vistas were the accessories. Dosso did paint fluid, evocative pictures with esoteric subjects, such as the *Three Ages of Man* in New York (possibly a fragment) or the *Travellers in a Wood* in Besançon. There is even a pure landscape, but this is a fragment.[178] The best example of what Giovio meant by a *parergon* is perhaps the *Landscape with Figures on a Country Road* recently on the art market in New York – a painting without any discernible subject, and definitely not a fragment.[179] Altdorfer's and Dosso's pictures afforded recreation a discrete, even institutional, shelter. Such a painting was an authentic innovation, as far as we know, even over classical art. The landscape paintings described by the third-century Sophist Philostratus, for instance, were panels (*pinakes*) inserted into the walls of a villa.[180] And the landscapes by the first-century painter Studius, noted by Pliny and Ghiberti (see p. 33), were only frescoes. 'Among artists', according to Pliny, 'great fame has been confined only to those who paint *tabulas*'.[181] Portable panels were a more prestigious field – too prestigious for empty landscape.

Now instability was permanently built in to the structure of the work. Derrida's 'supplement' is officially superfluous; in fact, it fills a lack. And the *ergon*, contrariwise, is officially self-sufficient; in fact, it needs a supplement. With the independent landscape, that mutual incompleteness became the basis for the structure of the work. Without a subject in sight, the setting remained suspended in its supplementarity. All those suspicious and useless recreational moments were absorbed into the work. The work of art became an object that worked and diverted at the same time. But this duality was no longer a hierarchy. The new frame devalued or even obscured entirely the old internal divisions, the boundaries between work and accessory that once ran across the life of the painter and the surface of the painting. The dissolution of these interior frontiers had ethical implications, for it placed work in an uncomfortably ambiguous and dependent relationship to pleasure. The work now displayed the escape from temporal prisons, from responsibility, from community and sociability, from profitable labour, from the imperatives of salvation; it displayed a movement without end, blocked by the frame from any possible end.

The achievement of this frame was first articulated by Kant in his *Critique of Judgement*. The frame in Kant's scheme definitively severed the work of art from the world. It disqualified the world as a criterion of evaluation of the work. The work manifested, moreover, an 'artificial free beauty' that may be taken not as a poor imitation, but as a metaphor for natural beauty. Derrida's analyses of Kant in his essays 'Parergon,' in *The Truth in Painting*, and 'Economimesis', reveal the power and appeal of the scheme. Kant's 'pure cut' between work and world, announced and guaranteed by the frame, makes possible all the various modern interpretative protocols. Formalist, allegorical, propagandistic, expressionist, psychoanalytic, utopian: all these hermeneutics of the work of art have proceeded from a stable

notion of the frame. Nor are 'contextual' readings exempt. For the very notion of context depends on a clear understanding of where the text ends. There can be no thought of transgression without a boundary to cross.

But in *The Truth in Painting* Derrida also exposes a latent instability in the Kantian version of the structure of the work. It turns out that the *parergon* is still alive. The old hierarchy of work and by-work, work and supplement, ought in principle to have been abolished by the 'pure cut'. But Kant's remarks on the frame are inconsistent in a way that undermines the accomplishment of the cut. Derrida's basic purpose was to reveal the precariousness of the modern doctrine of the aesthetic. But his analyses also cast a spotlight backwards in time, and thus prove useful to the present study. For the historical roots of Kant's uncertainty lie within an early sixteenth-century investigation of the tension between subject and setting.

Derrida first focused on a parenthetical comment made by Kant about the *parerga* or ornamental accessories to the aesthetic object.[182] Kant argued in §14 of the *Critique of Judgement* that 'even what is called *ornamentation* [*Parerga*], that is, what is only an adjunct, and not an intrinsic constituent in the complete representation of the object, in augmenting the delight of taste does so only by means of its form'. Kant then gave three examples of *parerga*: the frames of pictures, the drapery on statues, and the colonnades of palaces. 'But if the ornamentation does not itself enter into the composition of the beautiful form – if it is introduced like a gold frame merely to win approval for the picture by means of its charm – it is then called *finery* and takes away from the genuine beauty.' Kant thus defined a penumbral zone whose relationship to the proper work of the work of art was contingent on the character of the effect it exercised on the beholder. If it appealed to taste through its form, then it belonged to the work; if it relied on mere charm or *Reiz*, then it was extraneous to the work.

Immediately there is trouble. The placement of architecture alongside the plastic arts unhelpfully reintroduces the question of function. It led Kant to insinuate an ontological boundary between the nude sculpted body and its sculpted garment that one is hard-pressed to reconcile with modern aesthetic doctrine. It also encouraged him to raise the possibility that the frame around a picture – the literal framework in carved, painted or gilded wood – might actually and essentially contribute to the work of the picture. It appears to us that modern artists place the 'pure cut' clearly on one side of the frame or the other: either the frame is part of the work or, more usually, it is not. Indeed, in the twentieth century the pure cut was taken so seriously that the frame was often jettisoned altogether. For Kant, by contrast, the frame is still a *parergon*. It supplements the work: it is not supposed to be necessary to the work, indeed frames are more or less interchangeable. Yet the work cannot do without *a* frame. The frame is two-faced: it looks outward and inward at once. From the point of view of the work, it belongs to the wide world beyond the pure cut. From the point of view of the wide world, however, it is firmly nailed to the work.

For Kant, the pleasurable or underdetermined accessory was still slightly suspect. Kant hesitated, in effect, before the thorough modern symbiosis. The full embarrassment of this hesitation is brought out in a later passage singled out by Derrida: 'So

designs *à la grecque* [i.e., straight-line designs in labyrinth form], foliage for framework [*Laubwerk zu Einfassungen*] or on wall-papers, etc., have no intrinsic meaning; they represent nothing – no Object under a definite concept – and are free beauties.' Here the frame actually serves as an illustration of the essential properties of the aesthetic object, the locus of an artificial free beauty. There is nothing parergal about it anymore.

The recognizably modern frame was in place before any theoretical discourse had addressed it and explicated it. By the time Kant defined the aesthetic object, the frame and the artistic personality who drew or made it were givens, historical *faits accomplis*. Kant acknowledged the *ad hoc* and insufficiently theorized nature of this frame when he gave the frame, in this pair of comments from the *Critique of Judgement*, a 'thickness'. The frame in these passages is not merely the public marker of a one-dimensional border. By looking past the stable and clean frame, the one-dimensional frame, and instead treating the frame either as the accessory to the work, or as the very emblem of aesthetic gratuitousness, Kant in effect placed himself within the problem that the Renaissance had posed to itself. He raised a question that was in some ways already obsolete in the eighteenth century. But in so doing he suggested the historical source of his own inquiry into the structure of the work of art.

How did the by-work come to take over the work in the Renaissance? To start with, artists began to perform in the marginal zones. The margins are the locus of the work's own internal commentary on the conditions of picture-making, and on the identity and character of the artist himself. In these penumbral spaces the artist leaves deictic signs, signs that plainly confess the materiality of the picture and unmask any fictions of a non-existent fabricator or a transparent picture plane. The supplement was likewise the locus of the signature. Indeed, the warships which Protogenes painted in the *parergia* of his frescoes, Pliny reports, served precisely as a signature: they identified him as one who had begun as a mere ship-painter.[183] A connoisseur culture, in turn, dedicated to discriminating between one picture and the next on the basis of workmanship or authorial handwriting, tends to follow the lead of the artist and shift its attention from centre to margin.

In Antiquity, the *parergon* was normally understood as subordinate, by-the-way, trifling. Pliny told endless anecdotes about the virtuosity of painters precisely because virtuosity was considered slightly frivolous and beside the point, just as we might enjoy odd anecdotes about composers or writers even though we are convinced that such curiosities have no bearing on the value of the works. It was subject-matter that mattered. Thus, the consternation of Protogenes when the Rhodians paid too much attention to an ingenious detail in one of his paintings. Protogenes had painted a satyr standing by a pillar with a partridge perched on top of it. Everyone admired the partridge. 'When Protogenes saw that the *ergon* [the main work] had become the *parergon*', he obtained permission from the authorities to efface the partridge.[184]

The German Renaissance contributed to the broader process of centring the supplement by aggressively converting portions or aspects of the picture that had once

been accessory to its purpose, landscape in particular, into the most conspicuous theatres for pictorial ingenuity and inventiveness. The public personality of the artist, not merely manifested in some abstract design or idea behind the picture, but palpable in its very substance, reassembled and reunified both the picture and the beholder's experience of it. The experience of the German picture became indistinguishable from the experience of this personality.

The key was a notion of style, or a personally specific contribution to the picture, grounded in execution rather than in invention, selection or judgement. German painters in the first decades of the new century, following Dürer, began to mark their pictures with recognizable personal styles, which often took the form of a distinct *ductus* or linear mannerism, or even with signatures, usually monograms or initials. The ambitious artist sought not merely to control the outcome of the work, but actually to register and lay bare his control directly in the work. Legible in the stylish line, in principle, are the conditions of its own creation, the time it took to make it, the speed of the hand.

In this scheme the artist is closer to the scribe or the clerk than to the poet. Indeed, in medieval jurisprudence, 'style' had drifted far away from its older rhetorical associations and had become a pragmatic means of identifying or authenticating legal documents: the maintenance of a formal or procedural standard protected the document against forgery. It provided the document with a provenance.[185] The historical link to a place and time of execution, in other words, was forged on the mechanical level of legal procedure, or even of penmanship. This was also the function of the clerk's paraph or flourish, an abstract and unrepeatable signature meant to link the document with a particular hand and to foil counterfeiters.[186] This recalls the old sense of style as 'title or appellation'. Falstaff, for example, exclaimed 'Ford's a knave, and I will aggravate his style'.[187] The usage is ancient in English, but survives today only in the phrase 'self-styled'.

This sense of style as personal mark was also current in Renaissance Germany. The theologian Hieronymus Emser, for example, thought to refute Luther's attribution of a polemical pamphlet to him by an appeal to style: 'Except for someone completely blinded like you, no one would judge that to be my style or invention.'[188] Style as an unrepeatable flourish established a link to the artist's person that was both more direct and ultimately less suggestive than that established by style as a general principle of procedure. Here, style was explicitly associated with the concrete historical actions of a particular individual, and not merely a rhetorical decision that might reflect super-personal principles, or which might have been made at any time prior to the execution of a work. At the same time, because the executive gesture itself is not closely interrogated, the link to person proposed by a pen stroke does not yet beg difficult questions about the nature of personhood.

The self-presentations of German artists of the High Renaissance were extraordinarily strident and blunt. Only Dürer, among the Germans, rivalled the great Italian personalities in sophistication and self-esteem. And yet Altdorfer and Huber, Lucas Cranach and Hans Burgkmair, Matthias Grünewald and Hans Baldung Grien, not

to mention such one-dimensional figures as Mair von Landshut or Urs Graf, or the still lesser epigones of Dürer and Altdorfer, nevertheless presumed to sign their pen drawings and to put before the eyes of the world coherent and premeditated linear styles. This phenomenon attracted little attention in Europe at large, except in the person of Dürer, who was marvelled at by Italians as a singularity, a kind of isolated comet. Indeed, Vasari made a point of mentioning that Dürer, even 'while still quite young', signed his prints with his own hand.[189] By the end of a generation, the irruption of the signature had subsided, leaving only ripples.

The claim of this book, put in its strongest form, is that the independent landscape was born directly of this radical intrusion of the German artist's personal authority into his works. Outdoor settings were especially susceptible to the self-aggrandizing and self-advertising devices of the authorial persona. Landscape was a hospitable venue for pungent colouristic effects. Trees and mountain-ranges encouraged eccentric details and calligraphic line. Several Renaissance texts on pictorial randomness actually associate landscape with freedom from rule. In his treatise on painting Leonardo recommended that the artist examine stains on walls or mottled stones, for 'you will be able to see in these the likeness of divine landscapes, adorned with mountains, ruins, rocks, woods, great plains, hills and valleys in great variety'.[190] Vasari later reported that Leonardo's contemporary Piero di Cosimo had delighted in imagining battle scenes, cities and landscapes in stained walls and in clouds.[191] Imagination without study was futile, of course: remember Leonardo's strictures against Botticelli (p. 55), who frivolously made landscapes by throwing sponges against the wall. The point was that in the landscape the imagination had plenty of leeway. Contours could bend this way or that, forms and motifs could be juxtaposed and rearranged *ad libitum*, all without impairing verisimilitude.

A swift, slight pen sketch by Dürer can stand as an emblem of this entire phenomenon (illus. 35).[192] Here Dürer seems to be trying out a new quill, taking rapid, natural strokes, loosening his hand in preparation for a more disciplined drawing.

35 Albrecht Dürer, *Quarry*, c. 1510,
pen on paper, 6.1 x 4.
British Museum, London.

His scratchings drift between three semantic possibilities: at some moments they mean nothing; at others they become calligraphic, like fragments of a signature; at still others they blend into the contours and shading of the rock and the bush. One starts to wonder whether there was any landscape before Dürer's eyes at all. Perhaps linear whimsy and thoughtlessness naturally drifted toward landscape.

Many comparable observations can be made about the Venetian *paese* as well, in paint as well as in the graphic media. Giorgione's damp, slow-burning landscapes are inseparable from the contemporary cult of his personality. But setting in the Italian painting was closely bound to its subject. Writing on art in Italy, which was generally at pains to adapt painting to principles of classical rhetoric, prescribed a limited and functional relationship between subject and setting. Alberti, in his treatise *On Painting* of 1435, gave short shrift to backgrounds, and instead addressed the problems of representing bodies and composing them into an *istoria*. He only briefly treated the question of drapery and flowing hair as attributes of bodies.[193] In the sixteenth century Lodivico Dolce and Gian Paolo Lomazzo both placed great weight on the principle of decorum, or appropriateness of means to ends. This was the principal source of resistance to landscape painting in the Renaissance. Lomazzo's precepts reverberate in the treatise on 'the arte of limning' by Nicholas Hilliard, the Elizabethan miniaturist: 'the landship, weare it never so well painted, it weare not to the purposse or matter, but rediccalious and false . . . ;'[194] and in the *Graphice* of 1612 by Henry Peacham, which deprecates *parerga* as 'needless graces'.[195] Northern classicists in particular were defensive on this point, with good reason. The antiquary Franciscus Junius, for instance, in his *Painting of the Ancients* (1638), raised this warning: 'If we doe finde in the meane while, that the Artificers hit the true force and facilitie of grace better in these sudden [i.e., unexpected] things than in the worke it selfe, yet must wee never be so inconsiderate in our judgment, as to preferre the by-work before the work'.[196] At the very least, the supplement needed to be recharged with signification. This is the recommendation of Rembrandt's pupil Samuel van Hoogstraten in his handbook on painting, *Inleyding tot de hooge schoole der schilderkonst* (1678): 'The most praiseworthy way of decorating [a work of art] is with accessories [*bywerk*] which provide concealed elucidation.'[197] In practice, German painters also observed a distinction and even a hierarchy between subject and setting. Fifteenth-century Italian and German painting shared plenty of common sources. But there is no evidence that any Germans of Altdorfer's generation were cognizant of a rhetorical or neoclassical doctrine of decorum. The only functional analyses of pictorial structure to be heard were reactionary and curt: the protests of the theologians, Catholic and Reform, against the excesses of *kunst* or 'artistry' in the sacred image. Ambitious German artists answered this objection, with which they may well have sympathized, first by cultivating style, which was free of the crass materialist overtones of mere *kunst*, and which was not so obviously inimical to the purposes of devotion; and second by cultivating profane subject-matter and new kinds of pictures altogether. Thus setting was relatively painlessly isolated from the composition as a whole and made available for other pursuits.

Hans-Joachim Raupp has advanced an analogous argument about the peasant genre in German Renaissance art. He suggests, with a touch of deliberate hyperbole, that by the sixteenth century images of rural characters and episodes had more or less been drained of any original semantic charge. Instead, the entire genre served as an open field for the demonstration of artistic ability. In the realm of peasant iconography the artist was emancipated from the constraints of convention and doctrine, and could instead flex his style. Raupp even interprets a famous passage in Dürer's writings in this vein: 'An artist of understanding and experience can show more of his great power and art in crude and rustic things, and this in works of small size, than many another in his great work.'[198]

When the German artist applied his pervasive stylistic mark to the picture and began to upset the hierarchy between subject and setting, the boundary around the picture as a whole – the frame – became clearer and correspondingly more important. The frame defined the picture as the work of an artist. Wherever the artist–author manifested himself became the work of art; everywhere else was not-the-work, or the world. By severing the work from the world, the frame made the work truly portable. The frame isolated the work from ordinary objects and from the world in general, just as artists would eventually be distinguished from ordinary people by certain defining myths about them, and by expectations about their behaviour and appearance.

But there is a paradox here. The idea of style as trace – as a metonymy for the artist – is incompatible with the doctrine of the pure cut. The trace inhabits the work like an illicit agent from the world abroad. Thus the integrity of the work of art was compromised at its very inception. For it was exactly the authority of the self-promoting artist that severed the work from the world in the first place. And yet that artist's liberating performance immediately broaches the new imaginary frontier between inside and outside. The trace makes him present and absent at the same time. And in truth, the doctrine of aesthetic autonomy makes no more room for the deictic gesture than had the ancient orthodoxies of the Christian doctrine of images. In some ways the problem is more pressing here. For the old sacred image could afford to exclude the author: subject-matter alone, the holy personage, provided the work with its *raison d'être*. But what would justify the image of landscape, if not its author? This question was asked for the first time in the German Renaissance; European art posed the same question to itself repeatedly over the next five centuries. No answer was ever again so spirited and impressive as the first one.

2

Frame and work

Max Friedländer once wrote that Altdorfer invented not landscape painting, but rather *the* landscape painting.[1] This book is about that material object: the painted panel and the watercolour painting on paper, but also the pen-and-ink drawing and the etching. Altdorfer's wooded places look empty precisely because they appear on detached surfaces surrounded by frames. They are places physically severed from the figures and stories that would make them useful again. The independent landscape is an object defined by what it includes and excludes, and it is the frame that performs that selection. But the frame also cuts the picture off from the physical environments that would ordinarily legitimate its ineloquence. We need to bring the physical properties and historical coordinates of this object into clearer focus.

The German artist's career

Most German painters at the beginning of the sixteenth century earned their livings painting pictures of Christ, the Virgin and the saints. The public appetite for sacred images was voracious. The Swiss reformer Huldreich Zwingli, who liked pictures but felt compelled to condemn them,[2] lamented in 1525 that 'a reasonably old man may remember that there once hung in the temples not the hundredth part of the idols which we have in our times'.[3] Yet the repertory of subjects was still nearly as meagre as it had been two generations earlier. How was a painter to win more than a merely local reputation painting sacred images? The most conspicuous setting for painting and the most profitable artistic enterprise was the altarpiece. On the largest altarpieces, the huge retables with one or more pairs of hinged shutters and towering crowns of carved wood, the painter and the sculptor worked alongside one another, surrounded by carpenters, cabinetmakers, ironsmiths, locksmiths and sundry lesser painters, apprentices and shop-hands. The successful artist was the one who managed to control such projects: he subcontracted, he kept his own workshop busy and solvent, and he earned the confidence of the community or the church officials. At first it was the painters who tended to oversee such projects; later, as the retables became more complex, the sculptors began to dominate. Most powerful were the great sculptor-painters, such as Hans Multscher, Michael Pacher and Veit Stoss.[4]

Under these circumstances it was difficult to build a super-regional reputation. News about successful altarpieces travelled slowly and randomly, along rivers and trade routes. Eventually, the artist-entrepreneur would win another commission in a

different city. But the big retable projects lasted for years, as long as a decade, and in the meantime a reputation might stagnate. Moreover, a reputation was likely to be one-dimensional. The ability to build huge and materially splendid altarpieces frequently reflected no more than economic buoyancy and organizational talent. Clients may have known outstanding painting and sculpture when they saw it, but they did not necessarily know how to talk or write about it. It was easier to explain how a complicated retable worked – how the shutters opened and closed, what story was told in the central section, or shrine – or to marvel at audacities of scale, than to tell what a painting looked like, how it was beautiful, why it told the story so effectively. A reputation travelling by word of mouth alone, dependent on brittle and poorly articulated memories, would soon evaporate.

At the beginning of the sixteenth century, consequently, the south German landscape was fragmented into local artistic dominions. In Nuremberg, Dürer's teacher Michael Wolgemut oversaw the largest workshop and garnered the major commissions. Hans Holbein the elder, father of a more famous son but an acute observer of the physical world in his own right, dominated Augsburg. The outstanding figure in prosperous Ulm was Bartholomäus Zeitblom, a blandly austere, and now completely neglected, painter. The leading Bavarian altar painters were Jan Polack in Munich and Rueland Frueauf the elder in Passau and Salzburg. The horizons of most painters and sculptors ended with their city walls. Court artists, meanwhile, were either anonymous manuscript illuminators, or – like Emperor Maximilian's artistic factotum Jörg Kölderer – competent but uninspired handymen, variously responsible for designing festivals, organizing collective projects, illustrating genealogical treatises and decorating princely residences.

Altdorfer's Regensburg, 'Ratisbon' in Latin, roughly equidistant from Munich and Nuremberg, was an episcopal see and free Imperial city with a grand medieval past. In the twelfth century Regensburg had been the leading trading centre in southeast Germany. The Dominican Albertus Magnus, mentor of Aquinas, held the bishopric in the 1260s. Book painting had flourished in the local monastic workshops. Aeneas Silvius, in his ingratiating survey of German lands and customs, written in 1458 immediately before he was elected Pius II, called attention to the magnificent stone bridge across the Danube, built in the mid-twelfth century and even today carrying two lanes of traffic; to Regensburg's many churches, especially the cathedral; and to the Benedictine monastery of St Emmeram, which reputedly sheltered the bones of St Denis, piously stolen from the abbey in Paris.[5] Prestige earned Regensburg its own two-page spread in the Nuremberg Chronicle of 1493 (illus. 36).[6] The city is thick with church spires and patrician defensive towers. The cathedral, accurately enough, is shown still under construction.

But in recent decades the city had fallen into debt and political disarray. Regensburg fell far behind Nuremberg, Strasbourg, Ulm and Augsburg, the Imperial cities to the west, each of which was four or five times as populous. In a schematic image of the Imperial cities in the Nuremberg Chronicle, Regensburg was classed, together with Cologne, Constance and Salzburg – all ecclesiastical cities that had seen better

days – among the *Rustica*, and represented as a cluster of shabby farm buildings. Old buildings in heavy grey stone were infrequently replaced by modern structures, and indeed Regensburg remains today one of the best-preserved Romanesque cities in Europe. Around 1500 it had 10,000 inhabitants, but no major panel painting workshop. The wing panels on the high altar of the cathedral had been painted in the 1470s by an outsider, possibly Rueland Frueauf of Salzburg.[7] The biggest local painting workshop belonged to the manuscript illuminator Berthold Furtmeyr.[8] It is possible that the Regensburg manuscript painters were powerful enough to resist the introduction of the press. For apart from a missal published in 1485 by a Bamberg printer who had moved his equipment temporarily to Regensburg, not a single book was printed in the city before 1521.[9]

It is assumed that Altdorfer was actually born in Regensburg, and not in one of the numerous villages in Germany and Switzerland called Altdorf, because his Christian name and those of his siblings Erhard and Aurelia were associated in various ways with the city's past. Their father was almost certainly the painter Ulrich Altdorfer, who was inscribed as a citizen in 1478 but then in 1491 was forced to quit the city in poverty. Albrecht Altdorfer later returned to Regensburg. In 1505, probably in his early twenties, he was entered in the books as a citizen, described as a 'painter from

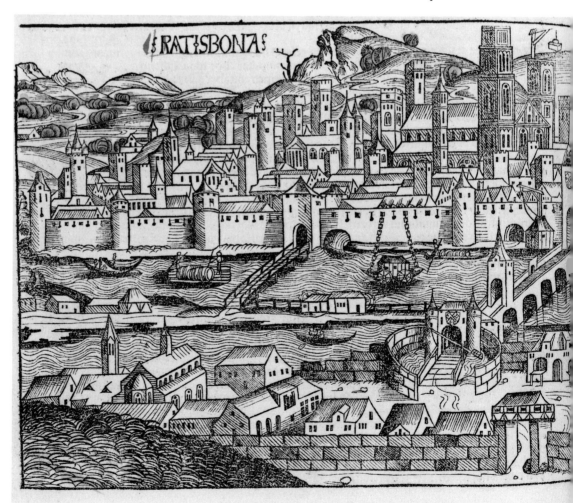

36 Workshop of Michael Wolgemut, *View of Regensburg*, woodcut, from the *Liber chronicarum*, 1493, 19.2 x 53.5. Beinecke Rare Book Library, Yale University, New Haven.

Amberg'. Amberg was a court city thirty miles to the north, the capital of the Upper Palatinate, and Ulrich may have settled there after he left Regensburg. Yet neither father nor son is recorded as a citizen of Amberg at any point between 1491 and 1505. Perhaps Albrecht was working temporarily in Amberg shortly before he returned to Regensburg to claim his citizenship.[10]

Albrecht and his brother Erhard were undoubtedly trained first by their father. Although Altdorfer's works have little in common with Berthold Furtmeyr's frank and imperturbable miniature style, the brothers may well have studied under Furtmeyr as well. Among the most appealing possibilities is a Prayer Book in Berlin commissioned probably by the Bishop-Administrator of Regensburg, Johann III of the Rhineland Palatinate, and painted in 1508 or shortly thereafter.[11] The full-page miniatures, based on Dürer's prints, must have been executed under Altdorfer's direct impact, or even supervision. And yet no early example of Altdorfer's own miniature work has ever been found.[12] The best argument for his origins as an illuminator is not documentary but deductive: he is too facile with the smallest brushes, and too comfortable on parchment, to be self-taught. Moreover, it seems highly unlikely that the Emperor Maximilian and his historian Johann Stabius would later have commissioned the *Triumphal Procession* miniatures from Altdorfer if he

had no professional credentials at all (illus. 137).[13] These were not the only miniatures produced by Altdorfer's shop for Maximilian. The full-page hunting scene and the marginal portraits of Habsburg rulers on a copy of the so-called 'house privileges' are dated 1512 and signed 'A.S.' by an artist under the direct influence of Altdorfer.[14]

Altdorfer's earliest surviving works are not book illuminations. His verifiable output before 1510 consists of four small panel paintings, fifteen engravings, and ten drawings. Yet already before the end of that decade, Altdorfer had begun working for the Emperor, and had earned a commission to paint a large altarpiece for the abbey church of St Florian near Linz, some days' journey down the Danube from Regensburg. By 1512 his drawings were already being imitated and copied by a flock of pupils. Doubtless there were smaller altar projects in those early years, now lost or even, perhaps, unrecognized. The scaffolding of Altdorfer's success was nevertheless amazingly impalpable. This fragility is deceptive. The lesson of Dürer's career, which was proceeding ten or fifteen years in advance of Altdorfer's, was that a reputation is more efficiently broadcast by signed sheets of paper than by a huge, immobile and labour-intensive altarpiece, or by a time-consuming illuminated manuscript that would be shut up in a library for years.[15]

Dürer's pre-eminence as a model has been slightly underrated in the Altdorfer literature of our own century. In 1675, Joachim von Sandrart, the German academician and biographer, made no mention of any connection between the two artists.[16] Back in 1609, however, Matthias Quad von Kinckelbach, an engraver and historian, had described 'Adam Altdörffer' of Regensburg as Dürer's pupil. Granted, this was a connoisseurial judgement. Quad von Kinckelbach mainly knew the late engravings, for he grouped Altdorfer together with Jacob Binck, Sebald Beham, Georg Pencz and Heinrich Aldegrever: 'Their work, in which one still perceives clearly the Dürerian *vestigia*, leads one to believe that they were his apprentices.'[17] But in 1831 Joseph Heller, the biographer of Dürer, recorded a drawing in red chalk of a sleeping old woman that, according to an 'old' inscription on it, had been given by Dürer to Altdorfer in 1509.[18] That drawing is lost; it may have been a copy of one of two extant pen drawings by Dürer of sleeping old women (or men) with covered heads.[19] We ought to keep in mind this shard of evidence, however exiguous, and in addition remember that the executors of Altdorfer's estate found among his possessions a panel painted by Dürer.[20] An encounter between Altdorfer and Dürer in 1509 is entirely credible. There is no need to insist on a face-to-face meeting. Altdorfer knew Dürer's prints by heart. In 1509, for example, he made an engraving of a standing Madonna and Child based closely on an engraving by Dürer of 1508.[21] Dürer was, in these years, overwhelmingly the outstanding silhouette in the fields of vision of ambitious German painters. Indeed, Dieter Koepplin, impatient with unnecessarily circumstantial explanations of the sources of Altdorfer's style, once protested that the towering figure of Dürer would suffice; beyond that, the only preconditions were that Altdorfer 'have good brushes and pens at his disposal and get enough to eat'.[22]

Dürer offered a new model of the painter's career. He demonstrated that a reputation was most effectively disseminated by signed and dated pieces of paper. The

practice of signing pictures with initials or monograms was more elaborately developed in southern Germany than anywhere else in Europe because of the example of engravings. The German engravers of the fifteenth century regularly used monograms. Martin Schongauer of Colmar monogrammed all his engravings. Schongauer was also the first German artist to build a national reputation. He did this by capturing the attention of literary humanists, who transformed his colloquial epithet *Hüpsch*, or 'beautiful', first into *Schön*, evidently with mnemonic or alliterative reference to the surname, and then into Latin.[23] For at least a generation Schongauer remained, for many people, a legendary figure, perhaps the only non-local artist known to them by name.[24] The young Dürer pursued that reputation in 1492 only to arrive in Colmar too late, a year after Schongauer's death. Later in the decade, after his first Italian journey, Dürer began building his own reputation through monogrammed prints. The famous monogram 'AD' appears on an engraving for the first time around 1495, on the *Virgin with the Dragonfly* (B.44). Dürer was the first engraver to nest one initial inside the other. He must have done this to distinguish his monogram formally from all the others, much as Schongauer had distinguished himself by using antiqua capitals in his monogram and by separating the initials with a cross. Around 1496 or 1497 Dürer began monogramming his woodcuts. This was an entirely new step. Many fifteenth-century book illustrations had been marked with single, or sometimes two, initials. These almost surely identified the cutter and not the designer, and probably meant nothing outside the trade.[25] Other woodcuts were signed with full names, indeed earlier and more often than engravings were. These, apparently, designated the artist responsible for the drawing.[26] Until the 1480s, ambitious painters scarcely got involved in woodcut book illustration. The pioneer was Dürer's teacher Wolgemut.[27] But Dürer went a step further when he began monogramming woodcuts printed on separate sheets of paper. He was offering them as works of art, alongside his engravings and even his painted panels.

Dürer immediately attracted the attention of literary humanists and antiquaries who wanted a contemporary German cultural hero, a rival figure to the Italians.[28] Conrad Celtis, for example, wrote a series of Latin epigrams on Dürer before 1500.[29] The result of the combination of self-inscription in prints and the efficient distribution of prints was that Dürer's early fame was quite uncoupled from his painting. Like Schongauer, he caught the attention of humanists with prints; but in Dürer's case the reputation actually addressed the prints, and in some circles, no doubt, even the drawings. Erasmus, for example, praised Dürer's ability to depict even meteorological phenomena and the human character with black lines alone.[30] Dürer had found his ideal audience. The humanists themselves, with whom he enjoyed manifold personal contacts, convinced him of the urgency of fashioning a reputation. In his drafts for the treatise on painting, Dürer initially insisted on the disinterestedness of artistic activity: 'Painting is useful', he wrote, 'even when no one thinks so, for one will have great pleasure occupying oneself with that which is so rich in pleasure'. But then he quickly conceded the attractions of fame: painting is also useful because 'one wins great and eternal remembrance [*Gedächtnis*] with it, if one applies it right'.[31]

71

Other enterprising artists took Dürer's career as a model. The field of activity for painters – the subject-matter they could treat, the kinds of objects they could make – had become too narrow and limiting. Talent was abundant, and appreciative beholders and buyers scarce. A generation of painters born between 1470 and 1485 imitated Dürer by launching their careers with small private paintings and graphic work, by going over the heads of the large workshops, so to speak, directly to a public. Success came quickly. In 1502, the year Lucas Cranach was first documented in Vienna, Altdorfer, Matthias Grünewald and Hans Baldung Grien were still unheard from, and Hans Burgkmair had produced only insignificant works. But only a decade later these five figures, alongside Dürer, dominated German painting. By that time Dürer had already received and completed his great commissions and had more or less retreated from altar painting into graphic work and theoretical writing. The others had all established conspicuous public careers. Baldung had completed his stint with Dürer in Nuremberg and set up shop in Strasbourg; in 1513 he was to begin work on a high altarpiece at Freiburg. Cranach presided over a vast workshop at the court of the Elector of Saxony in Wittenberg. Burgkmair supervised a huge painting and graphic industry in Augsburg. Grünewald had begun work on his altar-piece at Isenheim probably in 1509.

By the early years of the second decade, moreover, Dürer, Burgkmair, Cranach and Altdorfer were all working for the Emperor. They could do this without taking up residence in Innsbruck or Vienna, for Maximilian was merely one of many clients. What was the source of their sudden stature? The great German painters of that generation, with the exception of Grünewald,[32] all emerged on the strength of their graphic work and in general their smaller, portable works. They all monogrammed their prints and small paintings. Their early success in this new market won them still more lucrative traditional commissions and granted them a psychological margin for formal and intellectual experimentation. They earned reputations among literary humanists who had influence with the Emperor. They even built up workshops based on their graphic practice: young artists came to Dürer and Burgkmair and were put to work designing woodcuts. In the decade of the 1510s, the years of their mature fame, these artists consistently distinguished themselves from contemporaries such as Martin Schaffner and Bernhard Strigel, who produced no small-scale works at all that we know of, or Jörg Breu, Hans Schäufelein, Hans Kulmbach, Leonhard Beck, Hans Springinklee and Wolf Traut, whose graphic work consisted mostly of book illustrations.

Dürer provided this generation not only with the example of his career, but also with a new set of criteria for discriminating among works and among artists. These criteria were ultimately formal and intimate; they were aspects of execution rather than invention. But they were given breathing space, room to unfold and display themselves, in the new realms of subject-matter, the new formats and media, and the new compositional formulas opened up by Dürer. Together with the nomadic Venetian Jacopo de' Barbari, Dürer introduced pagan subject-matter to the German engraving. He initiated a massive extension of the artist's activity beyond the altar-

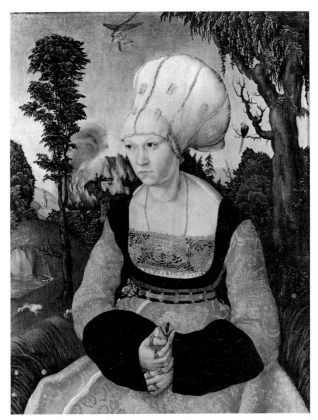

37 Lucas Cranach, *Portrait of Anna Putsch*, *c.* 1502, oil on panel,
59 x 45. Collection Oskar Reinhart, Winterthur, Switzerland.

piece, into private and portable objects. He inspired even journeyman artists to monogram their works. He advanced the techniques of engraving and woodcut until they were capable of displaying the most inimitable and distinctive attributes of a draughtsman's hand and registering broad ranges of authorial tone. Finally, he introduced new narrative tactics and an unprecedented attentiveness to the tension between subject-matter and setting, including landscape.

The first German artist to compete with Dürer on his own terms was his exact contemporary, Lucas Cranach. Cranach was born in 1472 in Kronach in Upper Franconia, fifty miles north of Nuremberg. Nothing is known of his activities before the first years of the new century, when he surfaced in Vienna. There he painted a pair of wedding portraits for the poet, physician and university professor Johann Cuspinian and his wife Anna Putsch, daughter of an Imperial chamberlain and sister of a cleric (illus. 37). Cranach painted another pair of portraits, dated 1503, for an unidentified man, possibly a jurist, and his wife.[33] He placed all four sitters in outdoor settings among symbolically charged flora and fauna. The outdoor setting itself is not unprecedented. A portrait of a long-haired young man with landscape visible over each shoulder, for example, is often attributed to Dürer, and is dated to the late 1490s.[34] But Cranach has set his landscapes vibrating. He embeds astrological and alchemical symbols in terrain, and naturalizes them as diminutive figures and animals. The combat of eagle and swan above the head of Anna Putsch signifies a

73

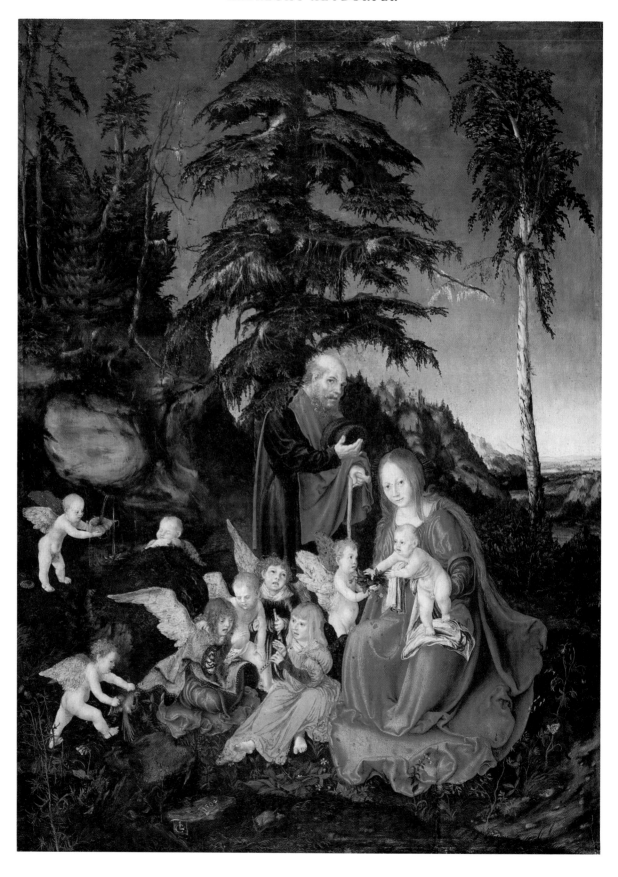

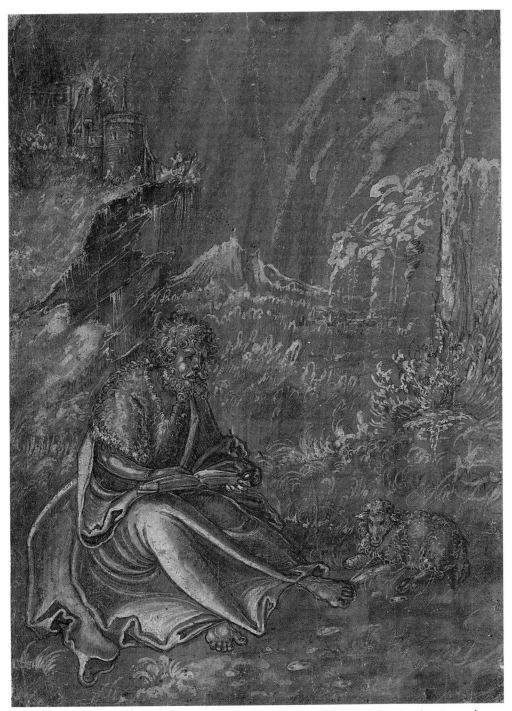

39 Lucas Cranach, *St John the Baptist in the Wilderness*, *c.* 1503, pen with white heightening on brown
grounded paper, 23.5 × 17.7. Musée des Beaux-Arts, Lille.

38 Lucas Cranach, *Rest on the Flight into Egypt*, 1504, oil on panel, 70.7 × 53.
Gemäldegalerie, Berlin.

conjunction between Jupiter and Apollo: a favourable complement to her husband's melancholic temperament. The red parrot associates Anna Putsch with the sanguine. The women in the backgrounds of both portraits – one linked with fire and the other with water in the female pendant – incarnate a purifying proximity to elemental nature. Nature serves as inspiration to Cuspinian, the neo-Platonic poet. Cosmic harmony is both precondition and object of his writing.[35]

The same people who commissioned Cranach's Viennese portraits very likely also took an interest in Cranach's independent sacred images, such as the astounding *Rest on the Flight into Egypt* of 1504 (illus. 38).[36] The painting is a simplification of Dürer's woodcut *Holy Family with Three Hares* (B.102). But unlike in a print or a drawing, Cranach's figures detach themselves instantly from their ground. The figures are all pale flesh, hair, and warm, manifold fabrics, completely unlike the earth that supports and shelters them. Nevertheless, the bough of the fir-tree probes forward into the animated circle, half human and half divine, and alights on Joseph's shoulder. This physical overlapping of setting and subject-matter at the very centre of the picture is one of the boldest passages of the German Renaissance.

By 1505, when he was called to the court of the Elector Frederick the Wise of Saxony, Cranach had already produced a considerable body of graphic work and independent painted panels.[37] He quickly gained a reputation among literary human-ists. Christoph Scheurl, the Nuremberg humanist and jurist, praised him for painting 'with wonderful speed'; Cranach's tomb remembered him as *pictor celerrimus*.[38] In his *Elementa rhetorices* of 1531, the erudite reformer Philipp Melanchthon, Luther's deputy, invoked Cranach to illustrate the humble style; Dürer and Grünewald occu-pied the two higher ranks.[39]

Cranach's early drawings on coloured grounds – the *John the Baptist* in Lille of around 1503 (illus. 39)[40] and the *St Martin and the Beggar* in Munich, monogrammed and dated 1504[41] – were among the first autonomous drawings in the history of Western art. They were drawn with pen and ink and finished with touches of opaque white pigment, on paper coated with chalky grounds, usually in earth tones. These drawings, neither reproductions of existing works nor preparatory studies for future works, were offered as works in their own right. Paper prepared with coloured ground was first used as a drawing support in Tuscan painting workshops of the fourteenth century.[42] The ground provided a middle tone between the darker outlines and shading and the heightening in opaque white. The technique proved ideal for working out tonal values in life drawing or in direct preparation for painting. It flourished in Italy until the early sixteenth century, when it was replaced by chalk drawing. At this very moment, however, the German coloured-ground drawing broke out of the workshop. Partly because the ground masked the physical support of the drawing, partly because its triple tonality of ground, black pen and opaque white heightening simulated some of the effects of painting, the coloured-ground drawing stood more easily on its own than the ordinary pen drawing. The earliest dated and indisputably independent coloured-ground drawing is Bernhard Strigel's *Death and Amor* of 1502.[43] The idea was seized upon immediately by Cranach, and within the next years

by Altdorfer, Huber, Baldung, and especially the Swiss artists Leu, Manuel Deutsch and Graf. By 1508 the independent coloured-ground drawing was so well established in Germany that it was in turn imitated by the chiaroscuro woodcut (see p. 246).

The coloured-ground drawing became one of the great theatres for personal style. The pen slid easily on the smooth coloured ground. The ground encouraged swifter outlines, broad, looping modelling strokes, even gratuitous flourishes of the pen. Rapid execution of the sort admired by the humanists became an aspect of personal style. Some of the drawings were no doubt executed within a matter of minutes, perhaps even under the eyes of the patron. The initials or monogram that appeared on nearly all coloured-ground drawings, finally, guaranteed the authenticity of those pen-strokes: the drawing was the product of an unrepeatable set of creative gestures and a particular moment in time.

In the drawing of John the Baptist, Cranach created a wilderness of opaque heightening coarsely brushed on a streaked brown ground. The subject-matter – the seated saint together with his attribute, the lamb – is outlined with black pen and self-contained. Nevertheless, the work is more like a print than a painting, for the setting is created out of the same substance as that of the figure. The white heightening serves several different functions at once. In the drapery it makes areas of lighter tone, even an effect of sheen on the cloth. On the Baptist's fur tunic and in the wool of the lamb it describes individual curled hairs. Along the edge of the cliff above the saint's head it traces a tense and quivering profile of rock. The background is described almost entirely with rude white brushstrokes. In the distant mountain and in the tree at the right, white is outline, substance and tone all at once. This confusion of descriptive tasks was to become a central theme in Altdorfer's work. Lines this versatile were eventually to detach themselves from their representational function.

Altdorfer, following Cranach, began making autonomous drawings on coloured ground at the very start of his career. Altdorfer's earliest known work is a pen drawing on white paper in Berlin, dated 1504 and unsigned, a comic *Loving Couple* (illus. 40).[44] Echoes of Cranach's woodcuts are found in the figure and especially the face of the youth, the rough drapery of the woman, the wild mood. But Cranach's line was never so fine and tremulous. Cranach never had the patience to vary the length and intensity and density of his pen-strokes in the way in which they are varied here. The drawing proceeds more fundamentally from Dürer. Four drawings by Altdorfer on coloured ground are monogrammed and dated 1506, all depicting subjects outside the familiar territory of New Testament iconography: *Samson and Delilah*,[45] *Witches' Sabbath*,[46] *Pax and Minerva*,[47] and *Two Lansquenets and a Couple*.[48] These are all finished works, as complete and as self-sufficient as prints. The *Two Lansquenets* in Copenhagen (illus. 41), on a red-brown ground, plants a pair of overstuffed, plumed foot-soldiers before a wide band of rough pen slashes, a wall of grass. Like the other four drawings of 1506 – and unlike all but a very few later sheets – the drawing is framed by a black pen-line.[49] Hanna Becker thought that the Copenhagen sheet was a copy because the border cuts off the arm and leg of a soldier.[50] But a frame that cuts off a figure is also a more assertive and conspicuous frame. It enhances the

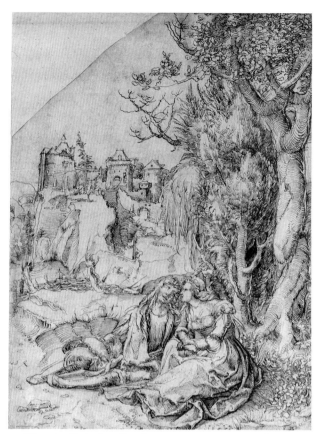

40 Albrecht Altdorfer, *Couple*, 1504, pen on paper, 28.3 x 20.5. Kupferstichkabinett, Berlin.

effect that the scene has been fortuitously captured, a slice of real life. Hans Mielke, too, reads the borders as proof that the compositions were determined in advance and not spontaneously invented. Indeed, he believes that all of Altdorfer's finished drawings were *Reinzeichnungen*, or fair copies: copies after himself, as it were. Mielke did prove that pupils made close copies of Altdorfer's drawings in the shop, by showing that both the *Samson and the Lion* and its copy were drawn on paper cut from the same sheet.[51] It is true that the appeal of these drawings was that they did not look copied or premeditated, but spontaneous. But spontaneity could be affected or imitated. Wolf Huber seems to have copied his own landscape drawings. Nevertheless, although we have copies by pupils and followers after drawings by Altdorfer, we have no pairs of drawings both by Altdorfer that would verify Mielke's hypothesis. And, in fact, these drawings are generally far from 'fair': they are thick with overlappings, second thoughts, blunders. The black border was a way of asserting the finished quality of the drawing in these early years of the autonomous drawing; it imitated the border of woodcuts and engravings. Later it became unnecessary.

Another pair of coloured-ground drawings by Altdorfer are monogrammed and dated 1508: the *St Nicholas Calming the Storm* at Oxford[52] and the *Wild Man* in London (illus. 105). The *Christ in the Garden of Gethsemane* and the *St Margaret*, both in Berlin, are monogrammed and dated 1509.[53] It is hard to overstate the

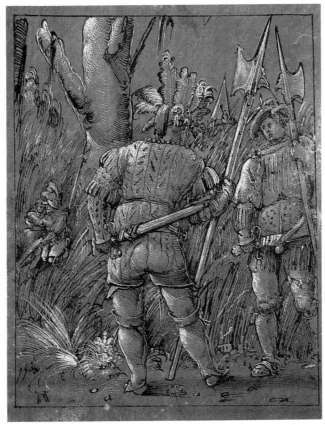

41 Albrecht Altdorfer, *Two Lansquenets and a Couple*, 1508, pen
and white heightening on red-brown grounded paper, 17.6 x 13.7.
Statens Museum for Kunst, Copenhagen.

significance of these signatures. More than anything else it was the monogram and the
date, inscribed on small tablets or cut stones, that sealed off the autonomous drawing.
There is no indubitably authentic signature or monogram on any German pen-drawing
before Dürer.[54] Most, and perhaps all, of the monograms on Schongauer's drawings,
for instance, were applied by later owners, among them Dürer himself.[55] Dürer began
initialling his own drawings before 1495. In 1497 he first used the nested monogram,
D inside A, on a drawing, the *Lute-playing Angel* in Berlin.[56] But most of the early draw-
ings that Dürer signed merited initials only by virtue of their proximity to more formal
media: some copied Italian engravings, others were painted on parchment like minia-
tures. Even Dürer did not simply begin by monogramming ordinary pen-drawings,
although he would do so frequently later on.[57]

Dürer was the only important artist of his century or even for several centuries
who regularly signed his drawings. He was more of a loner than a pioneer. The
impact of his innovation was short-lived and local, but intense. Every German artist
of the sixteenth century who monogrammed a pen-drawing was directly or indirectly
following Dürer's lead. Altdorfer's monogram itself, with its A nested within a larger
A, directly emulated Dürer's. The initials on fifteenth-century engravings, by contrast,
were never nested or entwined. Dürer's pupils and direct associates – Hans Baldung
Grien, Hans Kulmbach, Hans Schäufelein, Hans Springinklee, Hans Leu the

79

younger – all entwined or nested their initials on drawings.[58] But there is no proof that Altdorfer had ever seen a *drawing* by Dürer before 1506, signed or unsigned. Altdorfer may actually have imitated not the monograms on Dürer's drawings but those on his engravings, as well as the monograms on his own engravings, thus negotiating the transition from the reproductive medium to the drawing all on his own. Indeed, when Altdorfer framed his monograms and dates in little boxes, as he did in three of the 1506 drawings (all but the Copenhagen *Lansquenets*), he was certainly imitating Dürer's prints and not his drawings. There were virtually no precedents for framed or 'motivated' dates or monograms on drawings. In fifteenth-century German engravings, initials and dates appeared anywhere on the surface; Schongauer was the first to place his monogram consistently at the lower centre. Dürer began framing the monogram only after the turn of the century. And, indeed, Altdorfer never again dated or monogrammed a pen-drawing in this way.[59]

Under the aegis of the signature, such pictures began to distance themselves from other pictures, and from the functions that most pictures ordinarily fulfilled. The trace of an absent artist transformed the merely physically independent painting or drawing into a 'work'. Dürer actually wrote explicitly about the manifestation of the artist's personality in the work, in the passage from his treatise on proportions, the so-called 'Aesthetic Excursus', quoted earlier. First, Dürer describes imagination or inventiveness as a 'power' granted by God to the great artist. Then he admits that this artist's essential ambition is to reveal himself in his works, within the customary boundaries of function, iconography and decorum: 'He that desires to make himself seen in his art must display the best he can, so far as it is suitable for this work.' Power reveals itself, miraculously, in the most negligible vestige of the hand's movement.

An artist of understanding and experience can show more of his great power and art in crude and rustic things, and this in works of small size, than many another in his great work. Powerful artists alone will understand that in this strange saying I speak truth. For this reason a man may often draw something with his pen on a half-sheet of paper in one day or cut it with his little iron on a block of wood, and it shall be fuller of art and better than another's great work whereon he has spent a whole year's careful labor, and this gift is wonderful.[60]

The value of the work is independent of the quantity of labour lying behind it. The trace of the artist's divine gift permits the frame to close off the picture and pronounce it finished. The clean cut of this external frame was in turn the prerequisite for any really adventurous tinkering with the internal structure of the narrative picture.

Subject and setting

Altdorfer's *Dead Pyramus* in Berlin is a good example of a narratological experiment made possible by this new enfranchisement of the drawing. The sheet is unsigned – or has lost its signature – but must date from *c.*1510 (illus. 42, 43).[61] It was executed in black ink and opaque white heightening on paper coated with a deep blue ground. This drawing stages a direct conflict between setting and subject-matter. The scene opens on a still forest space and a scattering of brittle, fleshless trees, etiolated by

an unseen moon. At the foot of the tallest tree, at the mouth of an arched tunnel, on stony ground rimmed with underbrush, lies a man in the costume of a soldier. This figure is not easily identified. If the drawing is still a narrative, then it has become antagonistic to its own pretext. But the figure does resemble figures from other pictures, in particular the dead Pyramus in a woodcut by Altdorfer.[62] The story of the lovers Pyramus and Thisbe was told by Ovid in book IV of *Metamorphoses*; today it is best remembered from the version clownishly performed in Act V of *A Midsummer Night's Dream*. Frustrated by their elders, the couple planned a nocturnal tryst outside the walls of Babylon, at the tomb of Ninus, near a mulberry tree and a spring. Thisbe, arriving early, encountered a lioness and fled, leaving behind her veil, which the lioness tore and marked with bloody jaws. Pyramus found the veil and, assuming the worst, killed himself with his sword; Thisbe then returned to the scene, discovered the corpse, and also killed herself. The story was absorbed into profane iconography as early as the twelfth century. Most recently, in 1505, it had been engraved by the Bolognese Marcantonio Raimondi (B.322). Still other pictures encourage the identification of the figure by showing that Pyramus sometimes wears the slit tunic of a lansquenet and that the arched cave can stand as the tomb.[63] But where are the spring, the lion and, above all, Thisbe? (Is she cowering behind one of the trees to the left of the tomb,[64] or is the beholder of the picture cast as Thisbe?) The best clue to the identity of the recumbent figure is the slender dagger fixed in his chest.

The *ekphrasis* or description of this picture was impeded by the supine lansquenet. The story he belongs to has been torn apart. One is tempted instead to remain in the upper three-quarters of the picture and continue describing the firs, their bark and branches and thinning foliage, the pendulous mosses, the fragment of remote mountain profile, and even the sky between and behind the trees. Setting does not merely fail to contribute to subject-matter, but also pulls us away from it. On the other hand, the very obscurity of setting's commentary on subject-matter can become another sort of contribution. The arch appeal of this drawing consists precisely in its iconographic frugality. By omitting components of an established narrative, it rejuvenates that narrative. The drawing places the beholder between two suicides, the one attested to by the corpse and the other merely anticipated. The beholder is forced to recognize the story from the inside out, and is made to wonder, perhaps for the first time: how impetuous was Pyramus's suicide? how long did he wait? where is Thisbe and when will she return? The drawing has delivered the story back into the hands of the beholder. It has surrendered control over the temporal structure of the story; now the story stretches forward and backward in the beholder's mind. The last indications of narrative time within the drawing are the raised knee, implying a fairly recent fall to earth, and the radiating ringlets of hair, perhaps a survival from Marcantonio's version, recapitulating the violence of passion. All the rest have vanished. Like any narrative image, this drawing represents a static moment, a configuration of bodies in space, in such a way that the immediate temporal antecedents and consequences of that moment are called to mind. The static image is physically incapable of reproducing continuous time; instead it demands that the beholder

42 Albrecht Altdorfer, *Dead Pyramus*, *c.* 1510, pen and white heightening on blue grounded paper, 21.3 x 15.6. Kupferstichkabinett, Berlin.

43 Detail from *Dead Pyramus*.

extend the action forward and backward in the mind. The image dramatizes the contrast between the intense fullness of the single described moment and the emptiness of all the ghostly and imagined moments before and after. An image is more disorderly and gratuitously informative than a written text can ever be. The painter or draughtsman, unlike the writer, is virtually obliged to include more information than the subject requires. For the painter has to fill a frame; the writer simply stops when he is finished, and the edge of his text becomes his frame. Thus pictorial narrative turns a necessity into a virtue. The subject-matter of a narrative image is always partially absent: the beholder's attention is always displaced toward something adjacent to the represented moment. Altdorfer's drawing carries this displacement to an extreme.

But this rejuvenation of narrative is ultimately hazardous to narrative. The laconic narrative lives on the fringes of intelligibility. It is in danger of falling entirely silent, as it has in a strange drawing by Altdorfer in Frankfurt where an anonymous prostrate man, sharply foreshortened, sprawls (again with raised knee) beneath a monstrous cluster of fir-trunks (illus. 44).[65] Moreover, setting begins to generate its own independent meanings, probably not narrative at all, possibly quite inadvertent. Setting, which has been described and not 'told' by the draughtsman, which is so susceptible to and even inviting of the beholder's secondary description, installs alternative temporal structures. Altdorfer's *Dead Pyramus* precipitates temporality down to an elemental state, to the quivering of foliage and to the imperceptible pace of vegetative growth. Setting betrays subject-matter by broaching themes in its own right. Description in this drawing cannot simply be classified as either functional or decorative.

The internal boundary that the naming of subject-matter drew between setting and subject turns out to be permeable, even unstable. The narratologist Gérard Genette has shown how verbal narration enjoys a temporal coincidence with its object that verbal description cannot share: narration itself mimics the temporal succession of events, whereas description must struggle to account for static or spatial properties in a temporal medium.[66] In the image, which offers a spatial analogy to phenomenal reality, this imbalance is reversed. The pictorial *historia* is constantly drifting back toward description, toward a report on the physical attributes of things in the world. The text, at least, has the option of saying either 'a man stabbed himself and fell to the ground', or 'a man lies on the ground with a dagger in his chest'. The former statement narrates; the latter describes a state and only implies an event. The image can only make the latter sort of statement. It can only represent movement by showing a 'still', as it were, and hoping that the beholder will extrapolate backward and forward. Description can only offer circumstantial evidence; indeed it can only show (*evidentia* means 'showing clearly') and never tell. It turns out that everything in the picture, even the corpse, is a description. Is narrative ever embodied in an image? The real subject-matter of narrative is not the human figure, but the event. Narrative describes events; it accounts for change through time. But because only verbs can accomplish this with authority, the image is reduced to describing the premises or

44 Albrecht Altdorfer, *Dead Man*, *c.* 1515, pen and white
heightening on olive-brown and orange grounded paper,
17.8 x 14.2. Städelsches Kunstinstitut, Frankfurt.

the results of events. In the image, description is perpetually encroaching on the
story. It overwhelms even the human figures, until everything has become setting
and until the story is disembodied. Description brings to bear on the image a levelling
power: it disassembles the hierarchy between action and stasis, eventually social
hierarchies, also perhaps the hierarchy of the historical and the natural, or the animal
and the vegetal.[67] And this is what the *Dead Pyramus* represents: the body is in the
process of being absorbed back into the forest, reclaimed by coils of calligraphy. Line
here is the spokesman for the organic, for process. The forest advances on the
remains of narrative.

Altdorfer was exploiting an intrinsic ambiguity of setting. Setting, the zone of
accessories or *parerga* enveloping the movement at the centre, was the zone within
the picture most independent of prescription and convention. The morphology of
the human figure was severely constrained by workshop tradition, by the knowledge
and expectations of beholders, and by fundamental principles of anatomical verisimil-
itude. Setting, on the other hand, could unfold and diversify in any direction without
necessarily foiling the purpose of the picture. Setting was the least resistant part of
the picture. Any number of conceivable settings could effectively host a given event.
An outdoor setting could accumulate geographical or meteorological attributes, or
pockets of authentic topographical data. A tree or a mountain could assume new

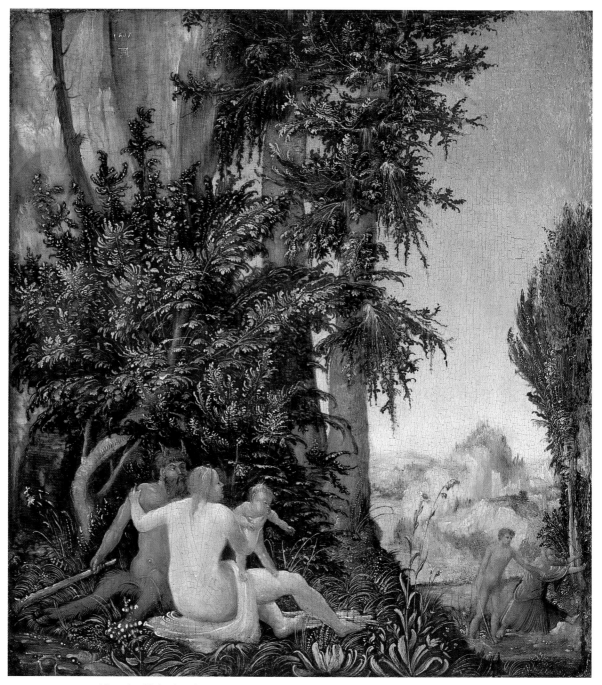

45 Albrecht Altdorfer, *Satyr Family*, 1507, oil on panel, 23 x 20.5. Gemäldegalerie, Berlin.

46 Albrecht Altdorfer, *Wild Family*, *c.* 1510, pen and white heightening on grey-brown grounded paper, 19.3 x 14. Graphische Sammlung Albertina, Vienna.

contours almost *ad libitum* and still be recognized as a tree or a mountain. Dürer had demonstrated this already in his woodcuts and engravings of the 1490s.

This is the process that led Altdorfer to the independent landscape. The analysis of the process has taken the *Dead Pyramus* as a starting point in order to unearth the roots of landscape within the narrative image. The descriptive line tends to dissipate solid bodies. Substance in the *Dead Pyramus* is at the mercy of Altdorfer's rampant and ambitious pen. The protagonist of the drawing is caught in a web of line; he bleeds into the earth, overwhelmed by the canopy of calligraphy closing in over the space where he once stood. He is drained of substance, becomes one with the dark blue ground. Line erodes matter; it etches matter away. The eye, instead of lighting on and gauging bodies, can actually leaf through the layers of overgrown penmanship: first the white scribbles and the long dripping flourishes, then the black scribbles, then the shading in black and white, finally the tenuous outlines, only to arrive at nothing, a blank ground, pure colour. And when line contests the presence of physical substance, it also contests subject-matter. It ridicules the illusion that subject-matter, and certain kinds of meaning, inhabit measurable bodies. Instead, it leaves those meanings in the custody of an artist. When Dürer rebuked the artist who departs from nature, imagining vainly that he will find better on his own (see p. 13), he may have been thinking precisely of Altdorfer.

The settings of many of Altdorfer's early drawings are contentious in just this way. Their subject-matters belong to the repertory of the quasi-narrative hagiographical or profane print. But they approach these subjects from an oblique angle. Their freshness and appeal is grounded in the strange sense of humour, the *ad hoc* icono-clasm, of the draughtsman. Altdorfer twists every theme into burlesque. He lets a layer of unruly new growth spread over the old subjects. Altdorfer's predecessor here was the Housebook Master, the late-fifteenth-century Rhenish engraver and painter who had cultivated a similarly dishevelled and disrespectful tone. In some of Alt-dorfer's drawings, like the Paris *Witches' Sabbath* and the Oxford *St Nicholas Calming the Storm*, the turmoil and indiscipline of the setting are built into the subject-matter. More profoundly unbalanced are those drawings where subject-matter seems almost arbitrarily beleaguered by its surroundings. The *Two Lansquenets and a Couple* in Copenhagen (illus. 41), for instance, offered a reverse perspective on the loving couple familiar from fifteenth-century engravings. Here the couple vanishes into an ocean of grass, while the bulky comrades in the foreground, one turning a bulging back to the beholder, spy on the lovers, stand guard, or wait their turn with the woman. The *Dead Pyramus* belongs to this latter category of drawing.

Altdorfer was allergic to bombast and heroic equipoise. In these drawings he intrudes clumsily and disingenuously on narrative by rattling the hierarchy of subject and attributes, or by inflating attributes into false subjects or decoys. Altdorfer fol-lowed both Dürer and Cranach, for example, in exploiting the tree. The tree is the ideal parodic double of the human subject. It is anthropomorphic in structure, but elastic in size; it is naturally immobile, and so mocks the artificial immobility of the depicted human figure; it can appear almost anywhere without special iconographic

47 After Albrecht Altdorfer, *Madonna and Child in a Forest*, *c.* 1510(?), pen and white heightening on olive-brown and orange grounded paper, 17 x 14.7. Herzog Anton Ulrich-Museum, Braunschweig.

justification and is thus largely exempt from conventions of decorum or narrative veri-similitude. There are many examples of the exempted tree among Altdorfer's drawings on coloured ground. In a drawing in Braunschweig, another excellent copy, the Virgin and Child are framed entirely by trees (illus. 47).[68] The drawing hyperbolizes a familiar iconography, the Madonna and Child in the open air: part Madonna of Humility, part excerpt from the Flight into Egypt. They are framed by trees, but also by a curtain of modelling lines, literally hundreds of blunt parallel strokes in black and feathery white coils, a foil so dense that it almost loses its representational value.

Once the tree is perceived as an element of pictorial structure, architecture, too, can come to look like mere setting, with its ties to iconography unravelling. In the

48 Albrecht Altdorfer, *St Francis*, 1507, oil on panel, 23.5 x 20.5. Gemäldegalerie, Berlin.

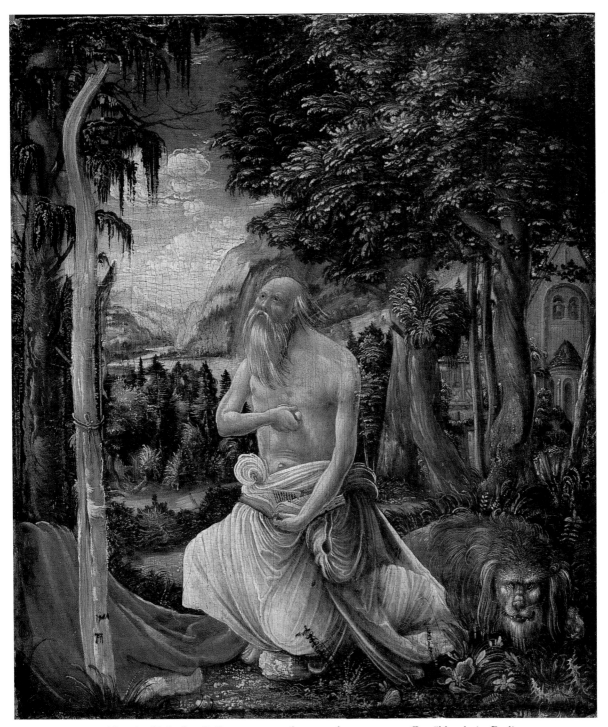

49 Albrecht Altdorfer, *St Jerome*, 1507, oil on panel, 23.5 x 20.4. Gemäldegalerie, Berlin.

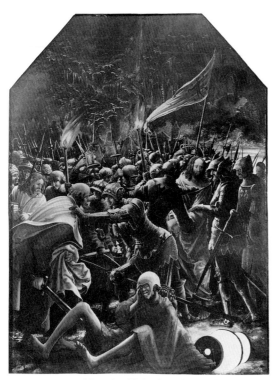
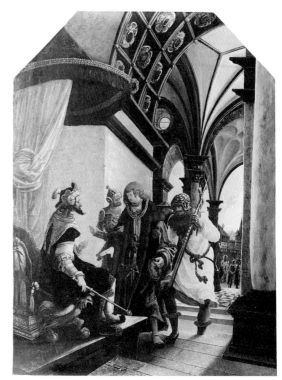

50 Albrecht Altdorfer, *Arrest of Christ*, from the St Sebastian altarpiece, *c.* 1515, oil on panel,
129.5 x 97. Augustiner-Chorherrenstift, St Florian, Austria.

51 Albrecht Altdorfer, *Trial of St Sebastian*, from the St Sebastian altarpiece, *c.* 1515, oil on panel,
128 x 93.7. Augustiner-Chorherrenstift, St Florian, Austria.

52 Albrecht Altdorfer, *Birth of the Virgin*, *c.* 1520, oil on panel,
140.7 x 130. Alte Pinakothek, Munich.

53 Albrecht Altdorfer, *Marcus Curtius*, 1512, pen and white heightening on olive-green grounded paper, 19.5 × 14.4. Herzog Anton Ulrich-Museum, Braunschweig.

panels of the St Florian altarpiece, landscape and architecture perform comparable structural functions. In the *Arrest of Christ* (illus. 50) Altdorfer painted a forest that encloses the actors like a constructed interior;[69] the interior architecture of the *Trial of St Sebastian* (illus. 51), meanwhile, arches and twists like a forest.[70] Architecture also enters easily into a competitive relationship with subject-matter. Italian painters had for decades been constructing cities and palaces at the expense of narrative, and not only in model drawings like those in Jacopo Bellini's sketchbook. Later on, Altdorfer made this rivalry a theme of some of his most ambitious panel paintings: the *Birth of the Virgin* (illus. 52), with its enormous celebratory angelic chain weaving hazardously among the pillars, the unlikeliest possible setting for a birth;[71] and the *Susanna and the Elders* (illus. 55) of 1526, with a triumphant and exotic palace that looks like it is still growing, upward and outward.[72]

What would an independent landscape look like if it were made out of architecture? In a drawing of the *Death of Marcus Curtius* dated 1512 (illus. 53), the hero bears the same structural relationship to the city that Pyramus bore to the forest.[73] The drawing was inspired by a Cranach woodcut of *c.*1507, which itself followed a small northern Italian bronze relief, where a tempietto and a row of half-clothed figures stood for the Roman forum and the populace, the site of the hero's self-sacrifice and its witnesses. In Altdorfer's drawing, the tempietto has become a pair of massive columns. Rome is now a deserted Gothic nightmare in imperial proportions. Marcus Curtius is about to drop out of the picture altogether. After such a disappearance, the picture would be pure urban setting. Within the rhetorical analysis carried out

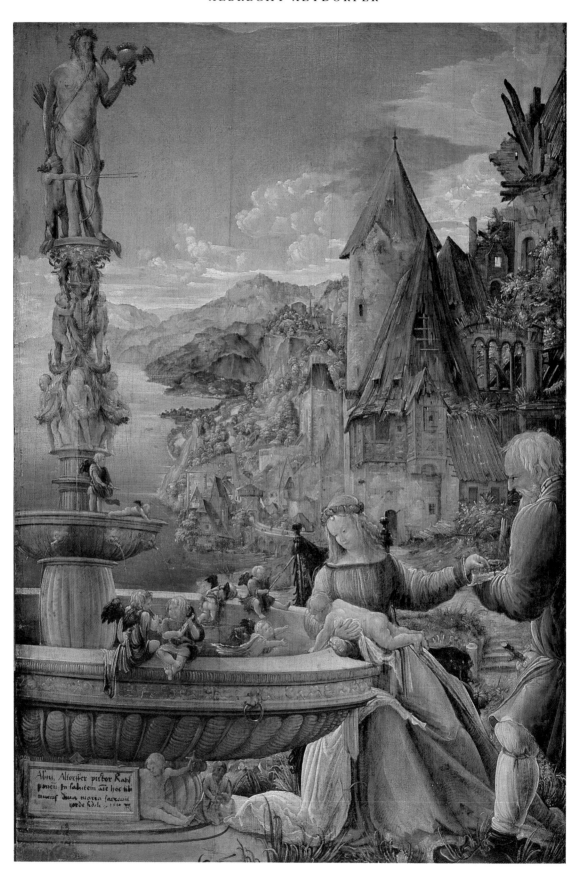

55 Albrecht Altdorfer, *Susanna and the Elders*, 1526, oil on panel, 74.8 x 61.2.
Alte Pinakothek, Munich.

54 Albrecht Altdorfer, *Rest on the Flight into Egypt*, 1510, oil on panel, 57 x 38.
Gemäldegalerie, Berlin.

56 Albrecht Altdorfer, *A Church on a City Street*, 1520, pen and white heightening on dark brick-red grounded paper, 17 x 14.7. Teylers Museum, Haarlem.

here, this setting would be indistinguishable from a woodland, pastoral or marine setting. If 'landscape' is the disappearance of subject-matter, then such a picture would be a landscape.

That urban landscape does exist, and it is one of the most curious works in Altdorfer's *œuvre*. A drawing on a dark brick-red ground in the Teylers Museum in Haarlem represents nothing but a church on a city street and a handful of random passers-by (illus. 56).[74] Just as for the empty landscape, there are precedents for the street-scene in marginal spaces. One of the *bas-de-page* calendar scenes in the Turin Hours, Flemish work of the mid-fifteenth century, represents a low frieze of urban house-fronts and passers-by, both smart and shabby.[75] The margins of the page offered a safe house for the subject-less vignette. But Altdorfer's Teylers drawing shares its technique, its format, and its degree of finish with ordinary single-scene narratives. The drawing is dated 1520 and is falsely inscribed with Dürer's monogram. Beneath that monogram are traces of an Altdorfer monogram. There are really no barriers to accepting the drawing as autograph, even if the date is correct. Since Altdorfer had by that time largely given up drawing on coloured ground, there are no proximate standards by which we can judge the style, no morphological niche in which to insert it. Nevertheless, there is great refinement and the aura of exploration and novelty in the speckled glow of the church walls, in the smudges of white at the horizon, in the flared and dramatic contour lines in black. The drawing has been associated with the plans to build a new chapel for the miraculous image of the Schöne Maria of Regensburg, the cynosure of the pilgrimage of 1519–21. But it would make no sense to bury an architectural projection in this darkest of coloured

grounds or to surround it with aimless pedestrians in archaic robes.[76] There is no fundamental difference between such a drawing and a picture of an empty forest. The independent landscape is what remains not when 'culture' has been subtracted from the scene of narrative – leaving 'nature' behind – but when subject-matter is subtracted.

Of course it is madness to read drawings in this way. The forest enveloping the Braunschweig Virgin and Child is no mere pretext for penmanship. The forest powerfully inflects subject-matter. It shelters the holy refugees from a hostile pagan culture; it links them to a pristine and pre-ecclesiastical cult. Marcus Curtius will never really disappear from the city. The Teylers street-scene must have had a meaning. And yet there is a place for the perversely anti-iconographic reading. Such a reading serves a heuristic purpose: one needs to ignore the referential workings of the image, provisionally, in order to penetrate to a level of pictorial structure that underlies reference and makes reference possible. Such an analysis – like the rhetorical analysis of a text – can reveal affiliations and distinctions among images that were otherwise invisible. More important, the structural analysis opens up the possibility of a historical exegesis of the work. It makes it conceivable to write about images and about other aspects of culture in commensurate terms. Not before the analysis arrives at the level of structure will it have a chance of improving upon the approximations of 'contextual' art history.

It is not obvious that such a mode of reading is an anachronistic imposition upon the historical material. Circumstantial and textual evidence alike suggests that beholders were capable of looking *through* subject-matter long before the establishment of an art-critical discourse. Assignation of value and discriminations made among works and artists were largely governed by judgements about how images worked, not what they said. To read a forest as a pattern of pen strokes, in other words, is not to break with a tradition of interpretation, but rather to rejoin that tradition.

In Altdorfer's time, the most conspicuous platform for structural experiments was the portable painted panel. The panel, the descendant of the ancient icon, was in these very years overtaking the manuscript illumination as the format *par excellence* of the private devotional image. Independent panels commonly showed figures and scenes extracted from familiar narrative sequences, sometimes incorporating dramatic references to the iconic roots of the format. The painted panel became a basic calling-card of the ambitious artist and a much favoured collector's item. Altdorfer's immediate models were again Dürer and Cranach. His earliest dated paintings were independent panels: the *Nativity* in Bremen, the *Satyr Family* in Berlin, and the *St Jerome* and *St Francis* in Berlin, all of 1507.[77] The three in Berlin at least were certainly meant for domestic spaces; they are already 'cabinet' pictures of some sort.

Altdorfer signed all four of the 1507 panels with his monogram. The largest is the *Nativity* in Bremen, measuring 42 x 32 centimetres, or a few centimetres larger than the woodcuts of Dürer's *Apocalypse*.[78] The other three are much smaller. The *Satyr Family* (illus. 45), only 23 x 20.5 centimetres,[79] tells an unintelligible story

related to a drawing of a *Wild Family* (illus. 46) in Vienna.[80] In the panel, Altdorfer lets the material slide toward burlesque. He refuses to maintain a decorous tone, rejecting both Dürer's brimming poise in his engravings of *Hercules at the Crossroads* (B.73) and the *Satyr Family* (B.69, illus. 98), and the still seriousness of Jacopo de' Barbari in his own *Satyr Family* engraving.[81] Altdorfer's loutish satyr cocks an eyebrow and reaches for his club; his mate restrains him with one hand as she hoists their child with the other. The exchange between the nude man and the alarmed woman in red, in the background, is incomprehensible. The difficulty in reading the narrative is inseparable from the incompleteness and impertinence of the setting: coarse, sandy earth and deep green foliage, topped with gleaming highlights but with few transitional tones in between, all in the rude tonality of Cranach's early paintings. The flailing trees and the cliff impend over the wild family and fill two-thirds of the picture. The nineteenth-century art historian G.F. Waagen saw this painting in the Kränner collection in Regensburg. As if in answer to Schlegel's question about the *Battle of Alexander*, he simply described it as an example of 'how early this painter cultivated landscape as a genre its own right'. Waagen dismissed the satyr family itself as mere 'staffage', 'as tasteless in invention as it is weak in drawing'.[82]

Identical in size to the *Satyr Family* are the pair of panels in Berlin representing St Francis and St Jerome (illus. 48, 49).[83] They may have been pendants, although surely not a hinged diptych, for Altdorfer would not have monogrammed and dated

57 Albrecht Dürer, *St Francis*, *c.* 1500–05, woodcut,
21.8 x 14.5. British Museum, London.

both panels. The *St Francis* is hardly larger than its model, a woodcut by Dürer (illus. 57).[84] Altdorfer has extended the composition to the sides, added a foreground tree, and pushed Brother Leo to a distant middle-ground. He preserves the posture of Francis, his cocked, oblique skull, and his gaping mouth. Perhaps the *St Jerome* reproduces, with comparable fidelity, a lost woodcut.[85] Both pictures obey a tighter discipline than the coloured-ground drawings. Trees grow straight and refrain from anthropomorphic behaviour. These are sincere and stolid compositions, remote in mood from the affable, tousled, mock-magic *Satyr Family*. They are built of simple

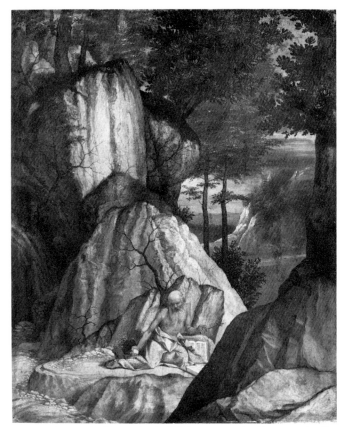

58 Lorenzo Lotto, *St Jerome in the Wilderness*, 1506, oil on panel, 48 x 40.
Musée du Louvre, Paris.

elements (trees at the left edges, middle-ground masses at the right) and animated by long, clean diagonals of gaze (and in the *St Francis*, of drawn lines as well). There is information everywhere on these surfaces, far more information than, for example, in Dürer's woodcut. Altdorfer has thickened Dürer's woodcut landscape with paint. Paint twists around a tree-trunk, drips from the end of a branch, piles up in bright flecks on the outer surface of a sombre deciduous crown, frosts a wild flower or a weed, fills the last hole of a composition with a two-tone vista of silky mountains. Paint can glue the elements of a picture together with colour. This had not happened in Cranach's paintings or in Altdorfer's *Satyr Family*. The two hagiographical paintings move entirely within a range of green and gold.

The *St Francis* and the *St Jerome* are the overgrown ruins of devotional images. The aura of the human figures has been dispelled by the vegetation. Altdorfer's panels are exact contemporaries of Lorenzo Lotto's *St Jerome in the Wilderness* (illus. 58) in Paris.[86] Lotto's hermit, seated on a natural platform like the Madonna in Altdorfer's Braunschweig drawing, is inert, overwhelmed by the rock faces massing behind him. Bernard Berenson wondered whether Lotto's panel had not once been attached to a humanist portrait, just like the *Allegory* and the *Dream*. Such unbalanced pictures stand at the threshold of the independent landscape.

There are few documentary footholds for Altdorfer's biography in these early years.

In 1509 he was paid by the city for a painted panel in the choir of the cathedral. By 1513 he was able to buy a house in the Oberer Bachgasse; this house still stands today. His financial anchor was the commission for the massive winged altar at St Florian, which he finished by 1518 but may have begun as early as 1509 or 1510. In 1510 he made a donation of one of his own small paintings, presumably to a local church or chapel. The *Rest on the Flight into Egypt* (illus. 54) in Berlin is piously inscribed, on a panel propped against the base of the fountain, 'Albrecht Altdorfer, painter of Regensburg, dedicates this gift to you, divine Mary, with faithful heart, towards his own salvation'.[87] Christian angels swarm among their stone counterparts, the pagan victories on the column supporting the idol. The fountain itself is inspired by Mantegnesque prints. One of the stone children, apparently converted, brandishes a cross. The basin crawls with detail but is unstable, as if the weight of the Christ Child is about to topple it. The Virgin, who somehow has found a chair, accepts cherries from Joseph. Mountains, coast, decaying roofs and isolated ruins are compressed into an airless compost. The panel is a little too high, as if the towering idol has imposed an unreasonable standard.

Prosperous merchants were not yet extinct in Regensburg. In 1508 Johannes Mosauer of Regensburg rented the largest vault in the Fondaco dei Tedeschi in Venice, freshly decked with Giorgione's baffling frescoes. The city rented a vault as well.[88] Altdorfer, too, was looking far afield. His encounters with Italian prints are directly legible in his early works. The figure of Pax in the coloured-ground drawing in Berlin, for example, is based on one of the Muses in Mantegna's Louvre *Parnassus*, transmitted probably by an engraving of Zoan Andrea. The fountain in the *Rest on the Flight* also derives from northern Italian engravings.[89] Altdorfer established contact with the humanists surrounding Maximilian. Joseph Grünpeck, an astrologer, dramatist and Imperial secretary, opened a *Poetenschule*, or Latin school, in Regensburg in 1505, and resided in the city periodically until at least 1511. At some point between 1508 and 1515 Grünpeck composed for the benefit of the Emperor's grandson, the future Charles V, a chronicle of the lives of Maximilian and his father, the *Historia Friderici et Maximiliani*. The manuscript was illustrated with coloured pen-drawings, possibly as models for woodcuts in a planned publication. These illustrations have only very recently – and convincingly – been reattributed to Altdorfer.[90] In 1512 Maximilian gave a house in Regensburg to his court historian Johann Stabius, who designed the iconographic programme for the imaginary Triumphal Procession, and hired Altdorfer to illustrate it. Through Stabius, Altdorfer could easily have extended his contacts with humanists and with sophisticated artists like Dürer and Burgkmair, if he did not enjoy such contacts already. It was here, among the antiquaries and literary humanists, who had studied in Italy or looked to Italy for guidance, who were familiar with pagan stories and medieval romances alike, who all knew Dürer and his work, that one seeks the original audience for Altdorfer's singular prints, drawings and panel paintings.

The landscape study

The concomitant of the frame is composition. A picture is 'composed' when its contents acknowledge, through their disposition, the edges of the surface they occupy. Such a picture will have trouble upholding the pretence of being a mere arbitrary excerpt from a plane of infinite extension. It becomes a visual 'field' unified by the presence of a fixed beholder. This is a picture that – true to Hegel's normative diagnosis of the 'accommodating' modern work of art – manifestly exists for its beholders, 'for us'.[91] The literal frame – a drawn or painted border, a wooden brace – simply confirms a state of affairs that the surface data have already conceded.

What were the components of a landscape composition? Horizontal bands of earth, water and sky inside a circle, a shorthand for the view obtained from an ordinary earthbound standpoint, once sufficed to represent the entire sublunary realm. We saw an example in the sarcophagus of Darius painted by Apelles, in the fifteenth-century Dutch manuscript (illus. 30). Later, the standard repertory of terrestrial features expanded. An inscription on the tomb of the French miniaturist Simon Marmion reveals that the painter's genius was legible as much in his accessories as in his figures. The list reads in part like a description of a background landscape: 'Sky, sun, fire, air, ocean, visible earth, metals, beasts, red, brown, and green draperies, woods, wheat, fields, meadows; in short, I represented by my art all sensible things.'[92] The landscape in a picture by Simon Marmion served, like the inscription itself, as a catalogue of the painter's mimetic talents.

How was such a catalogue consolidated on the picture surface? Accessories, 'sensible things' strewn randomly across the plane, lay vulnerable to the contempt of classicists such as Michelangelo. A full-page woodcut in a Book of Hours printed in Paris in 1505 scatters Marian emblems and inscriptions around the figure of the Virgin (illus. 59).[93] Christian exegesis of the Song of Songs read the garden, the olive tree, the fountain, the portal, the city and the fortified castle as emblems of the Virgin. These interpretations penetrated the hymnal literature in the High Middle Ages and were common coin by the fifteenth century. This woodcut page is *pure* composition: the emblems float in equilibrium, evenly distributed, exclusively for 'our' benefit. The emblems do not reproduce any conceivable disposition of objects in the physical world. Eugenio Battisti has shown how Venetian devotional panels naturalized such symbols by embedding them in a background landscape.[94] In Giovanni Bellini's *Madonna of the Meadow* (illus. 60) in London, for example, the Marian symbols are plausibly planted in foreshortened terrain.[95] They are disguised as random objects embraced by the painter's vision, the objects that simply happened to be found behind this open-air Madonna and Child. Nevertheless, they are evenly distributed on the picture plane and perfectly legible, and indeed are no less perspicuously presented than the floating symbols on the printed page. The Venetian background is both setting *and* composition: spatial illusion that fails to disrupt planar organization.

59 French master, *Emblems of the Virgin*, woodcut, from a Book of Hours, Paris, 1505.
Houghton Library, Harvard University, Cambridge, Mass.

This synthesis of two-dimensional pattern and three-dimensional illusion, grounded in terrain or floor, is fundamental to the post-Renaissance idea of a pictorial work. Disconnected botanical studies, like Dürer's watercolour blossoms or the beautiful and only recently identified sheet of peonies by Martin Schongauer, play no part in the history of the pictorial landscape.[96]

Bellini's background was a picture within a picture, rimmed by an invisible internal frame. In principle, the coherent background landscape ought to pass for an independent composition even after it is extracted from its matrix. This actually happened with a famous pair of landscapes in Siena, a view of a city and a view of a castle by a sea (illus. 61).[97] These panels are confusing because they are composed like pictures.

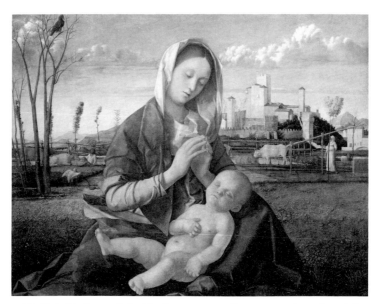

60 Giovanni Bellini, *Madonna of the Meadow*, c. 1505, oil on canvas (transferred from panel), 67 x 86. National Gallery, London.

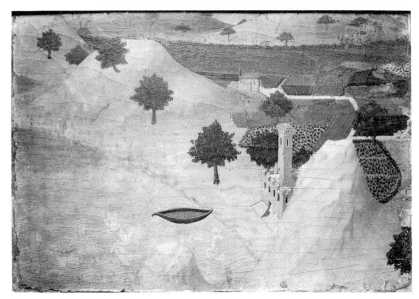

61 Sienese master, *Landscape Fragment*, 15th century, tempera on panel, 22 × 33.
Pinacoteca, Siena.

Landscape backgrounds, no less than complete pictures, were subjected to conventions of symmetry and asymmetry, balance and imbalance. The arc of the coast, for example, linking one edge of the picture to a perpendicular edge, was a device that would be picked up by the early topographical draughtsmen as well, to help mould their reports into pictures. The Sienese panels are not in fact fourteenth-century independent landscapes, as many have argued, or even topographical descriptions. They are, instead, fragments cut out of a larger, lost composition, probably fifteenth-century.[98] Painters copied modular background landscapes like these and repeated them from one picture to another. They could count on beholders to see the invisible frame. Painters saw them: the Italian eye quickly isolated the Flemish landscape from its context (see illus. 25, 26). When the two frames – the interior frame around the view within the composition and the exterior frame around the physically independent panel or drawing – were finally resolved into one, the result was an independent landscape.

The obvious frame for a landscape within a composition was the window. Windows frequently opened onto composed views both in the backgrounds of portraits, such as Dürer's Madrid *Self-portrait* of 1498,[99] and in narratives, such as Giovanni Bellini's *Annunciation* in the Accademia, a pair of canvases that once served as organ wings in Santa Maria dei Miracoli.[100] In one curious instance a painted view was inserted into a sculpted altarpiece. On the rear wall – a real wooden panel – behind the Annunciation in a late fifteenth-century altarpiece in Meersburg on Lake Constance, a painted landscape masquerades as a window (illus. 62).[101] The painter has, in effect, painted an independent landscape that is legitimated only by its participation in the fiction of the carved room.

Windows were easy to justify or motivate within a picture; most rooms had them. The most ingenious embedded landscapes were those framed not simply by a window

62 German masters, Annunciation altar with landscape painted on inside wall of shrine, *c.* 1480s (sculpture), *c.* 1500–10 (painting). Unterstadtkapelle, Meersburg am Bodensee.

but, more slyly, by a fortuitous conjunction of architectural or geological elements. In an antiquarian engraving of *c.*1507 of the equestrian monument of Marcus Aurelius in Rome, Nicoletto da Modena simply punched a rectangular hole in a rear wall and filled it with a cliff landscape (illus. 63).[102] Jean Pélerin-Viator, the learned cleric of Toul and the first Northern theorist of perspective, introduced a woodcut view of Sainte-Baume in Provence, a pilgrimage site, in the second edition of his treatise *De artificiali perspectiva* of 1509 (illus. 64).[103] He framed and rhymed the hill with an Italianate triumphal arch that had been printed alone and empty in the first edition. In Giovanni Bellini's *St Jerome* in Washington, dated 1505, a natural stone bridge unevenly frames a landscape.[104] But Bellini had constructed the finest of all landscape frames already in his Pesaro altarpiece of the early 1470s (illus. 65).[105] The square aperture in the back of the throne, behind the heads of Christ and the crowned Virgin, frames a view onto a fortified city. That landscape would also be visible if the throne were absent altogether; but then it would be mere background, as in Bellini's *Madonna of the Meadow*. The device of the Pesaro altarpiece is more radical than a mere window, for the throne does not need the aperture to function as a throne. The throne is perversely transformed into a picture frame that actually resembles the real frame of the altarpiece.[106]

Fifteenth-century workshops commonly kept stocks of drawings of standard landscapes to be inserted into the backgrounds of narrative paintings. In fact, Bellini reused the framed landscape of the Pesaro altar in his Madonna Barbarigo of 1488, now in San Pietro Martire in Murano. Another landscape with a fortified hill and buildings in brush and white heightening on coloured paper, tattered and worn after long use, was reincarnated in the backgrounds of paintings by Bellini, Bartolommeo Veneto and others.[107] Both Pisanello and Jacopo Bellini, Giovanni's father, had compiled modelbooks with samples of landscapes.[108]

63 Nicoletto da Modena, *Marcus Aurelius*, *c.* 1507, engraving, 21.2 x 14.4. Graphische Sammlung Albertina, Vienna.

64 Jean Pélerin-Viator, *La Sainte Baume*, from his *De artificiali perspectiva*, published in Paris in 1509 (2nd edition), woodcut. Houghton Library, Harvard University, Cambridge, Mass.

Early Netherlandish landscape backgrounds were also assembled from a few simple elements. But no shop drawings survive. A late-fifteenth-century German scribe called Stephan, from Urach in the Swabian Jura, copied what looks like a standard cliff pattern from a Netherlandish painting or miniature into his own modelbook (illus. 66).[109] Stephan's book is an anthology of amateurish sketches and copies, mostly of ornamental motifs, from French, Burgundian and Italian sources, probably for eventual use in manuscript illuminations. The cliffs on the right of this page, bearded, tree-topped, menacing, were staples in Netherlandish manuscripts and panels. The towering cliff became one of the chief compositional schemas of the early empty landscapes in manuscripts – the illustration to the Swabian Chronicle, for example (illus. 18, 19), or the travel descriptions in Schedel's manuscript.

Cliffs became a German predilection. Sheer cliffs, often topped off with castles, commonly filled the windows in the backgrounds of narratives and, increasingly, portraits.[110] In a drawing in Erlangen, a brightly watercoloured cliff, an imaginary precipice sprouting spindly trees, towers over a castle and a dock (illus. 67).[111] The view is primly framed – the thin grey borders on the sides and the lower edge certainly precede the drawing – and large enough to be inserted directly into a background window. This is the compositional convention that provoked the young Dürer to draw fanciful cliffs, such as the flinty *Cliff Landscape* (illus. 68) in Vienna, with a ghostly wanderer visible at the lower centre, arm outflung.[112] This drawing is based on a workshop formula from Wolgemut's shop, perhaps specifically the *Landscape with Wanderer* (illus. 69) in Erlangen, with its colonnade of ghoulish, beetling mono-liths.[113] The tree splits the landscape between wilderness and civilization. The wanderer, with a drawing-board on his back, hunts for views. Wolgemut's workshop,

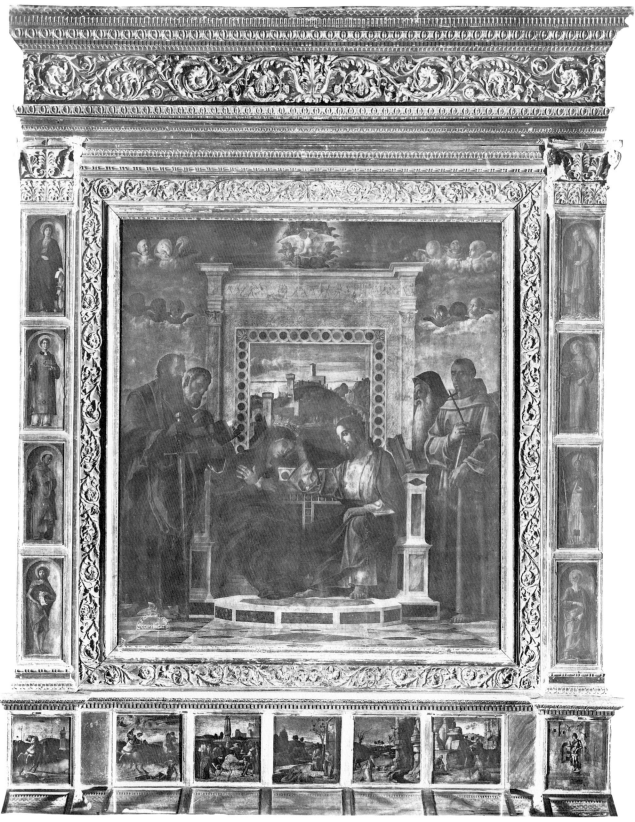

65 Giovanni Bellini, *Coronation of the Virgin*, early 1470s, oil on panel, central panel 106 x 84.
Museo Civico, Pesaro.

66 Stephan von Urach, *Landscape Study*, from his Modelbook, late 15th century, pen and watercolour. Bayerische Staatsbibliothek, Munich.

67 German master, *Cliff Landscape with River*, late 15th century, watercolour and gouache on paper. 20.1 × 10.6. University Library, Erlangen.

however, left no relics of such sketching tours. Even Dürer, at the start, was content to draw indoors. In his Vienna landscape he converted the cliffs into an open field for free play of the pen; his curving modelling strokes create rock that is alternately frothy, knobby, metallic. Only later would he attempt to depict real cliffs.

In the 1490s, on his first Alpine crossings and at home in Nuremberg, Dürer made a series of watercolour studies of outdoor scenes and motifs.[114] These watercolours were his private notations of potential pictorial motifs. About thirty survive. They served as memoranda for future works, and indeed many were reincarnated in the backgrounds of his prints (see p. 119, illus. 83, 84). Dürer did not bother signing them (all the monograms and dates were added by followers or later owners). Some represent swatches of unprepossessing mountainous terrain, corners of the landscape too negligible and obscure to serve any topographical purpose. A study in Berlin of a quarry or a cliff-face with dead branches, for example, seeps across the sheet of paper with little regard for the edges (illus. 70).[115] The motif is not positioned in space or attached to the earth. The sheet says little about scale or distance. It looks like a fragment, and at the time would have held little interest for anyone outside a painter's workshop. But many of the surviving landscape watercolours look more like finished pictures: views of cities, buildings, local landmarks, some tree studies (illus. 151–2). In other cases Dürer assembled impromptu compositions out of the natural material. The *Pond in the Woods* (illus. 74) in London, for example, is built on a grid of two stands of firs and a band of clouds.[116] Evidently Dürer chose to leave the trees on the left unfinished in order not to mask the clouds. The horizon, not a line but the edge of the wash, is bent in an arc.[117]

This becomes a pattern, then, in the first years of the new century: model drawings and life studies increasingly resemble complete and self-sufficient pictures. They are

68 Albrecht Dürer, *Cliff Landscape with Wanderer*, *c.* 1490, pen on paper, 22.5 X 31.6.
Graphische Sammlung Albertina, Vienna.

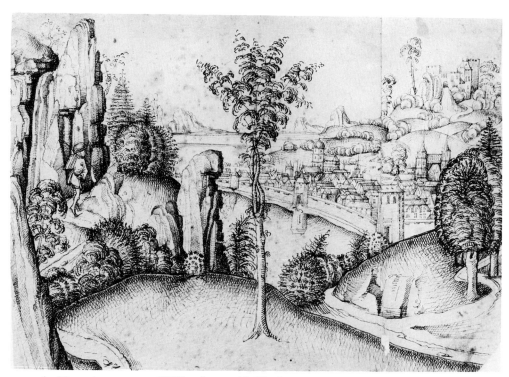

69 Nuremburg master, *Cliff Landscape with Wanderer*, *c.* 1490, pen on paper, 21.1 X 31.2.
University Library, Erlangen.

70 Albrecht Dürer, *Quarry*, c. 1495, watercolour on paper, later dated 1510, 21.4 x 16.8. Kupferstichkabinett, Berlin.

detached from their workshop usefulness. They start to exhibit bravura effects of colour and line, strong style. The cliff in particular served as a template for some of the earliest independent landscape drawings. Urs Graf, a Swiss follower of Altdorfer, transformed a cliff, in a drawing dated 1514, into a wild anti-gravitational fiction (illus. 71).[118] Hans Leu and Niklaus Manuel Deutsch made similar landscapes, and frequently signed and dated them (see illus. 162–3). Functionally, these drawings have nothing in common with the modelbook studies: they are not pointing toward any future work. And yet their spirit of fantasy and hyperbole is not alien to the old pragmatic cliff studies.

A *Cliff with Castle* (illus. 72) in Milan, in pen and ink with softly inflected grey-brown, violet-pink and blue-green washes, might have begun as a model-drawing intended for future applications.[119] But the date '1509' promoted the drawing into a work. This drawing was recently attributed to Wolf Huber.[120] But these pen contours, tactful, springy, tremulous, are more proper to Altdorfer. One recognizes them from early pen-and-ink drawings – the *Samson and Delilah* (1506), the *Venus and Cupid* (1508; illus. 159), the *Historia* illustrations.[121] Moreover, the date, which is surely original, is not in Huber's hand.[122]

A pen-and-ink study in Vienna, close to Altdorfer and yet impossible to pin on him, describes a dense circle of deciduous trees on and around a woodland knoll (illus. 73).[123] The sheet is essentially a study, an exercise in foliage and in style. The pen pursues a horizontal theme, in the chopping modelling strokes and in the spreading boughs, against the double verticals of tree and picture format, just like Dürer's

109

71 Urs Graf, *Cliff*, 1514, pen with watercolour and gouache on
paper, 21.2 X 15.8. Kupferstichkabinett, Basel.

pen in the 'scribbled' landscape we looked at earlier (illus. 35). The stifling pressure
of the trees against the frame, and the lack of interest in the psychological and
dramatic possibilities of open space, suggest a partial copy from a larger composition.
The draughtsman may also have known Altdorfer's etching of the *Small Fir* (illus.
171).[124] But someone, perhaps a collector, wanted to see a work in this drawing. A
tablet with Altdorfer's monogram and the date 1512, not in Altdorfer's hand, hangs
from a branch.[125]

What makes a study into a picture, if not the signature? The Florentine Fra
Bartolommeo in the years around 1500 drew numerous pen studies of trees, farm
buildings and monasteries. This was highly unusual practice. Some are notations from
life and later reappeared in the backgrounds of his paintings. Others are invented. Fra
Bartolommeo copied a castle in a landscape from the background of Dürer's *Hercules
at the Crossroads* engraving, for example, and then used it with some modifications in
his own landscape sketches.[126] Fra Bartolommeo's drawings generally submit to pic-
torial conventions familiar from more public works. They are generous with margins
and peripheral information, and give ample indications of scale and distance. Fra
Bartolommeo's studies were identified from the start as landscapes. An inventory of
the painter's workshop drawn up after his death in 1517 mentioned a cache of '106
foglie di paesi'.[127] When Pierre-Jean Mariette, the eighteenth-century collector and
connoisseur, came across a pair of landscape drawings by Fra Bartolommeo that
pressed too closely against their upper edges, he stuck on strips of blank paper and
gave them, in Chris Fischer's phrase, 'breathing room' (illus. 75).[128] Mariette con-

72 Albrecht Altdorfer, *Cliff with Castle*, 1509, pen with watercolour and gouache on paper, 17.9 × 14.1. Biblioteca Ambrosiana, Milan.

73 Follower of Albrecht Altdorfer(?), *Group of Trees*, *c.* 1510–20, pen on paper, 20 x 14.
Graphische Sammlung Albertina, Vienna.

74 Albrecht Dürer, *A Pond in the Woods*, *c.* 1495, watercolour and gouache on paper, 26.2 x 37.4. British Museum, London.

verted a study not sufficiently cognizant of its audience into a modern picture, simply by extending the edge of the paper outward to exactly the point where it became a frame.

Breathing room transformed a foliage study into a landscape. German painters in Altdorfer's time often rehearsed passages of foliage in brush drawings in bright opaque colours on dark grounded paper. The technique simulated the painter's process of pyramidal layering – light on dark – in foliage. A sheet in Budapest, the *Landscape with Village* (illus. 77) of 1517, has been attributed both to Altdorfer and to Huber.[129] But the date was written by neither artist.[130] The spectral foliage is built up incrementally, in painterly rather than linear fashion. This sheet may have even begun life as a pure foliage study, converted only at the last moment into a landscape by an afterthought of mountains and buildings. Why does staffage of this sort transform a foliage study into a landscape? It is not so much that the settlement or the mountain in the corner introduces content, but rather that the establishment of a diagonal axis creates space. The autonomy of the early landscape rests on just such structural analogies with established types of pictures.

But then some collectors did not require 'breathing room'. A frame and a date were enough to pry a *Foliage Study* (illus. 76) in Berlin out of its practical context.[131] The undulating boughs in white, grey and black overlaid on brown ground might rehearse painted effects. But the sheet is dated 1519 in an old hand and a black

75 Fra Bartolommeo, *Landscape with Five Farm Buildings*, pen on paper, 11.8 x 22.1.
Graphische Sammlung Albertina, Vienna.

76 German master, *Foliage Study*, 1519, brush and pen with opaque white and grey on brown grounded
paper, 11 x 15.4. Kupferstichkabinett, Berlin.

border has been drawn around the whole drawing.

Not a single foliage study on coloured ground is attributable to Altdorfer. But he was the great innovator in the technique, and all the drawings belong to his orbit. A second generation of German draughtsmen was liberated by Altdorfer's stylistic project and moved in an opposite direction from the sobriety of Dürer or Hans Holbein the elder. These artists were liable to whip up an ordinary tree study into a Medusa or a dervish. A number of drawings have been convincingly attributed to Hans Leu the younger, one of the Swiss pioneers of the independent landscape drawing. Leu was born c.1490 to a Zurich painter of the same name. Between 1507 and 1513, apparently, he studied with Dürer in Nuremberg and perhaps Baldung in Freiburg or Strasbourg. From 1514 he was based in Zurich. In pen-and-ink landscapes dated 1513, 1516 and 1517 (see illus. 162), Leu proceeded from the example of Wolf Huber. But in his drawings on coloured ground he was closer to Altdorfer. The bridge between Altdorfer and Leu was possibly Dürer's circle in Nuremberg.[132] Leu may have had contact with Erhard Altdorfer, who in some accounts was working near Dürer around 1510.[133] He may also have been in Nuremberg in 1512, where Altdorfer had already caught the attention of humanists associated with the Emperor. Like his compatriots Urs Graf and Niklaus Manuel Deutsch, Leu tended toward the fantastic and the flamboyant. He built foliage not piecemeal but impetuously, out of harsh, rocking slashes of the pen. A *Tree* (illus. 78) in Dessau, on coloured ground, overwhelms the tiny town and mountain described in white in the lower-left corner.[134] The sulking tree has stepped out of line, detached itself from the other accessories, and moved to centre stage.

Still more ambitious is a splayed, muscular tree in pen with white heightening on a grey-green ground, in Copenhagen (illus. 81).[135] This disorderly tree of indeterminate species has shifted to dead centre. Its branches are flung beyond the borders of the drawing. The tree overwhelms the walled town and icy mountain at the right. It obliterates the sky. The surface of the drawing is perturbed as much by colouristic effects as by the snaking, coiling, trembling lines. White heightening and deep shading produce a dense crinkling of the picture surface and an agitation of the spectrum within a shallow layer of space. A drawing in Dresden by the same hand places a tree before a town and castle, in pen and wash on reddened paper (illus. 79).[136] These two trees pose a sticky connoisseurial problem. They work entirely within the structural framework of the autonomous drawing on coloured ground established by Cranach and especially Altdorfer. They are not really experimental – they are already too stylish and swaggering – and yet they are too muscular for Altdorfer himself. The two trees are instead generally attributed to Altdorfer's brother Erhard, who is not exactly a ghost, but who, like the Historia Master, has become something of a connoisseurial expedient.[137] These drawings, together with a horizontal mountain landscape on red-tinted paper in Paris (illus. 80),[138] take a single linear idea of Altdorfer's – the arcing, wrenching modelling line – and elaborate it into a comprehensive structural principle. The result in each case is a powerful and controlled linear web, an entire landscape cut from a single cloth.[139]

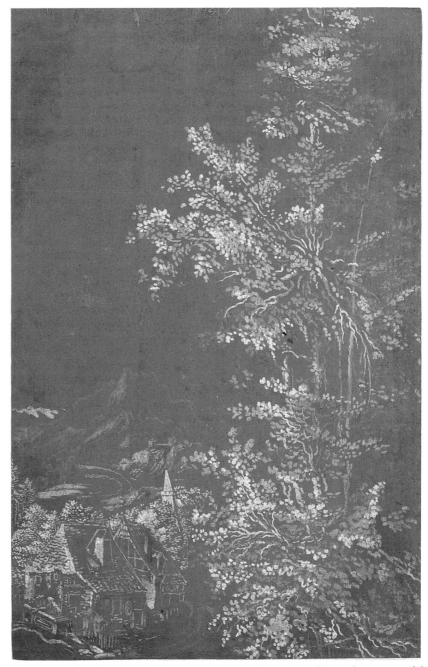

77 German master, *Landscape with Village*, 1517, brush with opaque white and grey on red-brown grounded paper, 17.3 x 11.3. Museum of Fine Arts, Budapest.

78 Hans Leu the younger, *Tree*, early 1510s, pen and brush with opaque white on red-brown grounded paper, 21.1 x 13.2. Staatliche Galerie, Dessau.

79 Follower of Albrecht Altdorfer, *Landscape with Tree*, *c.* 1525–30, pen on red-tinted paper, 28.1 × 19.4. Kupferstichkabinett, Staatliche Kunstsammlungen, Dresden.

80 Follower of Albrecht Altdorfer, *Mountain Landscape, c.* 1525–30, pen on red-tinted paper, 12 X 14.5. Musée du Louvre, Paris.

Some draughtsmen extracted composed landscapes whole from the backgrounds of prints. German artists were plundering German landscapes as assiduously as the Italians did. And there was nothing novel about this practice: pictures had always been the best source for pictorial ideas. A tree-topped mass of rocks on red-tinted paper (illus. 82),[140] for example, reproduced with impatient slashes of the pen the complex background of Dürer's engraving (B.61) of *St Jerome* (illus. 83). Dürer himself had built the bladed bluff in the engraving upon one of his own watercolour studies, a filmy orange meditation on a rock mass, which he inscribed 'steinpruch', or 'quarry' (illus. 84).[141] A mountain landscape, also in Erlangen and also on red tinted paper (illus. 85), was copied with *brio* from the woodcut of the *Visitation* from Dürer's *Life of the Virgin* (illus. 86).[142] The copyist charged Dürer's august and chilly mountain profiles with a heated energy. He set the sky vibrating, shattered the wall at the left into a muscular cliff, and even scooped out an entire hill and replaced it with a coastline. A *Mountain with Castle* (illus. 88) in Paris, derived from Dürer's *St Eustace* engraving (B.57; illus. 89), is still more ambitious. It manages not to praise Dürer, but rather to bury him beneath a white, chalky ground and various flat washes and gouaches.[143] In each case, the copyist rounds off the edges of the extracted passage and presents it even more lucidly as an integral composition.

In two remarkable cases German copyists actually extracted entire landscape set-

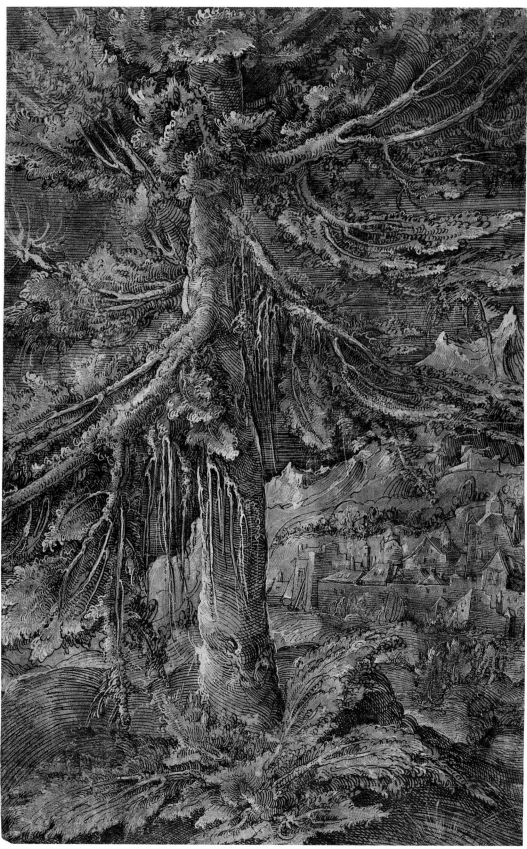

81 Follower of Albrecht Altdorfer, *Landscape with Tree*, *c*. 1525–30, pen with white heightening on grey-green grounded paper, 30.6 x 19.5. Statens Museum for Kunst, Copenhagen.

tings and left the figures behind. A pen-and-ink drawing in Frankfurt converted Cranach's *St Jerome* woodcut of 1509 (B.63) into a landscape not by isolating a background view, but simply by omitting the hermit and the lion (illus. 90, 91).[144] The copyist, who must have known vertical landscapes, perhaps one of Altdorfer's etchings (illus. 173), looked through the figures and still saw a composition. The saint has been replaced by a lowly bush. The tree leans into the picture as if to fill the vacuum. A dashing watercolour and gouache foliage study in Budapest (illus. 87)[145] copies Altdorfer's *Satyr Family* panel of 1507 (illus. 45). The copy simplifies the agitated spray of the painting by fanning it out, using more of the flat of the brush and less of the tip. It softens the texture of the foliage. The drawing, which is narrower but nearly as tall as the panel, has simply removed the figures. It certainly follows, rather than precedes, the panel: the two long flower-stems in the lower-right corner, for example, make no sense until one finds them grounded at the lower edge of the panel. It is possible that a pupil or follower of Altdorfer seized upon the *Satyr Family* as a model for an exercise in brush drawing. It is more tempting to imagine that someone in Altdorfer's lifetime already considered the subject-matter of the panel dispensable, in effect – like Waagen in 1845 – *saw* the *Satyr Family* as a landscape. In the drawing the draughtsman simply carried through this perception. In the other copies of landscapes just discussed, motifs were extracted and framed even when they were not neatly framed within the work, in a window or an arch, as in the Italian or older Netherlandish works. This willingness to reframe is carried to an extreme here. The entire setting is extracted and a frame is drawn around it on the *inside*, leaving a hole in the middle. The idea of formal completeness is at this point running ahead of the idea of semantic completeness. The inside frame seals off the setting from the human figure which used to justify it and give it purpose, while the outside frame – still in place – makes the picture a work. It is a composition without subject-matter. The key to the picture's status as a 'work' is formal completeness, not content. Still, the gap between the two leaves an emptiness at the centre of the picture. This emptiness could now become an aspect of meaning in its own right.

The landscape picture within a picture, and the figure composition robbed of its figures, are really two separate phenomena. The framed view, the *veduta inquadrata*, is already and legitimately empty, a safely packaged accessory. It belongs only incompletely to the fictional world proposed by the complete picture. To extract it and make the invisible frame visible is simply the logical consummation of a latent idea. The complete landscape setting minus its figures, on the other hand, is always marked by those figures. Why is the foreground in such eviscerated landscapes still continuous with the beholder's space, if not for the sake of the missing figures? The empty setting retains the reverberations of the fictional world to which it once belonged. For that setting was a product of the centrifugal and dramatic energy of the figures: the figures had determined the setting. Waagen was thus missing the point when he dismissed the figures in the *Satyr Family* as mere staffage, in effect wishing that the panel looked more like the wild copy in Budapest. In Altdorfer's independent landscapes, the energy of those absent figures persists like the light of dead stars.

82 Nuremberg master, *Cliff Study*, after *c.* 1496, pen on red-tinted paper, 29.5 x 20.1. University Library, Erlangen.

83 Albrecht Dürer, *St Jerome*, *c.* 1496, engraving, 32.4 x 22.8. Metropolitan Museum of Art, New York.

84 Albrecht Dürer, *Quarry*, *c.* 1495–6, watercolour and gouache on paper, 29.2 X 22.4.
Formerly Kunsthalle, Bremen (missing since 1945).

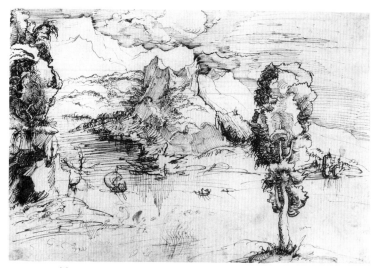

85 German master, *Mountain Landscape*, *c.* 1510–15, pen on light red-tinted paper, 19.8 x 29.9.
University Library, Erlangen.

86 Albrecht Dürer, *Visitation*, *c.* 1504–5, woodcut, 30 x 21.

87 Follower of Albrecht Altdorfer, *Foliage Study*, after 1507, gouache on paper, 21.4 x 15.3.
Museum of Fine Arts, Budapest.

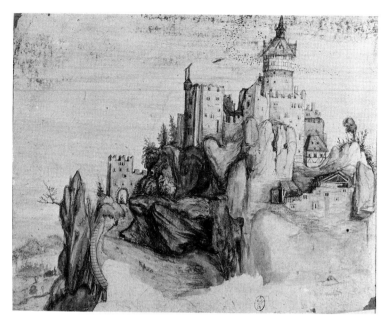

88 German master, *Mountain with Castle*, early 16th century, watercolour and gouache on paper, 10.9 x 13.4. Musée du Louvre, Paris.

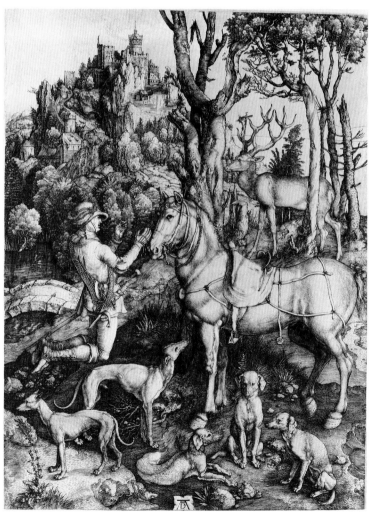

89 Albrecht Dürer, *St Eustace*, *c.* 1501, engraving, 35.3 x 25.9. Metropolitan Museum of Art, New York.

90 German master, *Landscape, c.* 1510s, pen on paper, 26.7 x 19.6.
Städelsches Kunstinstitut, Frankfurt.

91 Lucas Cranach, *St Jerome*, 1509, woodcut, 35.5 x 22.6.
British Museum, London.

3

The German forest

Learned Germans in Altdorfer's time contemplated the face of their native landscape with a morbid relish. At the heart of this – mostly – imaginary Germany lay a black monster, the vast Hercynian forest. They knew all about the forest from ancient geographers and historians. The Stoic geographer Strabo described the Hercynian forest as 'rather dense' with 'large trees'; it 'comprises a large circuit within regions that are fortified by nature'.[1] Caesar himself, in his *Gallic War*, admitted that 'there is no man in Germany we know who can say that he has reached the edge of that forest, though he may have gone forward a sixty days' journey, or who has learnt in what place it begins'.[2] Where exactly would one find the Hercynian forest? In some accounts it ran clear from the Cevennes to the Carpathians, an amorphous leviathan of wooded highland. As segments of that highland acquired names of their own, the Hercynian forest shrunk. Eventually the name adhered only to the very centre of the continent, as a collective designation of the ring of forests encircling the kingdom of Bohemia: the Riesengebirge, the Erzgebirge, the Harzgebirge, the Fichtelgebirge, and so forth.[3] In Willibald Pirckheimer's treatise on place-names, the *Germaniae explicatio* of 1530, the Hercynian forest has more or less vanished.[4] Indeed, by Altdorfer's time the road and the city had largely dismembered the primeval forest. A map of 1516 by Erhard Etzlaub pictures – from about the vantage-point of a helicopter – the neatly trimmed fragments of the old Imperial forest belonging to the city of Nuremberg (illus. 92).[5] The sale of lumber harvested from these stands was strictly regulated.[6] The *silva hercyniana* had to be revived in the mind.

For literary humanists, that forest came to stand for all that was distinctive about Germany. Wild landscape terrified and repelled foreigners. Tacitus in the *Germania*, his monograph on the land and character of the Germans, had described 'a formless terrain and harsh climate, dismal to till or to behold, unless it were one's native land'.[7] Modern Italians savoured the obscurities of the German forest in the backgrounds of Dürer's engravings. But they had little taste for the reality. Giovanni Antonio Campani, a papal official attending the Imperial Diet in Regensburg in 1471, pined for the Campagna in his letters home: 'O, what a chasm separates the Danube from the Tiber!'[8] The Venetian Paolo Pino, writing in the middle of the sixteenth century, conceded that rough country could furnish inspiration: 'The Northerners show a special gift for painting landscapes because they portray the scenery of their own homeland, which offers most suitable motifs by virtue of its wildness.'[9] Even Conrad Celtis, the brilliant poet and peripatetic evangelist of German literary culture, con-

92 Erhard Etzlaub, *Imperial Forests around Nuremberg*, 1516, parchment, 60 x 69.
Germanisches Nationalmuseum, Nuremberg.

ceded in his Ingolstadt Oration of 1492 that the forest sheltered highwaymen and impeded progress: 'Even now when, after the draining of marshes and the cutting down of vast forests, our climate is more cheerful and our land populated with famous cities, we still fail to dislodge the leaders of that robber crew.' But then Celtis pointed out that the Antique writers, even as they shrank from the distant image of this 'coarse and raw' land, also praised the courage of the sylvan tribe.[10] 'Germany is inhabited', wrote the first-century Roman geographer Pomponius Mela, 'by a hardy and robust people who find in war an outlet for their natural ferocity and in strenuous exercise an employment for the vigour of their bodies. They take pleasure in braving the cold and go about naked until the age of puberty. . . . When they reach manhood they cover themselves with a skin or a garment made of the bark of trees.'[11] The forest was the source of the various Teutonic strengths. Tacitus, writing from a safe distance, imagined the Hercynian forest as 'a nurse with her infant cares' escorting its people – the bellicose Chatti, predecessors of the Franks – across Europe and

129

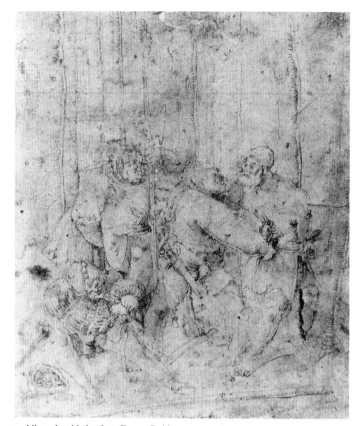

93 Albrecht Altdorfer, *Forest Robbery*, c. 1508, pen on paper, 17.7 × 14.6.
Kupferstichkabinett, Berlin.

finally setting them down at the edge of the plains. Even he conceded that the German nation 'is distinguished by hardy bodies, well-knit limbs, fierce countenances, and unusual mental vigour.'[12]

Celtis saw the irony coiled within the account by Tacitus. Scorn for German simplicity unwittingly rebounded on Rome in the form of a moral critique of decadent civilization. Celtis was the first creative reader of the *Germania*. He single-handedly inaugurated a native industry of learned geographical writing. The key intellectual manoeuvre was the conversion of the forest from the blight into the pride of the land. The forest became at once a hazardous wilderness and a stage for chivalric heroism; it sheltered the satyr, the wild man, even – in Celtis's profound imagination – the Druid priest. The forest became an open-air temple; it became the seat of the Muses. These ideas were so fresh that they could only be put forward tentatively, experimentally, often with tangible excitement. The glamour of the forest lay in its precarious double nature: awe could easily collapse back into fear, mystery into obfuscation, heroism into barbarism. The strange appeal of the dark places comes across even better in pictures than in the texts of the humanist geographers, which were constrained by powerful generic conventions and by the unspoken authority of foreigners, dead or alive. Altdorfer, for example, actually depicted a forest robbery, in a pale, crinkly pen drawing, now in Berlin (illus. 93).[13] A burly gang of three has stripped a traveller of coat, shoes and gold, and bound him to a tree. In his university

94 Albrecht Altdorfer, Woodcut, 31.3 x 25.8. Herzog Anton Ulrich-Museum, Braunschweig.

address Celtis had complained of forest robbers; in the *Amores*, his geographical love-poem published in 1502, he narrated an encounter with a pair of them on the road between Nuremberg and Regensburg:

> It is a place where hills are lifted from the bending valley,
> And a dense forest of pines covers all sides;
> In the middle of the space is a well-trodden road in a narrow track;
> Watered by a lake, it leads through putrid fields.
> Behold, two thieves spring forth from the forest on the left and right
> With iron swords and spears![14]

But the thieves, moved by the poet's supplications (delivered in Latin, if we are to trust the poem), spared his life. The drawing could almost illustrate this episode. Danger in Celtis's vignette and Altdorfer's drawing becomes an attribute of the forest, just as in those seventeenth-century Dutch landscapes where marauding highwaymen constitute the innocuous filler, the staffage.

Pen, brush, and chisel were steadily domesticating the forest. The fifteenth-century German architect petrified the tree into pinwheeling rib vaults and foliated capitals; the sculptor carved wooden thickets around altar-shrines, choir-stalls, and chancels. By the end of the century the church space itself was overgrown. Carved branches embraced and crowned the great winged altarpieces; they crawled along the ribs of vaulted ceilings; they framed and supported sculpted figures and reliefs; they even

95 Albrecht Altdorfer, *St George and the Dragon*, 1510, oil on parchment attached to panel, 28.2 x 22.5. Alte Pinakothek, Munich.

96 Detail from *St George and the Dragon*.

97 Albrecht Dürer or follower, *Satyrs*, woodcuts, each 53.5 x 32.5.
Herzog Anton Ulrich-Museum, Braunschweig.

surrounded the panel painting and threatened to supplant the plain wooden frame. Vegetation thrived under the shelter of a pretext such as the Tree of Jesse or the Tree of Life. Karl Oettinger's magisterial and fascinating pages on the *Himmelsgarten*, or Heavenly Garden, have given the ornamental branch an iconology as well as an iconography. Carved and painted leaves transformed the entire southern German church space into a magical bower, a liminal zone where light and dark mingle and compete, a wild garden for the Queen of Heaven.[15]

Altdorfer's forests are the successors to the ornamental engravings of the Master E.S., Schongauer and Israel van Meckenem, with their impenetrable flat tangles of vines and tendrils. Ornamental prints were the school for surface. Trunks, branches and leaves project easily onto the plane. German ornamental foliage brought out not the regularities but the caprices and vagaries of vegetal form. Later in his career, Altdorfer made the lushest, most dynamic foliate woodcut of all, a monumental S-branch framed by swelling balusters (illus. 94).[16] The rootless frond – sprouting tendrils and teutonized acanthus leaves – snakes back upon itself, terminating in a hairy Papageno-mask confronting a bird. A pair of ornamental woodcuts with satyrs and nymphs designed by Dürer, or by one of his pupils, are mirror-images, but not exact replicas (illus. 97). They join along all four edges, remarkably, to form a continuous expanse of two-dimensional forest, a paper tapestry. They might have served as patterns for carved, woven or embossed leather ornament; or, if collected in sufficient quantity, they might themselves have covered a surface.[17]

But ornamental prints were not *pictures*. At most they extracted figures and themes from pictorial contexts and pressed them flat. The paper tapestry does not represent

98 Albrecht Dürer, *Satyr Family*, 1505, engraving, 11.5 x 7.
National Gallery of Art, Washington DC.

an encounter between nymph and satyr, so much as refer to one. It quotes Dürer's engraving of the subject of 1505 (B.69; illus. 98), but then flattens out the figures, illuminates the dark crevices of forest, and drains the encounter of temporality and drama. The figures of the paper tapestry are simple-minded, and obedient to the laws of two-dimensional pattern. The ornamental print can show, but cannot tell. The paper tapestry translates the erotic shadow over Dürer's engraved figures, for example, into monstrous, deadpan hieroglyphs of genitalia, traced in bent and bound branches.

In his early paintings Altdorfer tried something altogether new. He pulled foliate ornament into the narrative or hagiographical picture and converted it back into representation. He preserved the flatness of the ornamental forest, but then laid on thick layers of colour, crusty or slick. Altdorfer brought the forest inside the picture frame. He permitted the leafy surfaces to interfere with subject-matter and to obstruct the lucid extension of space into depth. Ornamental foliage provided the structural principle of the picture. When the forest is seen from within, and when there is less space for things to happen, then the picture comes to represent a certain experience of the forest. The picture represents closeness, loss of freedom of movement, filtered light and dense air, incomplete knowledge. Landscape became independent not when it opened up, but, paradoxically, when it closed in on itself.

135

99 Albrecht Altdorfer, *Landscape with Footbridge*, 1516(?), oil on parchment attached to panel, 42.1 × 35.1. National Gallery, London.

100 Albrecht Altdorfer, *Landscape with Castle, c.* 1522–25, oil on parchment attached to panel,
30.5 x 22.2. Alte Pinakothek, Munich.

Painting liberated itself from ecclesiastical architecture, in the powerful historical schema of the Vienna School of art history, when it achieved the illusion of space. Once the modern painting was able to create its own space, it could be detached from the altar or the plastered wall and remounted somewhere else. Through illusionism, painting absorbed architecture and sculpture into itself; the painting succeeded ecclesiastical architecture as the *Gesamtkunstwerk* and the comprehensive image of heaven and earth. In one form or another this idea has governed modern thinking about the rise of landscape as an autonomous genre in the Renaissance. The central theme in most stories about Western landscape painting is the pictorial conquest of outdoor space. This revolution was achieved by means of various technical devices, such as the regular (although not necessarily measured) diminishment of objects into depth, or so-called atmospheric perspective, whereby distant objects are dissolved in blue haze. But the successful illusion of outdoor space was largely an achievement of the fifteenth century. Like the illusion of indoor space, where rigorous linear perspective can come into play, this illusion primarily served the aims of effective narrative painting. The space was built, as it were, as a theatre for human figures. The picture that actually *broke* with the fifteenth century was the narrative that refused its figures that hard-won spatial niche, and instead redirected the beholder's attention to the surface. That picture is Altdorfer's *St George and the Dragon* in Munich, dated 1510.

The *St George* is closely affiliated in technique and format to the empty landscapes. Altdorfer's forest pictures spoke a new language. In order to grasp what they are saying about the forest, about the native landscape, and about the locus of worship, we need to decipher this language.

Two-dimensional pleasures

St George and the Dragon measures 28.2 x 22.5 centimetres, slightly larger than the Berlin panels of 1507. The support is parchment, glued to a limewood panel (illus. 95, 96).[18] Altdorfer also painted two independent landscapes on parchment pasted on panel: the *Landscape with Footbridge* in London (illus. 99), monogrammed and once dated,[19] and the *Landscape with Castle* in Munich, with monogram (illus. 100).[20] A third landscape in this medium has been lost. The picture was described in 1783 by the engraver Christian von Mechel, in his catalogue of the Imperial Collections in Vienna, as 'a tall fir tree in the middle of a wild mountainous landscape, with a lake, a city on the banks of the lake, and a castle on a mountain visible in the distance'. The picture was painted on parchment pasted on panel and was monogrammed and dated 1532 on the trunk of the tree.[21]

Three landscapes were painted with watercolour and gouache on paper: the *Landscape with Church* from the Koenigs collection in Haarlem, missing since the Second World War, monogrammed and dated 1522 (illus. 101);[22] the *Landscape with Sunset* in Erlangen, with monogram (illus. 102);[23] and the *Landscape with Woodcutter* in Berlin, with monogram (illus. 1).[24] Very close to the Koenigs sheet, but not by

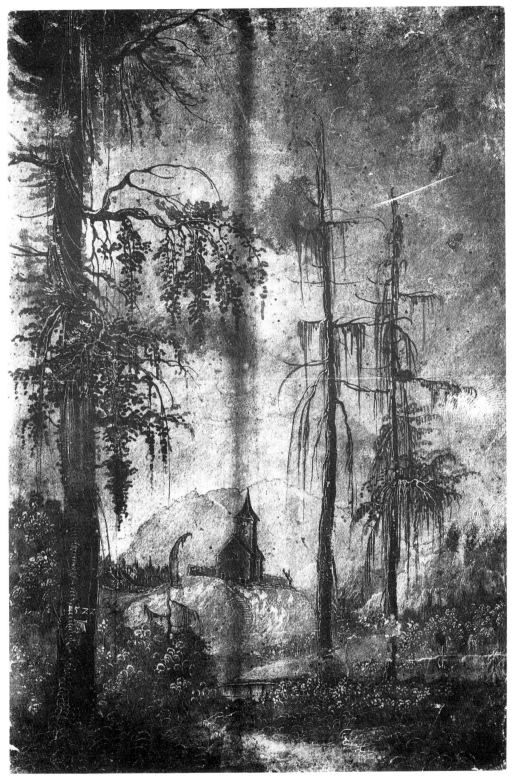

101 Albrecht Altdorfer, *Landscape with Church*, 1522, pen, watercolour and gouache on paper,
20.4 x 13.8. Missing since 1945.

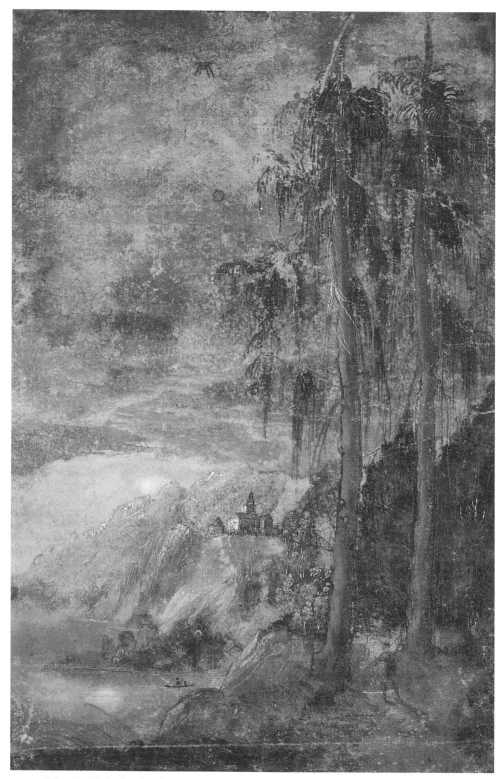

102 Albrecht Altdorfer, *Landscape with Sunset*, *c.* 1522, pen, watercolour and gouache on paper, 20.2 X 13.3. University Library, Erlangen.

103 Detail from *Landscape with Sunset*.

Altdorfer, is the *Landscape with Tree and Town* in Vienna, once monogrammed and dated 1525 (illus. 104).[25] All the painted landscapes on paper have pen-and-ink underdrawing.

What sort of a sample is this? There is no reason to believe that Altdorfer produced landscape paintings in huge quantities. His paintings were already scarce by the early nineteenth century, when they were single-mindedly hunted by the Regensburg collector Kränner.[26]

Altdorfer's pragmatic rebuttal to modern 'spatial' painting was the technique of the miniature. In his pictorial investigations into botanical structure he drew on the practices of the manuscript painter. Miniature painting was by this time a beleaguered art. But as we saw, Altdorfer had local and perhaps even familial ties to the tradition. The *St George* and the two landscapes on panel combined the support and, at least to some extent, the medium and technique of the book miniature with the format and the physical independence of the panel. The manuscript page had traditionally sheltered the most radical structural experiments. The wood panel now carried the experimentation into the open.

Not all painted parchments were bound into manuscripts. In the 1460s the painters' guild of Ghent successfully sued certain illuminators, including Alexander Bening, who wished to paint miniatures that were independent of books.[27] These painters evidently relished an opportunity to expose their brushwork to the open air rather

104 Follower of Albrecht Altdorfer, *Landscape with Tree and Town*, 1525, pen and light watercolour on paper, 27.2 x 19.2. Graphische Sammlung Albertina, Vienna.

than bury it in a book. A sheet of parchment with a painting of the Vera Ikon and a hymn to St Veronica hangs on the wall in the background of a donor portrait by the Fleming Petrus Christus, from the middle of the fifteenth century. The sheet, which is arched at the top and is therefore not a page torn from a book, is attached to a panel with a border strip of red leather or cloth and metal tacks.[28] Another wing with a donor portrait, again by Petrus Christus, shows a parchment with an image of St Elizabeth of Hungary, this time attached to the wall with lumps of wax.[29] The fourteenth-century German mystic Heinrich Seuse explained in his autobiography how he once painted a devotional image 'an ein bermit' and attached it to the window of his cell.[30] A detached sheet of three saints by the Nuremberg miniaturist Albrecht Glockendon, a follower of Dürer, is initialled and dated 1506.[31] Around 1500 parchment also became a favoured medium for the highly worked independent drawings that appealed to collectors and patrons; the pen-and-brush drawings of pagan subjects by Francesco Francia, for example, use this support.[32] Dürer also made many watercolour and gouache drawings on parchment, including the *Lime Tree* in Rotterdam (illus. 151).[33]

Many of these pictures survive attached to their original wood panels. Dürer painted several pictures on parchment attached to panel, for example the *Madonna with the Carnation* in Munich, dated 1516.[34] Several lost paintings by him were described in old inventories as 'uf Perment': the portrait diptych of the Strasbourg painter and his wife, and the *Death of Crescentia Pirckheimer*, dated 1504.[35] In fact, most of the surviving fifteenth-century panels with parchment grounds are portraits. Hans Memling's *Portrait of a Man Holding a Medal* in Antwerp, with the continuous landscape background (see p. 73, n. 34), was painted on a parchment ground. Cranach, Burgkmair and Holbein all did portraits on parchment grounds, precursors of the Elizabethan portrait miniature.

But it is often hard to say exactly when these pictures were attached to their panels. Some parchments, both manuscript pages and independent sheets, were glued to panels well after they were painted, in order to protect them. The tattered edges of a portrait by Cranach in Berlin suggest that the painted parchment circulated for some time before it was laid down on panel.[36] In 1493 Dürer sent his *Self-portrait* home to his betrothed rolled up like a scroll, and only mounted it on panel later.[37] Miniatures were also mounted so that they could function as portable panels, or even as altars. A large miniature of *St Jerome in a Landscape* recently acquired by the Louvre and attributed to Simon Bening, the son of Alexander Bening of Ghent, is painted on paper glued to panel.[38] Simon Bening also made a triptych on vellum, the *Martyrdom of St Jerome*, now in the Escorial.[39] The *Descent into Hell* by Giovanni Bellini in Bristol is essentially a painted pen drawing on vellum attached to a panel.[40] It was learned only recently that Jan van Eyck painted his tiny *Stigmatization of St Francis*, now in Philadelphia, on a parchment ground. The technical examination revealed that the parchment was attached to the panel only after it was painted.[41]

But others, particularly the German portraits, were painted on parchment that was already attached to the panel. Panel painters, after all, had been using leather and

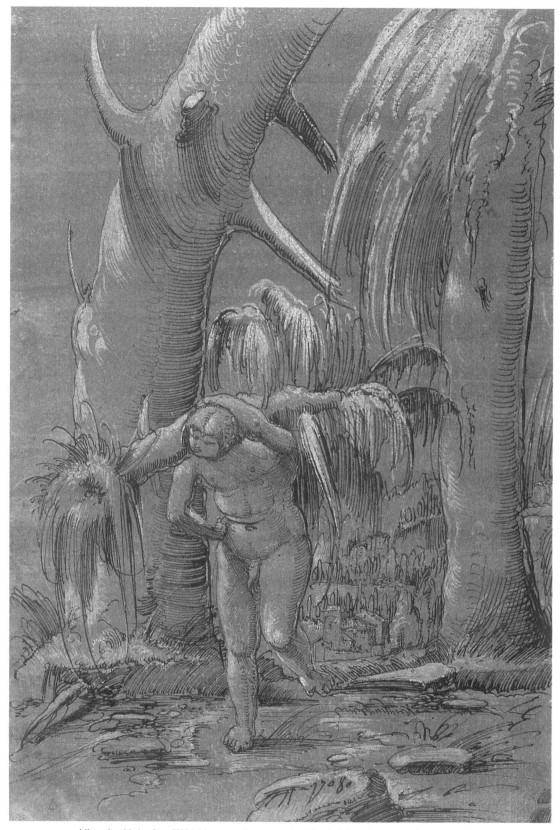

105 Albrecht Altdorfer, *Wild Man*, 1508, pen and white heightening on red grounded paper,
21.6 x 14.9. British Museum, London.

parchment grounds since the twelfth and thirteenth centuries.[42] Holbein's early portrait of Benedikt von Hertenstein in New York, dated 1517, is actually painted on *paper* attached to panel.[43] It seems inconceivable that a painter would have piled up so much pigment on a thin, flexible, unattached sheet. The same can be said of most of the paintings on parchment grounds. Altdorfer, too, appears to have used the parchment as a ground. The *St George* and the two landscapes are not simply water-coloured pen drawings that later happened to be attached to panels and perhaps embellished with opaque paint. No paintings or drawings by Altdorfer on unattached parchment have survived. Nor do the attached parchments show the kind of deterioration on their margins that would indicate prior circulation free of the panel. Although none of these pictures has been submitted to a modern examination, there are at present no technical grounds for believing that Altdorfer's parchment supports were attached to their panels subsequent to the execution of the paintings.[44] One specialist, Eberhard Ruhmer, did believe that the *St George* and the two landscapes were originally executed on detached sheets and only later stuck to their panels. Indeed, he actually suggested that they were merely nature studies elaborated into paintings. But Ruhmer had no new physical evidence to offer. Indeed, he mistakenly described the ground of the London *Landscape* as paper rather than parchment.[45]

The exchanges between panel and miniature painting were especially complex during the first third of the fifteenth century, as the interminable debate about the relationship of Jan van Eyck to the Turin–Milan Hours attests. The ties between panel painting and miniature painting workshops have, if anything, been underrated. It was more common for established panel painters to cross over into miniatures than vice versa.[46] We saw in Ghent that panel painters jealously protected their market. Yet the more important masters were free to take on miniature commissions. Gerard David maintained close contacts with Simon Bening in Bruges, and very likely painted miniatures himself.[47] Altdorfer illustrated the Triumphal Procession and other Imperial books and projects, and set any number of his pupils to work with the fine brush. Versatility was the norm in southern Germany until well into the sixteenth century. Followers of Dürer and Altdorfer, such as Sebald Beham, Georg Pencz and Hans Mielich, confronted after the Reformation with a catastrophic decline in the demand for sacred images, apparently took whatever miniature work came their way.[48]

Parchment was a safer ground than bare wood. It would not so readily twist and split the paint layer. A panel painter used a parchment ground when detail and technique mattered – that is, when he could expect his picture to be scrutinized at close-quarters by knowledgeable eyes. Fine brushes and the parchment ground were for private paintings. In the forest of *St George*, a fragment of illumination endlessly multiplied, Altdorfer adopted the miniaturist's technique of pyramidal layering, from dark to light, from deepest green to brightest yellow. But Altdorfer's display of technique, highly effective at point-blank range, was exactly what upset the balance between subject and setting, first in the *St George*, then in the independent landscapes.

In his *St George*, with its impenetrable wall of deciduous foliage, Altdorfer duplicated the layout of his *Satyr Family* panel of 1507 (illus. 45), and his drawing of a *Wild Family*

(illus. 46): a massive leafy foil behind the figures in the left half, an opening onto distant mountains, and a closing repoussoir of smaller trees at the right edge. It is as if St George has returned to the site of the *Satyr Family* many years later only to find it overgrown. Wilderness was the conventional pictorial setting for St George's heroics. The subject was enormously popular in the fifteenth and early sixteenth centuries – Altdorfer himself took it up in two drawings, a woodcut, and an engraving.[49] But wilderness had never before encroached so deeply into the territory of subject-matter.[50]

The antithesis of the narrative with augmented setting was the dramatic 'close-up', a compositional type that Dürer had adopted from the Venetians. The close-up pared setting away from narrative until nothing was left but a dense nucleus of event and emotion.[51] It is possible that while he was in Italy Dürer saw a *Presentation*, a *Circumcision* or an *Adoration of the Magi* by Andrea Mantegna or Giovanni Bellini. In 1506 he painted his own *Christ Among the Doctors* (illus. 106).[52] Dürer saw the close-up as

106 Albrecht Dürer, *Christ Among the Doctors*, 1506, oil on panel, 65 x 80. Thyssen-Bornemisza Collection, Lugano-Castagnola.

an antidote to certain prolix and centrifugal tendencies of German narrative painting. A narrative pulled in close to the surface shares some of the density and simplicity of the icon. The *St George* is thus the exact opposite of a dramatic close-up. The picture retreats from the hagiographic subject. This diminishes the event and magnifies the landscape setting. The encounter with the dragon, whose very body is absurdly foreshortened, is pressed hard against the lower edge, cropped to ridiculous proportions, completely isolated from the castle and the princess – the tokens of civilization and normalcy – that usually appear in such scenes. Just as the close-up is a technique of exclusion, this retreat entails a corresponding inclusion. The picture generously embraces information far in excess of the minimum necessary to identify and motivate the story. But this information is monotonous. Beyond a certain point, the accumulation of unmotivated detail offends against the subject.

The dramatic close-up of Venetian painting and of Dürer's *Christ Among the Doctors* compelled the beholder's seriousness and concentration. The close-up rallied the attention of the beholder with the spectacle of its own effort, like an elaborate new staging of an old play. The retreat and the inclusiveness of the *St George*, by contrast, are the opposite of a staging. They relax the rhetoric of narrative. Such a slackening can make an ironic point about the inattentiveness of the world to momentous events, particularly Christian events. This was a favourite tactic of Netherlandish painting. Sixteenth-century versions of the *Carrying of the Cross*, derived from a lost composition by Jan van Eyck, drastically subordinated the sacred event to a panoramic landscape.[53] Pieter Bruegel sustained this inversion in his own *Carrying of the Cross*, but also in paintings such as the *Conversion of St Paul* or the *Fall of Icarus*. In Altdorfer's *St George*, the event really has become unimportant.

If Dürer in his close-up was trimming the ragged outer edges of the narrative picture, then Altdorfer in the *St George* was defying the modern compulsion to create floor-space for the narrative actors, to convert the heart of the picture into a stage. He draws the forest inward, tight around the figures. He represents the forest from the inside out. Without three-dimensional scaffolding, details and textures tend to scatter the beholder's attention across the surface. This is what happens in a curious engraved collage of the 1510s by Agostino Veneziano, later a pupil of Marcantonio in Rome (illus. 108).[54] The print juxtaposes tree-trunks and animals extracted from Dürer's engravings to a landscape background derived from Giulio Campagnola. This is a truly subject-less picture. The muzzles of the animals point in every possible direction, as if they themselves were looking for the lost centre.

The German artist wove vegetal settings around his figures in the confidence that setting would collaborate with figure. The tree was an extended attribute of the figure. Its branches celebrated or lamented the religious subject no less than did the collapsing folds of drapery. In a woodcut of St Dorothy of *c.*1400, one of the earliest surviving woodcuts, the tendrils press at the saint from all sides, like an incessant musical accompaniment (illus. 107). Their pattern may be read as a graphic analogue of her spiritual beauty.[55] To create an imbalance between subject and setting, the German painter practically needed to overthrow subject altogether.

As long as carved or painted foliage is relegated to the frame, it adorns the material panel itself. If it lies inside the frame, it adorns the subject-matter of the picture. Does ornament enhance or distract? The Florentine Alberti addressed this problem with principles of rhetoric. Classical literary or rhetorical theory imposed clear limits on the contribution that ornament might make to subject-matter. Rhetoric condoned the pleasing elaboration of language under the term *ornatus*. The acknowledged purpose of ornate language was to produce delight (*delectatio*) in order to stave off boredom (*taedium*). But the power of ornament was regulated by the normative criterion of decorum (*aptum*), or the appropriateness of the linguistic form (*verba*) to the subject-matter (*res*).[56] Decorum maintained the equilibrium between the subject and its treatment.

Painting was not so clearly articulated into functional components, into *res* and

107 German master, *St Dorothy*, *c.* 1400, woodcut,
27.1 x 19.7. Staatliche Graphische Sammlung, Munich.

108 Agostino Veneziano, *Animals in Forest*, 1510s, engraving 14.5 x 20. Graphische Sammlung
Albertina, Vienna.

verba. Nor was painted ornament easily isolated from the picture as a whole. Alberti barely distinguished between ornamenting and teaching: 'Thus whatever the painted persons do among themselves or with you [the beholder], all is pointed toward ornamenting or teaching the story (*istoria*).'[57] Nevertheless, ornament that threatened to distract attention away from the *istoria* would need to be physically isolated from the narrative by a precise boundary. Pleasure is a dangerous quantity in a sacred, or indeed any expository, picture. The most powerful ornament would need to be quarantined on or outside of the frame. This is brought out by a passage near the end of book Two of *On Painting*, where Alberti condemns the use of gold in narrative painting on the purist and idealist grounds that the qualities of the material will interfere with the more 'honest' illusions achieved by the technical prowess of the painter: 'I should not wish gold to be used, for there is more admiration and praise for the painter who imitates the rays of gold with colours.'[58] Yet, 'I would not censure the other curved ornaments joined to the painting such as columns, carved bases, capitals and frontispieces even if they were of the most pure and massy gold. Even more, a well-perfected *istoria* deserves ornaments of the most precious gems.' This is an extraordinary concession. Alberti would never tolerate such ornaments if they appeared inside the frame, not only because they were fashioned out of or coated with gold, but also simply because they obeyed autonomous formal principles. Those curves neglected to contribute to the *istoria*. But he permitted gold, gems and curves if they appeared on the frame, that is, on the far side of a newly stable and impermeable frontier between work and not-work.

Alberti, like the classical rhetorical handbooks, domesticated pleasure by compartmentalizing it. The frame absorbed the centrifugal energies of ornament. The danger of ornament exceeded the simple threat of distracting the beholder's attention. For ornament supplements its object: it is superfluous to the object but at the same time threatens to supplant it.

In the North, the relationship between painted subject-matter and its ornamental accessories was never so acutely defined. The structure of the religious image was subjected not to formal literary or rhetorical analysis, but at most to the strictures of literary humanists and theologians. These critics were nevertheless alert to the pedagogical and moral potency of images: 'loquax enim res est tacita pictura' (Truly a silent picture is a loquacious thing), warned Erasmus.[59] Learned men generally mistrusted any contribution of the artist's that threatened the primacy of subject-matter. Hieronymus Emser, for example, Luther's opponent, complained in 1522 that 'the more artfully [*kunstlicher*] the images are made, the more their beholders are arrested in gazing at the art and manner of the adornments [*bossen*].'[60] Colour fell under particular suspicion. In a dialogue of 1528 Erasmus praised Dürer for managing in his prints to convey all things with black lines alone, 'such that if you should spread on pigments you would injure the work'.[61] Johann Aventinus, the great Bavarian historian, who was Altdorfer's contemporary and fellow-citizen in Regensburg from 1528 until his death in 1533, once complained parenthetically that 'poets do not write history, but rather paint it over with colours and thus hide the

truth under verse and fables'.[62] But the poet's contribution was not merely distracting; setting did not merely funnel attention away from subject. Erasmus despised the 'blandishments' of colour. Colour was a *dangerous* supplement. For the contribution of the poet, or the colourist, moved on temporal scales beyond the capacity of the historian, and threw open the pictorial work to an unprecedented range of material. It discovered a subject-matter more general, and at the same time closer to sensory experience, than the myths of eschatology and hagiography.

The miniaturist's brush, to start with, discovered foliage. Technique in the *St George* captured aspects of what Ruskin would have called the 'truth' of foliage. Outer leaves tend to catch the light first and screen the inner depths of the tree. Moreover, the tips of the branches of some trees at some times of year, particularly evergreens, are brighter because they are younger. The fundamental formal unit of the *St George* is this overlaying of light strokes upon a dark ground to describe the body of a branch. Then the units multiply, so that the picture surface *realizes* natural disorder. It does not merely offer a parcel of disorder embedded within order – it lets disorder become the ordering principle of the entire picture. Individual trees are hardly to be distinguished from one another. A cluster of slender trunks emerges at the left; a more bulky trunk gleams forth at dead centre; the two trunks at the right disappear into the swarm of green. The rest is a conversation among branches. Some grow straight upwards, distributing feathery twigs to either side; some drift out laterally into space; some convulse and ramify in all directions at once. The proliferation of branches is not entirely random. The ranks of horizontal canopies, for instance, climb diagonally upwards from left to right, forming a thick pillar that leans heavily against the backward diagonals of the visible tree-trunks. But geometry is secondary to the surface chatter of the leaves. To scrutinize the technique is to feel the entire forest growing at a wildly accelerated pace out toward the picture surface. It is as if Altdorfer has transcribed the movement of a single branch in all its consecutive phases. The device would not be successful with ordinary subject-matter or with the human figure. The tree, on the other hand, with its repetitive structure, could more easily be set in motion.

Altdorfer's setting multiplies and accumulates formulaic units of vegetation. It fills the surface by repeating elemental patterns, unconstrained by a text or the demands of mimesis. In the *St George*, the pattern is the finger of brightness at the tip of the leaf standing out against a slightly darker leaf; that leaf is then defined against a darker branch, and that branch against a still darker background of dense forest. Hence every element in the foliage picture is both figure and ground at once. Ornament fills the surface, as it does in the woodcut tapestry with the satyrs, until there is no breathing room.

In the terms of Wilhelm Worringer's classic essay of 1908, *Abstraction and Empathy*, ornament reduces form into elemental abstractions of the organic or the inorganic.[63] When natural form is reduced to the plane, in Worringer's account, it is extracted from space. Altdorfer, too, practices a kind of abstraction, simply because the leaf, frond or blade can come to no longer look like itself. Instead, each becomes a unit

within a technical formula, estranged from its mimetic task, which is fulfilled only by the sum of the units. But it is a strange kind of abstraction. For although Altdorfer's leaves drift away from mimesis and flatten out on the plane, they move not toward geometrical or analytic form, but toward the personal and the unrepeatable. Using this technique Altdorfer could continue adding leaves and branches almost without thinking about trees, just as he or any German artist might have piled folds of drapery without thinking much about clothing. His ornament can appear, for a moment, unmoored from any origins in organic or inorganic form.

This is more than a mere neglect of subject-matter. The leaves represent phenomena and experiences more general than the adventures of a particular militant saint in a forest, and even more general than the appearance of a generalized northern European deciduous forest. The painting imitates a certain kind of movement and certain effects of light and colour that can be observed out of doors. The painting belongs to two other time-scales, besides the time of the narrative and the time of a beholder's experience of forests. It belongs to the time of growth and to the time of artistic fabrication – creation by the cosmic schedule and creation on a human scale.

Altdorfer is *apparently* blind to the whole; in fact, his blindness generates an entirely new structural principle. In this picture the multiplication of abstract, or supposedly abstract, units runs up against no natural limits. 'The picture stops', wrote Max Friedländer of the *St George*, 'but nowhere comes to an end'.[64] Neither the outer edge of the panel nor the figures at the bottom seem capable of arresting the accretion of ornament. Neither is an authoritative frontier. The wall of branches can be read first as an inward extension of a German foliate frame, and then, by a kind of gestalt switch, as an outward extension of the conventional wilderness setting of St George's adventure. Alberti's rhetorical analysis of frame and narrative would find no foothold here.

Repetitious ornament anaesthetizes the beholder to subject-matter. The beholder's willingness to be distracted stands behind the passivity, the masochism, the abdication of intellect and control implied in Western aestheticism. The beholder of the first landscapes was the first to retreat into the green and suffocating shade described by Andrew Marvell in his poem 'The Garden'. The post-Renaissance aesthetic experience was indeed born, paradoxically, out of an anaesthesia, and not only out of an amnesia, the gradual forgetting of subject-matter.

This investigation into movement did not necessarily flow out of the direct observation of the natural phenomenon. Few painters in the early sixteenth century actually drew trees and flowers and mountains from life. Landscape painting, for the most part, slid directly from abstract, dimly-lit – in a sense, proto-academic – contests for the better pictorial solution to a bookish ideal of nature, without going out-of-doors at all. In some ways the development of landscape painting resembles Worringer's description of the movement away from abstraction and towards empathy, that ingenious model of the rise of naturalism that omits mimesis. To be sure, the German painter of the early sixteenth century approached natural phenomena without fears; or at least without genuine fears, for any atavistic symptoms of anxieties may be dismissed as selfconscious and 'stylized', such as Dürer's fascination with the demonic

and with random form. But the new engagement with the outdoors was also more complicated than a simple access of empathy, or Worringer's Renaissance 'joy' in natural form. The approach to landscape passed by way of phenomenal attributes, such as movement, which were not yet known as 'nature'. Moreover, it happened through abstraction, style and ornament, and not against them, as in Worringer's account. Altdorfer did not simply exclude chaotic or arbitrary phenomena any more than he tried to reduce them to crystalline or inorganic elements. Rather, he conquered the chaotic and the arbitrary by adopting and appropriating their energy. The artist himself became the arbitrary force, the wilful and unpredictable agent; he personally installed a new lawfulness. Altdorfer's foliage is by no means the equivalent of Dürer's irregular chunks of rock, like the *Quarries* in Bremen and Berlin (illus. 70, 84), which would have given pleasure to very few. Nor does Altdorfer's foliage offer the pure and idealized beauty of form, the 'formed' form that lay behind the medieval word *formosus*; it resists inorganic regularity and true abstraction. The foliage belongs to neither category, neither form nor non-form. Movement was not necessarily understood as an attribute of the organic. A painter had to invent his movement anew, on paper or panel, before he could seize it intellectually and begin to lean toward it empathetically. His invention resembled an effect described tentatively, and only conditionally sanctioned, by E.K., the contemporary commentator of Spenser: '[I]n most exquisite pictures', E.K. remarked in defence of Spenser's deliberate archaicisms, 'they use to blaze and portraict not onely the daintie lineaments of beautye, but also rounde about it to shadow the rude thickets and craggy clifts.' E.K. probably had in mind Netherlandish landscape paintings. 'Oftimes we fynde ourselves', he continued, possibly under the influence of Paolo Pino's comments on Northern wildness, '. . . singularly delighted with the shewe of such naturall rudeness, and take great pleasure in that disorderly order'.[65]

Germania illustrata

Strange wilderness, then, that affords the beholder such sheltered pleasures. The energy of forest strife and combat has been absorbed by the vegetation and dissipated in ornamental abstractions. The antipathetic forest is framed and benign. In Altdorfer's *St George* the forest has switched its allegiances. It has become the attribute of the saint rather than the dragon: no longer an obscure and baleful habitat, but rather the embroidered ceremonial backdrop to St George's private tournament. The saint has become a colleague of those maddened knights in chivalric epics who took to the forest and later returned to court and civilization charged with the glamour of the wilderness.[66]

Another symptom of this process of aesthetic absorption is the promotion of the Wild Man to the province of the painted panel. Already in the fourteenth and fifteenth centuries, the themes of combat and raw sexuality clustered around one of the spectres of German folk culture – the hairy, club-toting, mortally jealous Wild Man.[67] But he belonged mostly to poetry, pageantry and profane decorative programmes. In

109 German tapestry, *Scenes from the Life of the Wild Men, c.* 1400, height 82.
Stadtmuseum, Regensburg.

fifteenth-century Swiss or Alsatian tapestries the Wild Man might gambol among his own Wild Family, or pursue a Christian maiden.[68] One of the best such tapestries was owned by the city of Regensburg, and was probably already on display in the Rathaus in Altdorfer's time (illus. 109).[69] The Wild People acted out imaginary trajectories – simultaneously dreamt of and feared – of unsupervised love. German artists of Altdorfer's generation folded into this tradition the novel Italian figure of the satyr. In Dürer's engraving of 1505, the satyr, with leafy head and erect penis, aims his horn at his human bride; the legs of the child – flesh or fur – are invisible (illus. 98). The satyr appealed to humanists because it linked ideas about nature with Antiquity.[70] The satyr dwelt at the centre of the pantheistic animated cosmos, before Christianity, before civilization. Whether the Germans heard all these overtones is another matter. In Altdorfer's drawing of 1510 of a forest family, furious horizontal linear vibrations generate a kind of force-field that mimics narrative and psychological energies (illus. 46). The bearded club-wielder is a fleshy Wild Man. In the little painting of 1507, which seems to represent another moment from the same obscure story, raffish wild folk take refuge beneath an unruly tree and a bare escarpment (illus. 45). Here the satyr has grown horns and hoofs.

Altdorfer's *St George* belongs alongside pictures like these, or like his own *St Francis* and *St Jerome* panels, where the forests enter into conversation with the hermits (illus. 48, 49). Altdorfer transposed biblical or profane episodes – Samson and the Lion, Christ on the Mount of Olives, Pyramus and Thisbe – to leafy native settings. He lifted the figures for his *Madonna with Blessing Christ Child* of *c.*1515 (illus. 110) from an engraving by Giovanni Antonio da Brescia.[71] But then he set them down in a corner of the forest, with a splayed fir and homely buildings, all described with a sleek sheen and a rhythmic array of lights and darks derived from the engravings of the most celebrated native master, Dürer. In this engraving Altdorfer performed an operation exactly complementary to Italian artists' various extractions and implementations of the Northern landscape setting. Altdorfer's dissection of the image along the subject-setting frontier reaffirmed the traditional distribution of pictorial components according to national gifts and propensities: Italians knew figures, Germans knew landscape.

But the framed German forest also hosted ever more uncanny and menacing personages and events. In his finished drawings on coloured ground, Altdorfer planted lovers and lubricious witches among the trees. Hans Baldung Grien, who must have been

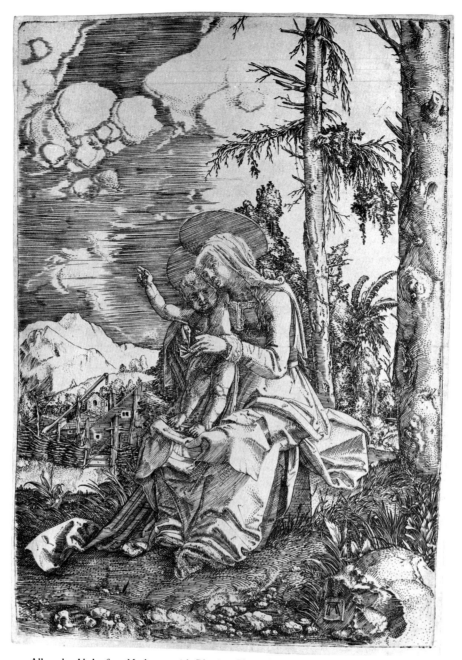

110 Albrecht Altdorfer, *Madonna with Blessing Christ Child*, *c.* 1515, engraving, 16.4 X 11.7. National Gallery of Art, Washington DC.

looking at Altdorfer's paintings and drawings, staged an inscrutable encounter between Death and Vanity in a weeping forest (illus. 111).[72] The painting dates from c.1509–10, after Baldung had completed his apprenticeship with Dürer and returned to Strasbourg. (In the late nineteenth century it was still attributed by the Kunsthistorischesmuseum to Altdorfer.) Baldung's forest is not so much a place as the moveable scenery of the imagination, as appropriate a pictorial background to one of his morbid rebuses as plain black. The dissolving, entwining, mossy fronds represent a space within the mind where vanity is converted into consciousness of mortality. The dark grove at the heart of the forest witnessed extremes of desire and violence. In a series of woodcuts of 1534, Baldung corralled herds of bucking, foaming, ejaculating horses within impenetrable walls of forest.[73] A strange woodcut of 1522, designed by a Master N.H. and cut by Hans Lützelburger, pits naked forest-dwellers against an iron-wielding army of peasants, as if to illustrate the antagonism between nature and civilization, between forest and field (illus. 112).[74] The print looks like a deliberate transposition of Pollaiuolo's *Battle of Naked Men*, that most spectacular of Quattrocento prints, from a vineyard to a forest setting, and from the cool, even grey of the best Italian engraving manner into the clamorous idiom of German woodcut. Peter Parshall interpreted this print as a selfconscious demonstration of a 'hyperborean style' that was rooted in the works of Altdorfer and Burgkmair, and especially in their woodcut work for the Emperor of the 1510s.[75] The icicles of foliage depending from stiff perpendicular branches are as rebarbative as the peasants' pikes and scythes; this is no setting for a heroic encounter in the nude.

All these pictures betray mixed emotions about the forest. Already the Wild Man tradition wove the strands of dream and danger side by side. The forest dweller in Altdorfer's London drawing of 1508 – naked and therefore excluded from the city in the background – is a benign giant, massive, bent under the burden of an uprooted tree, a heathen St Christopher (illus. 105).[76] In the old tapestries, the Wild Man used an uprooted tree as a walking-stick.[77] Here the tall-tale attribute has been naturalized: the trunk is too massive to be manipulated, and Altdorfer's Wild Man is not a giant, but man-sized, as if the picture illustrates imaginary ethnography. This Wild Man is no longer coated with fur or swaddled in moss, but simply naked. His nudity distinguishes him from more traditional lightly-clad wilderness heroes who retained ties to civilization and to subject-matter: Samson, St Jerome, Hercules. Nudity is the first step toward the elimination of subject-matter. It is already strange enough that an anonymous bare-chested figure, belonging to no story in particular, should supplant the hagiographical or mythological subject and occupy an entire picture field.

The forest sheltered a simpler existence. The Germans made their own version of the pastoral *loci amoeni* or the georgic retreats sketched out in Virgil and Horace, and amplified in reams of modern verse. Rich and lettered Italians had been living out similar rustic fantasies since the time of Petrarch, but the Germans imagined a wilder haven. Their forest dwellers lived brutally and precariously, but were innocent of enervating luxury, clerically-imposed morality, or foreign meddling. Civilization

111 Hans Baldung, *Allegory of Vanity*,
c. 1509–10, oil on panel, 48.0 x 32.5.
Kunsthistorisches Museum, Vienna.

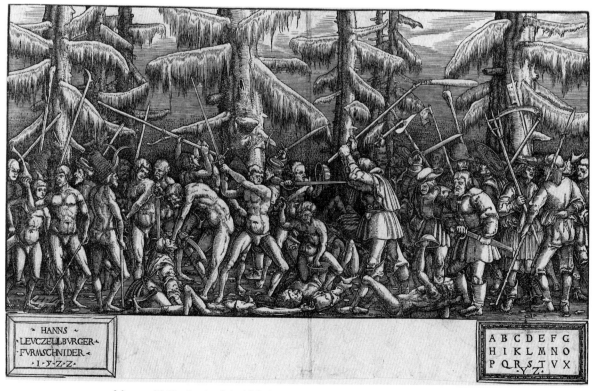

112 Master, N.H., *Battle of the Naked Men and the Peasants*, 1522, woodcut 14.8 x 24.
Kupferstichkabinett, Öffentliche Kunstammlung Basel.

brought mixed blessings, and German readers and beholders were fascinated by this paradox. Pictures such as Altdorfer's *Wild Man* in London implausibly juxtapose deep forest with a background glimpse of city, as if civilization, the ideological foil to wilderness, needed to be visible as well. Everyone was reading the first bulletins from the New World.[78] In 1508 Hans Burgkmair illustrated an account of an East Indian expedition.[79] Germans of this generation came to savour the satirical flavour of the reversal of hierarchy. In Hans Sachs's poem *Klag der wilden Holzleüt uber die ungetrewen Welt* ('Lament of the Wild Forest-People over the Perfidious World'), first published in 1530, the rude family speaks for itself:

> Alas! Society corrupts
> And rampant perfidy erupts . . .
>
> And so we left our worldly goods
> To make our home in these deep woods
> With our little one protected
> From that falsehood we rejected
> We feed ourselves on native fruits
> And from the earth dig tender roots . . .
>
> And thus removed from civilization's
> Shams we've lived for generations
> United in our simple life.

Finally, a historical explanation for the Wild Man. The text, printed on a broadsheet, was keyed to a woodcut by Dürer's pupil Hans Schäufelein: a sylvan Adam and Eve, with hairy chests and an uprooted tree (illus. 113).[80]

Germans scarcely needed exotic new data from the other side of the Atlantic: they had authoritative and suggestive textual evidence of their own savage past from Tacitus. The manuscript of the *Germania* was discovered in a German monastery, either that of Hersfeld or Fulda, in the 1420s. Poggio Bracciolini knew of its existence, but probably never got his hands on it. The manuscript finally surfaced in Rome in 1455.[81] Aeneas Silvius quoted liberally from it in his own treatise on the Germans, a disingenuously flattering response to German grievances against the papacy. He used Tacitus's ethnography to impress on the Germans how dramatically their lot had improved since Antiquity. Although Tacitus's text was published in 1471 in Rome and in 1473 in Nuremberg, it attracted no attention in Germany until the publication in 1496 of Aeneas Silvius's *Germania*. Jakob Wimpheling, the Alsatian humanist, drew on Tacitus in his own *Germania* of 1501, but generally cited the same passages that Aeneas Silvius had cited. Celtis was more aggressive. He published an edition of Tacitus in 1497, and when this was reprinted in 1500 he appended the third chapter of the *Norimberga*, his own monograph on the city of Nuremberg – the chapter about the Hercynian forest.[82] Erudite patriots like Wimpheling and Heinrich Bebel refuted Aeneas Silvius – the dispute with the papal curia, two generations later, was by no means resolved! – by returning to his own primary source. The Germans used ancient ethnology as ammunition against the financial and political –

113 Hans Schäufelein, *Klag der wilden Holzleüt, c.* 1530, woodcut 26.2 x 39.5.
British Museum, London.

and ultimately psychological – burdens imposed on them by Rome. Resentment
against Italian highhandedness and, above all, against the clergy's exploitative trade
in indulgences (paper promises of time off from Purgatory) finally found a voice.
Germans seized the foreign distaste for their native landscape and reversed it. Celtis
saw in great Rome the mere shell of ancient splendours:

> Sed tantum magnas tristi cum mente ruinas
> Conspicio, veterum jam monumenta virum.
>
> (But such great ruins I observe with sadness,
> Now the mere monuments of ancient men.)

The Hercynian forest was by contrast still vigorous, teeming, endlessly replenishing
itself. The humanists made the forest the attribute of the nation.

This was a momentous step. Granted, the Wild Man provided a partial precedent.
He, too, personified local landscape: the legends surrounding him tended to survive
longest in the wildest and roughest regions.[83] But never before had the landscape
been so systematically and selfconsciously shaped into a collective emblem – not of
empire or state, nor of region or locality, but of nation. Tacitus delivered the raw
ethnographic material. The *Germania* staged simple contrasts between the piety,
familial coherence and military virtue of the German tribes on the one hand, and
the corruptions of city life on the other. This model was easily translated to the
present. Historicism was still the exclusive luxury of the literary antiquaries, while
painters and illustrators automatically transformed the remote and exotic into the
near and topical. Altdorfer's primitives may allude to the German *Urzeit*, but like the

Wild Man in London they tend to skulk along the outskirts of what looks like modern civilization, as if they were still to be found in the woods flanking the Danube. No one actually ventured to illustrate Teutonic antiquity until the end of the century, when appeared the woodcut vignettes accompanying Abraham Ortelius's charming series of essays on the mores and customs of the pre-historic Germans.[84]

Patriotism fuelled ambitious new geographical and ethnographic projects. By 1495 Celtis had written his supplement to Hartmann Schedel's World Chronicle, the *Norimberga*, a history and topographical description of the city. In the first chapter he described himself as a German 'born in the middle of the Hercynian forest' (he hailed from Wipfeld in Lower Franconia, some fifty miles northwest of Nuremberg).[85] The *Norimberga* was published in its entirety in 1502 as the pilot to a planned *Germania illustrata*, a massive, collaborative survey of German lands and peoples. In the same year Celtis published a geographical poem, appended to his *Amores*, under the title *Germania generalis*. His project was modelled on the second book of Aeneas Silvius's *Germania*, but above all on the *Italia illustrata* of Flavio Biondo of 1451, the pioneering modern treatise in historical geography. Biondo's excursions into Antiquity made perfect sense, given the geographical and linguistic continuity of classical Roman and modern Italian civilization. The German projects turned Antiquity against Italy and thus took on a more strained and polemical flavour. After Celtis's death in 1508 the great project was taken up sporadically by Johann Aventinus and Beatus Rhenanus, but never completed. Several more reasonably scaled geographies appeared in its stead. Konrad Peutinger of Augsburg, improving on the scholarship of the Alsatian Wimpheling, claimed the lands on the left bank of the Rhine for Germany in his savoury and exquisite *Sermones convivales de mirandis Germaniae antiquitatibus* (1506). Franciscus Irenicus of Heidelberg compiled an *Exegesis Germaniae* from the ancient sources (1518). The highest standards were set by Pirckheimer's treatise on place-names, the *Germaniae explicatio* (1530), and Beatus Rhenanus's *Germanicarum libri tres* (1531).[86] Literary men had long found employment writing historical chronicles of cities or dynastic houses. The humanist geographers discovered a way to write for the nation.

Germany was to be 'illustrated': not only made to glow with the lustre of fame, but also, more simply, to be described. The humanist geographers and ethnographers were compilers. They accumulated local topographical data through travel and correspondence. They assembled catalogues and glossaries of historical events and personalities. They mined newly critical editions of classical texts for ethnological material. The facts alone would be sufficient to glorify Germany. The geographer had faith in the power of showing, in mere evidence. The model format for the clear and objective display of data was the picture. The geographies spread outward in space rather than time. As mentioned above (p. 47), humanists conventionally compared their grandest cosmographies to small painted panels. In his Ingolstadt Oration of 1492, for example, Celtis compared the ancient geographies to paintings. But these comparisons were purely metaphorical. More practicable was Joachim Vadian's analogy between painting and chorography, or the verbal description of particular places.

Chorography, he explained in his introduction to his edition of the ancient geographer Pomponius Mela (1518), describes a separate place 'in likeness to a picture'; indeed, 'if someone were to fashion a little image or a tablet of Rome from close range, he would be called a chorographer.'[87] Vadian might as well have been referring to Raphael's projected survey of Roman antiquities: a letter from a humanist poet at the papal court spoke enigmatically of 'painted panels' that would presumably have been prepared from the drawings by Raphael and his pupils, and which would eventually have fitted together to form a continuous and archaeologically reliable panorama of the ancient city.[88] Germans had some experience with urban topography, too. Painters often drew buildings and skylines from life in order to reproduce them in the backgrounds of their paintings. But the outstanding models in Germany were the woodcut city views of the Nuremberg Chronicle, prepared in Wolgemut's workshop (see pp. 208–12). The cities of the Chronicle provided an often reliable chorography that the text itself lacked.

Altdorfer's landscapes sit restively beside the geographical projects. They do not describe particular places. It is easy to measure the distance between these pictures and the idealized images of patriotic topography. Altdorfer's landscapes are upholstered with surpluses of colour, texture and calligraphy. The rough trace of the author disfigures the surface. The points of view and the horizons are low; if anything the pictures confirm the limitations of personal experience. Altdorfer indulged his own capacity for judgement and invented fictional places. Literary humanists, by contrast, tended to trust both authority and autopsy, and to mistrust independent judgement. Dürer, too, we recall, had warned against unchecked imagination (p. 13). Altdorfer's landscape, finally, is physically framed. The frame around the geographer's datum was always erasable; the ethnographical fact or the topographical description – like Raphael's Roman panels – would simply be added to an array of similar descriptions and facts. Individual descriptions could not afford to be too composed.

Altdorfer's landscapes would disappoint the geographer, who might have hoped that they would transcend the ambiguities and incompleteness of the verbal description of places. Instead of illustrating, they fall back into the obfuscated state of the text, irremediably different from its object. Altdorfer's landscapes actually belong to the minor rhetorical category of topothesia, or the description of fictional places. Vadian associated topothesia with 'poetic licence'. Topothesia interested not the geographers but the poets, especially the Germans who were reading and imitating Theocritus, Virgil and the modern Italian pastoralists, above all Jacopo Sannazaro, author of the *Arcadia*. Altdorfer's landscapes manifest no particular familiarity with the conventions of literary pastoral. But they share with pastoral a tendency to resist the simple notion of a comfortable retreat into nature. The elements of obscurity and surplus – which in Venetian painting, too, are correlated with the very idea of style – strike overtones of fear, dangerous eroticism, social conflict. Pastoral never allows fiction to become mere consolation.

Why associate Altdorfer's landscapes with the humanist topographical project at all? Because they represent German places. They raise the geographer's object of imitation up one level of generality. They are ideal particulars: fragments of a regional landscape that stand for a vaster whole, a landscape that would be strictly unrepresentable in such detail and at such a range. The essentially German ingredient, the link between picture and place, is the tree. The tree represents metonymically the entire German forest. The difference between the independent landscapes and the formulaic framed background of portraits or narratives lies in the variety of arboreal species, in the excess of data concerning foliage, and in the derangement of ordinary spatial structures generated by attentiveness to trees. Trees take over the pictures, structurally and psychologically. The German forest, nearly always recorded in the full bloom of high summer, is green, tumbling, profuse. In these landscapes the marks of civilization are enveloped or besieged by trees. The pictures even reproduce the ambivalence of the humanists toward the forest. In Altdorfer's pictures, forest condemns the architecture on the horizon; and at the same time the architecture offers an escape from trackless nature.

Altdorfer's *Landscape with Footbridge* in London (illus. 99), painted on parchment that is pasted on wood panel, is more than twice the size of the Munich *Landscape with Castle* or the *St George*, and four times as large as the watercolour landscapes.[89] The London picture is the least voluble and accessible of the landscapes, the closest to a drawing by Wolf Huber in spirit, even if far removed in technique and scale. The surface is hard to read, due to damage and repeated restorations. The painting came to light in Munich around 1910; it was purchased by Dr Rudolf Pfister, who removed the overpainting and revealed a severely abraded surface, with complete paint loss on one-fifth of the total area. Pfister reported a black border that was concealed by the frame, a monogram on that border, and the incomplete date *15–6* on the rock face at the lower right. The picture was acquired by the Munich dealer Böhler in 1917, and when Pfister saw it again at the Munich Altdorfer exhibition of 1938 he noted with horror that the date, as well as a thin stream of falling water and parts of the building at the left, had been overpainted. This intervention has been reversed, but the date is lost forever. Technique and structure nevertheless place the picture reliably in the middle of the 1510s.[90]

The basic schema of this landscape is familiar from other works: a group of bodies and masses is arrayed in the foreground in fairly complex relationships to one another, leaving open one or more views straight through to the background. In the London landscape, human figures have been replaced entirely by inanimate objects; or rather the figures have been metamorphosed into trees. The mop-headed tree in the right background resembles one of the Wild Men who clothed themselves in foliage.[91] The central tree, or cluster of overlapping trees, pitches slightly to the left and flails its limbs, as if it had not only an anthropomorphic structure but even a character. It recalls the central tree of Cranach's *Rest on the Flight* (illus. 38). The company of motifs is anything but self-explanatory. The building – with round-arched string-courses, four stories, and crenellations – is presumably the entrance to a castle,

perhaps a gate-tower, abandoned or ruined. Castles with round-arched windows are ubiquitous in Altdorfer and Huber. A railed bridge spans a stream-bed, a natural moat. A drawbridge closes the gap between bridge and gate. The bridge fastens one side of the picture to the other, fulfilling the function that gazes or implied movement would in a narrative. Between the supports of the bridge, in the middle distance, rises the thin spire of a church.[92] The overlapping of the top of the second window by the string-course is a detail too peculiar to be invented; it suggests that the painting was grounded at some stage in an observation from life. The weeds hanging from the roof and the dead branch recall the macabre vegetative excrescences on the ruined arches in the *Christ Taking Leave of His Mother* in London (illus. 13) or the *Separation of the Apostles* in Berlin.[93] Architecture here falls prey to the living tentacles of the forest. The clumsy convergence of the two mouldings is not easily explicable. Certainly it is difficult to imagine Altdorfer tolerating such a perspectival solecism in the 1520s, in the years of the *Susanna and the Elders* (illus. 55) or the *Birth of the Virgin* (illus. 52),[94] two large and exceedingly complex cabinet pictures. But this is a very different kind of picture. Everything is happening close to the picture surface. Altdorfer often used sharply angled lines in the upper corners to close his pictures in upon themselves: see the Bremen *Nativity* of 1507, the *Christ Taking Leave of His Mother*, or any number of prints, for instance the woodcut *Beheading of John the Baptist* of 1512.[95]

The disorderly geometry of this picture is as odd as the geometry of the *Satyr Family*, where the distribution of narrative between foreground and middle ground is not internally rationalized (illus. 45). Altdorfer is not offering an excerpt from an infinite and continuous space. Rather, he fragments space into independent parcels and then crams these into a frame. His frame plays an assertive role within the construction of the picture. It never falls across the composition accidentally. Altdorfer's frame is not trying to pass itself off as a window. The picture that breaks space in two, or refuses to penetrate into depth, simulates a different experience of forests than roomier and more continuous views. This forest obstructs and splinters vision. One feels that it could only actually be *seen* from the outside and from a distance. On the inside it is grasped by other senses. Pictures like the *Satyr Family* or the *Dead Pyramus* place the bewilderment of the forest wanderer in direct analogy to the wonder of the beholder before strange and incomplete stories (illus. 45, 42). The effort to represent the anti-visual experience of the forest is the essential link between Dürer's, Cranach's, and Altdorfer's revolutionary prints and small panels of the early years of the century, and Altdorfer's independent landscapes of the 1510s and 1520s. When landscape, an absence of subject-matter, is finally substituted for merely enigmatic subject-matter, the incompleteness is translated to the level of form.[96]

Joachim von Sandrart, in his *Teutsche Akademie* of 1675, made an odd comment about Altdorfer's pictures that seems to address just this structural peculiarity. 'His works appear somewhat unpolished [*wild*]', he said, 'because the backgrounds, according to the customs of the time, emerge just as hard [*hart*] as the foregrounds'.[97] Sandrart missed the spaciousness of the modern outdoor image.

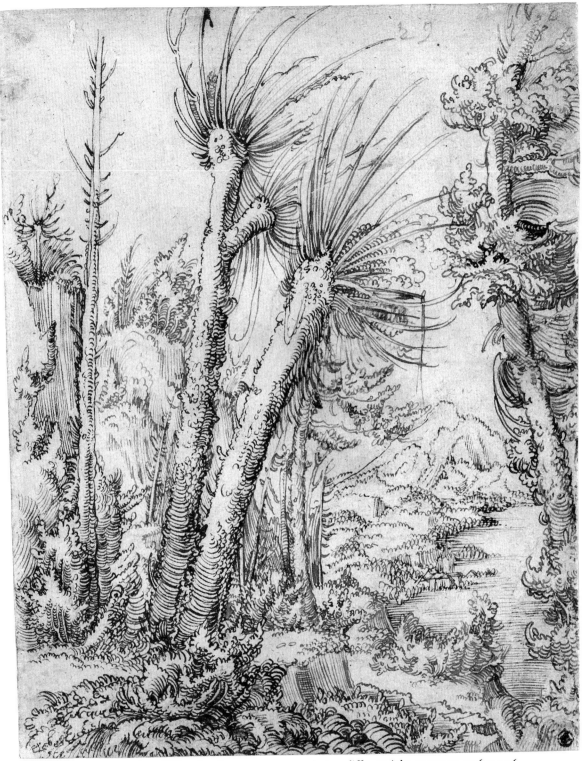

114 Wolf Huber, *Willow Landscape*, c. 1515, pen in two different inks on paper, 20.6 x 15.6.
Kupferstichkabinett, Berlin.

115 Wolf Huber, *Mill with Footbridge, c.* 1515, pen on paper, 14.9 x 15. Museum of Fine Arts, Budapest.

Wolf Huber's landscape drawings in pen and ink also 'fold' and disrupt space. The *Willow Landscape* in Berlin is a petrified pagan narrative, full of potential energy in the foreground (illus. 114).[98] Sometimes confusion in Huber follows from the honesty of unselective observation, or at least from the pretence to such honesty. This accounts for the deadpan meaninglessness of drawings like the *Mill with Footbridge* in Budapest, where the beholder's impulse to break through the picture surface, to move into a fictional space, is stymied by intransigent data (illus. 115).[99] The confusing foreground configurations in Huber and Altdorfer are normally calculated; they cannot be attributed casually to inexperience or uncertainty. Altdorfer and Huber created the fundamentally non-spatial landscape, a landscape that simply neglected to describe terrain. Some later Western traditions would scarcely recognize such a picture as a landscape. Indeed, the non-spatial landscape would have a difficult time of it in the generations to come.

For now, however, the non-spatial forest served as the chief proving ground for a regional manner of painting. Altdorfer transferred selfconscious localism from the level of content – the new 'subject' of the forest itself, a fictional topography – to the level of style. This was no arbitrary manoeuvre. The principles of the style – winding and unruly lines, the proliferation of disorderly ornament, the 'folded' and impenetrable space – derive from the experience of the forest itself.

This is more abstract than any previous emblematic association between landscape and community. Altdorfer's landscapes illustrate an *idea* of local flora and terrain: the *genius loci* but not the place. Ambrogio Lorenzetti's *Allegory of Good Government*, painted in 1338–40 on the walls of the Sala dei Nove in the Palazzo Pubblico, Siena, describes the fertile fields beyond the city walls, which are protected by the allegorical figure of 'Security'.[100] No such planted symbols or inscriptions channel the reading of Altdorfer's pictures. Flemish calendar and encyclopaedic miniatures laid out an ideal image of cultivated countryside (see pp. 35–7 and illus. 20). The Limbourg brothers, the outstanding miniature painters in Paris around 1400, painted in the *Très Riches Heures* a series of views of lands and holdings belonging to their patron, Jean, Duc de Berri.[101] In Altdorfer's landscapes nothing happens – no farming or building, no rural pastimes, no animals, wild or domestic – that would constitute commentary on the symbiosis of community and land. Franconian painted altarpieces in the last half of the fifteenth century were studded with local topographical detail that was grounded in accurate on-site drawings. Out of this practice emerged Dürer's watercolours of particular places in and around Nuremberg, such as the *Wire-drawing Mill* (illus. 152; see pp. 212–3). Altdorfer's buildings, by contrast, are unidentifiable.

Altdorfer offers *characteristic* fragments of local landscape. His views are neither samples of the real, nor anthologies of ideal features. Rather, he characterizes a regional landscape through its most idiomatic features. He does not smooth out rough edges and suppress deviations from the mean. This approach to regional landscape overlaps with Altdorfer's hyperbolic and self-indulgent stylistic proclivities. His fictions reveal landscape and self through identical means: exaggeration of the irregular, magnification of the anomalous, celebration of the ragged surface.

This peculiar overlap of the descriptive and the stylish accounts for the grinding of gears one is apt to hear when these landscapes are submitted to contextual or materialist explanations. Altdorfer went directly from his eccentric narratives to his empty forests, from one kind of fiction to another. He did not even need to go out of doors. Altdorfer's supplement to geography was style, and it is this supplement that gives his landscapes their uncanniness – the sense that the familiar has suddenly become unfamiliar, dreamlike, self-sufficient. These landscapes are too empty, as if in fact one *were* looking at a huge imaginary map under the most intense magnification, zeroing in on unnamed patches of terrain that resemble the surface of the earth, yet are drained of human activity and removed from history.

Altdorfer's epigones and imitators picked up on exactly this feature of his work. Reception is invaluable evidence: it reveals what contemporaries found distinctive and impressive. The characteristic tree became the common denominator of a class

of paintings collected by the older historiography under the name of a river: the Danube School, or Danube Style.[102] The Danube School refers to an imagined community of painters united by their shared affection for the wooded country of the Danube valley in Bavaria and Austria.[103] In this historiographical tradition, the filial heroes are Altdorfer and Wolf Huber, whose cities Regensburg and Passau are linked by the river. The patriarch, meanwhile, is Lucas Cranach, who worked for a period in Vienna, further downstream, in the early years of the century. There is a core of historical truth to all this. The graphic exploration of wild setting had roots in raw-boned Bavarian and Franconian painting. But unruly trees had nothing in particular to do with the Danube valley: they could have characterized practically any wooded country in central Europe. Altdorfer might have met Cranach; Huber and Altdorfer certainly knew each other. But the core of the 'school' was really Altdorfer's invention of a personal language of foliage, a set of arboreal hieroglyphics that served him both in narratives and in landscapes. The splayed fir branch and the dripping coiffure of willow became his emblems. Gerard David – at least according to Esther Cleven (p. 40) – established a similar link between his name and the look of his painted trees. But Altdorfer injected a more immediate physical trace of himself into his emblem. His temperamental tree stood both as the physical product of his fluid brush, and as the recognizable symbol of his fluidity and idiosyncrasy. Others mimicked Altdorfer's trees, and around those imitations gelled a regional style. The widening circles of fascination can be seen in the corpus of tree studies drawn in the spirit of Altdorfer (illus. 73, 76–9, 81). The earliest repercussion in a printed medium was a series of twenty-six woodcuts illustrating a miracle at Mariazell.[104] Later, the dripping tree was transferred to the medium of wood relief by the Master I.P.[105] But the forest was wildest in paint, for example in the altar of the Holy Blood at Pulkau in Lower Austria, attributed to a gifted follower of Altdorfer;[106] or in the little *St John on Patmos* by an anonymous Bavarian master (illus. 116).[107] Foliage and underbrush, distant and near, twinkle on the surface. St John stares at the wall of trees and, presumably, at the Apocalyptic Virgin snared in the branches.

The motifs spread quickly to Nuremberg. Baldung first mimicked Altdorfer in the Vienna *Allegory of Vanity*, as we saw (illus. 111), and then again – surely with more irony – in the sweetish *Holy Family* beneath a dripping fir, in Nuremberg (illus. 117).[108] Hans Suess von Kulmbach, Dürer's most dutiful pupil, painted a sylvan St Catherine in 1514.[109] Altdorfer's contributions to the Triumphal Arch and Procession attest – if there were any doubt – that he was well-known in Nuremberg and Augsburg. And because the 'look' of the local landscape was founded on line, there was really no reason that personal style had to defer to a regional or 'Deutsch' style, as Baxandall suggested.[110]

But this is no school. Artists in Bavaria, Franconia and Switzerland were looking at each other's works, and they were probably aware that only one or two outstanding artists were responsible for the vogue of dripping trees. Once the 'look' of Altdorfer's and Huber's outdoor settings had been exported to northern Germany, to northern Italy, and far to the east, their style became a *de facto* regional style. The style arrived in these distant lands bearing a southern German label.[111]

116 Bavarian Master of the Munich John on Patmos, *St John on Patmos*, *c.* 1515, oil on panel, 27.3 X 17.4. Bayerisches Nationalmuseum, Munich.

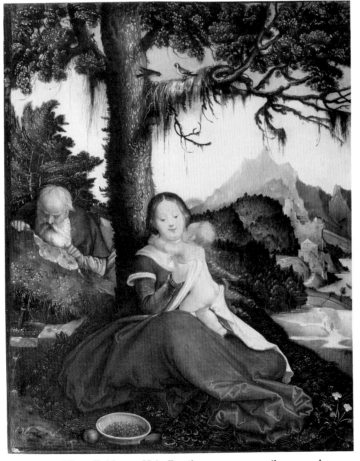

117 Hans Baldung, *Holy Family*, *c.* 1511–14, oil on panel, 48.5 X 38.5. Germanisches Nationalmuseum, Nuremberg.

What is remarkable is the notion of an entire pictorial system grounded in a local physical environment. This is equivalent to the traditional correlation of Giorgione's and Titian's colourism with the actual effects of sunlight, water and atmosphere in Venice. The Venetian Paolo Pino was pointing towards something like this when he attributed the superiority of the Flemish landscape to the savage Northern terrain itself (see p. 128). He implied that the heterogeneity and disarray of the land, once transferred to a two-dimensional surface, automatically made for more interesting pictures. Pino, no traveller, slightly overestimated the ruggedness of the Low Countries. But his remark, and the old cliché about Venetian painting, suggest how natural environments might begin to be perceived in pictorial terms, that is, as 'views' already organized within the conventions of planar and painterly representation. The ready-made landscapes of the fifteenth century, framed in windows and arches, foreshadowed this development. Then when sixteenth-century writers tried to describe real scenery, they often did so in the terms that painting provided for them. The poet Aretino admitted that he admired the sunset in Venice with new eyes once he had seen Titian's canvases. And most amusing of all is Karel van Mander's encomium to the landscapist Coninxloo: 'The trees in this region, normally rather scraggy, are now starting to grow in the manner of his trees, as well as they can.'[112] These are the true origins of the 'picturesque', that reversal of the process of figuration whereby the forms and structures of remembered landscape pictures are imposed on the perception of actual landscape.[113]

Such a reversal is a precondition for the thesis proposed here, namely that the German landscape was providing not just the furniture of the pictorial landscape (trees, mountains, castles), but its formal and structural principles as well. The forest was seen as a picture; only then could a picture of it be painted. But then one only saw the forest as a picture if one already knew pictures. This feedback effect locks the culture of picture-making into an unusually intimate relationship with the land. Land and picture share a common structure. Only one further link is necessary to support the idea of a 'national style': the link between the nation and the land.

The first link – style with the look of the country – was explored in the 'Small Landscapes' published by Hieronymus Cock in Antwerp around the middle of the sixteenth century, and in general in Bruegel's circle. The prints had a constituency of amateurs and collectors, but this public hardly thought of itself as a nation. Not until the first decades of the next century did any Northern culture make the second connection – between the look of the land and the idea of nation – in any way comparable to what happened around Altdorfer. Simon Schama invented a memorable *double entendre* to describe the unprepossessing rural scenes of Esaias van de Velde, Pieter de Molijn or Salomon van Ruisdael, the Haarlem landscapists of the 1610s and 1620s: he called them 'plotless places'.[114] They are plotless because they have never been measured or charted; they are places that will never be paced off into plots. They are also plotless because they are the most unlikely stages for significant human action; they cannot sustain stories. The plotless places may or may not have been drawn from life. In effect, they are lost places, for they could never

be identified. These little fictions were the foundations for two generations of much grander Dutch landscape painting that explored the idea of the local. The generalized meditation on the local and the native is contingent on a fictional faculty. Fiction, in turn, requires a certain detachment from the notion of a particular place – although not necessarily from particular fact – and a resistance to the temptation to control place, to plot it, with a continuous sweep of the gaze.

The Haarlem landscapists were among the first Northern painters to constitute themselves selfconsciously as a school. Sixteenth-century Italian painters certainly formed regional allegiances, but this was new in the North. The Haarlemers were bound together neither by court nor formal academy, nor by a common master, nor by common patrons, but in a sense by the local landscape itself. Most of the outstanding figures were refugees from the war with the Spanish in the southern Netherlands. They shared both a painful experience of exodus, and the hope of a new beginning in a favoured land. Van Mander, in his life of Albert van Ouwater, even invented a pedigree for the Haarlem school in which landscape played a central part. After praising Ouwater's landscapes (see p. 45), he reported that 'one can also hear it said and asserted by the testimony of the oldest painters that it was Haarlem where the best and earliest manner of landscape painting originated at a remote period.'[115] And the French edition of Guicciardini's notes on Netherlandish painting, published in 1609, described a history painting by Dirk Bouts that in passing 'made a counterfeit from life' of 'the lovely environs of Haarlem ... together with the convent of the Regulars, the house of Cleef, the "Chien de terre", the forest called Aerden-Hout, and the hollow tree once celebrated in these parts, as well as the northern side of the great cemetery of Haarlem'. The painting, which must have been made around the middle of the fifteenth century, is lost.[116] What is most remarkable, again, is that the local landscape endowed the Haarlem school not merely with a sense of community or common purpose, and not merely with a common subject-matter, but also, more mysteriously, with a common style. It was as if the sober and unpretentious pictures of van de Velde and Molijn were literally smeared with the sand and gritty mud of the damp coastal lowland. By the same token, surplus and obfuscation, the attributes of thicket and grove, were all at once understood to characterize German painting itself. The German painting manifested an idea of German painting. This was especially true of the independent landscapes.

Dieter Koepplin connects this originary consciousness of a German painting style with the early enthusiasm among humanists and academicians for Lucas Cranach. Humanists encouraged a nascent German painting tradition at the very moment they chose to assert their own intellectual and political independence from Italy.[117] The unanticipated success of the Reformation, ironically, ended up dispersing much of the nationalist momentum; the confessional dispute and its endless political repercussions soaked up all the cultural energy of the Germans and preserved the territorial fragmentation of the nation for generations to come. But in the meantime, and most intensely in the two decades immediately preceding Luther's break with Rome, humanists sorely resented any assumptions of Italian cultural superiority. Conrad

Celtis evaded the fact of Roman imperial domination with a glamorous fable about Druids. Julius Caesar had described the old Celtic priestly class as primitive natural philosophers and spuriously connected them with the Greek inscriptions on ancient German monuments reported by Tacitus.[118] Celtis then imagined that the Druids, after Tiberius had driven them out of Gaul, took refuge in the Hercynian forest and brought religion to the Germans. With his friend Johannes Tolhopf, a canon at Regensburg, he inspected a ruined monastery in the Hercynian forest – actually the Fichtelgebirge, north of Regensburg – and described seven-foot statues of Druid priests.[119] The Druids were eventually converted to Christianity by the German emperors, and their monasteries – including St Emmeram in Regensburg – were given over to the Benedictines. Celtis related this story in his *Norimberga*, in the poem *Germania generalis* (the verse prelude to the planned *Germania illustrata*), and again in the *Amores* and the *Odes*. His pupil Aventinus, the historian, later reported that in conversation Celtis would frequently and vividly evoke the mysteries of the Greek-speaking Druids and their open-air cult.[120] Celtis found some thin corroboration of his theory in the fabulous genealogies of Berosus, the Chaldean chronicler invented by the forger Annius of Viterbo. Annius, for his part, resented the Greeks; his fictional compilation, published in 1498, proposed an alternative ancestry for Italian culture. Celtis simply turned Annius's weapons against the Italians. His oneiric prehistory of German culture stands alongside the pompous genealogies invented by Emperor Maximilian's court historians, and the hieroglyphic rebuses assembled by his wise men and artists (among them Dürer).

The humanists' relationship to the Roman legacy was of course more complicated than this. None of them, with the exception of the cavalier and satirist Ulrich von Hutten, was ready to renounce Latin. The rejuvenation of the vernacular tongue was carried out not by a humanist but a theologian: Martin Luther. Nevertheless, the humanists began to assemble a canon of medieval Latin authors united by their German origins and subject-matters. Celtis discovered in the library at St Emmeram – in 1493 he lived in Regensburg and served as rector of the cathedral school – the writings of Hrosvitha of Gandersheim, the tenth-century nun and poet; he published them with an enthusiastic introduction in 1501. Johannes Trithemius, the erudite Benedictine abbot and intimate of Celtis, published in 1494 the *Liber de scriptoribus ecclesiasticis*, an embryonic history of German literature.

Likewise, when it came to painting, most of the humanists would have agreed with Dürer's irritable assessment of the native tradition. In notes made in 1513 for a planned treatise, Dürer complained that 'in our German nation in these times there is a great deficiency in the true art of painting'. He elaborated on this judgement in the dedication of his *Four Books on Proportion*, published posthumously in 1528: 'It is clear that German painters are not unskilled with the hand and with the use of colours; but they have been lacking until now the art of measurement, as well as perspective and the like.'[121] Again, Dürer has painters such as Altdorfer in mind. And by publishing his system of measurement he was offering a practical antidote for the riven, intemperate, characteristically German picture surface. Yet Dürer's

strictures are mixed with pride. He was no mean fantasist himself, especially with the pen line. The humanists, despite or even because of the overwhelming presumption of German cultural inferiority, soon began to name and praise modern native painters in their patriotic pamphlets and histories. Dürer caught their attention, after all, even before he had emerged as a classicist and a theoretician of art. Jakob Wimpheling, in his *Epithoma rerum Germanicarum* of 1505, wrote of the fame of the engravers Israel van Meckenem and Martin Schongauer. Most outstanding, to be sure, was Albrecht Dürer, 'whose pictures are brought to Italy by merchants; there they are treasured as would be the pictures of Parrhasios and Apelles'.[122] Beatus Rhenanus, in his emendation to Pliny's *Natural History*, published in 1526, listed the great Germans of the day: Dürer in Nuremberg, Baldung in Strasbourg, Cranach in Saxony, and Holbein of Augsburg, now Basel, 'who painted Erasmus twice'.[123]

Did the humanists manage to rise above mere chauvinism and grasp the fundamental principles of a German painting? In fact they wrote almost nothing about style. The real testimonials to a newly self-confident German manner of painting are the works themselves. Bernhard Decker has constructed an elaborate case, almost entirely on internal evidence, for a thorough-going historical consciousness among German wood sculptors of the period. Carved altarpieces in the first decades of the sixteenth century, Decker argues, deliberately echoed the structure and iconography of German devotional images of the early fifteenth century. Many of these old cult images survived in local churches. Instead of replacing them with modern works, some parishes chose to incorporate them physically into new altarpieces. In other cases, sculptors preserved the old works in spirit by imitating archaic iconographies and even styles. The Master H.L. transposed the phrasing of thirteenth-century stone draperies into his own frenetic wood sculptures. And Hans Leinberger, the great Bavarian sculptor and exact contemporary of Altdorfer, mimicked in his carved Madonnas the spinal sway and the thick, swinging drapery folds of much older monuments. His *Madonna and Child* now in St Kassian in Regensburg, coarsened by layers of modern paint, referred back to the Beautiful Madonnas of the early fifteenth century (the *St Dorothy* woodcut was a graphic translation of such a figure: illus. 118, 107).[124] At the same time it invoked the ardent rhythms of mid-fourteenth-century architectural sculpture; a local example is the *Madonna and Child* in the choir of the Niedermünster in Regensburg (illus. 119).[125]

This case needs to be extended to painting. There is in fact ample evidence for close contact between Altdorfer and Leinberger. It appears that the painter Georg Lemberger, who worked in Altdorfer's shop for several years after 1513 and contributed to the *Triumphal Procession* miniatures, was Hans Leinberger's brother. In 1515 Altdorfer painted the wings for an altar in Scheuer for which Leinberger supplied the central carved Madonna.[126] In 1520 or 1521 Altdorfer designed a new altarpiece for the church of the Beautiful Maria in Regensburg, at the epicentre of the pilgrimage; the central sculpted image may very well have been the St Kassian Madonna.[127] Altdorfer demonstrated his own historical selfconsciousness in his partially modernized versions of an old local icon, a Byzantine Madonna of the *Hodegetria*

118 Hans Leinberger, *Madonna and Child*, c. 1520, limewood with modern paint layer, height 90. St Kassian, Regensburg.

119 German master, *Madonna and Child*, mid-14th century, Niedermünster, Regensburg.

type (illus. 120, 121). The icon, then and now enshrined in the Alte Kapelle, evidently served at least temporarily as the original focus of the pilgrimage.[128] In his colour woodcut, printed from five separate tone-blocks, Altdorfer scrupulously preserved iconographic elements from the archaic tradition: the star on the forehead, the tassled mantle, the raised hands of Child and Virgin.

That pilgrimage sprang from, among other sources, a profound popular impatience with the modern, unfocused cult of images. Churches had become crowded with panels and sculptures, many emblazoned with the arms of their ambitious patrons. Sober-minded churchmen like Erasmus were constantly lamenting profane margin-alia and brazen displays of skill which threatened to distract the worshipper. The simple and powerful contours of the early fifteenth-century image seemed to cut through this centrifugal profusion of detail. The sculpted Virgin and Child out-weighed all the teeming painted panels. In the eyes of layman and theologian alike, it seemed a relic of a simpler, more pious epoch – the times remembered by Zwingli's aged worshipper, who was nostalgic for a bare church wall. Hieronymus Emser agreed with Protestant iconoclasts that modern art had lost sight of its purpose. 'In former times,' he conceded in a pamphlet of 1522, 'as I have seen in many old monasteries and churches, they used to hang quite plain [*schlicht*] pictures'. The historically

120 German master(?), *Madonna and Child*, 13th century, tempera on panel.
Alte Kapelle, Regensburg.

conscious sculptor or painter was, in effect, heeding Emser's advice: 'It would be much better if we followed the ancients and had completely plain images in our churches.'[129] The learned theologians roundly mistrusted modern ostentation and technical prowess. Tilman Riemenschneider's revolutionary decision to leave his glowing limewood figures unpainted may have been rooted in such a principled distaste for colour.

Celtis shared some of this cultural pessimism: 'Now the times call us to follow the old footsteps of the fathers', he announced in the *Amores*. Celtis seized on the description by Tacitus of the ancient German songs as manifestations of a morally pure *simplicitas*. But Celtis would never have elevated the rude style, however virtuous, into a general aesthetic principle. Simplicity unleavened by Latin was mere barbarism.[130]

Dürer, especially later in his career, is said to have achieved a simple style. This is misleading, for the model for Dürer's simplicity was not the plain manner of older images, but rather the vigour and lucidity of the new theological prose, of Luther's German. Philipp Melanchthon in a text of 1531, we recall, transferred to painting the old rhetorical schema, the *rota virgiliana*, and distinguished three levels of style: high (Dürer), middle (Grünewald), and low (Cranach; see p. 76 above). A decade later he refined this observation. Dürer's style was lofty *because* it was plain: late in his career, Dürer himself had told the reformer that he had renounced his erstwhile tastes for 'bright and florid pictures' and 'extraordinary and unusual designs'. Instead

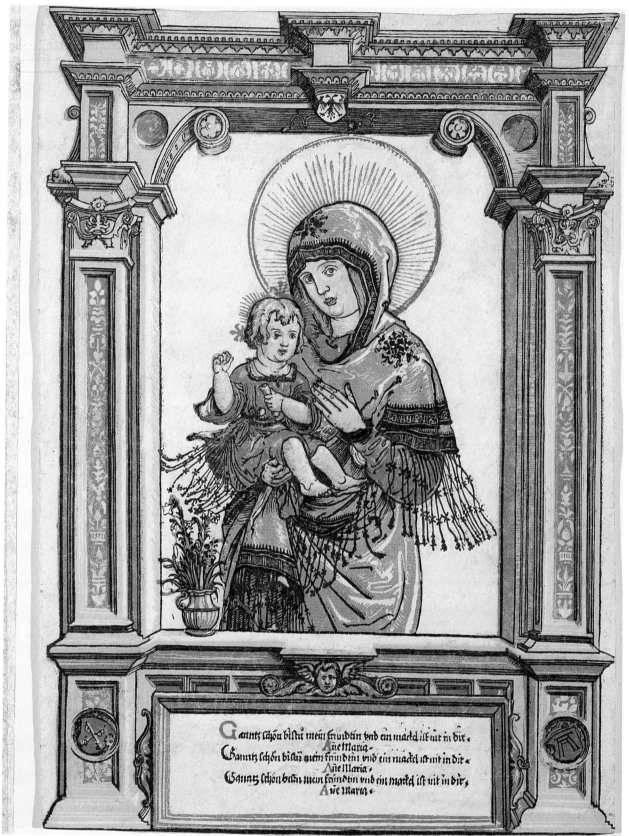

121 Albrecht Altdorfer, *Schöne Maria of Regensburg, c.* 1519–20, woodcut with five tone-blocks, 34 X 24.5.
National Gallery of Art, Washington D C.

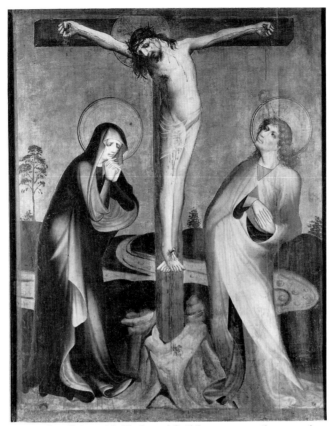

122 Bavarian master, *Crucifixion with Virgin and St John*, c. 1400, oil on panel, 177.5 x 136.5.
Bayerisches Nationalmuseum, Munich.

he came to understand that 'simplicity and sobriety are themselves the highest orna-
ment of art'.[131] Dürer's late simplicity, exemplified by the *Four Apostles*, is clean-lined,
clear-voiced, at worst ponderous. The truly plain image in Dürer's *œuvre* is not hard
to find: Dürer himself described some of his earlier prints as 'schlechtes Holzwerk':
slight or plain woodcuts.[132] The *St Francis* that Altdorfer emulated in his 1507 panel
belongs to this group (illus. 57). The 'schlechtes Holzwerk' were smaller and a little
less polished than other single-leaf woodcuts by Dürer. But he did not necessarily
consider them substandard or perfunctory; nor were they necessarily aimed at a
popular audience, as some have supposed, for the *St Francis* has a Latin inscription.
Plainness had an aura of its own.

The exemplars of the plain style belonged to the older history of German painting:
for instance the impassive, gaunt, blunt *Crucifixion* from the Augustinian church in
Munich, now in the Bavarian National Museum, from around 1400 (illus. 122).[133]
Such a picture linked the modern beholder with the gloom and fervour of fourteenth-
century Bohemian painting. Grünewald must have been looking at paintings like this
one. Altdorfer, too, in his Kassel *Crucifixion*, recreated the severe mood of a century-
old painting (illus. 11). He painted another *Crucifixion*, now in Budapest, on an archaic
gold ground, imitating the powerful, crowded Crucifixions of the mid-fifteenth
century.[134]

Altdorfer was no ingenuous provincial. His *simplicitas* was deliberate. Moreover,

it had its limits. Altdorfer was partial to the charms and mysteries of modern Italian ornament and style, which he knew from engravings. Like the literary humanists, he was unwilling to renounce the Mediterranean entirely. Even in the Kassel and Budapest Crucifixions, Altdorfer borrowed postures and gestures from Mantegna. But his bluff, frank *alla prima* painting technique – the pyramidal layering of opaque pigments – carried connotations of sincerity and lack of pretence. His pictures looked handmade, homespun, guileless.

The simple and pious style was essentially a *familiar* style. It called to mind old and long-neglected works. One imagines the German painter pursuing both archaic piety and the native traditions of foliate ornament and mannered line without contradiction. In the old Madonnas, repetitions of looping drapery folds had generated an otherworldly, untouchable aura (illus. 107). The vine and the branch had encircled and celebrated the German Virgin. The archaicizing German work likewise cultivated the uncultivated order of growth. Celtis's primeval life of simplicity, after all, sketched out in the *Amores* (II, 9), was life according to the laws of nature. Foliage was natural ornament. Altdorfer replenished the leafy tendrils of the fifteenth-century branch, teased them out, twisted them back upon themselves. The old forest was endlessly increased and multiplied, every linear idea carried vigorously to its illogical conclusion.

Neither the box-like perspectival construct nor the Albertian rhetorical theory of narrative was permitted to intervene and make order out of all this. The forest was disclosed in disorderly pictures simultaneously as the emblem of Germanness, as the source of the stylistic principles of German painting, and as the ideal vehicle for those principles. The folded, crinkled, self-similar forest became a motif unto itself, extracted from old images and converted into a stylistic 'hieroglyph' or formula. In sculpture, at least – and this insight we owe to Bernhard Decker – such formulas revived an earlier moment in the history of the cult image, and at the same time symbolized a new sense of distance from that moment.

Outdoor worship

Altdorfer's landscape paintings invaded the home territory of the devotional panel. The modern and portable sacred image – Altdorfer's own small panels of 1507 and 1510 are good examples – combined elements of both portrait and narrative. In the High Middle Ages, under the influence of popular hagiographical literature and devotional poetry, the sacred portrait, the icon, was set in motion. The emblematic attributes of the holy figure were elaborated into a setting. The sacred portrait came to resemble a scene, a narrated incident. Such images merged the rhetoric of the icon – a dialogue between portrayed and beholder – with the temporal structure of the single-scene narrative, a relatively brief segment of time held together by the visible actions and reactions of a central figure or figures.

Altdorfer's painted landscapes, vertical in format, have more in common with these devotional panels than with topographical drawings from the workshop model-book.

The sacred image provided the landscapes with a compositional template: low horizon, compressed and ill-defined middle-ground, foreground immediately continuous with the beholder's world. Such a setting was designed to fit around a dominant central figure. The emptiness of Altdorfer's landscapes is thus laden with significance; space now looks like the place where something is about to happen, or – as in the *Dead Pyramus* – where something has just happened. The landscape retains the ghost of a human presence, and a temporal dimension, even after it has been evacuated. This affiliation with the main tradition of the Christian sacred image fundamentally distinguishes Altdorfer's independent landscape from the profane decorative landscape.

The landscape painting echoes an object of devotion. It also represents a place of worship. John the Baptist, Christ, Mary Magdalene, St Anthony and St Jerome all at one point or another turned their backs on civilization. Christian *contemptus mundi* had elevated wilderness into a haven long before the German humanists had found Tacitus. But now the sinewy hermits had been extracted from their groves and caves. The empty landscape turned every beholder into a potential wilderness worshipper.

Churches in the backgrounds of pictures often served as metonymies for sociable religion or even for human society in general. The church on the horizon of a representation of St Jerome in the Wilderness – for example, in Dürer's engraving of around 1496 (illus. 83) – stands for the community temporarily abandoned by the hermit. The church in the background of Bruegel's *Blind Leading the Blind* in Naples completes the parable: the sightless parade stumbles away from the church. The isolated church in the forest landscapes of Altdorfer and Huber is more ambiguous. The church in Altdorfer's lost landscape watercolour from the Koenigs collection (illus. 101) is the safe house at the edge of the wilderness, the refuge from the spiritual terrors of the forest. Wolf Huber planted a chapel at the centre of one of his pen-and-ink landscapes, with a footpath leading to its door (illus. 123).[135] These are churches *of* the wilderness, not against it. Altdorfer's Koenigs landscape proposes a plain analogy between the comportment of a celebrant inside the fortified church and a beholder on the outside, either the implied beholder of the scene itself or the actual beholder of the picture. The sun is rising in the east, directly behind the apse. These pictures literally show the path to the church.

But there is plenty to look at alongside that path. Wilderness here is not simply the negative image of civilization, a setting hospitable only to the most chaste and otherworldly impulses. The luminous, precarious tranquillity of the forest makes a positive contribution to piety. The forest and the chapel are not antitheses, but extensions of one another. The sacred space is supplemented by natural ornament. The church itself is bare and sober, like the ideal mountain chapel imagined by Angelus Rumpler, a Benedictine abbot and follower of Celtis, in 1505. 'The older buildings have things more by necessity than as ornament', Rumpler observed; but now churches are 'ornate and embellished to such an extent that they offer more occasion to look around than to pray'. The modern church was overgrown: 'I do not reprehend the deserved ornament, but rather the superfluous.'[136] Excess could now spill out of the door and back into the forest.

123 Wolf Huber, *Landscape with Church*, c. 1518–20, pen on paper, 21.2 × 15.5.
Kupferstichkabinett, Staatliche Kunstsammlungen Dresden.

The new complementarity of forest and worship resonated in contemporary German culture in two ways. Sophisticated literary humanists and conscientious clerics alike, impatient with Rome, were revealing deeper streaks of anti-ecclesiastical rancour. The same humanists, meanwhile, took an antiquarian and nationalist interest in the wood-land cults of the ancient Germans, an ancestry that spiritually liberated them from Rome. It is no anachronism to associate the early sixteenth-century humanists with the German Reformation. Luther had ties with literary humanists at the University of Erfurt before he moved to Wittenberg. His teachings found an attentive early audience in the elite circle of Pirckheimer and Dürer in Nuremberg, which gathered around Luther's Augustinian mentor Staupitz.[137] The concept of ecclesiastical independence from Rome predated the Reformation. (Of course when they discovered that Luther himself was concerned pretty exclusively with saving souls, many literary humanists, including Pirckheimer, lost interest.) Celtis died in 1508, nine years before Luther's challenge to Rome. The poet registered his dissatisfaction with conventional religiosity by adopting the voice of a pagan. Celtis's fashionably Horatian ode 'Ad Sepulum disidaemonem' explicitly associated proximity to the *physis* with worship:

> God is within us, it is not necessary to gaze at divinities in painted churches.
> You wonder that I eagerly seek open waters and the warming sun?
> Here the great image of omnipotent Jupiter comes over me; here are the
> highest temples of the deity.

178

> The forest pleases the muses, the city with its unhealthy crowd is
> inimical to poets.[138]

Celtis was audaciously and half-seriously echoing what some radical Protestant con-
troversialists and sectarians – English Lollards and Bohemian Hussites – had said a
century earlier: ignore the clergy and the images and instead worship outdoors.[139]
Some of the early Protestant hostility to images apparently survived among the
Waldenses, the durable and mysterious Alpine heretics. Aeneas Silvius in his history
of Bohemia reported that the Hussites, after leaving the Church, 'embraced the
impious and fanatical sect of the Waldenses'. Among the doctrines of these heretics
he numbered the abolition of images of God and the saints.[140] Later in the sixteenth
century, and especially in the Netherlands, outlawed Protestants took to outdoor
sermonizing, or hedge-preaching. Their indifference to altar and architecture was
associated with the iconography of John the Baptist, who preached repentance on
the banks of the Jordan (illus. 138).[141]

Outdoor worship, then, was supposed to be an antidote to Pharisaical idolatry. But
orthodoxy saw things differently. If the one God were not anchored in a physical
image, the worshipper's attention would scatter and disperse, to every corner of the
physis. Some radical Reformers did indeed speak of a kind of natural theophany. But
the pantheistic streak in Protestantism had its roots in high medieval mysticism, and
in the notion of an infinite and ubiquitous God. More worrisome was the shadow of
true animism – the fragmentation of divinity and its illegitimate localization in natural
objects. Unfocused piety inevitably degenerated into heathen animism: many gods
residing in many objects, the one God nowhere. Cultures close to the forest were
automatically suspect. Biblical injunctions, or at least their modern translations,
explicitly associated the idolatry of the Gentiles with the shaded place: 'Ye shall
destroy their altars, and break down their images, and cut down their groves, and
burn their graven images with fire' (Deuteronomy 7:5). The aura of the outdoor
idol contaminated its surroundings. Virgil, too, had evoked the numinous fear, the
presentiment of the proximity of divinity, that hung about the bough. And the earliest
reports from the New World appeared to demonstrate conclusively the alliance
between wilderness and idolatry. The chronicler Peter Martyr, in his *De orbe novo* of
1530, described the totems and talismans of the people of Hispaniola: 'Some are
made of wood, because it is amongst the trees and in the darkness of night they have
received the message of the gods. Others, who have heard the voice among the rocks,
make their *zemes* of stone.' Peter then explicated the exotic practices for the benefit
of his patron and addressee, Emperor Charles V: 'It was thus that the ancients
believed that the dryads, hamadryads, satyrs, pans, nereids, watched over the foun-
tains, forests, and seas, attributing to each force in nature a presiding divinity.' Pagan
idolatry, surviving as it were in a time capsule, was the child of nature. 'You thought
that that ancient superstition had perished', Peter concluded, 'but you see that such
is not the case'.[142]

Aeneas Silvius, several generations earlier, had accused the ancient German tribes
of exactly this error: 'Earlier you lived in deepest darkness, ignorant of true belief,

idolaters without hope of salvation.' Aeneas actually contrasted the Germans with the Gauls, who according to Caesar had at least a priestly caste, the Druids, who conducted services and sacrifices. The Germans, on the other hand, 'only consider as gods that which they see and which benefits them: sun, fire, moon'. This was reason enough, Aeneas Silvius argued, to be grateful to the Roman church.[143] It is true that not even Celtis was prepared to embrace polytheism. His outdoor ode insists on a single, omnipresent Jupiter. And he solved the priestly problem, as we have seen, by inventing a Druid tradition east of the Rhine.

Wilderness, empty of altar and cleric, is thus the potential sanctuary of a devotional practice unharassed by multiple painted divinities or artificial ornament. Yet the suspicion of idolatry lingers. Once the idol is banished, the attention of the worshipper is liberated; but that attention is now free to wander and find a new focal point. Innocence is licence.

The image of the forest repeats this paradox. In the course of the Reformation, landscape painting won a special reputation for doctrinal probity. Because the picture was empty of figures, it supposedly could not itself become an idol. Landscape, purged of the intimidating presence of the human figure, provided an asylum for the beholder's delight in pictorial effects. An English miniaturist of the mid-seventeenth century, Edward Norgate, condoned landscape as a 'harmless and honest Recreation, of all kinds of painting the most innocent, and which the Divill him selfe could never accuse of Idolatry'.[144] But the landscape picture frames the forest, and embraces it within the field – the vertical panel – that was once reserved for sacred portraiture. Wilderness for the beholder is no mere setting: the structure of the picture converts it into an object. The early German landscape represents distractions threatening to become attractions. Just as the humanists overturned the instinctive hostility toward the wilderness, the painted landscape encouraged a paradoxical taste for the image of wilderness, the image of excess, disorder, living ornament. This overlapping of two pieties – towards the religious and the aesthetic object – undermined the innocence of landscape. In Celtis's ode, after all, *silva placet musis*.

Altdorfer explicitly raised the *possibility* of an instability within the landscape in the *Landscape with Woodcutter* in Berlin (illus. 1). This most beautiful and enigmatic of all Altdorfer's landscapes is a pen drawing overlaid with cool mineral blue, dark-green and brown washes and white and green heightening. Its dimensions (201 x 136 mm) are within millimetres of both the Rotterdam and the Erlangen landscapes. There is no way of knowing whether the black border, which is similar to the border around the Erlangen landscape, was drawn by Altdorfer or by a later owner. Apart from a group of early coloured-ground drawings, the only other works with such a border are the group of watercoloured etchings in the Albertina and two etchings in other collections (see pp. 77–8 and 260). The autograph monogram appears on the trunk of the tree at two-thirds height; there is no trace of a date.

Here the conventional framing tree has shifted to dead centre. The path that used to link foreground and middle-ground has instead wrapped around the tree, clearing a broad circular swath in the foreground. Axial symmetry is an unusual way to build

 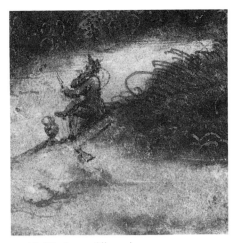

124, 125 Details from *Landscape with Woodcutter* (illus. 1).

a landscape; it would have little future as a compositional formula. The picture looks more like one of the fantastic tree studies by followers of Altdorfer that were discussed in chapter Two.

There is a potential audience for this tree already within the picture. At the base, sitting perhaps on a protruding root, is a woodcutter. He has laid his axe aside and crossed his legs; a jug rests before him. In his left hand he wields a knife; his right hand, presumably holding bread, is raised to his mouth. Who is the woodcutter? He is the archetypal forest dweller; he approaches settlements but he does not belong to them. He is the equivalent of the shepherd who appears in the rural settings of Netherlandish painting, and also to some extent of the wayfarer. Both shepherd and wayfarer resonate within Christian iconography, more so than the woodcutter. The woodcutter had only a modest position in medieval calendar cycles. He appeared more frequently in tapestries, sometimes gathering firewood in groups, sometimes together with shepherds.[145] The peasant, rooted to the soil, mistrusted the mobile and canny shepherd who understood weather and the healing arts. The shepherd was adept at woodcarving. He could not always attend church and needed to fashion his own cult images.[146]

Like many shepherds in German and Netherlandish paintings, this woodcutter is paired with a wayside shrine. Wilderness hermits were often depicted praying to sculpted crucifixes or even painted panels. But for most rural Christians the forest shrine had no such exotic connotations. Gabled boxes of this sort, usually containing Crucifixes, were commonly fastened to posts alongside roads and paths. They were ephemeral versions of the stone *Wegsäulen* (road-columns) or *Bildstöcke* (image-posts) which sprang up all over Germany in the fourteenth and fifteenth centuries and which still survive in some numbers.[147] But most shrines were ephemeral. In April 1519 the city of Regensburg paid the painter Jörg Mack for a Madonna supported on a post outside the chapel of the Schöne Maria.[148] A still more primitive version of the *Bildstock* was the image hung from a branch or wedged into the hollow of a tree-trunk. The *Bildbaum*, or image-tree, was usually a representative of an uncommon species, or a tree marked by some freakish trait, or simply an isolated or

126 Jörg Breu the elder, *St Bernard in a Cornfield*, 1500, oil on panel, 70 x 73.
Cistercian Abbey, Zwettl, Austria.

conspicuous tree. Altdorfer's picture may well have depicted a real tree, much like the old *Bildbaum* in a forest clearing near Würzburg where modern pilgrims still stop for lunch.[149] The picture makes it look like an ancient site: the shrine has evidently been growing skyward with the tree.

The shrine and its image served as a focus for prayer, a way-station on a pilgrimage route, or a votive or expiatory memorial to a miracle or a murder. The wayside shrine or the *Bildbaum* was a minimal chapel. In the harvest scene in Jörg Breu the elder's *Legend of St Bernard* altarpiece at Zwettl in Lower Austria, dated 1500, St Bernard kneels and prays toward a *Bildstock* in the upper-right of the panel, alongside a path and near a tree (illus. 126).[150] Breu may also have painted the votive panel of 1497 at Herzogenburg, with the view of Passau in the background, where the patron Georg Eisner kneels before a wayside shrine.[151] But the shrines addressed especially the rootless and the remote. They were reminders to Christians to maintain ties with the Church. Through such shrines the Church maintained its grip on a dispersed population. In some fifteenth-century pictures, they are simply a sign for the rural, for distance from civilization. They appear in backgrounds as arbitrary attributes of

127 Urs Graf, *Banner Carrier and Bildstock*, 1516, pen on paper, 31.6 x 21.7. Kupferstichkabinett, Öffentliche Kunstsammlung Basel.
128 Hieronymus Bosch, *Vagabond*, outside wings of the *Haywain Triptych*, *c.* 1490–95, oil on panel, 135 x 100. Museo del Prado, Madrid.

shepherds or wayfarers, for instance in an *Annunciation to Joachim* in a Bavarian altarpiece of the 1480s, at the heart of a vast valley landscape;[152] or in the drypoint *Stag Hunt* by the Housebook Master.[153] The *Bildstock* is the attribute of wilderness in one of Jörg Kölderer's *Fortifications* watercolours (illus. 143). In other pictures, the *Bildstock* appears just outside the gates of cities, for example in the woodcut views of Nuremberg (fol. 99v–100r) and Erfurt (fol. 155v–156r, here coupled with a low cross, just as in the Housebook Master's print) in the Nuremberg Chronicle of 1493. In his Rotterdam watercolour of a lime tree, Dürer included a *Bildstock* attached to a stone rampart (illus. 151). In still other pictures, the wayside shrine marks a spiritual path, the true path. In one of the woodcut illustrations to Sebastian Brant's satirical *Ship of Fools* of 1494, the shrine literally points out the road; the traveller– fool ignores its precept at his peril.[154] *Bildstöcke* were in fact frequently placed at crossroads. The Swiss artist Urs Graf in 1516 drew a swashbuckling *lansquenet* blithely ignoring a wayside shrine carved into a post (illus. 127).[155] Graf, who later sympathized with the Lutherans, ridicules the shrine with its hopeful horseshoes. The vagabond on the outside wings of Bosch's *Haywain Triptych* in Madrid, mean- while, passes a shepherd who plays the bagpipe beneath a tree-shrine, his staff propped on the prayer-rail (illus. 128). The pedlar in Holbein's woodcut from the *Dance of Death* (1538) points out his own path, by-passing a *Bildstock* in the back- ground, just as he is apprehended by Death. Finally, in Pieter Bruegel's *Haymaking* in Prague, the *Bildstock* alongside the path of the three foreground girls already has the character of a historical reference to earlier Netherlandish painting.

Some contemporaries feared that wayside shrines would encourage idolatry. The

183

Church ran a certain risk in extending itself to these diminutive unmanned outposts where worship could proceed unsupervised. Luther's objections are implied in his strictures against 'wilden Capellen und Feltkirchen' ('wild chapels and field-churches'). In particular, he was concerned about the hastily assembled pilgrimage chapels: 'Let each remain in his own parish church', he wrote in his pamphlet *An den christlichen Adel deutscher Nation* of 1520.[156] Huldreich Zwingli, the Swiss reformer and iconoclast, explicitly disapproved. A cantonal clerk, Valentin Compar, had written on behalf of wayside shrines:

A Christian walks across the countryside. He finds en route the Passion of Christ, once, twice, three times or more, in the *Bildstöcke* along the road; and just so many times he renders homage to the sufferings of Christ with his body by bowing down and removing his hat. . . . If however he found no image [*Bildnis*, literally portrait] en route, he would no longer think about God or his saints.

Zwingli responded in a pamphlet of 1525: 'A man does right, true, brave, steady honour to God when he carries Him around with him in his heart; God is wherever he wanders, even if he sees no idol-post [*götzenstock*] at all.'[157] In Zurich in 1524, a zealous iconoclast under Zwingli's spell publicly burned a *Feldkreuz*.[158] The erection of *Bildstöcke* in the Protestant territories was discontinued and no doubt many shrines were destroyed.

 The *Bildstöcke* reminded reformers of pagan idols. In sixteenth-century Netherlandish paintings such shrines often house Antique statues. In a *Flight into Egypt* by Lucas Gassel, dated 1542, the falling idol customary in representations of this episode is housed in a shrine on a tree.[159] Another pagan tree-shrine appears in a *Flight into Egypt* after the Brunswick Monogrammist.[160] In a *Landscape with Shepherds* by a follower of Patenir, a gabled shrine attached to a tree emits a cluster of rays.[161] The contents of the shrine are invisible to the beholder. A shepherd kneels before the shrine on a low rail placed there for that purpose. A second shepherd looks at the first and gestures toward the shrine. If the procession in the middle-ground represents the progress of the Magi toward Bethlehem, then these are the shepherds who received an Annunciation of the Birth. Yet there is no star or angel. Perhaps the Annunciation has taken the form of an image-miracle: the idol who occupied the shrine metamorphosed into a Christian image or otherwise gave a sign that a new order was at a hand.

 Altdorfer does not reveal whether his tree-shrine contains a false idol or a true god. The gabled box is turned away from the beholder. It recalls the new Crucifixions rotated 90 degrees in space, like the Crucifixion drawing signed I.S., after a design by Wolf Huber (illus. 129).[162] Altdorfer and Huber both made versions of this composition. The Crucifix viewed from the side was emphatically an anti-idol. It disrupted any unselfconscious participation in Christ's suffering, and instead presented the sacrifice as a mere event. The beholder is pushed back to the status of onlooker and granted the freedom and space to make a decision about possible involvement. In the Berlin landscape this displacement and estrangement of subject-matter is carried even further. The potential idol is now shrunken and invisible. Even the woodcutter

129 Master I.S., *Crucifixion*, 1511, pen and grey wash on paper,
21.9 x 15.5. Kupferstichkabinett, Berlin.

ignores the shrine. The shrine itself is so ambiguous that the woodsman's indiffer-
ence, his attention to his appetite, carries none of the moralizing charge of, for
example, the dissolute bagpiper's neglect of the Crucifix in Bosch's *Wayfarer* (illus.
128).

The real focal point of the picture – the potential idol – is the anthropomorphic
tree itself. The tree is a wooden figure, its material substance registering, like the
Caribbean talismans described by Peter Martyr, the topographical locus of belief.
The woodcutter, with axe at his side, is the notional maker of the idol; he initiates
the process that converts a raw tree into a statue. The woodcutter is the double of
the artist. Idolatry itself is not depicted within the picture. Instead the picture
tempts the beholder outside the picture with an idol. And only now, paradoxically,
does the woodsman also enter into an analogy with the beholder of the picture. His
moment of rest and refreshment overlaps with the beholder's moment of inspection
and contemplation. Pleasure – stasis, a satisfaction of appetite – has momentarily
drowned out the claims of work and of storytelling. In this picture all animate move-
ment has ceased. The path that once bridged foreground and middle-ground in
the independent landscape, implying an oblique movement and sustaining a ghostly
narrative vector, has looped back upon itself and surrounded the tree. This is not
the linear movement of the wayfarer, but the circular dance of the celebrant. But
there is no celebrant here. Instead, all the potential energy in the picture has spiralled
into the tree itself; the tree has absorbed that energy and has itself begun to sway.
The only implied movement in the picture is the swing of the trunk and the boughs.
The dance of the tree is restricted; it can only rise up beyond the upper edge of the

130 German master, *Crucifixion*, first half of 14th century, from the south
portal tympanum of Regensburg Cathedral.

picture, like a towering totem connecting earth and sky. The tree is thus both a deity
and its own celebrant.

The tree is also an immediately recognizable historical hieroglyph. There is no
danger of over-interpreting the great lurching sway in the lower third of the tree.
The bend in the trunk is simply too unnatural. It bends at the knees like an old
Bavarian sculpted Crucifix, indeed like the crucified in the early fourteenth-century
high relief above the south portal of the cathedral in Regensburg (illus. 130).[163] The
tree is a living Crucifix, even to the outstretched arms. If the shrine contains a
Crucifix, as most did, then the Crucifix duplicates itself. The Crucifix appears at
once inside and outside the shrine, in an artificial and a natural image. Under the
umbrella of the tradition of the *Arbor vitae*, and particularly in Reformation iconogra-
phy, any tree may stand for the Cross. In a miniature from the Lutheran Prayer Book
of Johann of Saxony, for example, by a follower of Cranach, a supplicant falls before
a sorrowful Christ seated at the base of a tree which is meant to be confused with
the Cross (illus. 131).[164] In the bipartite allegory known as *Law and Gospel*, or *Dam-
nation and Salvation*, invented by Cranach in 1529 and widely disseminated in wood-
cuts and books, the central tree stands in multiple analogy to the Tree of Paradise,
Moses' Brazen Serpent on the Pole, and the Crucifix.[165] Altdorfer's brother Erhard
designed his own version of the allegory for the woodcut title-page of the Low
German Bible published in Lübeck in 1531–4 (illus. 132).

Altdorfer has exposed his tree to idolatry simply by clearing a space around it.
The tree that stands alone was traditionally associated with centripetal worship and,
by extension, idolatry. The early Protestants who shunned churches for the open air

131 Follower of Lucas Cranach, *Man of Sorrows Beneath a Tree, c.* 1525–30,
miniature in a Lutheran Prayer Book of Johann of Saxony, 19.5 × 15.5.
Fürstlich Fürstenbergische Hofbibliothek, Donaueschingen.

risked association with this practice. The Church in northern Europe had to
suppress heathen tree-worship. Between the seventh and the twelfth centuries,
princes and clerics were constantly cutting down *lucos et arbores gentiles*, 'pagan groves
and trees'.[166] The original iconoclastic woodsman was no less than the Benedictine
missionary St Boniface, the Apostle of Germany, who in 724 felled a 'Jupiter' oak
in Geismar. Centripetal rituals such as maypole dances are pagan in origin and were
never absorbed by the Church. Lime trees or lindens, in particular, were the focuses
of festive dancing. Andreas Karlstadt, Luther's radical deputy in Wittenberg, actually
translated *lucos* or 'grove' in Deuteronomy 7:5 as 'lime tree'.[167] Roman colonists
had left hundreds of free-standing statues and monoliths, above all the Jupiter-
columns, of which many survive. Few late medieval or early Renaissance sculpted
figures stood in open spaces. Those that did usually served civic and commemorative
purposes or, in Italy, represented pagan or heroic subjects (including, to be sure,
Old Testament heroes); some were even refurbished and remounted pagan statues.[168]
The first monumental Virgin mounted on an outdoor column was in fact the stone
Virgin erected before the chapel of the Schöne Maria in Regensburg in 1519.[169]
That Virgin, which dominates the woodcut view of the pilgrimage site published by
Altdorfer's pupil Ostendorfer (illus. 133), was duly attacked as an idol by reformers
and other critics of the pilgrimage, including Luther and Dürer. What they objected
to was precisely the open space around the statue.[170]

In other ways the tree in Altdorfer's picture resembles a Virgin more than a
Crucifix. The sway in the trunk evokes the contours of the Schöne Madonna, the
nubile limestone cult figure of the early fifteenth century. Altdorfer's generation, we

132 Erhard Altdorfer, Title-page woodcut from Low German Bible, published in Lübeck in 1533, size of page *c.* 31 × 23. Houghton Library, Harvard University, Cambridge, Mass.

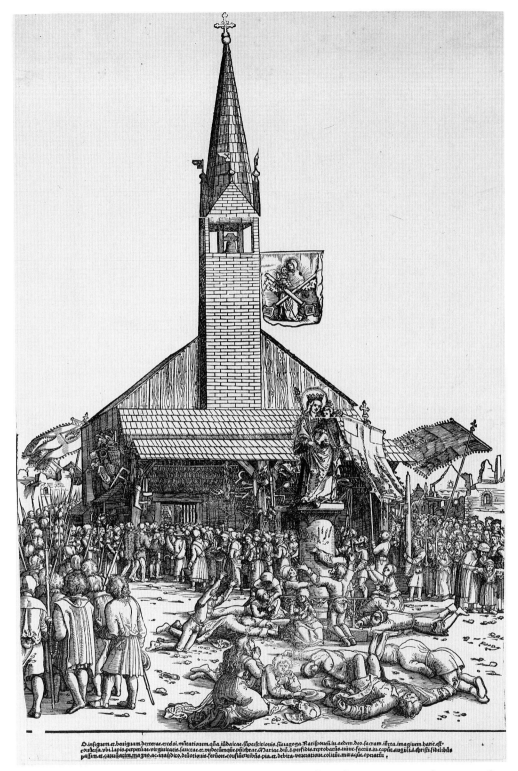

133 Michael Ostendorfer, *Pilgrimage to the Schöne Maria in Regensburg, c.* 1520, woodcut, 55 × 38. Kupferstichkabinett, Berlin.

saw earlier, deliberately turned to much older sculptures and paintings in search of fresh forms. They associated the serpentine and moody rhythms of the fourteenth and early fifteenth centuries with the imagined intensity of piety of a remote epoch. The standing Madonnas in particular, with their S-shaped spines and lush festoons of drapery, achieved an ideal overlap of sensuality and religious feeling (illus. 107, 119). Indeed, Altdorfer's tree is an image of the Schöne Madonna, with Christ – the shrine – slung on her hip, her drapery sagging and rising like the boughs of a tree.

The projection of the Madonna onto this tree is the natural consequence of the deliberate denaturalization of the tree, the bizarre swelling at the base, the violent lurch of the trunk, above all the colossal scale. If the woodcutter stands five feet tall, then there are at least fifty feet of tree *within* the picture. Yet this trunk is barely beginning to taper when it leaves the picture. We must be seeing only half its height. This tree is twice the height of the twin trees in the Erlangen landscape. The shrine, itself four-and-a-half feet tall, hangs a good twenty-five feet above the ground.

Even the monogram signals that the drawing is a fiction. This looks at first like one of those occasional monograms in Altdorfer's work that is naturalistically motivated or justified within the representation. Most signatures and dates since the Renaissance, in paintings, drawings and prints, float on the surface of the work. They are not meant to be confused with those other marks on the surface that represent 'things', even though they may resemble, or share the medium and even the ductus of, the representational marks. The signature fails to interfere ontologically with the representation. The modern signature in this respect is not fundamentally distinct from the fifteenth-century signature that appears on the frame of a painting. At the start of the sixteenth century, however, some German signatures began to be justified within the representation. Dürer introduced the practice by inscribing his monogram, in some of his engravings and woodcuts, on slips of paper or hanging tablets. But he never did this on drawings, except on preparatory studies for prints and a handful of drawings on coloured ground.[171] Altdorfer also justified his monogram in several early coloured-ground drawings and painted panels. In the *Samson and Delilah* and the *Witches' Sabbath* the monograms are carved on stone blocks in the lower corners; in the *Pax and Minerva* the monogram is written on a wooden tablet.[172] In the Bremen *Nativity*, a panel of 1507, the monogram and date appear on a slip of paper pinned to a ladder. Later, in the *Susanna and the Elders* and the Berlin *Landscape with Woodcutter*, the monograms are inscribed on tree-trunks, as if carved into the bark, just as in the *St Francis* and *St Jerome* panels of 1507 (illus. 48 and 49), or the *St George* of 1510 (illus. 95).

But in the Berlin landscape the internal justification of the signature collapses. The monogram is too high to have been plausibly carved into the bark, even if the growth of the tree is taken into account. In the Berlin landscape the monogram on the tree-trunk serves exactly the opposite purpose that it had served earlier. Instead of masking the status of the picture as a made object, it calls attention to it.

Within and around the fictional tree a drama is played out, an antagonism between line and colour on one side and substance on the other. Substance or mass is also

the correlative of subject-matter, for narratives in painting are embodied in bodies. Here, line and colour have ousted all the human figures, except for one minuscule puppet, and therefore all possible stories and subjects. But they have also laid siege to the tree itself. For all its height this tree is highly vulnerable. In sculpture, this drama of embattled substance manifests itself as the erosive action of space against mass. The Schöne Madonna sways because space is pushing at her, scooping away her substance; the physical vulnerability of the Schöne Madonna was part of the appeal. In two dimensions, line and colour become antagonists of substance. This was apparent in Altdorfer's *Dead Pyramus*, where a rampant pen line exercising both descriptive and performative powers, together with spectral heightening, reduced physical mass to ineffectuality (illus. 42).

How is this manifested in the Berlin landscape? Line is a dominant force; the picture leans back toward drawing, away from painting. Even under layers of colour the brown pen line makes its presence felt. The tremulous profiles of mountain and rooftop and the spontaneity of slashing, looping grass are as fresh as they are in the early drawings and in the *Historia* illustrations. The buildings in the background lean and quiver as if they were protoplasm; line prevails over mass. The profile of the mountain is puffy, not crisp. Lines in this drawing win an ontological independence from the objects they describe. They enter into an adversarial relationship with substance. The line, emancipated from the burden of illusionism, can appear to mock the body. A wave of lashing grass, monstrous in scale, rises behind the seated woodcutter. Line has the effect of thinning out substances, of draining them of mass. The tree's foliage is combed thin by rows of limp, hanging lines. The tree trunk and the buildings are overlaid with ladders of white heightening. Fine streaks of white and pink adulterate the blue of the mountains. Even the blue sky near the horizon is brightened and flattened by furrows of white.

Colour is not necessarily a victim of this erosive procedure. When colour allies itself directly with line, in the metallic green heightening in the foliage, then it too interferes with the presence of bodies. This uncanny green, just as in the Rotterdam landscape, rises off the surface; on long inspection the green begins to dominate the experience of the drawing.

Altdorfer's will to self-presentation in line manifested itself in pitched battles between space and body, energy and matter. In his work the body recoils from its surrounding space as if in pain; and yet the resulting contortions re-emerge as formulas of beauty. This is the figural drama in paintings such as the *Christ Taking Leave of His Mother* (illus. 13)[173] or the panels of the St Florian altarpiece, for instance the *Entombment* now in Vienna.[174] In these paintings much of the conflict is played out in drapery, and this follows a tradition in German art of exploiting drapery for formal purposes. Drapery could assume so many guises without violating credibility; drapery could generate energy but also absorb it. Earlier an analogy was proposed between drapery, the accessory to the represented body, and the flamboyant pen line, the accessory of the artist. Once this notion of style as a garment is accepted, it becomes easier to see how the gaunt and hollowed-out clutch of drapery became

identified with Altdorfer. It becomes possible to see the tree of the Berlin landscape both as a declaration of style, and as the figure of a densely draped Madonna. The entire picture collapses in on itself like a complexly gathered and fastened garment.

The picture really is *only* drapery, since this Madonna is decapitated. The border of the Berlin landscape cuts the tree off at the shoulders, and thus exercises a framing prerogative that painting enjoys and sculpture does not. The power of the frame symbolizes the power of modern aesthetic doctrine to stifle and neutralize the idol. At the same time, the truncation of the tree recapitulates the original righteous axe-stroke of St Boniface when he felled the 'Jupiter' oak. Altdorfer surgically transforms the Madonna into a tree – but in the name of a more pure and correct worship, or in the name of art? The headless image declines to name itself as either sacred or profane. A decapitated figure is the equivalent of a picture without a title. The *Libri Carolini*, a ninth-century apology for the Christian cult image, offers the example of a pair of portraits of beautiful women, a Virgin and a Venus, which cannot be distinguished from one another because they lack captions.[175] To complete this tree with a head, to identify it as a Virgin or a Venus, would be to turn it back into subject-matter.

Wanderer, traveller

The true secular painting is an object that constructs its own appeal. Like the icon, it collapses space in upon itself and suspends time. But the icon is a portrait: it lives off the prestige of an absent personage. The independent landscape definitively banishes that person. The solitary human presence, and the source of any temporal structure, is the beholder of the panel. The time of the picture becomes the time of its experience by the beholder. The forest interior is the perfect object. No roads lead out. The beholding subject submits to the confusion, the mixed pleasure and fear, of non-purposive wandering.

But landscape in the sixteenth century, even within Altdorfer's career, was constantly drifting away from solipsism, self-sufficiency, iconicity. Horizontal format – the format of the map and the skyline – in the end proved to be the course of least resistance. German landscape remembered the functions of topographical description and setting for stories. The horizontal picture made room for those purposive movements across terrain that create space, time and meaning: pilgrimage, campaign, travel.

The Netherlandish painting was always apt to neglect personality and event in favour of open country. But terrain in the Netherlandish landscape started to clothe itself in the aura of the diminished event. The trajectory of the traveller and the furrows of the ploughman themselves assumed epic dimensions. Altdorfer's deflation of the heroic moment was more thorough-going. The Bible, hagiography, history and myth were all subject to the same levelling forces: authorial wit and self-display. The Munich *St George* diminishes the event, and not merely to schedule another set of events in its place. The arch incompleteness of the independent landscape was

the natural extension of Altdorfer's profane and anti-monumental narrative tactics.

Yet independent landscape remained a moment and an impulse, and failed to unfold into a tradition. We saw at the start of this book how the pastoral moment, once planted within epic, eats away at it. Now the cycle is completed. The established pastoral – the picture emancipated from terrain and story – allows itself to be reorganized along the principles of epic.

In the Berlin *Landscape with Woodcutter*, the tree is the double of a human figure. Space clings to its branches, and the picture collapses inwards. But other landscapes by Altdorfer set their trees in motion, and in the process start to create true terrain. The low horizon of the vertical landscape makes it difficult to show the recession of terrain into depth. One pictorial device for clarifying this obscurity is an oblique row of diminishing trees. In the *Landscape with Church* from the Koenigs collection, the recession of the terrain from front left to rear right is paced off by a row of three gaunt firs (illus. 101). Two further landscapes in Altdorfer's manner, perhaps directly after lost compositions by him, are built the same way: the *Landscape with Mill* in Berlin, on brown grounded paper (illus. 134),[176] and the *Landscape with Tree and Town* in Vienna, in pen and watercolour on paper (illus. 104). This device had been employed already by Netherlandish painters of the previous century, for instance in the *St John the Baptist in the Wilderness* by Geertgen tot Sint Jans (illus. 27). Dürer also used it to create space behind an immobile foreground object in his early *Holy Family* drawing in Berlin.[177] In empty landscapes by and after Altdorfer, the cortège of trees moves across the terrain like the ghosts of human actors.

The tree closest to the front plane in each of these landscapes, the largest tree, serves as a partial frame and as a limit to the emptiness of the sky. More important, it extends upward beyond the upper margin of the picture and therefore implies a continued and indefinite advance of the parade of trees through the picture plane and toward the beholder. The structure of the picture invites the beholder to cross the plane and enter the empty scene. In the Rotterdam *Landscape with Church* and the Berlin *Landscape with Mill*, the huge trees at the front suggest that it is indeed the beholder who is moving. The beholder becomes an invisible protagonist who has already encountered many such trees and is progressing steadily toward the targets at the rear of the middle-ground, the church or the mill.

The *Landscape with Sunset* in Erlangen is a variation on the same structure (illus. 102). Again, the principal spatial vectors of the picture are oblique plunges into depth, beginning at the left foreground with a dark strip of turf, jumping to the right where a wayfarer with a sack on a stick approaches a pair of twin firs, and then jumping again along a coast and toward the solar disc on the rim of a mountain at the left rear. Again the low horizon recalls narrative compositions, and again the foreground space flows across the picture plane into the beholder's world. The continuous foreground also extends an invitation. It pulls the beholder across the picture-plane and into the scene to fill the gap in the centre of the picture.

In the Erlangen watercolour the trespasser is actually depicted. One feels that the spatial span of the landscape in this picture corresponds exactly to the next leg of

the traveller's journey. This is no random moment in that journey, for the wayfarer, exceptionally, can see and measure the path before him. The buildings on the hill which, like the Koenigs landscape, include a fortified church, are a destination. And in the Munich *Landscape with Castle*, one of the paintings on parchment-covered panel, a tiny wanderer follows a path alongside a looping muddy river, emerging out of the picture and away from the castle and the ridge of translucent blue mountains (illus. 100).

The trajectory of the traveller measured out the landscape and gave it dimension. His figure marked the terrain as an intermediary space. The landscape was the space between cities, between fortifications, between ploughed fields. That space was meant to be traversed. The passage through the wilderness, from one outpost of civilization to another, was still a considerable adventure in this period. Hardly anyone travelled alone. Celtis and Altdorfer both described the predations of the highwaymen. The pedestrian caught on the open road must be a madman, an outcast, a pedlar, or a student. In late medieval German culture, solitary travel took on a certain picaresque glamour. Lyric poetry often adopted the subject or the voice of the wayfarer.[178] A German iconographical peculiarity was the wayfaring artist. The Franconian painter took to the road in search of topographical views. A drawing in Erlangen, probably from Wolgemut's shop, showed a *plein-air* painter in search of views (illus. 69). Dürer, who in his youth was constantly travelling, copied that drawing (illus. 68). In the background of his *Self-portrait* in Madrid, dated 1498, he inserted a tiny Alpine wanderer, doubtless a memorial of his first Italian voyage.

Travel could now be motivated by sheer curiosity. Humanists legitimated the new impulse to see and record with a new epistemology: experience over authority. Curiosity drove Dürer far off the road in search of patches of earth and odd trees. He became a wanderer rather than a traveller. In one remarkable watercolour of a mountain watermill surrounded by unprepossessing scrub and pebbles, he actually portrayed a youth bent over a tablet, stylus in hand. Is this a portrait of an apprentice, or even an imaginary, retrospective self-portrait?[179]

The more conventional pictorial traveller does not escape the orderliness of narrative and doctrine so easily. The traveller in medieval paintings or tapestries was faceless and nameless, a type rather than a particular. He did not belong to subject-matter. Nevertheless he was more than mere innocent background filler. He was always heading somewhere, toward a rendezvous, an imminent event, the terminus of a pilgrimage or an exodus. The Holy Family crossed a wilderness to reach Egypt. Mary traversed a mountain to visit her cousin Elizabeth. The Italian wanderer was the shepherd. In the woodcut landscapes of Titian and Campagnola, clutches of shepherds and whole pastoral families huddle on the road, perpetual exiles or pilgrims (illus. 182). But the archetypal wanderer was the Prodigal Son, who swung like a pendulum away from civilization and morality, and then back again. Hieronymus Bosch made the forlorn background wanderer an emblem of the human condition (illus. 128). Life was a permanent pilgrimage, earth a mere way-station. Pieter Bruegel, finally, magnified the staffage figure, still a type and still faceless, and placed

him in the foreground. Bruegel's wanderer – not the Babel-builder – would inherit the earth.

The open road symbolizes choice. The wayfarer becomes a character in a moral narrative precisely because he is free to choose. He is suspended between those two fundamental categories of activity that the institution of landscape painting defined: work and play. He neither produces nor consumes. The traveller is beyond the protection of architecture, and indifferent to the exigencies of civilization. His freedom to choose one route or another, and his detachment from the ordinary binds of sociability, stand as metaphors for moral predicaments. And, in turn, the dilemmas and states of mind of the traveller–hero are projected onto the landscape. The wayfarer and his road will convert any terrain into a *paysage moralisé*, a landscape whose very features illustrate the rewards and hazards of ethical opportunity. Panofsky showed how Dürer placed his Hercules, in an engraving of *c.*1498, before a choice between Virtue and Vice. The picture is folded around a central cluster of trees. The Reformation woodcut – for example the title-page *Law and Grace* by Erhard Altdorfer – turned the symmetrical *paysage moralisé* to propagandistic purposes.[180] Albrecht, too, in his narrative paintings, allowed landscape to map out ethical order. In the *Christ Taking Leave of His Mother* in London, the Saviour, on the brink of his ministry in Jerusalem, graphically chooses the uncertainty of wilderness, on the right, over family and architecture on the left (illus. 13).

The best-known independent landscape by Altdorfer is the *Landscape with Castle* in Munich (illus. 100). This is the landscape most easily assimilated to the mainstream European tradition. It is open again to plot. The picture measures 30.5 x 22.2 centimetres, about the size of the *St George* or the Berlin *Crucifixion*. It is painted in fairly dense oils on a parchment ground on a boxwood panel, and is monogrammed on the tree-trunk at the lower left. Friedländer ranged it alongside the lost Vienna landscape, which was dated 1532.[181] But it could date from as much as ten years earlier.

The foreground of this landscape is a threshold, fringed with grasses, supporting two trees as if they were door jambs. Those trees no longer compete with the terrain, the spatial landscape, for attention. They retain a certain anthropomorphic vitality, indeed they resolve into two grotesque profiles in dialogue across the sky. But they have retreated to the margins of the picture; they have become setting again. In a narrative they might serve a function, like the trees bridging the composition of the *Martyrdom of St Florian* in the altar at St Florian. The *Landscape with Castle* is a settled composition, a retrenched composition. The heart of the picture is no longer at war with the margins, and mass is no longer besieged by space. Sky is neither left innocently blank nor arbitrarily enlivened, but rather collapses into a legible dramatic structure. Wedges of cloud rhyme both with the horizon and the tree silhouettes. The entire picture between the framing trunks is submitted to a grid of triangles. The Munich landscape extends and streamlines all the formulas of the three water-colours, just as it perfects their various motifs. Once again there is receding coastline, translucent blue mountains, evergreen forest, a castle, a looping river and an oblique

134 Follower of Albrecht Altdorfer, *Landscape with Mill*, 1520s, pen with grey wash and white heightening on red-brown grounded paper, 20.7 x 15.2. Kupferstichkabinett, Berlin.

135 Albrecht Altdorfer, *Crucifixion*, 1526(?), oil on panel, 40.5 x 33.1.
Germanisches Nationalmuseum, Nuremberg.

road (the sagging beam is evidently an open barrier), and a minuscule wanderer. The absolute size of a staffage figure does make a difference; here he is almost invisible.

The paint is denser here than in the London *Landscape with Footbridge*. It has been worked up toward the settled condition of oil painting. The sky is layered from blue to thick white, so that in the end it almost forms a textured *impasto*. Foliage is piled through at least four layers of green; at their tips the branches are visible blobs of paint. This is ornamental painting that knows its place, the forest of the *St George* seen from a safe distance, as it were. It has come to look again like a background. Indeed, it resembles the stable setting of the Nuremberg *Crucifixion*: a major event squarely centred (illus. 135). One is reminded of those settings of Altdorfer's *Satyr Family* or Cranach's *St Jerome* that were extracted by copyists.

This is really no longer a plotless place. It is the potential theatre for a comprehensible narrative. The openness of this view overwhelms the remnants of the non-visual experience of tangled forest, although the surface of the view is still stigmatized, for the close looker, by those earlier explorations into the non-visual. It is a much more reasonable hypothesis of a real place. The Munich landscape has in fact provoked various searches for topographical references. The picture was described in the Munich exhibition in 1938, and again in the Alte Pinakothek catalogue of 1963, as an accurate view of Schloss Wörth on the Danube near Regensburg; even the mountains in the background were named.[182] Winzinger was surely right to dismiss these topographical hypotheses. The castle does not resemble Wörth, which has a square tower. Schloss Wörth was restored and enlarged in the early 1520s by the Bishop-Administrator of Regensburg, Count Palatine Johann III. The castle *is* depicted accurately in a watercoloured pen drawing dated 1524, formerly in Dresden (illus. 187).[183] Nevertheless, Herbert Schindler persisted in identifying the Munich landscape as a *veduta*, and actually accounted for the round tower of Altdorfer's castle by imagining that the picture had been painted expressly for Johann, and that he had planned to rebuild Schloss Wörth in Renaissance style![184]

In fact, the picture does not have a title any more than the watercolours or the London landscape do. Yet this is a more subtle fiction. The pleasure of comparing it to a parallel empirical world is enhanced by its proximity to that world. It is works like the Munich landscape, more than either dry topographies or obstinate fictions, that actually create and reinforce regional and national self-images. Plotless places initiated the project, and settled and structurally stable fictional views completed it. In pictures like this, and above all in the etchings (the topic of the final chapter), the Germans learned to look at their own land, to read their own character in geography. The same process would be repeated in the Netherlands one hundred years later, when Esaias van de Velde and Salomon van Ruisdael were succeeded by Jacob van Ruisdael, Koninck and Hobbema.

In the wake of the definitive supplanting of fact by fiction, an impermeable frame has been erected between the picture and the world. The true frame of the Munich landscape is in fact the frame, not the framing trees within the picture. The newly

136 Albrecht Altdorfer, 'End of the Procession' from the *Triumphal Procession, c.* 1516–18, two
woodcuts, each 39 x 39. Graphische Sammlung Albertina, Vienna.

stable landscape will preserve this segregation of fiction from the world outside, even
when subject-matter is reintroduced.

Germans were enchanted and repelled by the figure of the soldier. The Imperial
armies were stocked with mercenaries: legions of coarse adventurers, earth-bound
cavaliers. The countryside was infested with these glamorous parasites, wandering
in symbiotic squalor with bands of prostitutes. These were the lansquenets who, looting
and proclaiming Luther as Pope, sacked Rome in 1527. Artists never stopped drawing
them. They were modern, raffish knights errant. An aura of romance – casual crime,
free-wheeling sex, unpredictable itineraries – clung to their slashed sleeves and
leggings. The eccentric Swiss Urs Graf and Niklaus Manuel Deutsch made a
specialty of drawing lansquenets. In their woodcuts and drawings, soldiers became
vehicles of ironic moralism (illus. 127). In Altdorfer's coloured-ground drawings they
became wood-spirits, slouching along forest paths, momentarily purposeless even if
ultimately trapped within some vaster military design. The crude soldier bulges with
appetite (illus. 41). His twilit existence was perfectly suited to Altdorfer's broken
landscapes. He belonged most completely to the forest when he was dead on its
floor, like Altdorfer's Pyramus, who wears the costume of a modern lansquenet (illus.
42).[185]

But Emperor Maximilian's manuscript and woodcut commissions forced Altdorfer
to marshal his lansquenets, to rally them to order. In the *Triumphal Procession* he
described row after row of glittering soldiers. But after all the pomp, the woodcut
procession peters out in a thread of stragglers, hangers-on, baggage-carriers, emer-
ging, appropriately, from a spiky forest (illus. 136). Behind the parade rises a solitary
chapel. Within the manuscript *Triumphal Procession* Altdorfer had a chance to paint
actual battles (illus. 137).[186] Several pages of soldiers carried wide banners illustrating
Imperial victories and captured cities, much like the banners in Mantegna's *Triumph
of Caesar.* Now it was not the individual soldier that fascinated, but the swarm of

199

137 Albrecht Altdorfer, 'The Great Venetian War' from the *Triumphal Procession, c.* 1512–14, pen, watercolour and gouache on parchment, size of sheet 45.3 x 90.6. Graphische Sammlung Albertina, Vienna.

an army. The medium also encouraged amazing and unprecedented effects in the landscape. In the miniatures for the *Triumphal Procession*, greens and yellows glow and lift off the page, and dominate the colour scheme out of all proportion to their surface area. They are seldom successfully reproduced in photographs. Most memorable of all – and this is the case in the Erlangen landscape as well – are the wispy streaks of pink and grey in the mountains, sheer filaments of opaque heightening traced with the narrowest of brushes. It was impossible to translate this effect into oil painting. The most profound and gratuitous exercises in this technique are the miniatures of the *Venetian War*, or the *Siege of Liège* and the *First Flemish Conquest*,

where the distant mountains are at once enlivened and dissipated by the trails of white on blue and purple ground.[187]

This was Altdorfer's apprenticeship for the *Battle of Alexander* (illus. 8, 9, 10). The *Battle* was Altdorfer's supreme opportunity. He renounced the mayorship of the city to complete the commission. Here terrain opens to receive the flood of men and horses. The picture begins at ground-level, at a plausible standpoint perhaps on a ridge overlooking the plain. Then the point of view climbs incessantly until at the top, from a stratospheric platform, the scene of the whole world unrolls.[188] This landscape is completely divorced from ordinary experience, for it seems to play no

part in the military action; it is invisible to the actors inside the picture. Instead, the landscape is made available to the angelic beholder, as a supplementary spectacle, and as an exegetical context and key. The vertical format squeezes the armies upward, up the surface of the picture. They actually cover the landscape, and swell and swarm unhindered by its contours. It is as if Altdorfer's fragmented, folded, divagating picture surface has been tilted backwards into space. The picture surface has been pushed back and absorbed into a spatial continuum. Now the vast mountain range stretching to the horizon is itself a crumpled and inscrutable surface; and the sky mirrors it like a second landscape.[189] But the picture plane itself is smooth. The picture offers no synthesis of the points of view, but it is not split between them either: instead the gaze – not the angle of the gaze, but its physical source, the body and the eye – steadily levitates. The swinging gaze that takes in this cosmos is singular. This gaze, triumphant counterpart to the drive and initiative of the soldier, the motor of war, sweeps away the intimate confusion of the early pictures. By the end, landscape is again bereft of its independence.

The foreground tree in a narrative picture, even when pushed to the margins, stands for the contingency and implacability of the empirical world. The tree is opaque and contributes nothing to the story. It threatens to block the view. The mere presence of the tree heightens the sense that the story is reliably told; for if the narrator has included even this uncooperative detail, the rest of the account must also be true. Thus the beholder believes in the Sermon of the Baptist described in a miniature by Narziss Renner, an Augsburg painter who knew Altdorfer's work (illus. 138). The scene is glimpsed only through a screen of foreground trees. The front edge of the *Battle of Alexander* is a lip of bare earth, a last link with the experience of the beholder. The framing tree at the left, however, has been cut down. The view of the historical event is unimpeded. The stump is the emblem of the triumph of the narrator over the landscapist.

138 Narziss Renner, *John the Baptist Preaching*, 1523, 22 x 16.2, miniature from a Prayer Book. Österreichische Nationalbibliothek, Vienna.

4

Topography and fiction

Altdorfer's painted landscapes, his fictional topothesias, were topographically useless. Their verticality controverted the surface of the earth. Goethe said as much about the old Netherlandish landscape painters. 'Human imagination', he observed in his *Italian Journey*,

always pictures the objects it considers significant higher, rather than broader, than they are . . . and thus endows the image with more character, seriousness, and worthiness. Imagination is to reality as poetry is to prose; the one thinks of objects as mighty and steep, the other spreads outward in the plane. Landscape painters of the sixteenth century, held up to our landscape painters, give the most striking example.[1]

Altdorfer's landscape drawings in pen and ink, on the other hand, are horizontal in format. Four works survive. Two are travel reports: the *View of Sarmingstein* in Budapest, dated 1511 (illus. 164), and the *Landscape with Willows* in the Akademie in Vienna (illus. 165). The *Coastal Landscape* in the Albertina, usually attributed to Altdorfer's brother Erhard, dates from about a decade later; it is close in spirit to the landscape etchings (illus. 188). The *View of Schloss Wörth* in Dresden, dated 1524 and lightly watercoloured (illus. 187), is the fourth example. In format and medium these drawings derived from a regional practice of topographical drawing. The earlier pair, fresher and more open in structure, with traces of the traveller's attentiveness and exhilaration, show the immediate influence of the work of Wolf Huber. Huber left about three or four dozen landscape drawings in pen on white paper, both vertical and horizontal in format; another 75 or 100 sheets are copies after lost originals or inventions in Huber's manner. The earliest dated drawing by Huber is the *Bridge at the City Wall* of 1505, in Berlin (illus. 156); the *View of the Mondsee* in Nuremberg is dated 1510 (illus. 158). Both are signed with initials. They suggest strongly that the original decision to frame the landscape and offer it as an independent landscape drawing was taken by Huber in the first decade of the century.

Huber did not arrive at the empty landscape by excluding subject-matter, but rather by offering topography as a picture. Huber's reconstitution of the image of the outdoors was comparable in procedure to Altdorfer's. He did it by fashioning his topographical views into compositions, that is, by subjecting them to the familiar conventions of two-dimensional organization. He also did it by presenting his pen line as the mark of a recognizable personal style; indeed, he monogrammed and dated many of his landscape drawings. Altdorfer took up the idea at once. The hypothesis of a meeting between the two in 1511, during a journey down the Danube by Altdorfer, is still a good one.

The story of Huber's invention and its success deserves an expansive treatment, but here it will have to be summarized. Wolf Huber was born in the Vorarlberg, probably in the mid-1480s, and settled in Passau sometime after 1510.[2] Not a single surviving painting predates the 1515 contract for the St Anna altar in Feldkirch.[3] It appears that Huber's career, too, was built on paper. His earliest works are pen drawings on coloured ground in the manner of Altdorfer.[4] His first woodcuts, under the impact of both Dürer and Altdorfer, date from around 1511. Huber also produced narrative or hagiographical drawings on plain paper. The earliest is the *St Sebastian* in Washington, dated 1509.[5]

The exchanges between Huber and Altdorfer extended over many years, and neither was manifestly more fertile than the other. Wolf Huber even made watercolour and gouache landscapes, although none on panel. The *Alpine Landscape* in Berlin, in watercolour and gouache over pen on paper, is initialled W.H. and dated 1522; the date was at some point, unaccountably, altered to 1532 (illus. 139).[6] With its vast, bowed horizon and its marbled sky, this drawing is pitched a rhetorical octave higher than Altdorfer's watercolours. But Huber has a heavier brush-hand and the landscape is dampened by all the opaque local greens in the foreground. A vertical sheet from the Koenigs Collection, lost since 1945, the *Mountain Landscape*, is also initialled and dated 1522.[7] Old descriptions give some idea of the intensity of the colours. The structure – dark repoussoir and mountain view within a narrow vertical format – and the saturated mood, not to mention the date, place it in direct analogy with Altdorfer's watercolour landscapes on paper. But both these landscapes are larger than Altdorfer's. Even larger is Huber's *Landscape with Golgotha* in Erlangen, a spacious, washy folio filled to the brim like a painting (illus. 140).[8] This is a strange, ambitious drawing, finished and yet open-ended. The crosses on the hill and the huge glowing emptiness in the foreground pull the drawing back toward iconography, as if the drawing were merely waiting for Christ Bearing the Cross, with a throng of onlookers, to materialize.[9]

But Huber's best graphic ideas were unfurled on plain white paper. His pen was on a tighter leash than Altdorfer's; it described smaller arcs, turned tighter corners, filled blank space more patiently and thoroughly. Huber's early pen drawings soon swerved from straightforward descriptive tasks. The tension between stylish line and the prosaic task of topographical description was driven to an extreme in his landscape drawings of the 1510s, as it also was in Altdorfer's *View of Sarmingstein* and *Landscape with Willows*.

The topographical drawing

It is astonishing to discover how seldom Renaissance artists actually took their equipment out of doors, to draw or paint under an open sky. Common sense suggests that they must have done so, for the only prerequisites were good weather and portable equipment. And yet it is amazingly difficult to show that artists did draw out of doors. Even the primary piece of evidence has been assailed: Leonardo da Vinci's *Arno*

139 Wolf Huber, *Alpine Landscape*, 1522 (later altered to 1532), pen with watercolour and gouache on paper, 21.1 x 30.6. Kupferstichkabinett, Berlin.

140 Wolf Huber, *Landscape with Golgotha*, c. 1525–30, pen with watercolour and gouache on paper, 31.7 x 44.8. University Library, Erlangen.

Valley Landscape (illus. 141) in the Uffizi, a pioneering testimony to the Renaissance spirit of direct inquiry into nature.[10] The sheet is dated 5 August 1473 in Leonardo's own hand. But Ernst Gombrich called attention to various spatial inconsistencies in the landscape and to resemblances with formulaic cliffs in the backgrounds of early Netherlandish paintings. He concluded mischievously that Leonardo had worked up the entire view in his workshop, at best from the memory of an outing along the Arno.[11] Suddenly, we cannot even be sure that we will recognize the drawing from life when we *do* come across it.

Plein-air drawing was certainly no ordinary exercise in the Renaissance. Only a few of Altdorfer's and Huber's contemporaries, for example Dürer, Fra Bartolommeo, probably Titian, regularly ventured out of doors with pen and paper. There is considerable evidence, however, circumstantial and material, of a German topographical drawing practice in the latter half of the fifteenth century. Accurate topographical reports mostly served practical purposes, inside and outside the painter's workshop. For example, buildings or terrain were often drawn from life in order to record claims to property. In that case the drawing stood as a finished product, a pictorial document with legal status. Archives are full of clumsy old maps drawn by local painters or even clerks.[12] A schematic watercolour map of Regensburg, perhaps connected with a legal dispute over property borders, was entrusted to an artist close to Altdorfer.[13] A watercolour and gouache painting in the Ian Woodner Collection describes from an imaginary viewpoint a clutch of high-roofed buildings – a farm or a lodge – menaced by a wriggling army of trees (illus. 142).[14] The draughtsman who traced these flared roofs and pursued the theme of trunk and crown into every corner was no amateur. The picture must have documented private property. Perhaps it was part of a larger map; this segment was done on four separate sheets of parchment stuck to paper. String holes along the edges indicate that the parchment was plundered from a bound book. The surveyor and cartographer Erhard Etzlaub did similar work for the city of Nuremberg: 'What was held by my lords the Council in and around the city', the calligrapher and mathematician Johann Neudörfer confirmed, 'in flowing waters, roads, tracks, towns, markets, villages, hamlets, woods, rights of jurisdiction, and other excellences, he showed forth for them in the district office in fair maps and pictures'.[15] Etzlaub's *Imperial Forests around Nuremberg*, also on parchment, takes a still higher vantage point (illus. 92). All these works function as maps but look like pictures. They eschew a strict overhead point of view in order to preserve the more familiar look of things. They are liberal with colour and superfluous detail. The same can be said of the topographical watercolours produced early in the century by Jörg Kölderer of Innsbruck for Emperor Maximilian. Kölderer and his workshop illustrated a pair of military inventories, the *Fortifications in South Tyrol and Friuli*[16] and the *Ordnance Book*.[17] These descriptions of batteries and arsenals are more soberly attentive to detail and structure than the rich and fanciful landscape miniatures of Maximilian's Tyrolean *Fishing Book* and *Hunting Book*. The fortification's watercolours, for example the description of Peitenstein nestled among jagged crags, are grounded in chalk underdrawings that were executed at the sites (illus. 143).[18] These

141 Leonardo da Vinci, *Arno Valley Landscape*, 1473, pen on paper, 19 x 28.5. Uffizi, Florence.

142 German master, *A Farm in a Wood*, c. 1500, pen with watercolour and gouache with white heightening on parchment; four sheets pasted on paper, 45.7 x 55.6. Ian Woodner Family Collection, New York.

143 Jörg Kölderer, *Peitenstein*, *c.* 1508, watercolour over black chalk, from manuscript *Fortifications in South Tyrol and Friuli*, size of page approx. 30 x 40. Österreichische Nationalbibliothek, Vienna.
144 Jörg Kölderer, *Achensee*, miniature from manuscript *Fischereibuch*, 1504, 32 x 22.
Österreichische Nationalbibliothek, Vienna.

fortifications, often built piecemeal and according to no plan, and perched on irregular and unwelcoming terrain, were not easy structures to draw. Ungainly perspectival solutions and outright failures of pictorial intelligence reveal the difficulty of the task. At the same time, the painter was mindful of his audience. These volumes were meant for the eyes of the Emperor. The green, pink and blue washes made the pages more presentable; so too did gratuitous pictorial touches like vegetation or, in the drawing of Peitenstein, a tiny shrine and crucifix beside the road. The Tyrolean *Fishing Book* of 1504 is a more splendid affair, executed under the sign of Diana rather than Mars.[19] The description of the Achensee, a finger-shaped lake northeast of Innsbruck, fills an entire page (fol. 3v) in true miniature technique, with layers of opaque pigment and shimmering streaks of white and real gold (illus. 144). These are the immediate technical models for Altdorfer's *Triumphal Procession* miniatures; in fact, until recently those magnificent landscapes were credited to Jörg Kölderer. The format of the page pushes the lake upwards. For all the fancy brushwork, the scene refuses to leave the page and recede into space. Maximilian himself cradles the prize fish in the lowermost vessel, while his deputies and huntsmen haul the nets and pursue horned game.

Most topographical drawings were the private memoranda of the painter, destined for transposition to the backgrounds of narrative panels. These drawings are mostly lost. But every reasonably accurate portrait of a celebrated building or a skyline in a painting must have been preceded by a study from life. Netherlanders who embedded urban portraits within a landscape were following the lead of Jan van Eyck. Every painter had seen the towers of the cathedral of Utrecht and of St Nicholas of Ghent

145 Michael Wolgemut, *Presentation of Christ in the Temple, c.* 1480–90, oil on panel, 222 X 147.
St Jakob, Straubing.
146 Lucas Cranach, *Martyrdom of St Erasmus,* 1506, woodcut, 22.4 X 15.8.

in the background of the Ghent altarpiece.[20] But the specialists in background topography were the Germans. The skyline of Vienna, for example, appears first of all in the *Meeting of Joachim and Anna at the Golden Gate* in the Albrecht Altar of 1440, at Klosterneuburg, showing the towers of St Stephen's cathedral and Maria am Gestade, completed in 1428 and 1433 respectively.[21] Vienna then reappears in the background of the *Flight into Egypt* of the Schotten Altar of 1469, in the Schottenstift in Vienna;[22] and in the central panel of the *Crucifixion* triptych of the 1480s, now at St Florian, by a pupil of the Schotten Master.[23] One centre of topographical background painting was Nuremberg. Michael Wolgemut, to select one example among many, grafted the Nuremberg castle into the background of a Presentation of Christ on an altarpiece in Straubing (illus. 145).[24] Lucas Cranach portrayed his patron's castle at Coburg, north of Bamberg, in the St Catherine altar, and then repeated the homage in his woodcut *Martyrdom of St Erasmus* of 1506, where the castle doubles as conventional background motif (as in so many Dürer woodcuts) and as pendant to the coats of arms hanging from the tree at the right (illus. 146).[25] Innumerable other passages in German panels certainly reproduce real but vanished buildings.

Workshops must have stocked portfolios of local views. Two possible early survivors from Nuremberg are a slightly wobbly view of the castle (illus. 147)[26] and a scrupulous transcription of rooftops surrounding the church of St Egidius.[27] But a group of six pen and watercolour drawings in Berlin associated with Wolfgang Katzheimer the elder, the leading turn-of-the-century painter in Bamberg, gives the best impression of what the Franconian *plein-air* drawings must have looked like.[28] This is the most

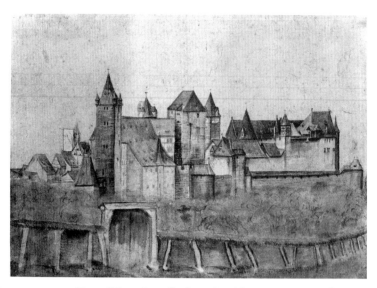

147 German master, *View of Nuremburg Castle*, early 16th century, watercolour on paper,
14.8 x 21.2. Germanisches Nationalmuseum, Nuremberg.

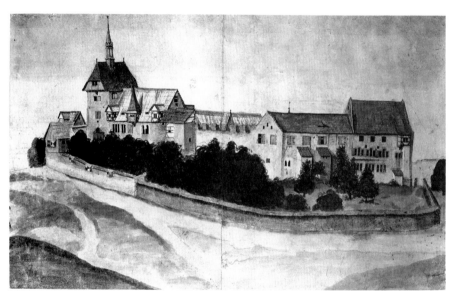

148 Bamberg master, *View of Imperial and Episcopal Palace in Bamberg*, before 1487, pen and
watercolour on paper, 19 x 47.2. Kupferstichkabinett, Berlin.

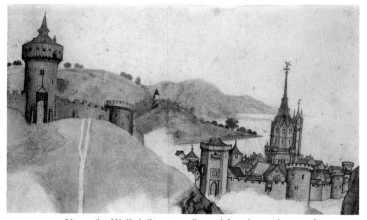

149 German master, *View of a Walled City in a Coastal Landscape*, late 15th century, pen with
watercolour and gouache, 7.3 x 13.5. J. Paul Getty Museum, Malibu.

important cache of true topographical studies before Dürer. The view of the Imperial and episcopal palace complex on the cathedral hill in Bamberg was drawn before a fire damaged the tower in 1487 (illus. 148).[29] This precise view, modified to account for the rebuilding completed in 1489, resurfaces in the background of a panel attributed to Katzheimer,[30] in a pen drawing in London related to the painting,[31] and in a woodcut of 1509 by Dürer's pupil Wolf Traut.[32] The views of Kloster Michelsberg and the Burggrafenhof, meanwhile, were used in the background of a *Bearing of the Cross* in St Sebald in Nuremberg, dated 1485.[33] These are the only chronological coordinates, and without them the watercolours would be extremely difficult to date. The views are drawn in black and red ink with occasional traces of preliminary black chalk. The washes are red, grey, yellow, blue and various greens. The use of perspective and the attention to detail vary; however, although they may be the work of three different hands, the six sheets surely belonged to the same workshop portfolio.[34]

There was certainly no requirement that background skylines be derived from life. One group of Franconian landscape drawings in pen, and often with watercolour as well, are simply fantastic, organic elaborations on the themes of castle and city. These drawings may share format and function with the true topographical reports, but they were not executed out of doors. The *Landscape with Wanderer*, which Dürer adapted in a drawing of his own, reappears in an altar panel in Bamberg (illus. 68, 69; see p. 105). A drawing of a *Coastal City* in Erlangen surfaces on the horizons of two Nuremberg altarpieces of the 1460s.[35] A *Mountain Landscape with Castle* in Leipzig is exceptionally complete, already a finished drawing.[36] The most appealing false topography is the *View of a Walled City in a Coastal Landscape* recently acquired by the J. Paul Getty Museum, a not quite stable collection of mountains and buildings in pen and soft washes (illus. 149).[37] The drawing has evidently been cut down from a larger composition study. The towers here vary only slightly from the towers of the Erlangen *Coastal City*.

What purposes did embedded topographical portraits serve? Some were narrative devices. Accurate reports on familiar and stationary objects vouched for the reliability of the narrator's reports on more complex objects. Background detail – just like the intrusive foreground trees discussed at the end of the last chapter – contributed to the rhetoric of realism. The success of realist fiction can turn on a thin margin of apparently superfluous information. Embedded topography also nurtured an increasingly sharply defined sense of place, a monumental consciousness. Attention to landmarks – buildings and skylines – formed the pre-history of the grander humanist project of regional and national illustration. And it must simply have given churchgoers pleasure to recognize local landmarks in an altarpiece.

There was always plenty of demand for views of cities, local or foreign. The medium of print seemed to lend any representation an aura of authority, and render accuracy unnecessary. A strange metalcut view of an unidentifiable city probably dates from the third quarter of the fifteenth century.[38] Many of the urban views of Schedel's Nuremberg Chronicle, designed and executed by Wolgemut's shop, were wholly invented, but many others, like the view of Regensburg, were prepared by

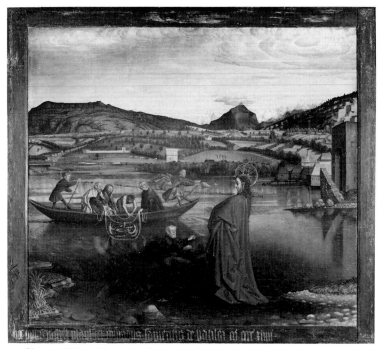

150 Konrad Witz, *Miraculous Draught of Fishes*, 1444, oil on panel, 132 x 155.
Musée d'Art et d'Histoire, Geneva.

pen drawings from life (illus. 36).[39] So too were the panoramic views by Erhard
Reuwich that were published as woodcuts to Bernard von Breydenbach's *Pilgrimage
to the Holy Land* in 1486. Such woodcut views persisted as basic structural templates
for Huber's and Altdorfer's pen-and-ink landscapes.[40]

The topographical memorandum did not so frequently embrace mountains, which
were more difficult to depict. The great exception is the *Miraculous Draught of Fishes*
by Konrad Witz, an outside wing from the St Peter altar of 1444 in Geneva (illus.
150).[41] The picture looks southeast across the lake, toward the peak of Le Môle
flanked by the Voirons and the Petit-Salève. Earlier we came across the description
of a lost painting by Dirk Bouts, from the middle of the fifteenth century, which
portrayed landmarks of Haarlem, among them a tree (see p. 169). Dürer, too,
portrayed a particular tree, the *Lime Tree* in Rotterdam, a magnificent simulation
of a mottled, glinting, leafy mass in watercolour and gouache on parchment (illus.
151).[42] This is possibly the famous tree on the ramparts of the Nuremberg Castle
under which Philipp Pirckheimer celebrated his wedding on 11 March 1455, the
very day, in fact, that Dürer's own father first arrived in the city.[43]

For some artists, the process of making the topographical portrait became more
interesting than any possible use in a painting. This is evident in Dürer's *Lime
Tree*, whose ineffable technique, part watercolour and part miniature, would never
translate into oil paint. This is what was happening generally in Dürer's landscape
watercolours of the 1490s. The fifteenth-century Franconian topographical drawings,
and more especially Wolgemut's shop practices, stood directly behind Dürer's travel
reports, or his views of places around Nuremberg, such as the *Wire-drawing Mill*

(illus. 152).[44] This enormous and extremely still watercolour describes a cluster of buildings on the River Pegnitz just west of the city. The whiteness of the paper slides behind the layers of wash and gouache and illuminates the scene from below. Any patch of this vision is ready for transfer to a painting. But Dürer has knit topography into a landscape. He accomplishes this with colour, with an intellectual grasp of the continuity of terrain, and even with an aesthetic principle, a formal module provided by the steep and slightly flared straw roofs. These are the German rustic roofs *par excellence*, which we saw already in the Woodner property drawing (illus. 142), and which Vasari praised in Dürer's *Prodigal Son* engraving, as 'most beautiful huts after the manner of German farms'.[45]

Dürer's studies are finer and more scrupulous, and at the same time more festive, than their predecessors. They constantly exceed any requirements that practical function would impose. Description has become an end in itself. Dürer's watercolours were probably not seen by many beyond his shop and circles of friends and supporters. But proof that they were regarded from an early date as self-sufficient pictures is provided by a watercolour cliff study in the Uffizi (illus. 153).[46] This work describes a triangular segment of cliff in pale, controlled layers of watercolour. The cubic shelves of rock, and the additive procedure in general, suggest a northern Italian hand, and indeed call into doubt the status of the sheet as a life-study. The watercolour technique and such tactics as the blank sky can only have been learned from the example of Dürer. Perhaps it was even a copy after a Dürer watercolour, left behind in Venice in 1495 and now lost.

Accuracy – or the look of accuracy – was prized for its own sake. Johann Neudörfer, in his notes on local painters published in 1547, recounted the young Dürer's peregrinations after his disappointment in Colmar. 'Even as he travelled further in search of his art', wrote Neudörfer, 'he was nevertheless passing his time with counterfeits of people, landscapes, and cities'.[47] Later in life Dürer reverted, when executing a landscape, to the classic medium of the fifteenth-century life-study: silverpoint. The silverpoint, a metal stylus with a silver tip, was easier to carry around anyway. On a trip to Bamberg in 1517 Dürer stopped to draw the village of Reuth and its environs (illus. 154).[48] Just as in the *Wire-drawing Mill*, the horizontal is cut by a welter of harsh thatched slopes. Dürer's pupil Hans Baldung also left a corpus of silverpoint landscapes and views.[49] Surviving topographical drawings from the 1520s and beyond suggest that Dürer's precocious attentiveness to his surroundings was installing itself within normal artistic practice. An unknown, confident hand described the coast of Lake Constance in pen and coloured washes.[50] The sheet is inscribed with the place, Goldbach near Überlingen, and the precise date, '1522 on St Michael's Day': the marks of a traveller. The close-up on the verso is even lovelier (illus. 155). Scribbled notes in the grass and water fix the proper colours; perhaps the artist had a mind to convert the sketch into a more public medium after all. But for the moment the lazy, practiced wanderings of the pen sufficed. Pleasure in the 'counterfeit' no longer needed to be justified.

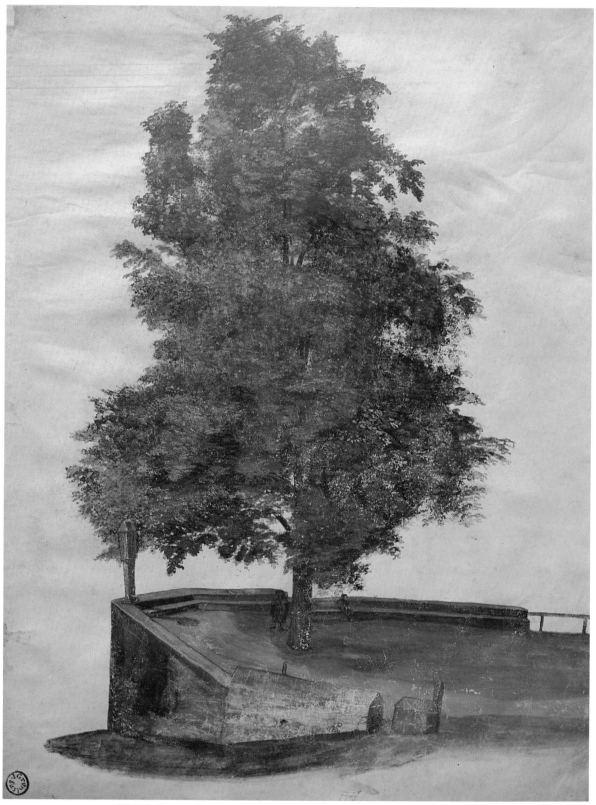

151 Albrecht Dürer, *Lime Tree*, *c.* 1493–4, watercolour and gouache on parchment,
34.3 × 26.7. Museum Boymans–van Beuningen, Rotterdam.

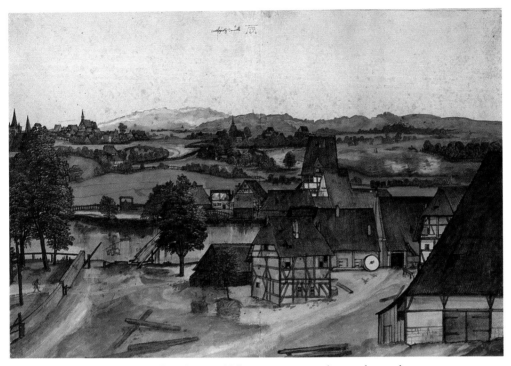

152 Albrecht Dürer, *Wire-drawing Mill*, *c.* 1494, watercolour and gouache on paper, 29 x 42.6. Kupferstichkabinett, Berlin.

153 Northern Italian master, *Cliff*, late 1490s, watercolour, 20.2 x 27.3. Uffizi, Florence.

154 Albrecht Dürer, *View of Reuth*, *c.* 1517, silverpoint on parchment, 16 x 28.2.
Missing since 1945.

155 German master, *River Bank*, 1522, pen on paper, 9 x 14.1.
Germanisches Nationalmuseum, Nuremberg.

Style in Altdorfer's pen-and-ink landscapes

Wolf Huber in his earliest dated drawing, the *Bridge at the City Wall* of 1505, adopted a point of view and a medium proper to the topographical report (illus. 156).[51] The technique of dusting or rubbing the paper with a dry powder, usually red chalk or cinnabar, although not mentioned in Cennini's handbook, was used in Florence from the beginning of the fifteenth century. Red tint was a quicker and cheaper substitute for opaque coloured ground. Germans used it for pen drawings of some degree of finish which were expected to last some time, such as workshop models and sketchbook pages.[52] We have already looked at several drawings in this technique: two copies after Dürer prints, the *Quarry* after the *St Jerome*, from the so-called Wolgemut sketchbook in Erlangen,[53] and the *Mountain Landscape* after the *Visitation* (illus. 82, 85), and two landscape drawings usually associated with Erhard Altdorfer (illus. 79, 80). Huber recorded every element of the bridge's structure and every feature of the terrain behind it. He maintained a stationary standpoint, apparently on a small island in the middle of the river, and dutifully and awkwardly registered the odd foreshortened bulb of earth looming between himself and the gatehouse at the end of the island. But in Huber's drawing, just as in so many early life-studies, and in Dürer's watercolours, an initial openness to physical data transforms itself in the process of execution into a will to closure and finish. The *Bridge at the City Wall* is bracketed at the upper-left and -right by a tree and a tower, at the lower-left and -right by repoussoirs of earth. The bridge itself is outlined twice to distinguish it from the background. When he was finished, Huber did what Dürer almost never did: he dated his landscape.[54] The date was apparently not added later, for its line resembles too closely other lines in the drawing. It actually belongs to the drawing, to the composition, as so many of Huber's dates and monograms will in the landscapes to come.[55] This is one of Huber's earliest drawings (see pp. 203–4). The date marks neither a moment in the history of the depicted city, nor a moment shared between artist and patron (for example, a date on a presentation or contract drawing), nor a precise moment of observation (for example, the date recorded by Leonardo on his Arno landscape), but rather a moment in the career of the draughtsman. The young draughtsman who dates a drawing evinces a certain confidence that he will, indeed, have a career.

In the *View of Urfahr*, the town across the Danube from Linz, fifty miles downstream from Passau (illus. 157), Huber is even more stubbornly literal than in the *Bridge at the City Wall*.[56] Here he is standing on the ramparts of the castle of Linz, high above the river. Everything is described in an extremely pale monotone. The mountains are shaped not by hatching but by soft, dotted contour lines. But Huber includes within the scene a pair of rooftops rising into his field of vision and eclipsing the brittle bridge linking Linz with its suburb. The bridge, because it serves both as an illusory link between spatial layers and as a diagonal in the picture-plane, became a primary compositional device of the mature landscape. Later on in his career, when

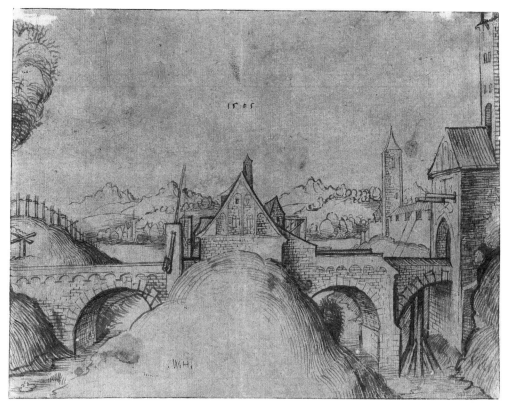

156 Wolf Huber, *Bridge at the City Wall*, 1505, pen on red-tinted paper, 19.9 x 26.5.
Kupferstichkabinett, Berlin.

157 Wolf Huber, *View of Urfahr*, c. 1510, pen on paper, 13.3 x 14.8.
Museum of Fine Arts, Budapest.

158 Wolf Huber, *View of the Mondsee*, 1510, pen on paper, 12.7 x 20.6.
Germanisches Nationalmuseum, Nuremberg.

he was decidedly more interested in making good pictures than veracious reports, Huber would never let the principle of optical fidelity spoil the effect of such a device.

For his extraordinary *View of the Mondsee*, monogrammed and dated 1510, Huber took up a stance close to the surface of the earth and set out to describe everything adjacent to the horizon in pure contours (illus. 158).[57] He drastically foreshortened the intervening terrain. This is the formula of the skyline, and yet it is not a city that is described, but a lake and a mountain, the Mondsee and the Schafsberg in the Salzkammergut, about fifty miles south of Passau. The *View of the Mondsee* is one of the most beautiful of all German drawings, and unamenable to photographic reproduction. The pen line trembles while it traces mountain profiles, tiny loops of trees on the far bank, the mossy rails of the footbridge, the wattle fence at the right. One thinks of it as the tense, idolatrous pen of the 'close looker', the pen of obsessive scrutiny and patience. In fact, its closest relative is the pen line of some early drawings by Altdorfer on plain white paper, including the manuscript illustrations to Grünpeck's *Historia*, as well as some pure fictions – the *Lady on Horseback* in Berlin, the *Couple in a Cornfield* in Basel, the *Venus and Cupid* in Berlin (illus. 159); the last two are dated 1508.[58] These palaeographic analogies, as well as Huber's work on coloured ground from as early as 1505, suggest that contact between the two may have preceded Altdorfer's Danube journey of 1511.[59] Altdorfer's independent drawings could easily have floated down-river to Passau. Altdorfer turned to plain pen on white paper

159 Albrecht Altdorfer, *Venus and Cupid*, 1508, pen on paper, 9.7 x 6.6.
Kupferstichkabinett, Berlin.

particularly when he was preparing a print. The *Historia* illustrations were supposed to become woodcuts. The *Venus and Cupid* was in fact made into an engraving.[60] But Huber's *Mondsee* lives completely in the present. The threadlike lines pull the beholder in close behind the draughtsman, compelling the beholder to duplicate the original, reverential act of looking. Depth in this landscape is created by almost imperceptible modulations in the thickness and tone of line; even good photographs flatten it out. The sheet points neither backward to a natural object, nor forward to the closure and plenitude of a fully public work.

The views of the Mondsee and of Urfahr are thus still topographies. And yet at the same time they are already independent landscapes. They have begun to emancipate themselves not from subject-matter but from topography. The foreground intrusions contest the clarity of presentation and the plenitude of information promised by the topographical report. Those intrusions are themselves the yields of the most exacting and scrupulous optical honesty. Pure mimesis here defeats itself; it is the victim of what might be called perspectival irony. The self-defeat of the low point of view runs parallel to the inversion of subject and setting in narrative. In this case, impertinent foreground objects and wide open sky compete with the proper object of the topographical drawing, namely, the natural and architectural landmarks. The town of Urfahr and its hills are wedged between sky, blank river and disembodied rooftops. The Mondsee is interrupted and obscured by a mere footbridge. A feeble pollard willow in the foreground, the closest approximation of a human figure in the drawing, becomes the unlikely protagonist. Setting threatens to humiliate the topographical

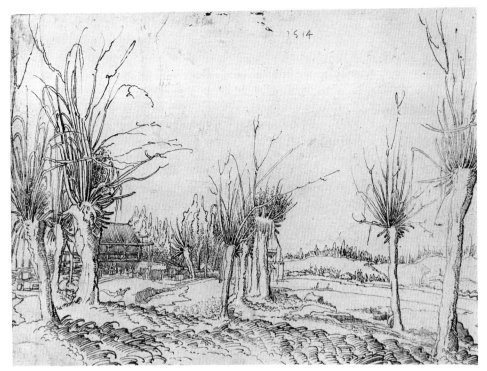

160 Wolf Huber, *Willow Landscape*, 1514, pen on paper, 15.3 × 20.8.
Museum of Fine Arts, Budapest.

fact, to reduce it once more to the status of setting. The topographical fact starts to look dead in comparison to a springy tree, a mountain face, an expanding sky. What makes the *View of the Mondsee* a *picture* is finally its unremitting sensitivity to its own edges. The drawing can be parsed like a classical period, as if it were the end product of a dozen draughts. Huber knew exactly where to stop describing. He drops three clusters of rocks into the foreground, then leaves the bottom layer blank to balance the sky. The foremost tree, last in a parade driving obliquely into distance, closes a gap in the mountain profile. The entire surface of the earth bulges slightly, bringing the landscape to a close at the left and right, and bending every log out of the horizontal or the vertical. For all the microscopic energy, the drawing has a structure.

Huber's pen-and-ink landscapes staked their appeal on the apparently serendipitous pictorial activity of trees, bridges and forest paths. Watermills and small farms are the ostensible subjects of the *Mill with Footbridge* (illus. 115) or the two *Willow Landscapes*, all in Budapest, the latter pair dated 1514 (illus. 160).[61] But in the *Willow Landscapes* the trees themselves, grotesque fruits of human cultivation, take over the drawings. They loiter like actors without a script. When Huber's landscapes become vertical in format, the line bends toward the fantastic. In the *Castle Landscapes* in Oxford and Berlin, from the early or mid-1510s, chimerical mountains and castles rise straight up out of the forest as if to answer the anthropomorphic willows (illus. 161).[62] The pen line is even and self-possessed, released from its rivalry with the contours of the natural object. From this point on, most of Huber's landscapes are fictional. Whereas prosaic attentiveness spreads outward in the plane, in Goethe's

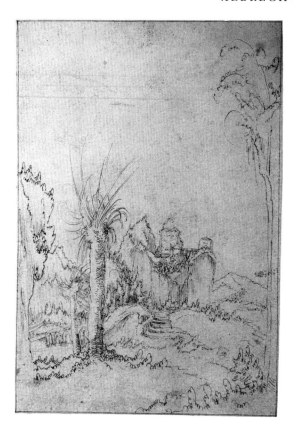
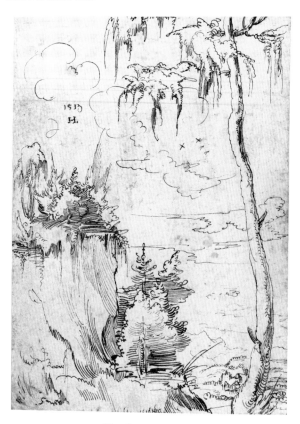

161 Wolf Huber, *Castle Landscape*, 1510s, pen on paper, 19.1 x 13. Kupferstichkabinett, Berlin.
162 Hans Leu the younger, *Landscape with Cliff*, 1513, pen on paper, 22 x 15.8.
Kunsthaus, Zürich.

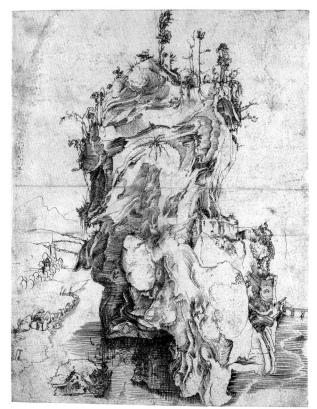

163 Niklaus Manuel Deutsch, *Mountainous Island*, pen on paper, 26 x 19.8.
Kupferstichkabinett, Berlin.

164 Albrecht Altdorfer, *View of Sarmingstein*, 1511, pen on paper, 14.8 x 20.8.
Museum of Fine Arts, Budapest.

terms, fantasy imagines objects mighty and steep. Once the formulas of fiction had been established, there was little piety for the facts of topography. After Urfahr, the Mondsee, and the view of the Harburg of 1513,[63] only four or five of Huber's landscapes depict identifiable places.[64] In the vertical drawings, especially, the manipulations of foreground trees and the perverse perspectives on architectural elements begin to overlap with the new unstable or 'folded' compositions with figures. The *Willow Landscape* in Berlin (illus. 114) tentatively builds a space back into depth, then masks it with a screen of trees. In his vertical landscapes, Huber preserves the technique of the early topographies, but adopts the format, structure and mood of vertical narratives. Huber's vertical landscapes are affiliated both with Altdorfer's coloured-ground drawings and with his own narratives on plain white paper.[65] Huber's poetic vertical distortions of landscape and its conventional motifs exactly parallel Altdorfer's ludic and satiric warping of subject-matter.

Huber's production rapidly began to proliferate in several directions at once, and he continued to monogram and date landscape drawings until a year before his death in 1553.[66] The quantity of surviving drawings, the dates and the monograms, and above all the incidence of multiple copies indicate that Huber succeeded in establishing some kind of a market for independent landscape, comparable to and contemporaneous with the Venetian market for the landscape woodcuts and drawings of Titian and Domenico Campagnola. By the middle of the 1510s, Huber's drawings

165 Albrecht Altdorfer, *Willow Landscape*, c. 1511, pen on paper, 14.1 X 19.7.
Akademie der Bildenden Künste, Vienna.

were being copied by other hands. Yet despite the evident success of his landscape
formula, few among Huber's peers thought to follow him. Only the Swiss experi-
mented with the fictional pen-and-ink landscape in vertical format. A landscape by
Hans Leu the younger in Zurich is monogrammed and dated 1513 (illus. 162).[67]
The drawing starts as a cliff, like the study-turned-picture by Leu's countryman Urs
Graf (illus. 71). But the lanky, moody tree at the right closes off the picture surface.
In the 1510s Niklaus Manuel Deutsch drew a *Mountainous Island* in the shape of a
grotesque head (illus. 163).[68] As independent-minded as the swashbuckling Graf,
Manuel simply let his contours flow until the rock melted. It is a fanatically vertical
drawing, the antithesis of a panorama: for here the earth itself has lost contact with
the earth. The biographical contacts between Huber and the Swiss are difficult to
establish. Koepplin has suggested, indeed, that the provocation to draw landscape
may have come from Altdorfer rather than Huber, perhaps by way of Nuremberg,
where Leu seems to have spent some time in the early 1510s.[69]

Altdorfer never drifted as far from topography as the Swiss did. His *View of
Sarmingstein*[70] and the *Willow Landscape*,[71] like Huber's early landscapes, are funda-
mentally views of places (illus. 164 and 165). Altdorfer drew them from the banks
of the Danube in 1511. That journey took him at least as far as Castle Aggstein in

the Wachau, which is attested in the background of his woodcut *St George* of 1511,[72] and possibly as far as Vienna. The works are the only documents of the trip.[73]

There is no proof that the two pen drawings were done from life. But there rarely is proof. One expects from a life drawing a certain irregularity or intractability of detail. The random detail – again the effect of the real – convinces the beholder that the draughtsman has recorded precisely what he saw, without excessive regard for pattern or decorum. Even this calculation will not guarantee that a drawing was physically executed out of doors. Altdorfer's drawings could conceivably be *Reinzeichnungen* or fair copies worked up, indoors, from more informal sketches.[74] But this is not the impression the drawings make. The *plein-air* encounter leaves a trace, the imprint of the draughtsman's haste before the multiplicity of phenomena, or of his despair in the face of a problem beyond his technical means, or of his satisfaction over an ingenious solution to a problem. The dramatic compression of the moments of witnessing and of bearing witness is accompanied by a certain sense of adventure – especially during this infancy of life-drawing. The draughtsman confronted with the full complexity of the earth's surface quickly discovers the limit of his descriptive powers. The trace of the out of doors, the mark that the draughtsman leaves on topography, is what happens when that limit is breached.

It is often very hard to say whether Huber's drawings were done directly from life or worked up from sketches, or whether indeed they were not complete inventions. The same is true of Altdorfer's *Willow Landscape*, and would be true of *Sarmingstein* had Meder not identified the place. However, these drawings bear all the marks of the dramatic encounter with the natural datum. They employ the formulas of *plein-air* drawing: horizontal format, low point of view, arbitrary intrusions of banal objects into the field of vision, hurried, unintelligible, or even excessively reverent line. But at the same time they are already fictions. For these drawings are all highly composed, alert to two-dimensional pattern and the edges of the picture-field; they are stylish, finished, and often signed or dated.

Life-drawing in this period is the aberration. The old model-book landscapes, the workshop templates and paradigms, were all fictions. So were Huber's and Altdorfer's drawings. The only difference was that the new fictions *referred* formally and structurally to an original outdoor encounter, even if that encounter never actually happened. The trace of the life-drawing is absorbed into the fiction. These are highly packaged topographies.

This packaging in the *View of Sarmingstein* takes the form of both vertical exaggeration and a rhetorical overburdening of the pen line. Both these themes were salient in the coloured-ground drawings. The continuity of *Sarmingstein* with Altdorfer's other drawings resides in hyperbole and in the preenings of the pen. Indeed, the attribution is founded on this continuity. (At the same time, the date is so obviously written by Altdorfer that it almost suffices as proof; it is of no importance that its ink is slightly browner than the rest of the drawing.) The method of drawing mountains by tracing dentate outlines, shading them with tight rows of single strokes, and finally coating them with trees made with impatient elliptical loops is abundantly familiar

166 Albrecht Altdorfer, *St Christopher*, *c.* 1510, pen and white heightening on green grounded paper, 17.9 X 14.4. Graphische Sammlung Albertina, Vienna.

from Altdorfer's drawings, for example the backdrop of the *St Christopher* on green ground in Vienna (illus. 166).[75] The mountains in this drawing stretch and overcome the scored plane of the water, as if in comical geological collusion with the gravitational pull which tumbles the saint. The *View of Sarmingstein* is a denser and more disciplined drawing than any of the coloured-ground drawings, more compulsively intent upon its object, obedient to a more inflexible genius. The outlines of the mountains are crisp and attenuated; the rows of shading strokes are so tightly ranged that they produce an almost metallic sheen; the trees are less flippant, indeed some are even shaded horizontally. (The pen line of the *View of Sarmingstein* is actually finer and less bold than it appears in reproductions.) One is inclined at first to explain this density as the consequence of the topographer's earnestness and attentiveness. But in fact the line of *Sarmingstein* is the same tense and fragile line of the other early, entirely fictional, drawings on plain white paper. It is, again, the line of the *Venus and Cupid* (illus. 159), of the *Couple*, of some of the *Historia* illustrations; the line that Huber extended into his *View of the Mondsee*. It is a line that shrinks from the calligraphic and nevertheless parades as an artefact, as the only vaguely reliable trail of a highly selfconscious hand. The frequency of its tremors and the tight radii of its curves should not be mistaken for any special reverence for the object. What, then, is the distinction between the drawings on plain paper and those on coloured ground, if it is not subject-matter or tone? It may only be the medium. Plain paper normally put up a slightly stiffer resistance to the flow of the quill pen. The only coloured-ground drawing to share this line was Altdorfer's early *Samson and Delilah*, dated 1506.

The *View of Sarmingstein* focuses on a fortified church at a bend of the Danube. The place was identified by Meder, with the help of Matthaeus Merian's *Topographia provinciarum austriacarum* (1649), and local historians, as Sarmingstein, just below Grein, about forty miles downstream from Linz. Altdorfer described both steep banks of the river, the slouched terraces of fir and rooftop and the stone wall, the cylindrical gate-tower already in ruins and almost lost among the brush, the wooden bridge over the mouth of a mountain tributary, and the hedged road at the river's edge.[76] The church and its outlying structures cover the centre of a great perspectival X, a diagonal quartering of the drawing surface. Sarmingstein is very much the functional, and no doubt the literal, starting-point of the drawing. The church itself, whose roofs and walls and windows are accounted for with some degree of precision, benefits from a kind of attentiveness lacking in the remainder of the drawing. At the same time, the church is a terminus, the embattled target of centripetal forces generated by the taut coils and chords of ink. These forces descend on Sarmingstein along the arms of the perspectival X, vibrating with concerted tension.

The modelling strokes are pulled out of the vertical; the mountain at the extreme upper-right is bent into a quarter-circle; soft and meaningless arcs are described in the sky. This force in the drawing, which seems to disdain objectivity, is the compulsion to organize the topographical data into a composition. The pictorial organization of the *View of Sarmingstein* is manifested in the coordination of the topographical

object – the church and its outbuildings – with its setting. That coordination is achieved by means of a two-dimensional figure, that X which exists only on paper and yet does not quite negate the empirical world. This chiasmus serves as an internal frame, a stretcher, for the entire picture, independent of the topographical object, and at the same time it preserves the primacy of that object. The X is the equilibrium of mutually indifferent forces: the more or less systematic projection of a three-dimensional continuum onto a plane; the artist's consciousness of pattern in that plane and his constant awareness of edge and corner; the tendency to exaggerate vertically; the energy of the stylish pen line. The vertical shading lines in the mountains at the left lean first in one direction and then the other (they shift not so much from left to right as toward and away from the focal buildings). The hostile bluff behind the church leans hard to the left and appears almost to twist back upon itself. The rotation at the upper-right is both a surrender to the pull of the centre and a shrinking from the confines of the corner. The fortification itself has fallen back upon itself, settling back on its haunches as if better to absorb the shock of the converging river-banks. At the same time, the triangles of river-bank are expected to generate an illusion of depth, of spatial recession. This is one of the effects of the loose, calligraphic modelling lines in the upper-right of the picture. They are less densely packed than their counterparts in the distant mountains, as if they somehow represented real lines in the mountain face and their spacing were simply a function of their proximity to the picture plane. There is in fact no reason why abstract modelling lines should change their form as a function of apparent distance. The effect is disconcerting, for one can imagine that the distant modelling lines would also expand into an equivalent looseness and springiness if they could be seen at closer range.

The *Willow Landscape* is an even more demonstrative drawing (illus. 165). The two trees of the foreground and the meaningless knoll of the foreground, the very ground the draughtsman sits on, are the progeny of the same compulsive literalism that afflicted Huber the topographer. The sheet is undated, but Meder associated it closely, and not unreasonably, with *Sarmingstein*, on the basis of the buildings visible in the middle ground. Nevertheless, the trees obstruct the view to such an extent that it is impossible to be sure. The topographical object has been overwhelmed by the composition. The triangular narrowing of the valley from left to right is perfectly explicable in its own right. But when the spatial recession represented by that planar convergence (i.e., from front left to right rear) is crossed at right-angles, impertinently, by the vector of the crippled willow (from front right to left rear), then suddenly the relationship between surface pattern and spatial illusion is perceived as a relationship of tension. Instead of seeing a place, the beholder sees overlapping triangles and intersecting planes. The slope of the mountain at the left, even with its crooked terraces and its shifting modelling lines, becomes a single plane, and the dark oblique face of the more distant mountains still another plane, each slightly out of alignment with the planar sweep of the entire valley. The curve of the second willow, amazingly, becomes an object of interest. This sort of double meditation (draughtsman's and beholder's) on how space

is filled only takes place on two-dimensional surfaces. Space does not become interesting until it is empirically annihilated, flattened on a picture plane.

The most headstrong fictional device in the *Willow Landscape*, the most conspicuous discontinuity between observation and execution, is the pen line. The monogrammed tablet suspended from the lesser tree is not autograph, but rather the well-informed, perspicacious, or fortuitous gloss of a later owner. For the attribution cannot be doubted. In effect, the drawing is signed: the scrub at the lower edge, at the foot of the bent tree, has degenerated into a kind of indecipherable organic scribble, calligraphic, unrepeatable, no longer of the represented world. This is not merely a broader spacing of the modelling network at closer range, as in *Sarmingstein*. In passages like this, the pen temporarily uncouples from mimetic responsibility. Such passages serve as signatures throughout Altdorfer's work, for example in the foregrounds of the London *Wild Man* (illus. 105), the Weimar *Couple*, the *Beheading of St Catherine* in the Akademie in Vienna, or some of the *Historia* illustrations.[77] The grassy flourish recalls Dürer's swift landscape sketch (illus. 35), where half-automatic scratchings assumed the form of the outdoor object. Such passages are naturalized versions of the scribe's calligraphic flourish, or the unrepeatable paraph of the medieval clerk (see p. 62). In Altdorfer's drawn *View of Schloss Wörth* a calligraphic flourish in the sky may actually replace the monogram (illus. 187). Altdorfer drew the same mark, with a brush, before and after his monogram in the *Susanna and the Elders* panel, on the tree at the lower left (illus. 55). Oettinger thought he saw A and A intertwined in the flourish, and wondered whether Altdorfer was experimenting with a new signature. Erhard Altdorfer, finally, on a woodcut title-page in the Lübeck Bible of 1531–4, wedged his own monogram among the loops of just such a flourish.[78]

Signatures fulfil their purpose by being inimitable. What makes the scribbled grass in the foreground of the *Willow Landscape* inimitable? It is not absolutely random, for like any signature it is grounded in a representational code, in this case what might be called the orthography of vegetation. Individual curves and flourishes may respect an ornamental logic, by tapering or diverging according to some abstract or geometrical principle. And yet the entire cluster of pen marks gives an impression of randomness. The individual line, on close examination, represents nothing. The lines are juxtaposed meaninglessly and adventitiously. This crypto-signature cannot be reduced to any single rule or proposition.

The random line, then, is fundamentally an unpredictable and unrepeatable line. The effective guarantor of these qualities is the speed of the draughtsman's hand. The hand moves faster than the mind; the pen stroke cannot be broken down into a series of component decisions. The word 'random', indeed, derives from the Old French *randir*, meaning 'to run'. The haphazard happens quickly; it is the movement of a horse running loose, out of control. The horse makes its decisions on the run, shifting direction instantaneously, although not necessarily irrationally. This is the sort of impetuous movement Goethe was seeing when he made these notes about Dürer and his contemporaries: 'They all have, more or less, this meticulousness [*etwas Peinliches*], in that when confronted with monstrous objects they either lose

their freedom of action, or assert it, insofar as their spirit is great and has grown toward those objects.' Goethe conveys precisely the precariousness of a fastidious description. 'Thus in all their observations of nature, even in the imitation of it, they pass over into the adventurous [*ins Abenteuerliche*], indeed become mannered.'[79]

The adventurous draughtsman exploits the quill pen. The quill leaves a margin of 'play' or 'give' between hand and paper that permits great sensitivity but also great freedom, including the freedom to wander or err. The minute tremors of the quill-drawn line can register the contours of a leaf or the vagaries of a physiognomy. In the same instant, the quill can slide just out of control, slightly beyond the radius of intention. The antithesis of this equilibrium between singularity and accuracy is the earthy, emotional chalk stroke of Grünewald. Although he was the only outstanding figure of his generation not to stake his career on graphic work, Grünewald was nevertheless a superlative draughtsman. His chalk is attentive exclusively to surface, to the muted broadcast of light on surface. This is not to say that line is absent; on the contrary, his quavering drapery hems and spiralling rows of pleats are among the comeliest linear effects of the High Renaissance. But these contours are by-products of the reverence for surface, and have nothing to do with the undisciplined play of the drawing instrument.

Altdorfer's two black-and-white landscapes hover just on either side of this ideal equilibrium between sensitivity and freedom. The quill of *Sarmingstein* is tightly gripped and registers contours like the needle of a scientific instrument, in a fuzzy vibrato. The pen passes over into the adventurous only in the interiors of the mountains, as a diversion from the monotony of modelling, or in the sky, where there are no contours at all. The *Willow Landscape*, by contrast, begins to surrender to the momentum of the random. The bent tree is itself a calligraphic singularity writ large. Here Altdorfer takes the liberty of haste. His distant forests are scribbles. His *ad hoc* procedure leads him into culs-de-sac, like the row of trees that overlaps the modelling strokes in the cliff behind, just to the left of the base of the bent tree, or the icy mountain profiles at the upper-left that failed to meet and were instead, expediently, joined by a diffident and unconvincing vertical drop. The corollary of the freedom to bend lines is the freedom to omit lines. The wide blankness of the mountains would be inconceivable in *Sarmingstein*, where an obsession with transcription and a *horror vacui* combined forces to fill the sheet to its edges.

The adventurous line eventually abolishes the existential distinction between one object and the next. Once line is read as a trace of a manual gesture, its reference to an empirical signified is weakened. The trace is present and persuasive, whereas one absent signified is as good as another. Once subjected to such treatment, even terrain can spill upward over the horizon and flood the sky. This happened in Altdorfer's *Battle of Alexander*, but also in the furrowed, pulsating skies of Huber's drawings (illus. 200).[80] Style converts sky into upside-down landscape. The human figure is equally vulnerable. Wölfflin first called attention to the visual rhyme between the hunched figure of St Anthony and the hill-town in the background of Dürer's engraving of 1519 (illus. 168).[81] Dürer petrifies his subject-matter. He means to

167 Albrecht Altdorfer, *Saint, c.* 1517–18, pen on paper, 11.1 x 9.8.
University Library, Erlangen.

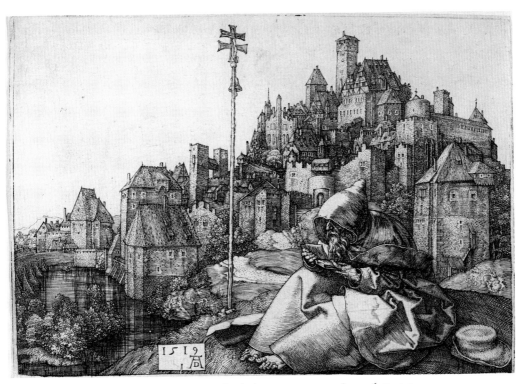

168 Albrecht Dürer, *St Anthony*, 1519, engraving, 9.6 x 14.3.
Metropolitan Museum of Art, New York.

231

169 Wolf Huber, *Portrait of a Man*, 1517, pen on paper, 14.4 X 11.
Guildhall Library, Corporation of London.

evoke by this device the monumental, imperturbable gravity of the saint's person. But the device also bleaches out the distinction between setting and subject. The power of the visual rhyme – the signifier – seduces the beholder into experiencing the engraving on another level; seeing prevails over knowing. The engraving becomes all setting, like a landscape.

Altdorfer made a man-mountain of his own in a fine-spun pen drawing of a saint in Erlangen (illus. 167).[82] This is the exact opposite of a landscape with anthropomorphic trees or cliffs. A cliff becomes a person when its random contour all at once resolves into a meaningful profile. The silhouette of the human figure is so distinctive that when it emerges in a landscape it dispels randomness; meaning adheres to the profile. The loose or arbitrary landscape motif will all at once look overdetermined. The human figure that starts to look like a mountain, on the other hand, dissolves back into randomness. It is a human contour whose distinctively human lumps and excrescences have all collapsed inwards, toward the finitude of the monolith. Altdorfer's pen then begins to create its own excrescences, as if reanimating the statue. The pen circles in upon itself, performing hundreds of licks and feints within the body. The halo is an obvious object to describe with a clean sweeping stroke; instead the line dances. Huber, meanwhile, in a portrait drawing of 1517, described a face with the very lines he ordinarily used to describe terrain. The face is modelled with curved rows of interior contours (illus. 169).[83] The pen moves around the face and the garment as if it were still inside the *Golgotha* landscape (illus. 200). Once one has seen this face–landscape, it is hard to look back at Huber's real landscapes in the same way.

Such examples spell out an alternative to a theory of early landscape grounded in content or the absence of content. They question the very category 'landscape'. Why study landscapes separately from other kinds of pictures? Why indeed, if the real story being told is the genesis of the historical category 'work of art'? When an artefact is experienced as a presence rather than as the sign of an absent object, distinctions of content fade in importance. This is no anachronism. The power of the phenomenal image to disrupt its own reading shadowed the entire history of Christian art. Fear of this disruption lies at the source of the iconoclastic impulse. Over the course of the sixteenth century this experience was domesticated and institutionalized in aesthetic doctrine, in prints, in collecting, in the entire secular culture of images. This culture was of course not so indifferent to content. It actually protected the landscape. The empty landscape became the emblem of the new legitimacy of the phenomenon, and of its new authority over subject-matter. Landscape as a work of art, curiously, had no trouble absorbing the re-introduction of story and time. Landscape would survive the loss of its strict independence from subject-matter. For from this point on, the genre 'landscape' stood for the institutional independence of the framed image, any framed image.

5

The published landscape

One of the cornerstones of the new secular culture of pictures was the print. Altdorfer trumped Huber when he discovered a way to reproduce his landscape drawings mechanically. Altdorfer made nine landscape etchings, seven of which are horizontal in format, the other two vertical (illus. 171–9).[1] All are monogrammed, none are dated. A tenth etching, horizontal in format, is monogrammed by Altdorfer's brother Erhard (illus. 180).[2] These etchings had low print runs, a limited direct audience, and almost certainly no international audience. They were revolutionary landscapes, but they ignited no revolution. German printmakers were imitating Altdorfer's invention as early as the 1530s; most important were the landscape etchings of Augustin Hirschvogel and Hanns Lautensack of the 1540s and 1550s. Any influence that Altdorfer's landscapes exerted was indirect, through the agency of these epigones. In Antwerp in the 1550s and 1560s, notably, the cunning printmaker and publisher Hieronymus Cock published entire albums of landscape prints, capitalizing on Patenir and the Flemish world-landscape. Cock hired an artist recently returned from Italy, Pieter Bruegel, to design his landscapes. Titian and some of his followers, meanwhile, had been publishing landscape woodcuts in Venice since the late 1520s. The Venetian prints had their own independent impact on Cock's production. Landscape rapidly became one of the major categories of collectable prints. This landscape was no longer green. Greenness had been the primary epithet of the lost outdoors; even Erasmus had seen the wisdom of God manifested in 'greening' nature (*naturae vernantis*).[3] But humanists reflexively mistrusted painted colour. Erasmus, when he eulogized Dürer's black lines, spoke for the most rigorous and suspicious of them. The print stripped the landscape down to its skeleton. It detached the representation of landscape from the putative psychological function of real landscape. The black and white landscape thus opened a gap – or revealed a gap – between the critical amateur and the beholder who sought a memory or a promise of recreation in a surrogate nature.

Altdorfer's public

Who was the first audience for Altdorfer's landscapes? By the early 1520s, the years of the etchings, Altdorfer was firmly established in Regensburg. Since 1517 he had been a member of the Outer Council; in 1518 he bought a second house (which he sold in 1522). In 1519 he played a central role in the management of the sensational local cult, the pilgrimage to the Schöne Maria. From 1520 to 1525 he directed the

office of the *Hansgrafenamt*, which oversaw the city's craftsmen. In 1525 he was appointed director of a charitable institution in Ingolstadt. By 1520 or so, after he had completed his great altarpiece at St Florian and his various projects for the Emperor, Altdorfer may well have dissolved his workshop – just as Dürer did at a comparable point in his career – and retreated to more manageable and private projects.

Hans Tietze once said that Altdorfer painted for sophisticated amateurs, and that the first among them was the painter himself.[4] Artists were in fact the earliest collectors of drawings, and not merely as models or practical examples. Dürer owned and inscribed pen drawings by Schongauer. Samuel von Quiccheberg, the Antwerp physician who organized the Wittelsbach art collections along systematic lines, reported in 1565 that Hans Burgkmair had collected drawings.[5] One has to reckon with the possibility that Altdorfer's most eccentric pictures stayed in his shop, or migrated no further than another artist's shop.

Only one landscape by Altdorfer can be linked even tentatively with a historical person: the watercoloured drawing, dated 1524, of Schloss Wörth on the Danube, one of the residences of the Regensburg Bishop-Administrator Johann III von der Pfalz (illus. 187). Doubtless Altdorfer had all the contact he wanted with Johann, who held his office from 1507 until his death in 1538, and whose career in Regensburg thus overlapped almost to the year with the painter's. Old portraits of Johann, like the one by Hans Wertinger reproduced here (illus. 170), used to be attributed to Altdorfer. Altdorfer did make portraits – a pair survive – and may well have made

170 Hans Wertinger, *Portrait of Johann III von der Pfalz*, 1520s, oil on panel, 70 x 47.5. Bayerische Staatsgemäldesammlung, Munich.

one of the Bishop-Administrator.[6] Johann probably commissioned the Prayer Book of 1508 now in Berlin, which was executed by an artist close to Altdorfer. But there is no reason to believe that Johann took any special interest in landscapes and other portable pictures. His tastes ran, apparently, to more conspicuous luxuries. In 1535 Altdorfer painted an ingeniously prurient suite of frescoes in the baths of the episcopal residence in Regensburg. The painted architecture appears to emulate a contemporary

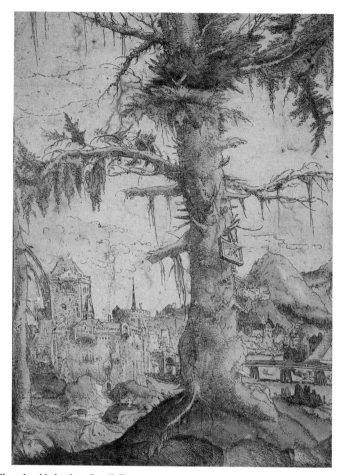

171 Albrecht Altdorfer, *Small Fir*, *c.* 1521–2, etching with watercolour, 15.5 X 11.5.
Graphische Sammlung Albertina, Vienna.

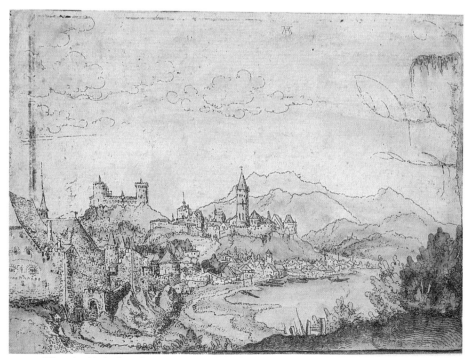

172 Albrecht Altdorfer, *City on a Coast*, *c.* 1521–2, etching with watercolour, 15.5 X 11.5.
Graphische Sammlung Albertina, Vienna.

173 Albrecht Altdorfer, *Large Fir*, *c.* 1521–2, etching with watercolour, 22.5 X 17.
Graphische Sammlung Albertina, Vienna.

174 Albrecht Altdorfer, *Landscape with Large Castle, c.* 1521–2, etching, 10.8 x 14.9.
Kupferstichkabinett, Berlin.

175 Albrecht Altdorfer, *Landscape with Fir and Willows, c.* 1521–2, etching, 11.5 x 15.5.
City Museum and Art Gallery, Plymouth, Cottonian Collection.

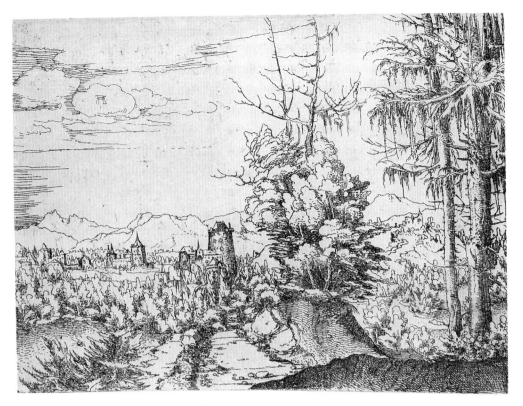

176 Albrecht Altdorfer, *Landscape with Two Firs*, *c.* 1521–2, etching, 11 X 15.5.
Kupferstichkabinett, Berlin.

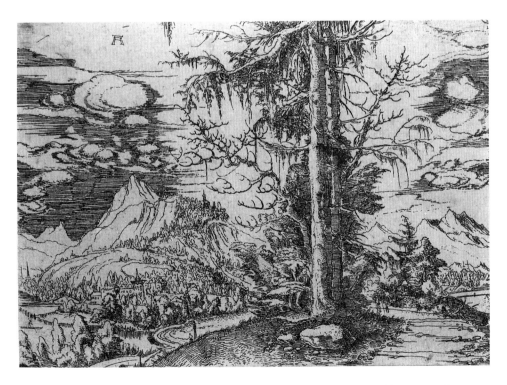

177 Albrecht Altdorfer, *Landscape with Double Fir*, *c.* 1521–2, etching, 11 X 16.
Kupferstichkabinett, Berlin.

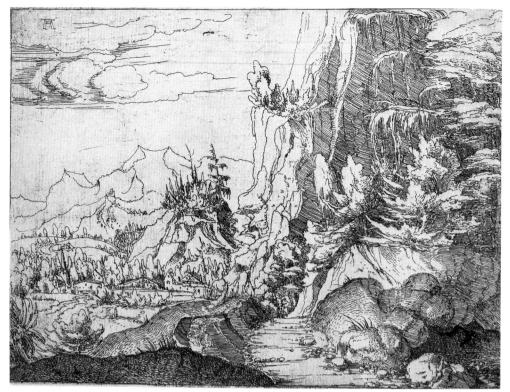

178 Albrecht Altdorfer, *Landscape with Cliff*, *c.* 1521–2, etching, 11.5 X 15.5.
Kupferstichkabinett, Berlin.

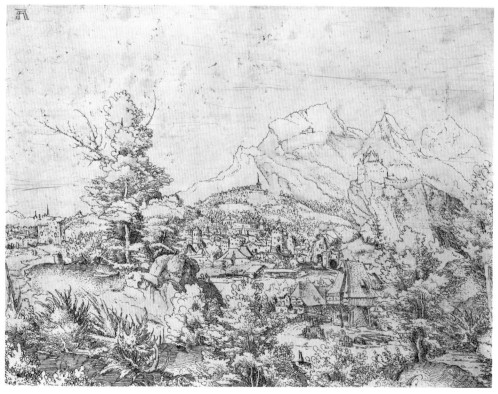

179 Albrecht Altdorfer, *Landscape with Watermill*, *c.* 1521–2, etching, 17.4 X 23.
National Gallery of Art, Washington DC, Ailsa Mellon Bruce Fund.

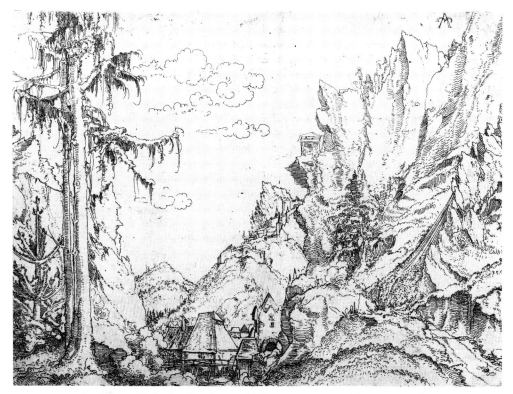

180 Erhard Altdorfer, *Landscape with Fir*, c. 1521–2, etching, 11.7 x 16.2.
National Gallery of Art, Washington D C, Pepita Milmore Memorial Fund.

addition to the Residenz in Trent – the best evidence yet that Altdorfer visited Italy.[7]

More important for the development of the first independent landscapes were probably the urban circles centred on humanist poets and antiquaries: the friends, acolytes, patrons and publishers surrounding men such as Conrad Celtis, Konrad Peutinger, Johann Cuspinian and Willibald Pirckheimer. Dürer, the son of a gold-smith, penetrated to the core of such a circle. Although many of the urban humanists had studied in Italy – at Padua or Bologna – they did not necessarily maintain academic ties. Celtis and Cuspinian held university posts, but Pirckheimer, a thorough patrician, practiced diplomacy and war alongside his philological pursuits. Celtis shaped several such circles into 'sodalities', German versions of the Italian neo-Platonic academies, which sponsored publications and devised fantastic, symbolic political 'programmes'.[8] The pattern held in Germany for no more than a generation, until the Reformation and the attendant crisis of the Holy Roman Empire began absorbing attention and energy.

The humanist societies flourished especially in the wealthy Imperial cities of Nuremberg, Augsburg and Strasbourg, which were unburdened by local potentates maintaining expensive courts. Elite culture in Bavaria, for example, was dominated – indeed somewhat stifled – by the Wittelsbach courts at Munich and Landshut.[9] The only major southern German painter to join the household of a prince was Cranach in Saxony. Martin Warnke has argued that Renaissance courts gave artists

unprecedented freedom and thus prepared them for modern self-reliance. The humanists hovering around the courts provided a conduit to the open market, and they began to surround art with critical writing and conversation.[10] Altdorfer's Regensburg, saddled with an unlettered Bishop-Administrator, offered nothing of the sort. But many of the best artists in southern Germany did enjoy the best of both worlds: they made forays into court service, but maintained residences, and their independence, in the cities. Wolf Huber in Passau, for example, at one point Altdorfer's virtual colleague, eventually found an audience among the humanists at the court of Bishop Wolfgang von Salm in Passau.[11] This flexibility was possible because urban painters' guilds in this period remained weak. Of course the guilds were weak precisely because the outstanding painters were too wilful and refused to co-operate. Indeed, in Nuremberg there was no guild at all until 1596.[12]

All the earliest collectors of small secular panels and prints must have had experience of northern Italian engravings. German antiquaries were decidedly literary-minded. Their curiosity about classical artefacts ran to coins, medals, inscriptions, maps. Deciphering iconography was a 'readerly' exercise, just as it is for modern art historians. Konrad Peutinger in Augsburg, for example, who was Maximilian's iconographical adviser, and who designed hieroglyphs and the programme of the Triumphal Arch, betrays in his writings little real interest in pictures. The real public for the new secular images must surely have held opinions on contemporary art. They had to know something about the ordinary devotional image, and about the functions it had been expected to perform; they must also have had some notion, garnered from travel or from conversations with travelled artists, of the recent history of German and Flemish painting, and also, perhaps, a feel for the best engravings or manuscript illumination. They had to be attentive to medium and technique, and be capable of isolating and judging pictorial devices and strategies. This was the sort of audience that was looking at Dürer's early engravings, Altdorfer's engravings that imitated *nielli* and his coloured-ground drawings, Baldung's esoteric and erotic painted panels, and the wood reliefs of Hans Leinberger or the Master I.P. Some must have begun collecting systematically – seeking out an impression of *every* print by Dürer, for example – although there is no hard evidence of systematic collecting at this date. The oldest print and drawing cabinets were assembled by the heirs to artists' workshops. Archduke Ferdinand of Tyrol compiled his massive collection of Netherlandish and German prints only at the end of the sixteenth century.[13] The oldest collection still intact today belonged to Hartmann Schedel, the author of the Nuremberg Chronicle, dean of Nuremberg humanists from the 1480s, and close friend of Pirckheimer's father. Schedel, who died in 1514, used to paste woodcuts and engravings, and even some drawings, into his books.[14] There must have been a transitional stage, now vanished and thus untraceable, between Schedel's method of preservation and the proper albums of the later sixteenth century: prints and drawings kept loose in portfolios and cabinets, for example. Thus one imagines the patrons and friends of Dürer and Altdorfer putting down the first layer of a recognizably modern, lay culture of collecting and connoisseurship.

The new learned taste for small pictures frequently overlapped with a taste for sheer colour or texture, for example in Altdorfer's *St George* panel. Humanism, in Fedja Anzelewsky's phrase, generally tempered a prevailing asceticism.[15] Humanist elitism and anti-ecclesiasticism was often translated into a contempt for everyday devotional images and their dreary subjects. After all, the old culture of secular imagery – above all the courtly and domestic murals and tapestries – had been more carnal and worldly than it was erudite. And after the Reformation, the fleshly impulses came to dominate again. Altdorfer's late engravings and the prints of the so-called Little Masters – the Behams, Georg Pencz, Heinrich Aldegrever, all pupils of Dürer and followers of Altdorfer – were often frankly pornographic.[16] Ostendorfer, Altdorfer's pupil in Regensburg, was sympathetic to the Reformation. He made his way in the 1530s by painting profane and worldly Old Testament subjects: Lucretia, Judith, Bathsheba. Presumably he lived off a local market primed by Altdorfer.[17]

Nevertheless, the essence of the humanist culture of pictures was not its worldliness. What was really new was the critical attentiveness to the practical problems of picture-making. This implied a willingness on the part of beholders to work backwards from the picture to the artist, to reconstitute, in the imagination, the process of creation. The idea of style – the mark on the picture surface read as the trace of the artist's hand – began with the artist's desire to assert a public presence. But the success of this gesture depended on a public open to this presence. The humanist public was eager for manifestations of virtuosity. Perhaps they had read Pliny's anecdotes about the Greek painters, or perhaps they were simply chauvinists looking for a counter-argument to the assumption of Italian cultural supremacy.

A humanist education was fundamentally rhetorical and philological. Literary humanists of Altdorfer's and Dürer's generation not only edited and published the corpus of classical lyric, but also composed huge quantities of neo-Latin verse. The sub-culture of humanist lyric provided models, historical and living, for the self-conscious and self-promoting artist. For the crucial formative decades, the last two before the Reformation, there is little evidence of a learned pictorial culture apart from the artefacts themselves. Judgements and hypotheses must have been honed in conversations. But they rarely made it onto paper. German humanists were, on the other hand, constantly apologizing for pagan literature. The poet Hermann von dem Busche, for example, complained of the anti-humanist sentiment among the faculty at the University of Cologne. 'One criticizes the extravagances of mythological fables', he wrote in 1518; 'another rails against the seductions of language, and another criticizes certain supposedly improper aspects'.[18] Would the humanists not have had to defend secular paintings against a comparable hostility? In conversation they must have developed a repertory of critical terms – like the terms increasingly clinging to poetic and rhetorical practice – well beyond the technical problems discussed in the workshop and the commercial formulas of altarpiece contracts. Some of the humanists must have seen the treatises and written dialogues on art circulating in northern Italian courts or in Florence. The German circles were, after all, the self-styled rivals of the humanist societies of Venice or Bologna.

All this surely made little sense to most artists. The various treatises which German artists published in the sixteenth century addressed methodical and technical problems, especially perspective.[19] Even Dürer, who visited Venice twice, and probably Bologna as well, in some ways never escaped the mentality of the workshop. The critical revolution has to be inferred, for example from the documented enthusiasm of the most sophisticated historians and literary humanists for Schongauer, Dürer and Cranach. Pirckheimer's remarkable friendship with Dürer, the intellectual energy he brought to bear on the artist's project, is attested in letters, writings and works. The lost conversation even echoes in the artists' own self-representations. Dürer portrayed himself in a humanist's fur-lined robe, flanked by a Latin inscription. Burgkmair, mindful of Pliny's anecdote about Apelles and Alexander, showed himself in a woodcut designing hieroglyphs for an attentive Emperor Maximilian. Ambitious artists found their own images in humanist discourse and in Antique texts as if in a mirror. But rarely did a humanist say anything in writing about pictures.

Altdorfer is actually the most interesting artist of the period who is *not* mentioned in a humanist text. Regensburg, although a free Imperial city like Nuremberg, was arid ground for literary culture. The city did not even have a printing-press until 1521. There was no visible society of humanists in Regensburg. The intellectual centre of the town was the Benedictine monastery of St Emmeram. Altdorfer painted the *Two St Johns* for St Emmeram, and possibly the *Christ Taking Leave of His Mother* as well (illus. 12, 13). Humanists often stopped in Regensburg to use the library: Hartmann Schedel in the 1480s and 1490s; the poet laureate Jacob Locher (Philomusus) in 1503; Johann Cuspinian. Conrad Celtis discovered the works of Hrosvitha of Gandersheim at St Emmeram in 1493. The historian Aventinus worked systematically through the library in 1517; he eventually settled in Regensburg in 1528 and died there in 1534.[20] The monastery sponsored no particular school or intellectual tendency in this period, but it did house several notable personalities. The sub-prior and librarian Erasmus Daum (Australis) was intimate with both Celtis and the mathematician and Imperial historian Johann Stabius. The abbot of St Emmeran from 1493 to 1517, Erasmus Münzer, cultivated antiquarian scholarship and numismatism. It was presumably Münzer who commissioned Altdorfer's *Two St Johns*, which was by no means a conventional devotional painting. The monk and chronicler Christophorus Hoffmann (Ostofrancus), an erudite opponent of Luther and an apologist for the anti-Semitic instigators of the Regensburg pilgrimage, wrote poems to his humanist friends.[21] The Dominican abbey of St Blasius, Albertus Magnus's base, also kept its library up to date with humanist editions of the Church Fathers and recent Italian historical writings.[22]

The Emperor had two men in Regensburg: Joseph Grünpeck, secretary, astrologer and composer of the *Historia Friderici et Maximiliani*, who founded a Latin school in 1505; and Stabius, who was given a house in Regensburg in 1512, presumably to supervise the work on the Triumphal Procession miniatures in Altdorfer's shop. Some of the cathedral canons might have taken an interest in pictures: Johannes Tröster, a bibliophile with pagan and Stoic leanings, and Johannes Tolhopf, the

friend who accompanied Celtis on his Druid expedition; both were dead, however, by Altdorfer's time. Celtis himself was rector of the cathedral school in 1493. The Regensburg clerics doubtless had contacts with canons in Passau or Eichstätt, some of whom had university training or held professorships at Ingolstadt. Well-travelled Regensburg merchants were other possible clients.

Not a single contact between Altdorfer and any of these men is documented.[23] Altdorfer did not leave any portraits comparable to the impressive and iconic image of the geographer, astronomer and historian Jakob Ziegler, painted by Huber in the late 1540s when Ziegler was sojourning at the episcopal court in Passau.[24] There is, however, some evidence from his pictures that Altdorfer profited from contact with philologists and university men. Bernhard Saran infers from the Berlin *Rest on the Flight* of 1510, for example, that Altdorfer knew Virgil's Messianic Eclogue and Ficino's commentary on it (illus. 54).[25]

Of course, scholars, poets and artists were constantly on the road, and there is no need to seek Altdorfer's contacts exclusively in Regensburg. Vienna was one intellectual centre of gravity, Nuremberg another. Celtis had formed a group around him when he arrived in Vienna in 1497, the 'Sodalitas literaria Danubiana', which included Cuspinian, Stabius, and the astronomer and antiquarian Johann Fuchsmagen. Cuspinian succeeded Celtis as leader of the society after his death in 1508. In 1501 Maximilian founded the 'Collegium poetarum et mathematicorum' at the University in Vienna and named Celtis and Stabius, and later Cuspinian, as professors. The neo-Platonist poet Vadian, editor of Pomponius Mela's geography, was their student. This was the world that Cranach found in Vienna in the early years of the century, when he painted the portraits of Cuspinian and his wife Anna Putsch (illus. 37).[26] Koepplin has suggested that Cranach was in Regensburg in 1504; this may have provided Altdorfer's initial link to Vienna. The situation in Nuremberg is more familiar. Altdorfer had the attention and the patronage of the Emperor and his advisers, if Hans Mielke is right about the *Historia Friderici et Maximiliani*, even before 1510. This contact alone would have sufficed to make Altdorfer's reputation in Nuremberg, although Dürer must have known his work, at least his engravings, even earlier. Ingolstadt, finally, forty miles upstream from Regensburg, a university town since 1472, was the prime magnet for humanists in Bavaria. Celtis, while teaching at Ingolstadt in 1491, founded the first of his sodalities, and that society was revived in 1516 under Aventinus.

This sort of circumstantial evidence is hardly a basis for a prosopography of Altdorfer's patrons and public. It can be said, at least, that the circle of amateurs supporting his work did not need to be large. The best guess is that Altdorfer made most of his wider contacts early in his career, between 1506 and 1515. Thereafter he turned inwards and concentrated on local affairs and court commissions. In 1526 the Alsatian humanist Beatus Rhenanus left Altdorfer off his list of the outstanding German painters. Evidently there were enough local amateurs to sustain Altdorfer in Regensburg. The career of Michael Ostendorfer, his pupil, also suggests this. But that local public remains completely anonymous to us.

'Printed drawings'

Print technology in this period was amazingly quick to adapt to shifts in taste. Only a few years after the invention of the autonomous drawing on coloured ground, the German amateur could buy a mechanical imitation. The chiaroscuro woodcut, with its multiple blocks of black lines and broad areas of colour, was invented by Jost de Negker of Augsburg in 1508, although Cranach claimed precedence by backdating some of his own chiaroscuro woodcuts to 1506.[27] The chiaroscuro woodcut reproduced many of the coloured-ground drawing's most distinctive attributes: the negative effect of white lines on dark ground, and the way in which the white heightening strokes freely detached themselves from representational tasks. But since the woodcut could not deliver the direct trace of the artist, it made no pretence of competing with drawings. The chiaroscuro woodcut was no hoax or cheap substitute; the technical achievement was a component of its value. It stood alongside the drawing, just as the Italian chiaroscuro woodcut stood alongside the wash drawing with white heightening.[28] Technology exempted the woodcut from the critical judgements that would ordinarily be brought to bear on a drawing. The movement of the pen on the blank woodblock and the final product were separated by a layer of technology. The empty surfaces on the block had to be chipped away – an almost mechanical process – and the block then had to be printed. Mechanical reproduction set the question of authenticity to one side. The amateur recognized the hand of Burgkmair or Cranach, for example, frozen, fixed by technology. But the print's difference from the missing drawing – its blatantly mechanical mimicry of the trace – only enhanced the drawing's prestige. The woodcut enshrined the drawing.

Altdorfer's landscape etchings stood in an analogous relationship to landscape drawings. The etching was Altdorfer's answer to Huber's cottage industry of landscapes. The corpus of pen-and-ink landscape drawings around Huber is a thicket of overlapping copies and variations. The basic conditions of production are not yet fully understood. It is unclear, for example, whether Huber copied his own originals, whether he permitted pupils or subordinates to copy them, or whether most of the copies were done by later followers or imitators no longer under his supervision. Some copies are actually dated to the second half of the century, or even to the seventeenth century. But most date from Huber's own lifetime. Huber made a big impression on other Bavarian and Austrian artists, and it is possible that all these landscape drawings were merely circulating from workshop to workshop. But no such corpus of copies after any other group of drawings by any other artist, including Dürer, survives. The monograms and dates make it likely that Huber was targeting a lay public. One even imagines him putting his apprentices to work producing landscape drawings, and so satisfying a market for landscapes that he himself had created with his initial experiments of the first decade of the century. Well over a hundred such drawings have survived, and there must once have been many more. But it is extremely difficult to discriminate between originals, Huber's own copies,

and the copies of pupils or followers without knowing how important it was to Huber himself to simulate or preserve the attributes of the original in those copies. Did he relax the linear tension in the copies, or blur the trace of the original act of creation, confident that wider circles of beholders would not regret the loss? Certainly he did not permit his monogram to be used indiscriminately. The dates refer to the date of the copy and not the date of the original, and this is consistent with the practice of those pupils or imitators who copied Altdorfer's coloured-ground drawings in the 1510s.

Since Giorgione, Venetian painters had also produced landscape drawings, or rather landscapes with pastoral or mythological accessories. Neither Giorgione nor Titian signed his drawings. This in itself is no proof that the drawings were meant to remain in the shop, as sources of ideas or even as direct models for paintings. These drawings are highly finished and were surely meant for the eye of the Venetian amateur. Perhaps they were given away as gifts. But Titian's pupil Domenico Campagnola – a Venetian of German parentage – began in the late 1520s to produce numbers of landscape drawings. Some of these he did sign, but the rest are extremely uneven in quality, and it is unlikely that he drew them all himself. In the 1530s and 1540s Campagnola, with the assistance of copyists, was evidently producing landscapes for a market. In 1537 Marcantonio Michiel saw some 'large landscapes in gouache on canvas and others in pen on paper' by Domenico in the home of Doctor Marco in Padua.[29] Domenico Campagnola certainly knew German work; perhaps he was aware of what Huber was doing.[30]

Some landscape drawings by Titian and Campagnola were made into woodcuts. Titian's designs had been disseminated in woodcut since 1510 or 1511, but it is not clear that Titian drew any of his landscapes with the intention of publishing them. It looks as if the cutters were adapting their technique to his graphic manner rather than the other way around. The *Two Goats at the Foot of a Tree*, printed in both black and white and chiaroscuro versions, is a landscape motif without the landscape (illus. 181).[31] It is impossible to imagine this woodcut as a painting or even as an engraving. Trunk and goats twist and spiral like an elaborate figure composition pressed flat in the front plane. The printed lines imitate a pen's light touch, or short strokes. Some impressions were even printed in brown ink so as to better imitate pen lines. Like the German chiaroscuro woodcut, the Venetian woodcut immediately settled into co-existence with its putative original. Domenico Campagnola certainly did design his own landscape woodcuts. He made woodcuts even as he continued to draw landscapes. The *Landscape with Travellers*, from the late 1530s, derives its panoramic structure from Netherlandish landscape and its woodcut line from Dürer (illus. 182).[32] Prints like this in turn exerted an impact on the mid-century Alpine landscapes of Bruegel.

Woodcut was closely related to the pen drawing – much more so than engraving. A woodcut began with a drawing on a block. The wood between the drawn lines was then cut away with chisel and knife, normally by a professional cutter. Finally the lines left standing were inked and printed, exactly as in letterpress technique. The lines of an engraved print, by contrast, were ploughed directly into a soft copper

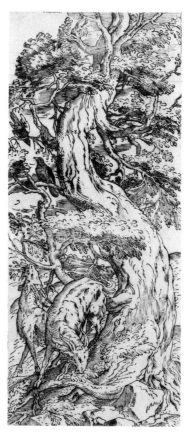

181 Titian, *Two Goats at the Foot of a Tree*, c. 1530–5, chiaroscuro woodcut, 49.3 x 21.7.
British Museum, London.

182 Domenico Campagnola, *Landscape with Travellers*, late 1530s, woodcut, 33 x 44.
Metropolitan Museum of Art, New York.

183 Albrecht Altdorfer, *St Christopher*, 1513, woodcut, 16.5 x 11.6.
National Gallery of Art, Washington D C, Rosenwald Collection.

plate. They were produced not with the light touch of hand and pen, but with a
firmly gripped engraving tool, or burin. The grooves produced by the burin were
then filled with ink. The lines of an engraving hardly resembled drawn lines at all.
Some engravings, to be sure, tried to imitate some aspects of drawing. The drypoints
of the Housebook Master, for example, with their burr of iron filings clinging to
either side of the engraved line, simulated the coarse warmth of the artist's own pen
stroke. The stippled engravings of Giulio Campagnola, Domenico's adoptive father,
imitated the smoky strokes of chalk. Altdorfer, like Dürer, made both woodcuts and
engravings. In one woodcut, the *St Christopher* of 1513, he particularly strove for the

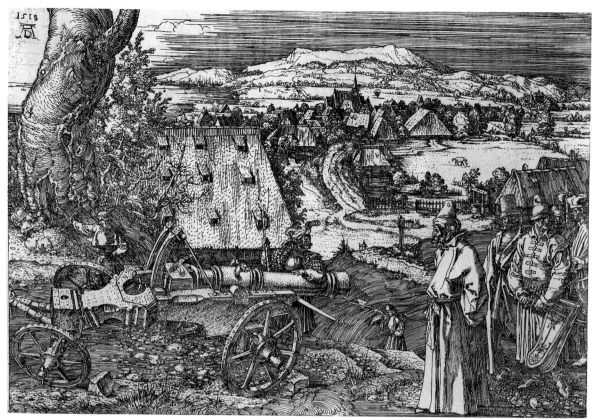

184 Albrecht Dürer, *Landscape with Cannon*, 1518, etching, 21.7 x 32.2. National Gallery of Art, Washington DC.

look of a loosely handled pen line (illus. 183).[33] The long, isolated string of the mountain profile and the free-floating loops of foliage along the tree-trunk are citations from Altdorfer's drawings; they are monstrosities in a woodcut.

Instead of competing with Huber by copying his own pen-and-ink landscape designs in quantity, Altdorfer had them printed. This time he passed over woodcut and turned to the absolutely novel technique of iron etching. Etching is closest of all to pen drawing. The design is scratched directly into a layer of wax spread on an iron plate. When the plate is submerged in acid, only those areas of the plate no longer protected by wax are eaten away. After the wax is scraped away, the grooves and marks left in the plate are filled with ink. Because the design is drawn in wax, the print pulled from the etched plate registers the artist's hand far more sensitively than an engraving does. Whereas the engraver pushes the burin with the palm of his hand, the etcher holds the needle like a pen, with his fingers. The scratches in the wax simulate the ductus of the finest drawn lines. Vasari, in his life of Giovanni Battista Franco, described etchings as *disegni stampati*, or printed drawings.[34]

Vasari neglected to say who he thought invented the technique. The first dated etching is Urs Graf's *Woman Washing her Feet* of 1513, although Daniel Hopfer of Augsburg, who was etching designs on iron armour in the 1490s, was probably the real pioneer.[35] Marcantonio Raimondi may have been making etchings as early as 1515, but this cannot be proven. Dürer's first dated etchings are the *Man of Sorrows*

and the *Agony in the Garden* of 1515.[36] The bizarre *Landscape with Cannon* of 1518, with Dürer's self-portrait as a Turk, was one of the immediate models of Altdorfer's landscape etchings (illus. 184).[37] The foreground drops precipitously to a shelf of middle ground that is filled by a huge barn. A wayfarer mounts the next incline and approaches a *Bildstock*. The level landscape, depopulated but for a tiny figure on the road and an enormous horse in a field, reproduces the silverpoint drawing that Dürer made the previous year at Reuth near Bamberg (illus. 154). The only follower of Dürer to try his hand at etching was Sebald Beham. Although the aims of etching were at the start very different, in practice it seems to have been associated with engraving. Artists like Cranach, Baldung and Huber, who produced woodcuts but few engravings, left no etchings at all.[38]

The etching did not supplant either the engraving or the woodcut. Because the etched line neither swelled nor tapered, it lacked vigour and drama. The etched line often looked weak and spidery. Etching did not demand the same manual control and discipline that engraving did. Vasari, who mistrusted etching, did condescend to describe the process in his life of Marcantonio, and he praised, faintly, the etchings of Parmigianino as 'cose piccole, che sono molto graziose'.[39] The facility of the technique also invited unorthodox experiments. Durer's so-called *Desperate Man* (B.70), a jumble of dimly related figures and motifs, is little more than a printed sketch sheet. The medium seems to have served in part as a semi-private record of ideas, a kind of modernization of the workshop model-book. Etching in the first half of the sixteenth century remained a marginal technique, despite all its pungent successes in the hands of Parmigianino, Schiavone and the Fontainebleau masters.[40]

Altdorfer's only dated etchings are two views of the interior of the Regensburg synagogue (illus. 185, 186).[41] The inscription on one of these extraordinary prints records the day of its destruction, 21 February 1519. The Jews of Regensburg, a community about 500 strong, had long been protected by the Emperor. Within weeks of Maximilian's death in January 1519, the city turned against them. The Jews were given two hours to clear the synagogue and five days to gather their movable property and leave the city. During the demolition of the synagogue a workman was gravely injured. Two days later he reappeared at the worksite. This miracle was attributed to the Immaculate Virgin, who was supposedly the special target of the blasphemies of the Jews and thus the particular beneficiary of their expulsion. News of the miracle spread, and in this way Regensburg became the focus of the massive pilgrimage of the Schöne Maria.[42]

One of the etchings shows an elder standing in the porch of the synagogue holding a book, while another figure crosses the threshold. The inscription, on a panel superimposed on the scene, reads 'Porch of the Jewish synagogue in Regensburg, demolished 21 February 1519'. The other etching shows the empty double-aisled interior. Fragments of a column and several arcades from the lectern or *bima* shown in this etching, incidentally, were excavated in 1940 and are on exhibit in the Stadtmuseum in Regensburg. What is not immediately clear is whether the prints are meant to represent the evacuation itself, or whether they only describe the building as it

185 Albrecht Altdorfer, *Regensburg Synagogue*, 1519, etching, 16.4 x 11.7.
Kupferstichkabinett, Berlin.

ANNO · DñI · D · XIX ·
IVDAICA · RATISPñ
SYnAGOGA · IVSTO
DE · IVDICIO · FVñ
EST · EVERSA

186 Albrecht Altdorfer, *Regensburg Synagogue*, 1519, etching, 17 x 12.5.
Kupferstichkabinett, Berlin.

had once looked. On the one hand, contemporary sources report that the evacuation was accompanied by laments and dirges, and that the Jews chose to desecrate the building with their own hands. The scene must have been chaotic and emotional. Nothing of the kind is described in the prints. On the other hand, the inscriptions refer to the destruction. The most plausible purpose of such a publication was to record the event, not the features of the building. The etchings seem comparable in function to illustrated commemorative or polemical broadsheets, like Michael Ostendorfer's slightly later woodcut of the pilgrimage itself (illus. 133). However he might have chosen to edit the scene, Altdorfer almost certainly made the drawings for these etchings on the very day of the demolition. It can be presumed that few Gentiles had enjoyed access to the early thirteenth-century building before that day. This is most important. If it is true that the sketches had to be made on that particular day, then most viewers of the etchings would have known this. The etchings, in effect, published the drawings that Altdorfer made on the site. The medium itself, because it refers to drawing, spoke for the credibility of the reportage. The synagogue views demonstrate more clearly than any other piece of evidence that the early etching was meant to be read as the reproduction of a drawing.

It is not so easy to say what else the etchings are about. Altdorfer did tend to aestheticize empty space; one is reminded of the Munich *Birth of the Virgin* (illus. 52) or even the *Church on a City Street* drawing in Haarlem (illus. 56), not to mention the landscapes. But it would be imprudent to associate this emptiness with the pathos of expulsion and injustice. Nor, unfortunately, can we read irony in Altdorfer's assertion, in the inscription on the view of the interior, that the synagogue was 'completely demolished according to the righteous judgement of God'. Altdorfer was, after all, a member of the municipal delegation that delivered the expulsion order. This is not to say that everyone at the time would have applauded the city's initiative. The Jews did not hesitate to challenge the expulsion. They addressed an appeal to Luther in the form of a psalm (in German, but in Hebrew script) even though the Reformer was not yet in any position to assist them. Their formal protest at the next Imperial Diet was at least partially acknowledged, and the city of Regensburg was penalized. According to an old story, Altdorfer used gravestones from the cemetery as pavement in his own house in Regensburg, whether to blaspheme them or preserve them we cannot say. A nineteenth-century author reported that abandoned headstones were used as pavement in his own parish in England.[43] This implies that the practice is not necessarily disrespectful. Indeed, Altdorfer's archaicizing version of the icon (illus. 120, 121) suggests that his interest in old local monuments was at least in part antiquarian.

The synagogue etchings are so accomplished that Altdorfer must have made other etchings before them. The only early survivor, none the less, is the feeble *Lansquenet*, a unicum in Berlin.[44] Probably dating from the 1520s is a series of etchings of ornamental vessels and a pair of column parts, several of which served as models for contemporary goldsmiths.[45]

One imagines the two Altdorfer brothers, Albrecht and Erhard, undertaking the

landscape etching project together, during one of Erhard's visits from the northern provinces. At the start of their careers they had worked together in Regensburg. Erhard's engraving of the *Lady with Coat of Arms* is monogrammed and dated 1506.[46] His engraving manner is a smooth and hollow version of his brother's. Two more early engravings and a number of pen drawings on white paper have been attributed to Erhard and, despite slim justification, have adhered to his name.[47] By 1512, possibly after a stint in Cranach's shop, Erhard was working for Duke Heinrich of Mecklenburg in Schwerin, near the Baltic Sea. He remained based in north Germany as court painter and architect until his death in 1562. Erhard did return to Regensburg in 1538 to sell the house he had inherited from his brother. But he must have made other trips south before then.[48]

It is difficult to form an idea of Erhard's career for the years when he was not in direct contact with his brother. The only certain works from the long Schwerin period are book illustrations, above all the woodcuts for Ludwig Dietz's Low German Lutheran Bible, published in Lübeck between 1531 and 1534 (and thus actually preceding by six months the first complete Bible in Luther's own High German). It is inconceivable that Erhard Altdorfer made an initial landscape etching all by himself in distant Schwerin. He must have learned the technique directly from his brother.

The two surviving drawings closest to the landscape etchings are the *Coastal Landscape* in the Albertina and the *View of Schloss Wörth*, dated 1524, formerly in Dresden but missing since the War. Both drawings measure several centimetres taller and wider than the largest of the etchings, and cannot be directly linked to them. The Dresden landscape, which is coloured with brown, blue, olive-green and red washes, is a topographical drawing (illus. 187).[49] It describes a hilltop castle at Wörth on the Danube, a residence of Johann III von der Pfalz, Bishop-Administrator of Regensburg and one of Altdorfer's patrons. Very likely Altdorfer presented the drawing to Johann on the completion of renovations to the castle in 1524. The drawing conscientiously and stiffly surveys the sweep of buildings at the base of the hill. In structure it is closest to the etching *Landscape with Watermill* (illus. 179); they even share a two-wheeled wagon, in the left and right foregrounds. But the Dresden landscape is a rhetorically chastened landscape. The slope of the castle hill is exaggerated, but the surrounding country has been protected from the depredations of Goethe's poetic and 'vertical' imagination. The Dresden landscape has no bombastic foreground noise and it has no posturing tree; every one of the etchings has such a tree. The pen line never swings, leans, or lurches; the ductus is resolutely and soberly vertical.[50]

The Albertina *Coastal Landscape* is, curiously, the best-known and the most durable attribution to Erhard Altdorfer (illus. 188).[51] The attribution was based exclusively on Erhard's landscape etching, which is a weak piece of work, inferior to all nine of Albrecht's etchings and quite unlike the Albertina drawing (illus. 180). The unwillingness to see Albrecht's hand in the Albertina drawing is based on the differences between this drawing and the *View of Sarmingstein* of 1511 (illus. 164) and the *Willow Landscape* (illus. 165). But the *Coastal Landscape* perfectly embodies the qualities that

187 Albrecht Altdorfer, *View of Schloss Wörth*, 1524, pen and watercolour on paper, 21.2 x 30.5. Missing since 1945.

the etchings were trying to publicize, even if it was not a direct model or study for an etching. The Albertina landscape is actually one of Altdorfer's most remarkable drawings. In no other landscape is a formal theme so persistently worked out and so tightly controlled. The graphic module or cell of this drawing is the collision of two angled strokes, a lively convergence that produces a wedge or splay. This module is recapitulated at every level of the drawing's structure: in the twitches of foliage, the odd angles of branch against trunk, trunk against earth, the masts and spars of the ships, the ridges of earth in the scooped-out river bank, and finally in the broadest compositional strokes – mountain profiles, the leaning tree, the receding row of ships, the arc of the cloud. This look of 'splay' makes the drawing as a whole feel precarious, high-strung, oversensitive. The look is encapsulated in the thatched farm buildings of the middle-ground, which have an animal-like presence and appear to be on the verge of shifting their stance. By a perspectival liberty, the right tower of the church in the dead centre of the composition is higher than the left tower, as if the building were about to topple or rear back on its hind legs. The landscape etchings try to replicate exactly this degree of graphic control.

It is hard to believe that Altdorfer would ever have brushed over lines like these with watercolour. Yet the Albertina in Vienna has a set of eight landscape etchings, including all but the *Landscape with Watermill*, as well as an impression of Erhard's

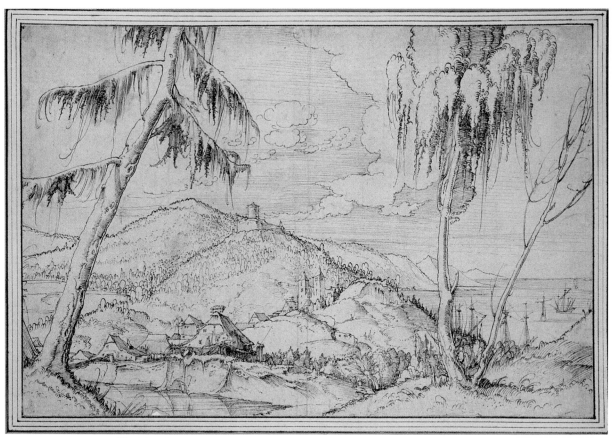

188 Albrecht Altdorfer, *Coastal Landscape*, *c.* 1521–2, pen on paper, 20.6 x 31.2.
Graphische Sammlung Albertina, Vienna.

189 Wolf Huber, *Landscape with Footbridge*, *c.* 1521–2, pen with watercolour on paper,
13.7 x 21.2. Kupferstichkabinett, Berlin.

257

etching, that have been coolly and expertly coloured with green, brown, red and blue washes. (There are only two other surviving coloured impressions.[52]) This raises the possibility that the etchings were printed as the skeletons of watercolour landscapes, to be fleshed out with layers of wash by Altdorfer or an assistant before they left the shop; that is, they were meant to remind beholders of Altdorfer's own painted land-scapes. The etchings do share many ideas with the watercolour and gouache paintings on paper, such as the *Landscape with Church* from the Koenigs collection and the landscapes in Berlin and Erlangen. Altdorfer's two etchings in vertical format, for example, the *Small Fir* (illus. 171) and *Large Fir* (illus. 173), resemble in structure his own watercolours more than they do any of Huber's pen drawings in vertical format. But the watercolour paintings were not merely coloured drawings, as some have thought, but paintings built upon pen underdrawings. The underdrawings in the Berlin, Erlangen and Koenigs sheets are neither as forceful as the true autonomous drawings, nor as fastidious and intense as the etched lines. It is true that the under-drawings in these watercolours did not need to be concealed – their visibility is part of the effect of the works. But they could never have stood alone. A sketch on the verso of the Erlangen sheet gives an idea of how one of those landscapes may have started out (illus. 190).[53]

190 Albrecht Altdorfer, *Landscape, c.* 1522, pen on paper, 20.2 X 13.3. University Library, Erlangen.

We have seen three watercolour and gouache landscapes by Huber: the *Alpine Landscape* in Berlin, the *Mountain Landscape* from the Koenigs collection, and the *Landscape with Golgotha* in Erlangen (illus. 139, 140). None of these works can be considered to be a coloured pen drawing; the underdrawings are well buried.

But what about the pen drawing with a light, translucent coat of coloured washes? Huber's *Landscape with Footbridge* in Berlin would look good even without its colours (illus. 189).[54] It resembles his plain pen-and-ink landscapes, even to the ironic prominence of the bridge, blocking the view of the town. Two watercoloured pen drawings can be attributed to Altdorfer: the Milan *Cliff* of 1509 (illus. 72) and the *View of Schloss Wörth*. There were several reasons a draughtsman might colour a pen drawing. First, accurate topographical memoranda were frequently coloured, for example the 'Katzheimer' group of views of Bamberg (illus. 148). Second, even invented landscape motifs which might later figure in the backgrounds of paintings were coloured with washes or opaque gouaches. The Milan *Cliff* derives from this tradition. A third type of watercoloured drawing was the composition study for a panel or glass painting. Examples by Cranach and Dürer survive. Finally, an artist sometimes coloured a highly finished pen drawing, perhaps a drawing meant for one reason or another for presentation to a patron. A famous example is Dürer's *Madonna of the Many Animals*.[55] Altdorfer's *View of Schloss Wörth* falls in both the first and last of these categories.

The landscape etchings, then, did not *need* to be coloured in, any more than did Altdorfer's or Huber's finished pen drawings. But Altdorfer would not have been astonished to learn that some subsequent owner had put a brush to them, and he may even have overseen the colouring of the Albertina set. Many impressions of the landscape etchings by Altdorfer's follower Augustin Hirschvogel, from the late 1540s, are also hand-coloured. Colouring prints was an old practice. Fifteenth-century woodcuts often left the workshop already coloured.[56] Altdorfer's *Schöne Maria* woodcut – a chiaroscuro woodcut with multiple coloured tone-blocks – imitated in turn the finest of these hand-coloured woodcuts; it was like a pre-coloured woodcut (illus. 121). This was also the procedure of the *Briefmaler* or 'paper-painters', who made simple devotional outlines with stencils and then coloured them in. Engravings were never coloured by their artists; nor, it is safe to say, were the fine, monogrammed woodcuts produced in Dürer's wake. However, many fifteenth- and early sixteenth-century owners coloured, or had coloured, their woodcuts and book illustrations. For instance, there are the tiny 'Mondsee Seals' which have been attributed to the young Altdorfer;[57] the fiery Cranach *Crucifixion* woodcuts preserved in Vienna, Munich and Dresden;[58] and many Dürer woodcuts, such as the *Bearing of the Cross* from the Large Passion in Boston.[59] Most of the prints in Hartmann Schedel's collection, including the engravings, are coloured. Even some much later collectors persisted in adding colour. Perhaps as late as the seventeenth century, a group of engravings by Dürer and Cranach in the Veste Coburg were treated to a lush coat of tempera.[60]

The coloured landscape etchings in the Albertina entered the collection as a group.

Konrad Oberhuber has recently called attention to the uniform black borders around all the Albertina etchings, and has argued that they are equivalent to the borders on certain other works: the coloured etching of a *Large Fir* at the Veste Coburg; the uncoloured *Landscape with Watermill* in Washington; and the Berlin and Erlangen watercolour landscapes.[61] If the borders were not applied in Altdorfer's shop, then presumably they were applied by a single collector. The Erlangen landscape, Oberhuber points out, has a seventeenth-century provenance. The core of the collection of the Margrave of Ansbach-Bayreuth was acquired from the engraver and publisher Jakob von Sandrart, nephew of Joachim von Sandrart and director of the Academy in Nuremberg from 1662. Perhaps all these sheets stem from his collection.

Extremely few impressions of Altdorfer's landscape etchings, coloured or plain, have survived. There are only three known impressions of the *Small Fir* and four of the *Landscape with Watermill*. The most common is the *Landscape with Two Firs*, with fourteen impressions. The etchings must have been rare even in the early seventeenth century, since there are none in the Peuchel Album in Munich, a nearly comprehensive collection of Altdorfer's prints completed by 1651.[62] Even more important, there are two impressions of Erhard's landscape etching, but none of Albrecht's, in the massive collection of Archduke Ferdinand in the Kunsthistorisches Museum, which was assembled near the end of the sixteenth century.[63] Altdorfer was not reaching for the broadest possible market. He probably released no more than a few dozen impressions of each landscape, and then gave them or sold them individually rather than putting them on an open market. These were highly refined and eccentric experiments in a novel medium. It seems most unlikely that their owners, as Hans Mielke suggested, would have pinned them to the wall.[64]

The landscape etchings certainly travelled quickly. The *Landscape with Two Firs* was closely copied in a pen drawing in Frankfurt, dated 1522 and monogrammed I.H.[65] A drawn copy after the *Large Fir* is dated 1522.[66] Narziss Renner adapted the right side of the *Landscape with Fir and Willows* in the background of his large *Geschlechtertanz* watercolour of 1522.[67] In his Prayer Book in Vienna dated 1523, finally, Renner used both the *City on a Coast*, in his *Lamentation*, and the *Large Fir*, in his *Visitation* (illus. 191).[68]

These adaptations provide a *terminus ante quem* for the landscape etchings. The dates on the drawn and painted landscapes by Altdorfer and Huber suggest a sudden concentration of interest in landscape in the early 1520s, perhaps exactly in 1522. Altdorfer's Rotterdam watercolour (illus. 101), Huber's *Alpine Landscape* (illus. 139), and Huber's Rotterdam watercolour are all dated 1522. Four of Altdorfer's etchings – as well as Huber's *Landscape with Footbridge* – are attested in copies or adaptations dated 1522 or 1523. The Dresden *View of Schloss Wörth* is dated 1524; the Vienna *Landscape with Tree and Town*, a copy, once bore the date 1525. Only two different sizes of plate were used among the ten etchings. They were conceivably done all at once in 1521 or 1522, the product of a single burst of activity.[69]

191 Narziss Renner, *Visitation*, 1523, miniature from a Prayer Book.
Österreichische Nationalbibliothek, Vienna.

Wolf Huber in his watercolour or gouache landscapes moved steadily away from the graphism and resistant surfaces of the first two decades of the century and instead toward cosmic settings. His drawings increasingly offer themselves as vertical transparent planes, like windows or theatrical frames. With their wide bowed horizons they are again the settings for events, and can summon up the pathos of emptiness. They take up ideas that Huber had already developed in his panel paintings; the bowed horizon line was almost a signature device. These features even invade his pure pen-and-ink landscapes of the 1530s to the 1550s.

Altdorfer too turned back to the scene of the world in his *Landscape with Castle* in Munich and his Berlin *Allegory*. But he resisted this temptation in the landscape etchings. It is true that here landscape space spreads outward from the tree, filling volume, and overwhelming the figures it contains. Behind the *Small Fir* – a huge and prickly tree, as histrionic as the tree in the Berlin *Landscape with Woodcutter* – a pedestrian crosses a bridge; another passes in a skiff; a wayside cross marks the path to the castle (illus. 171). A tiny wanderer moves into the middle distance of the *Large Fir*; another figure climbs a staircase from the river bank at the lower left (illus. 173). A traveller skirts the base of the mountain in the *Landscape with Cliff* (illus. 178). The most suggestive fiction of all is the *Landscape with Double Fir*, where a pair of enormous trunks, shadowed by a cluster of deciduous trees, sprawls out and takes over the surface of a horizontal panorama (illus. 177). These are colossal trees, already seventy feet high at the upper margin, to judge from the size of the figures at the lower right. A shock of foliage at the upper left, descending from beyond the frame, implies a tree that spreads as well as climbs. This is also the wildest sky among all the etchings. The dark parallels behind dry white mountains – evocative of Dürer's woodcuts – can be read either as darkest blue or as sunset (in the Albertina's impression the clouds are coloured pink-orange and the sky is blue, especially nearer the top). This etching expands the Berlin *Landscape with Woodcutter* outward into space. The same broad path, this time with a pair of wayfarers, loops around the pair of

trees and isolates them from the world. The tree-shrine, on the path below and to the left of the trees, has become a proper *Bildstock*; it is accompanied – just as in the Housebook Master's print or in the view of Erfurt in the Nuremberg Chronicle – by a cross.

None of the figures in the etchings does anything other than walk or pole a boat. Nobody hunts or ploughs a field. Six of the ten landscape etchings (including Erhard's) are purged entirely of human life; they are as absolutely silent as the Albertina *Coastal Landscape*. There are no animals, wild or domestic, in any of these works. In some, like the *Landscape with Large Castle*, the tableau fades back into air, as if struggling for life after the evacuation of story (illus. 174). In the *Landscape with Willow and Fir*, dishevelled trees have advanced forward and repelled the figures, taking over the picture surface by main force. The scale of the staffage matters enormously. The sheer magnitude of cliff and tree crushes any human pretension to significance. These are not merely the settings for absent histories. They are negative histories, representations of the inconsequence of human purpose. Suddenly Altdorfer is treading on familiar thematic ground, familiar to us, at least. The etchings, especially the horizontal ones, start to resemble seventeenth-century landscapes. They are far less recalcitrant and demanding than the earlier handmade works, where the 'folded' structure of the picture had resisted the spread of the horizon and the impulse to describe terrain. The etchings achieve their spaciousness, and the concomitant elevation of tone, at the cost of a certain intimacy and unpredictability.

And yet in the etchings the linear web retains a powerfully graphic character. The works resist being raised to the perpendicular plane. These are still flat surfaces with no pretensions to transparency. The technique of etching offered a way of bringing the print back to this state of flatness. Because they are made with a round needle rather than the bevelled burin, etched lines have a homogeneous character, especially in these earliest examples of the medium. Depth and colour were elusive. All this impeded the slide back toward theatrical illusion.

Space in the etchings opens up around the tree. Yet the tree lingers at the front, rooted stubbornly in the foreground. This opening of the space is not a grand retreat of the point of view, generously embracing wider swaths of terrain. It is really just an inflation of the picture surface, a lateral extension. The notional standpoint remains fixed, and the symbol of this is the brutal truncation of the foreground trees. The trees are not diminished in order to fit them within the frame, nor are they shunted to the side.

In the narrative and devotional images that immediately preceded the independent landscape, the depicted tree stood in a supplementary relationship to subject-matter. It filled a void at the centre of the narrative picture, and at the same time it brought something unanticipated to narrative: a superfluity of information about setting. The supplementary tree had the character of a *parergon*: it was indispensable to the proper work of the painting – telling a story – and yet stood outside that story and did not belong to it. Now, in the landscape etching, the centring of the supplement is complete. The public arrival of landscape as the sole iconographical justification for a

picture – as subject-matter – marks the end of the tree's destabilizing liminal role within the picture. Landscape in the first two decades of the century still had a dynamic, two-faced structure. An artistic personality in the world, a real historical actor and the physical manipulator of a pen or brush, could take up residence in landscape, and from that vantage-point control the exchange between the beholder and the picture.

Kant, in the passage in the *Critique of Judgement* singled out by Derrida and discussed earlier, offered three examples of supplements or *parerga*: a frame around a painting, a garment on a statue, and a column on a building. In the course of this book, the tree has appeared in all three of these guises, and in each case, in turn, it was translated to the heart of the picture. The foreground tree at the right or left edge of the picture was a *parergon* when it served the function of a frame. It protected the event at the centre from the outside world, particularly in drawings or prints, which had no natural or architectural frame around them. The gaze rolled around the trunk and into the fictive space. The branch and the vine had already insinuated themselves into this position in German altarpieces. But in Altdorfer's independent landscapes – the Rotterdam and Berlin watercolours, the London panel, the *Willow Landscape* in Vienna, the etchings – this framing tree abandoned its post at the margin. In these pictures there is nothing left to frame, nothing between the frame and the background. The tree moved to fill the lack by mimicking, with anthropomorphic postures and gestures, the human subject. But in doing so it upset its own parergal equilibrium, for now it filled a lack completely and participated fully in the work of the picture; there was no longer anything gratuitous about its contribution.

The tree was also a *parergon* when its foliage hung on the picture like a garment. The leaves of the framing tree adhered like a fringe to the sides of the picture and climbed across the upper edges. Passages of foliage could appear anywhere else within the picture too, virtually unmotivated, in any scale and at any distance. Foliage distracted, and it determined mood. But in the Munich *St George*, the garment overwhelmed and smothered the body, or rather, the story. In the Berlin watercolour, the garment clung to and became one with the body; it was indistinguishable from its sculptural skeleton. This was no longer the sort of statue which Kant had in mind.

The tree was, finally, a *parergon* when it stood like a decorative column before or within the architecture of the scene, imitating a structural element but in fact per-forming merely rhetorical tasks. Later it abandoned the pretence to structural utility. The tree moved into the open, cleared space around itself, and solicited attention. In the etching of a *Landscape with Double Fir* and in the Berlin watercolour, the tree actually monopolizes attention. The detached column, the column which supported no weight, was for Christians a clear danger signal, since it usually bore an idol. Pagan idols in illuminations and panel paintings were always represented mounted on free-standing columns. The Golden Calf stood on an open-air column. Solomon himself once fell under the spell of such an idol; the subject was engraved by the Housebook Master and drawn by Altdorfer on coloured ground.[70] The medieval Church abhorred the free-standing column, and many churchmen were appalled by

the stone Virgin erected in Regensburg in 1519 to attract pilgrims (illus. 133). Perhaps that is why Altdorfer so often lops off the crowns of his trees.

In the etchings, even the mountains are brought in close, in the sense that they are presented as experienced terrain, as massive and muscular obstacles to movement, as sites of terror and somatic ordeals. These are no longer the fanciful, bearded cliffs of the Netherlandish or German background, the interchangeable stage-flat lifted from the workshop modelbook. Instead, they point forward to the *Battle of Alexander* and to Bruegel. The mountains are also the markers of the local, for they attest to a specifically Alpine experience. They belong to the first generation of images that do so. With their trees, blank mountains, scored skies and castles they are like catalogues of German motifs – drawn both from the land itself and from Dürer's prints. They have become the counterparts to the Flemish visual landscape catalogues.

But unlike the Flemish landscapist, Altdorfer does not marshal all his pictorial means to the goal of perspicuous planar presentation, to display. Instead the key concept is 'splay', a bending, wrenching and distortion of matter that results from pulling it forward and pressing it against the front plane. This bending produces a new pattern for composition, based neither on the principles of two-dimensional symmetry or organic order, nor on the rational projection of the spatial continuum and its contents onto the plane. All the force, power, violence and difficulty of the landscape smashes against the plane and produces the twisted branch, the exploding bush, the scooped sandbank and the arcing pen line.

All these landscapes are fictions. The new frame isolates the picture from the world and establishes it as the zone of the hypothesis. Fictions serve many purposes, many of which emerge out of direct comparison with the empirical world. But the relationship between the fiction and the empirical world is not constant, and cannot be diagnosed from the fiction itself. In one crucial sense, however, Altdorfer's drawn and painted landscapes were not complete fictions. Line and brushstroke were still understood in those pictures as the indexes of an authorial hand. They established a link to the absent author that was at least consistent and reliable. That claim is swept away in the landscape etchings. The etching tries to replicate the pen line, and indeed it succeeds more fully than an engraved or woodcut line ever could. But it falls just short. In the *City on a Coast* or the *Landscape with Watermill*, the light touch often translates in the etching into a weak and broken line, an insubstantial sequence of dots and dashes (illus. 172, 179). And the swift or truly thoughtless pen stroke can never be rendered in etching at all.

Altdorfer's etchings also betray their remoteness from the hand in one drastic way: they all lean toward the left. All the tree-loops on mountainsides and blades of grass in foregrounds slope backwards, to the left. Trees, too, tilt to the left, most strikingly in the *Small Fir* and the *Landscape with Large Castle* (illus. 171, 174). The filaments of hanging moss swing with the trees, parallel to the trunks, as if carried by a breeze from the left. Shading lines run from upper left to lower right. Buildings and even entire mountains list to the left. Reversal of the image in the printing process has a devastating effect. Once perceived, it dominates the experience of the etchings. One

becomes aware, all at once, that Altdorfer's drawings had been leaning in a comparable way toward the right, and that this leaning had failed to interfere with the experience of the landscape. In the Albertina *Coastal Landscape*, the buildings pitched wildly to the right; in an etching they would have pitched wildly to the left (illus. 188). And yet in the drawing, if noted at all, they were perceived as contributions to the illusion of a homogeneous space, not as disruptions. There is no lateral symmetry, clearly, in the beholder's mind. The tilt to the right is absorbed into the experience of the drawn landscape because the beholder reads it as a sign of the manual origins of the picture. This tilt is a common phenomenon in landscape. In fourteenth- and fifteenth-century Franco-Flemish manuscripts, or in Sienese panel paintings, ranges of hills often tilt in unison to the right. The July fresco at Trent is a good example (illus. 16). In early seascapes, waves usually lean to the right, for example in Bruegel's *Naval Battle in the Port of Naples*, in the Galleria Doria-Pamphilj in Rome, or in his pen drawing of a *Seascape with a View of Antwerp* in the Seilern Collection. The forward-leaning pen or brush stroke, from lower left to upper right (or vice versa), is the natural stroke of the right-handed artist. In the drawing or the painting, the pitch to the right was a direct index, a trace, of the natural movement of the hand. The rightward tilt ought to ruin the picture's iconic claim to resemble the empirical world. (Whereas the index, in Peirce's familiar typology, is fabricated by the very object or event that it refers to, the icon merely resembles that object or event.) But it does not ruin the illusion, because the beholder accepts, and may even prize, the handmade character of the picture.

In the etching, the pitch is mechanically reversed. Tilt can no longer pass itself off as an index. It is not an icon of anything either. It only reminds the beholder again that the picture is *not* hand-drawn. Because the etching expels the trace of the artist, it is a more complete fiction than the handmade work. The landscape drawing and painting evicted subject-matter, but installed a style in its place, replacing one claim to presence with another. The etching carries out a more thorough supplanting of existence by depiction. This book has tried to demonstrate the inadequacy of the earliest landscape drawings and paintings to any physical or created nature, to a *natura naturata*. The etchings are in turn inadequate to a secondary nature, to the creative imagination that had fashioned itself in the likeness of a creative nature, a dynamic *natura naturans*. Moreover, the etchings disclose, retrospectively, a complex and hidden aspect of the handmade works' inadequacy. The etchings reveal a surreptitious coincidence and alliance between the left-to-right pen stroke, an index of the act of creation, and the normal left-to-right trajectory of narrative, an icon of temporal movement. Because the installation of the artist's personality in the picture was dependent upon the indexical quality of the pen stroke, even the empty landscape retained a vestigial tie to narrative. The full extent of landscape's structural roots in narrative is revealed only when it is reversed in the etchings. Once it is perceived, the left-to-right compositional structure of the early landscape sabotages any pretence to adequacy to nature. The primary *experience* of nature which landscape, at some level, promises to reproduce is nowhere to be found. A technological innovation

inadvertently unmasks a representational convention, and the entire process ends up demonstrating the apriority of the picture.

The etching was supposed to reproduce the special qualities of the pen drawing. It registered with unprecedented sensitivity the unique trajectories of the hand. But the product itself, the new work, was no longer unique. It was no longer a relic of the artist. The print enshrined the creative gesture as the new foundation of the work of art. And yet in that reproduction the gesture itself was lost. At the very moment that paintings and drawings were first collected *because* they were original, prints began to be collected *as if* they were original. Together with bronze sculptures – casts of 'lost' wax or clay originals – or casts of prestigious antiquities, themselves copies of lost Greek originals, engravings and etchings were among the collector's items *par excellence* of the sixteenth and seventeenth centuries. The compulsion to assemble a complete corpus of prints by a single artist, or to subject a collection to various taxonomic logics, led to the modern disciplines of connoisseurship and the *catalogue raisonné*. The print, by dissociating the value of the work from any claims to physical contiguity with the artist's hand, dematerialized that value. The attributes of the successful and desirable work were increasingly nameable and describable.

Order and disorder

In her recent and remarkable book on the classical landscape of the seventeenth century, Margaretha Rossholm Lagerlöf characterized earlier landscape as a genre suspended in 'a state of amazement'. The painter or draughtsman opened his eyes to the terrain and tree before he wielded any concepts for 'eliciting, elucidating, controlling'.[71] In 1520 there were still no rules. The publication of the landscape over the course of the next generation brought both loss and gain. Under the gaze of an increasingly knowing public, perpetually overcoming its own amazement, some of the oblique momentum of the original experiment petered out.

The direct trace of personality in the work was replaced by a fictional personality, an absent and more durable authorial ego. As Altdorfer grew in worldly stature, he disappeared from his works. Just like Dürer, Altdorfer is increasingly elusive in the last decade of his life. In 1526 he was elected to the Inner Council; in 1528 he was elected to the mayorship for a term, an honour he had to decline in order to finish the *Battle of Alexander* (illus. 8). What was he producing in these years? Slick, densely-wrought engravings, mostly pagan and erotic, and an eclectic handful of panel paintings, each more unorthodox and adventurous than the last. Altdorfer's artistic personality dissipates in a welter of cosmopolitan references and a centrifugal impulse to experiment. In these works, beneath all the extravagances of iconography and presentation, landscape has reverted to older modes. In the *Battle of Alexander*, narrative is toppled from the foreground and pushed into a vast background. This is the opposite of paintings by Raphael or Michelangelo, which magnify the heroic and pull it forward, compressing the background. The *Battle of Alexander* is the apotheosis of the 'world-landscape': a fictional assemblage of natural and constructed components

of the world, that is, in effect, a visual catalogue of the world. The world-landscape began as an idea, and was originally represented only in shorthand, summarily, as in the Tomb of Darius or on Pisanello's medal. The Netherlanders transferred the idea to the painted panel, where they could tilt the surface of the earth backward into space. Landscape was gathered together under the force of a fixed gaze. It became spatial rather than experiential. In Altdorfer's *Allegory* (dated 1531) in Berlin, a dimly intelligible proverb – Pride and Poverty? – becomes staffage within a hazy, sparkling panoramic landscape, Netherlandish in character (illus. 192).[72] By this time Altdorfer must have seen landscapes by Joachim Patenir, perhaps the *Assumption of the Virgin* commissioned by Lucas Rem of Augsburg around 1516–17, now in Philadelphia.[73] This was one of Patenir's earliest works and in its atmosphere and almost plausible hilly terrain it particularly resembles Altdorfer's *Allegory*. Yet in the *Allegory* the spaciousness is closed on the right by a true forest landscape, an impenetrable stand more ominous than any of Altdorfer's own earlier thickets, indeed more like a forest landscape by the later Flemings Bruegel or Coninxloo. *Lot and His Daughters* in Vienna, dated 1537, a year before Altdorfer's death, depicts an incestuous unequal couple: a leering male nude, life-size, lying with his own daughter, forms a horizontal sward of flesh that is almost unbearable to look at (illus. 193).[74] Part of the background is apparently a paraphrase of a little-known northern Italian panel, a nude in a landscape (illus. 194).[75] This modest picture was attributed by Berenson to the young Lorenzo Lotto and dated to *c*.1500. The figure and setting are both derived from Dürer and Jacopo de' Barbari. The flow of influence thus came full circle when the picture found its way into Altdorfer's hands. Altdorfer has set his story in a wooded landscape, and at the same time nested a second landscape within the picture, just as in a fifteenth-century Netherlandish or Italian painting.

Altdorfer's lasting impact in the German tradition – witness the comments of Quad von Kinckelbach and Sandrart – was felt in the graphic media. The so-called 'Little Masters', imitators of Altdorfer and Dürer, supplied the amateurs and collectors with dozens of tiny engravings, some hardly larger than postage stamps, which illustrate arcane and often lascivious curiosities of mythology and ancient history. But other Germans followed Altdorfer and Huber into landscape. One empty woodcut landscape is almost completely ignored in the literature (illus. 195).[76] The initials NM that appear on some impressions of this work refer to Niklas Meldemann, a *Briefmaler* in Nuremberg who published the print. But the design is attributed on stylistic grounds to Niklas Stoer, a painter active in Nuremberg from the 1530s until the 1560s. The black borders at the right and lower edges have led nearly every commentator to place the sheet in a lost sequence of woodcuts illustrating a battle or a parade, something like the *Triumphal Procession* Altdorfer designed for Maximilian (illus. 136).[77] But structure and motifs are derived from the independent landscape, etched and drawn. It is not impossible that Stoer was experimentally extending the medium of woodcut into the iconographic territory opened up by Altdorfer and Huber.[78]

The first etched landscapes were already being produced in Altdorfer's lifetime

192 Albrecht Altdorfer, *Allegory*, 1531, oil on panel, 28.9 x 41. Gemäldegalerie, Berlin.

193 Albrecht Altdorfer, *Lot and His Daughters*, 1537, oil on panel, 107.5 x 189.
Kunsthistorisches Museum, Vienna.

194 Northern Italian master, *Nude in Landscape*, *c.* 1500–10, oil on panel. Whereabouts unknown.

195 Niklas Stoer, *Landscape*, *c.* 1530s, woodcut, 28.2 x 40.4.
Germanisches Nationalmuseum, Nuremberg.

by a German master who used the initials P.S. This artist made and signed pen drawings that are very close to Wolf Huber's. An etching of a fortified city on a coast, a unicum in Königsberg (Kaliningrad), is dated 1536.[79] The landscape etchings of Jakob Binck, an artist born around the turn of the century and trained in Nuremberg, may date from the 1530s or even earlier. His *Landscape with Castle* published an idea that was really Huber's, if not Huber's actual drawing (B.97; illus. 196).[80]

The most enterprising students of Altdorfer's and Huber's landscapes were Augustin Hirschvogel and Hanns Lautensack, who made hundreds of landscape drawings and etchings in the 1540s and 1550s. Hirschvogel, the son of a successful Nuremberg glass-painter, was born in 1503. He travelled widely – stopping in Regensburg, perhaps, in the 1530s – before settling in Vienna between 1544 and his death in 1553.[81] Hirschvogel made thirty-five landscape etchings, some with small biblical scenes, dated 1545 to 1549. The *Conversion of St Paul* provides the text of the Lord's query (Acts 9:4) in the upper right (illus. 197).[82] But without the heavenly ray one would never find the figure of Saul himself, an indistinguishable lump, out of scale, lost in the flat landscape. Three of Hirschvogel's etchings directly follow landscape drawings by Huber.[83]

Hanns Lautensack was born around 1520 and also ended up in Vienna working for King Ferdinand.[84] He, too, was the son of a painter, Paul Lautensack of Bamberg. And like Hirschvogel, Hanns Lautensack was at least as familiar with Huber's landscape drawings as with Altdorfer's prints. In 1553 and 1554 he published a series of etchings in both horizontal and vertical formats, like this swarming *Landscape with a Natural Stone Arch* (illus. 198).[85] Many etchings by Hirschvogel and Lautensack ended up in the print collection of Archduke Ferdinand of Tyrol (the son of their patron King Ferdinand), alongside the landscape prints published by Hieronymus Cock in Antwerp and the pastoral woodcuts of Titian and Campagnola.

The earliest possible evidence of an international reception of the German prints is the series of etched landscapes set in elaborate frames by Antonio Fantuzzi, one of the Italians working for Francis I at Fontainebleau. Fantuzzi's prints have great documentary value because they reproduce Rosso Fiorentino's ornamental stuccoes at Fontainebleau, not all of which survive. But in the centre of these etched cartouches, in place of the mythological or allegorical scenes of Rosso's original scheme, Fantuzzi inserted landscapes of his own design (illus. 199).[86] Where did he get such an idea? He knew the Venetian woodcuts, and he may have known Netherlandish landscape drawings in the wake of Patenir, for example those of Cornelis Massys. But had Fantuzzi seen any etchings? One of his landscapes looks particularly German: a vertical wooded scene with a church and travellers.[87] Zerner dates Fantuzzi's prints to about 1543; the earliest dated landscape etching by Hirschvogel is 1545. Perhaps Fantuzzi saw something even older by Binck, the Master P.S., or even Altdorfer. Rosso's frame works the same effect on landscape as a text. The frame has nothing to do with the picture inside. It is imposed upon landscape from the outside, an emblem of the affectionate but condescending Italian taste for Northern landscape. This is landscape's mock independence. The frame is really the work, for it persists

196 Jakob Binck, *Landscape with Castle, c.* 1530, etching, 11 x 8.1.
British Museum, London.

197 Augustin Hirschvogel, *Landscape with the Conversion of St Paul*, 1545, etching, 9.8 x 26.2.
British Museum, London.

198 Hanns Lautensack, *Landscape with Natural Arch*, 1554, etching, 16.6 x 11.8.
National Gallery of Art, Washington DC.

199 Antonio Fantuzzi, *Decorated Cartouche with Landscape, c.* 1543, etching, 24.4 x 49.7.
British Museum, London.

from Rosso's original to Fantuzzi's reproduction. The landscape in the centre is interchangeable.

Ernst Gombrich, with a keen ear for textual evidence, equated the invention of independent landscape with the establishment of landscape as a genre.[88] His famous argument tells us nothing about the German landscape. Nevertheless Gombrich showed that in Italy landscape owed its new prestige and institutional status in large measure to Pliny, whose biographies, anecdotes and asides opened a window onto a well-established Antique culture of landscape painting and painters. Netherlandish landscape painters emerged, the argument runs, to meet the demands of a well-read Italian public. But institutional status – and this is decidedly not Gombrich's point of view – is a mixed blessing. Hierarchies of modes or genres – epic, georgic, pastoral; history, landscape, everyday life – were devised not to exalt the grand pictures, which needed no justification, but rather to provide a niche for the humbler pictures. The system of genres protected landscape, but it also held it hostage to epic. In exchange for physical independence, the landscape adopted the structure of epic. In fact the hierarchy of genres left the landscape mired in dependency, proclaiming a recreational purpose but all the while mimicking the epic in its structure. This is clear in the classical Italian tradition, which polarizes landscape. Intimate, experiential landscape lives only in drawings. In painting, by contrast, imagination explodes outward either into the most grandiose formats and moods – the ideal landscape of Claude and Poussin – or into romantic distortions or bizarre parodies of epic, for example by Salvator Rosa and, later, Magnasco. The Dutch and English, in their buying habits and artistic practices if not always in theory, were relatively insouciant about hierarchies.

The future of landscape was foreshadowed already in the mechanically reversed left-to-right pen stroke of Altdorfer's etchings. In this moment space again became an icon for time. The same possibility was latent in Huber. In one tumultuous early pen drawing – the *Golgotha* in Budapest – Huber introduced real narrative to the topographical format (illus. 200).[89] The date 1512 was read by Winzinger and others as 1502. This drawing would be absolutely astonishing if it were really done so early.[90] Here narrative is granted a foothold among the hills. The sun is the boiling source of all the kinetic energy in the landscape. Its rays shoot to every corner of the sky; when they touch earth, they scatter back upon each other, piling into turbulent hills, raking and scooping the terrain, shifting directions in the third dimension in an almost random fashion. In this work Huber seems to be constantly abandoning linear ideas and initiating new ones. The sun is suspended just to the left of the cross on the central hillock, in precisely the spot vacated by the body of Christ. The sun and its progeny of modelling lines are the afterglow of the cataclysm. In this drawing the landscape is the temporal extension of the narrative. It represents the world as the event would have left it, after time had resumed its customary pace. The world bears the scars of that event in its surface. Huber later repeated this experiment, in a grander and more tranquil tone, in the large watercolour *Golgotha* in Erlangen, which again depicts three crosses on a depopulated hill (illus. 140 and p. 204).

200 Wolf Huber, *Golgotha*, 1512, pen on paper, 10.9 x 15.7. Museum of Fine Arts, Budapest.

Narrative, or temporality on a human scale, was to infiltrate and re-establish itself within the terrains Altdorfer and Huber had opened up. This process was well under way in Lautensack's etchings. Then in the 1550s Hieronymus Cock in Antwerp started to publish his extraordinary series of engraved and etched landscapes. The earliest were the views of Rome that Cock himself etched from his own drawings and published in 1551. Twelve *Large Landscapes* were etched and engraved by Jan and Lukas Duetecum after drawings by Pieter Bruegel, and published shortly after 1555. Cock published further series of mountainous and rural landscapes in 1558, 1559, 1561 and 1562.[91] There were immediate reverberations in Italy, for example in the decorative frescoes at the Villa Maser in the Veneto.[92] The texts often inscribed below these landscapes legitimated the fundamentally recreational function of the pictures. Even the title page of the 1558 series, after drawings by Matthys Cock, advertised 'various landscape compositions with fine stories [*historien*] inserted into them'. The possibility of making order in a landscape by proposing analogies and contrasts between the terrestrial span and temporal events was already embedded within the Netherlandish narrative tradition. In van Eyck's *Bearing of the Cross*, open landscape carries the endless, chattering stream of ordinary lives and everyday happenings. No one inside the picture is aware that this particular festive execution will cut straight across the flow of history (see p. 147).[93] Pieter Bruegel's *Fall of Icarus*, or his own *Bearing of the Cross*, painted more than a century after van Eyck's death, stage the same dramatic irony. Patenir, the contemporary of Altdorfer, placed hermit saints in the heart of verdant topographies that symbolized the whole world in all its

splendid heterogeneity. Needless to say, this world held no allure for the saint. The beholder, meanwhile, was left to reconcile passive pleasure in Patenir's sublunary spectacle with the knowledge – acquired from Bosch's paintings, no doubt – that life itself is but a pilgrimage, and that we ought not to linger in the landscape but move on through it.[94]

Such pictures make visible a peculiarly Christian model of history. The human actor stands isolated against a backcloth of time. Eschatological doctrine places heavy demands on individual will; the actor is brought out in relief like a figure against a ground. Bruegel in his *Months*, the core of his huge achievement, dissolved that figure back into its ground. The iconography of the calendar, which illustrated the blind cleavage of human activity to nature, had long coexisted with Christian iconography in architectural sculpture and in manuscript illuminations. The calendar provided a scaffolding for decorative landscape painting. A series of *Months* by the Bavarian court painter Hans Wertinger, datable to the mid or late 1520s, bears the rough imprint not of Altdorfer's landscapes but of an older local tradition, above all Breu and Burgkmair of Augsburg (illus. 201).[95] One of Wertinger's panels is smaller than the other eleven, as if to fit an irregular space on a wall. The series may even have been inserted into a wall as panelling. Bruegel's panels were rooted in the same domestic and decorative tradition. He painted his *Months* for the villa of the Antwerp merchant Nicholas Jongelingk in 1565. Here Bruegel pulled together all the separate pockets of space that Patenir had used to compose his landscapes. The beholder outside the landscape, like the actor inside it, no longer rambles arbitrarily from one patch of terrain or one motif to another. Instead, the eye is steered through the picture. Bruegel unfolds the full pagan and Stoic dimension of the calendar. The Christian will is stifled by the cyclical rhythms of the cosmos; there is no possibility of striking out at cross-purposes with such a landscape. Bruegel's landscapes, in their lucidity and their lofty dismissal of the criteria of ordinary experience, could not be more remote from Altdorfer's forests. And yet in another sense they are the most self-sufficient of all landscapes. Bruegel does not introduce human actors in the hope of sharing in the significance of narrative. Rather, he magnifies the anonymous staffage figure into a shapeless, faceless parody of an actor: the impersonal is represented on a personal scale. Bruegel makes epics without actors.

The *Months* are today among the most famous pictures in the world. In his own time Bruegel's ideas were disseminated through prints. He made only one print with his own hands, the etching known as *The Rabbit Hunters*, which was also published by Cock (illus. 202).[96] The print is dated 1506, which ought to be read as 1560, placing the work just after the series of *Large Landscapes*. It resembles those landscapes in structure and measures about two-thirds their size. But Bruegel declined to reinforce his etched lines with engraving as the brothers Duetecum had done, and as a result the print is uniform in tone and lacks depth and colour. Nor is the plate deeply bit. Very few impressions have survived, perhaps as few as a dozen, either because the plate wore down quickly or because Bruegel treated it as an experiment (although Cock did agree to publish it). This etching is closer to Bruegel's drawings

201 Hans Wertinger, *June, or Harvest*, c. 1520s, oil on panel, 32.5 x 39.8.
Germanisches Nationalmuseum, Nuremberg.

202 Pieter Breugel the elder, *The Rabbit Hunters*, 1560, etching, 21.3 x 28.4.
National Gallery of Art, Washington DC.

than any of the other prints; and it is therefore closer to the German landscape etchings, to Altdorfer and Hirschvogel. But Bruegel drew completely differently from the Germans. His pen line is sober, self-effacing and earthbound, in the tradition of the old Netherlandish drawings in silverpoint. And then only this print, where the pure etched line is plainly legible as a direct trace of the hand, preserves and publishes the draughtsman Bruegel's habitual suppression of personal style. Here the absence of style – just the opposite of the German landscapes – is the analogue to the absence of narrative. Bruegel's panoramic landscapes are settings not for heroism but for the ceaseless, rhythmic rounds of labourer and animal. They represent the reconciliation of the horizontal picture surface's competing tendencies to show and to tell: on the one hand, to present material in its entirety, arrayed broadly across the plane surface, without syntax, and on the other hand to guide the eye through that material, to endow it with the structure of a story, from left to right or right to left. The trace of a forceful manual gesture, a finite and measurable vector, would disrupt this equilibrium. The theme of circular narrative is given a further murderous twist in this very print, where the second figure appears to be stalking not rabbits but the hunter himself – not completing a narrative but initiating an endless chain of violence.

All the themes of seventeenth-century Dutch landscape were incubating in the prints designed or inspired by Bruegel: the rivalry between nature's forces and Man's works; nature as the manifestation of the divine; nature as a source of consolation. But the metaphysical landscape would also meet resistance. The metaphor of nature, in the Western landscape, is always being deflated by the earthy, erotic, recreational proximity to the land. It is as if Altdorfer's shaggy, stifling forest interior – not yet apprehended as nature – is permanently sprouting up from the lawns and furrows of the epic landscape. The epic or textual landscape often modulated its own artificial order by feigning a natural disorder. The Netherlandish landscape looked like chaos to the eye of the 'Michelangelo' character in Francisco da Hollanda's dialogue. But it is not easy to represent randomness. Any evidence of the painter's intelligence, his art, will spoil the effect. The ideal was to *imitate* the random with art. Leonardo da Vinci scolded Botticelli for abandoning the attempt and instead resorting to a mechanical procedure (see p. 55). Netherlandish painters were, of course, not really strewing objects on the picture surface: their disorder was the product of design, and every amateur of art knew this and admired it. Karel van Mander in his didactic poem of 1604, the *Grondt der edel vry schilder-const*, explained how to simulate arbitrary disorder with a careful selection and placement of motifs. In chapter 8, 'On landscape', he wrote:

> In the foreground build no houses
> If one can instead strew half landscape and half figures;
> Yet one should treat this demand with moderation;
> And on the other hand one should avoid
> A heavy disposition and leave out empty places;
> Instead one should take care, as is fitting,
> Although not too much, to plant the ground
> With some lovely vegetation. (§ 22)

Van Mander is constantly stopping and starting, adding and subtracting, struggling to write a recipe for a decision-making process that good painters carry out instinctively.

> Great variety both in colour and in essentials
> We should wisely and respectfully pursue,
> For that brings the great prized beauty.
> Yet we must at the same time avoid an inappropriate excess
> Of cities, houses, mountains and other things;
> For excess hinders the enjoyment of beauty,
> Just as do too powerful perspectival effects. (§ 23)[97]

Perspective must cover the traces of its own construction. Artful art is no longer recognizable as art. The most skilful practitioner – van Mander's most attentive pupil, as it were – was Rubens, who in his own landscapes perfected the order of disorder.

Altdorfer's structural themes – difficulty, the fracturing of surface – were not seriously broached again in the Northern landscape until the end of the sixteenth century. The revival of interest in the early landscape parallels the so-called 'Dürer Renaissance' among the draughtsmen and miniaturists surrounding Emperor Rudolf II in Prague. Artists like Hans Hoffmann, Georg Hoefnagel and Hans Bol took ample advantage of their access to Dürer's drawings and watercolours in Prague and the Low Countries. But the simultaneous rediscovery of Altdorfer and Huber is attested by no documents other than the resultant works. Roelandt Savery and Paulus van Vianen, two artists in the occasional service of Rudolf II, were clearly looking at old German drawings, and not just of Dürer. Savery, a Flemish emigré to Holland, worked in central Europe between 1603 and 1614. Rudolf sent him to the Tyrolean Alps to make landscape drawings. In his inside-out forest views and lowly vignettes of Prague he reprised Huber's stubborn objectivity and inclusiveness. The Dutchman Vianen ended up as Rudolf's goldsmith after stints in Munich and Salzburg. His landscape drawings, like the *Willows on a Bank* in Berlin, bristle like primeval animals among the hyper-refined, sybaritic curves of his silver medals and plaquettes (illus. 203).[98] This drawing is grounded in a fresh and hungry scrutiny of the natural object; the scratching, slashing pen line is completely adequate and appropriate to the spiny trunk and underbrush. But again it is Huber who is governing both the selection and the framing of the view.

For the Dutch, the most important conduit of German ideas about the forest was Adam Elsheimer. Everyone in Europe knew the engravings made after the little paintings of Elsheimer, the ingenious German expatriate, follower of Caravaggio, chief of all the Northern painters in Rome. But on the way to Italy in 1598, at the age of twenty, Elsheimer had stopped in Munich and looked at the work of Dürer and Altdorfer.[99] The bizarre and the characteristic found a niche especially in the Dutch landscape prints. Hercules Segers certainly knew the etchings of Hirschvogel and Lautensack; so too did Ruisdael or Claes van Beresteyn, both connoisseurs of the fallen tree-trunk and the forest impasse.

German scholars used to write endlessly about the peculiarity and distinctiveness of the German image, at least until the Second World War threw a shadow over

203 Paulus van Vianen, *Willows on a Bank*, *c.* 1600, pen on paper,
14.7 x 19.7. Kupferstichkabinett, Berlin.

such pursuits, and before the art-historical profession agreed to bury its tendencies toward experiential criticism under a safe layer of historical materialism. Otto Pächt, the most perspicacious of the Structuralists of the later Vienna School of art history, the followers of Riegl, saw in German works an impenetrable, inscrutable picture surface that pulled its beholder out of passive self-sufficiency and into an act of participation. The beholder – past or present – who participated in such a picture, who moved among the shards of perspectival space and the pleats of texture and line, entered into the 'presence' of nature. Otto Benesch, Alfred Stange and Franz Winzinger, Altdorfer's neo-Romantic exegetes, were simply offering rough-hewn versions of the same insight. Are such interpretations worth untangling at all? The sensation of participation is, after all, familiar enough. It once tempted even the soberest beholders into essentialist explanations of form. At the core of Erwin Panofsky's interpretation of Dürer, for example, lay the conviction that fifteenth-century Northern art observes 'the luminary phenomena produced by the interaction of tangible and limited bodies with intangible and unlimited space', and then 'seeks to fuse both into a homogeneous *quantum continuum*, and to produce . . . pictorial images held together by the unity of a subjective "point of view" and of an equally subjective "mood".'[100] Panofsky was the other great pre-War reader, alongside Pächt, of Alois Riegl. Riegl's writings on Late Roman art and on the Dutch group portrait had tried to ground a severely historicist account of the development of visual form

in an empathetic psychology of perception. For many Germanic art historians, perceptual psychology became a means of preserving the integrity of their experience of the artefact, of their own penetration into the visual field, against the reductionism of historical practice. Thus Panofsky, hardly a chauvinist, could nevertheless, under the spell of Riegl's strangely methodical intensity, claim in his book on medieval sculpture 'a right to consider the inner "polarity", the tendency to outright extremism, as something peculiar – even if not exclusively so – to the German formal imagination'.[101]

The aim of this book has been, in the spirit of Riegl, at once to historicize such perceptions and to absorb them into the project of interpretation. Fear of anachronism – of assuming a false continuity between past and present visual cultures – has kept the image as phenomenon out of most historical writing. One notable dissenter is Baxandall's temperamental book about German Renaissance wood sculpture, which proposes powerful historical and materialist explanations for the distinctiveness of German form. And yet even that work declines to make that form altogether present. The crabbed, recalcitrant, rapturous German image is the invisible core of Baxandall's *Limewood Sculptors*, which was no doubt the intended effect. But in the present study the illegible phenomenon can hardly be circumvented. To position the abrasive encounter with the image at the centre of a critical project is no mere 'formalist scripturalism', in Derrida's phrase, 'which would come to efface or deny the scene supporting it'.[102] For in this case the intervention of a strong style, a fractious figural imagination, between nature and picture *is* precisely the scene. Hypertrophied branches and the shifting of the frame themselves constitute an interpretation of nature. These pictures offered nature *as* a sensory trap. The forest dissipated story and time. Thus it is peculiarly appropriate that the modern exegete for once denies history – the conventional 'scene' understood to support a picture – its customary privilege of limiting the exegesis.

Stylish line in Altdorfer functions exactly as did Alberti's accessories (the flowing hair and draperies). Personal style disrupts presences. It interferes with subject-matter and with topography. Style punctures any pretension of the mimetic image to provide direct experiential access to its absent object. The German artist inherited a tradition of sacred imagery whose representational claims rested not on any manifest adequacy of image to holy object, but on the image's authenticity, its provenance. To intervene in such an image with overt and arbitrary stylistic gestures was to throw that provenance open to the world. It publicly stripped the image of its symbolic pretensions, and replaced them with new quantities that could at best be read as allegories of the truth. The stylish image perpetrates an iconoclasm.

The historical Altdorfer never reveals more than a public and visible relationship to the Reformation. Many German artists committed professional suicide by embracing the politics of iconoclasm. Others survived by painting decorative murals, portraits, profane subjects, allegories. The ambivalence of thoughtful painters like Dürer was extreme. There is little hope of untangling the threads of principle and self-interest within Altdorfer's career. As early as 1525, when the fever of the pilgrimage to the Schöne Maria had subsided, Altdorfer engraved a portrait of Luther, copying an

engraving by Cranach.[103] The citizens of Regensburg were soon receptive to Reform; by the late 1520s only half were still accepting the sacrament of extreme unction, and new cemeteries beyond the city wall had to be built.[104] In 1533 Altdorfer the city councillor helped to send out a call for Lutheran preachers. But then in 1535 he was dispatched to Vienna to apologize to King Ferdinand for two Augustinian monks who had proved sympathetic to the Reformation. Regensburg held out longer than most communities: the city did not finally convert until 1543. Nor did Altdorfer himself abandon the old faith, or else he would not have been buried in the Augustinian monastery.

Perhaps the erasure of subject-matter was iconoclasm enough. Altdorfer did inscribe his response to Reform, in a sense, in the Berlin *Landscape with Woodcutter*, an ironic gloss on the sacred image. Independent landscape in its earliest form flouted the aims both of the Christian symbol and of the useful mimetic image, such as the topographical report, the nature study or the scientific illustration. The fictional landscape earned its double-edged reputation for innocence. Altdorfer arrived at independent landscape by looking away from subject-matter, or just to one side of it. Analogically and counter-intuitively, in a recapitulation of this original act of disrespect, the modern exegete needs to look away from the apparent subject – away from the natural datum, that is – and back toward the real context for meaning: the unravelling tradition of the sacred image. It is ironic that our own possible modern insight into this subversion of the symbolic image is achieved by means of sensation; that is, by an abrasive encounter with a marginal zone that is in competition with the human figure. For the Christian image had always claimed to make the mysteries present through the evidence of the senses. The sensory and the transcendent were meant to converge in the symbol. The difference is that in this new symbolism, the symbolism of the work of art, sensation does not open up a path out of the picture. How long will the 'aesthetic' experience be satisfied with displacement and solipsism? Eventually landscape will try to legitimate sensation by summoning an absent object, a metaphysics; and at that point it will be asking for another iconoclasm.

This interpretation of the earliest independent landscapes has been framed as a narrative. Because it names 'origins' as its subject, it makes no serious effort to detach Altdorfer's landscapes from later Western landscape painting. But Hans Robert Jauss warned against just this fallacy. He argued that to understand a pre-modern literary phenomenon within the structure of a 'genre', in particular to endow it with teleological meaning, and to see it as the origin or the first stage of a given genre, is to deny its singularity and its self-sufficiency.[105] And it is true that the latest stages of Altdorfer's landscape experiment have, in this account, been presented as the dissolution of the singularity of those landscapes, or at least as a blurring of the boundaries between the first landscapes and all the other works – including later landscapes – which fail to escape the temporality of human consciousness and human action.

This is exactly the moment to pause before Jauss's admonishment. For in fact neither the appeal nor the significance of Altdorfer's landscapes rests on their patri-

archal position at the head of some historical genealogy of landscape painting. These pictures tore themselves away from the human body, and from temporality on a human scale. Even when space opened up, in the etchings, graphism and the tree preserved the surface effect. And the vehemence of this effort, this force maintaining the surface tension, is accessible only if one reads the images *against* the rest of the landscape tradition. Seen from a vantage point inside this reading, Altdorfer's landscapes initiate not the history of landscape painting as we know it, but the history of a possible and for the most part unrealized landscape painting that resists history, and indeed seeks refuge from history in disorderly nature.

Notes

Abbreviated references are given in full in the Bibliography.

1 Independent landscape

1 – On this legacy see Karl Arndt, 'Pieter Bruegel der Ältere und die Geschichte der "Waldlandschaft"', *Jahrbuch der Berliner Museen*, 14 (1972), pp. 69–121.

2 – See, for example, *The Age of Bruegel: Netherlandish Drawings in the Sixteenth Century*, ed. John Oliver Hand et al. (Washington, DC: National Gallery of Art, 1986), nos 51, 62, 101.

3 – Amsterdam, Rijksprentenkabinet, inv. no. OB 847, 169 × 98 mm. Egbert Haverkamp-Begemann, *Hercules Segers: The Complete Etchings* (Amsterdam and The Hague 1973), no. 32, p. 85.

4 – In Ludwig Schorn's *Kunst-Blatt*, 2 March 1829 (no. 18), p. 71, where Frenzel compared Segers's 'mannered' foliage to Hirschvogel and Lautensack (not, however, to Altdorfer himself, as Haverkamp-Begemann reported, *Hercules Segers*, p. 35).

5 – Schiller, 'Über Matthissons Gedichte' (1794), *Werke* (Frankfurt, 1966), 4, pp. 401–18.

6 – 'Ich halt aber jnn solchem die natur füer meister und der menschen wan füer irsall', Rupprich, 3, p. 272, from a draft of 1512/13 of the so-called 'Aesthetic Excursus' in the Third Book of the *Vier Bücher von menschlicher Proportion*.

7 – '...die Nature Erlernen und Erkennen ... die Verporgen krefftige wirkung des Ertrichs erfarenn', London, British Library, MS Arundel 503, fol. 101r–102r. The manuscript was discovered by Dieter Wuttke, *Humanismus in den deutschsprachigen Ländern und Entdeckungsgeschichte 1493–1534*, Kleine Beiträge zur europäischen Überseegeschichte, 2 (Bamberg, 1989); English translation in press.

8 – 'Aber daz leben in der natur gibt zu erkennen die warrheyt diser ding. Darumb sich sie fleysig an, richt dich darnach vnd gee nit von der natur in dein gut geduncken, das du woellest meynen das besser von dir selbs zu finden; dann du wirdest verfuert. Dann warhafftig steckt die kunst inn der natur, wer sie herauß kan reyssenn, der hat sie.' From the published version of the Aesthetic Excursus. Rupprich, 3, p. 295.

9 – 'Item je genewer man der nature geleich macht, ie pesser daz Gemell zw sehen ist.' Notes for an introduction to the treatise on painting, Rupprich, 2, p. 100. Cf. the Aesthetic Excursus, Rupprich, 3, p. 295.

10 – Milan, Biblioteca Ambrosiana, inv. no. F 264 inf. 17. Watercolour and gouache on paper, 29.6 × 21.9 cm. Winkler 112; Strauss 1496/3.

11 – London, British Museum, inv. no. 1846-9-18-9. Watercolour and gouache, 295 × 196 mm. Winkler 121; Strauss 1496/2.

12 – *Treatise on Painting*, ed. and trans. A. Philip McMahon (Princeton, NJ, 1956), 1, p. 72.

13 – *Treatise on Painting*, ed. McMahon, p. 39.

14 – *Treatise on Painting*, ed. McMahon, p. 35.

15 – Windsor Castle, Royal Library, 19.1 × 15.3 cm. Kenneth Clark and Carlo Pedretti, *The Drawings of Leonardo da Vinci at Windsor Castle* (London, 1968), no. 12431v. A.E. Popham, *The Drawings of Leonardo da Vinci* (New York, 1945), no. 262b.

16 – Jean Paul Richter, ed., *The Notebooks of Leonardo da Vinci* (London, 1883), no. 456.

17 – Lottlisa Behling, *Die Pflanze in der mittelalterlichen Tafelmalerei* (Cologne and Graz, 1967), ch. 8.

18 – For a botanist's opinion, see Ernst Küster, 'Bäume und Baumkronen in Altdorfers Kunst', *Forschungen und Fortschritte*, 14 (1938), pp. 408–9.

19 – Winzinger, *Altdorfer Gemälde*, doc. 55.

20 – Ludwig Baldass, 'Die Bildnisse der Donauschule', *Städel-Jahrbuch*, 2 (1922), pp. 78–9, pl. 20, attributed the portrait to a follower of Altdorfer, while Winzinger, *Wolf Huber*, no. 300, attributed it to Wolf Huber; neither could identify the subject.

21 – Regensburg, Stadtmuseum, 41 × 27.5 cm. W.112. Munich 1938, no. 700. Berlin 1988, p. 23.

22 – Munich, Bayerische Staatsbibliothek, Cod. icon 366, fol. 28r. A.R. Peltzer, 'Sandrart-Studien', *Münchner Jahrbuch der bildenden Kunst*, 2 (1925), p. 126.

23 – Sandrart, *Teutsche Academie der edlen Bau-, Bild- und Mahlerey-Künste* (Nuremberg, 1675), I, pt 2, book 3, pl. BB. Sandrart's drawing was engraved for the book by Philipp Kilian. The portrait is reproduced in the modern, abridged edition by Peltzer (Munich, 1925), p. 65.

24 – Wolfgang Wegner, 'Wie sah Albrecht Altdorfer aus?', *Zeitschrift für Kunstwissenschaft*, 6 (1952), pp. 79–84, insisted that neither Sandrart's drawing nor Somer's engraving depends upon the other. He also reported Walter Boll's opinion that Somer copied the features of the wrong councillor from Mielich's miniature, with Sandrart presumably perpetuating the error. Wolfgang Pfeiffer, 'Wie sah Albrecht Altdorfer aus?', *Pantheon*, 46 (1988), pp. 60–62, argued that the portraits in Mielich's miniature are reliable

and that Sandrart and Somer's version should be trusted.

Heinz Jürgen Sauermost, on the basis of a putative self-portrait of the young Altdorfer in the high altar at Schwabach, identifies him with the *fifth* councillor from the bottom: 'Ohne Stoß – mit Altdorfer: Planung und Ausführung des Schwabacher Altars', *Jahrbuch des Vereins für christliche Kunst*, 14 (1984), p. 62, n. 65.

25 – St Florian, Kunstsammlungen des Stiftes, altarpiece of St Sebastian, *Pilate Washing His Hands*, W.14.

26 – Munich, Alte Pinakothek, inv. no. 688, 158 × 120 cm. W.50. On the commission see Gisela Goldberg, *Die Alexanderschlacht und die Historienbilder des bayerischen Herzogs Wilhelm IV. und seiner Gemahlin Jacobaea für die Münchner Residenz* (Munich, 1983); Goldberg in the catalogue of the Alte Pinakothek, *Altdeutsche Malerei* (Munich, 1963), pp. 202–17; and Winzinger, *Altdorfer Gemälde*, pp. 40–46.

27 – J. G. Keyssler, cited in Jan Białostocki, *Dürer and His Critics: 1500–1971*, Saecula Spiritalia, 7 (Baden-Baden, 1986), p. 161.

28 – Paul Wescher, *Kunstraub unter Napoleon* (Berlin, 1976), pp. 85–6, 133–4.

29 – Schlegel, *Gesammelte Werke*, 6 (1823), p. 166f.; 'Ansichten und Ideen von der christlichen Kunst', in *Kritische Ausgabe*, 4, ed. Hans Eichner (Munich, 1959), pp. 118–20. On Altdorfer's reception generally, see Reinhild Janzen's survey, *Albrecht Altdorfer: Four Centuries of Criticism* (Ann Arbor, 1980).

30 – Schiller, 'Über naive und sentimentalische Dichtung' (1795), *Werke* (1966), 4, pp. 304, 309.

31 – See especially Otto Benesch, *The Art of the Renaissance in Northern Europe* (London, 1965), ch. 3, and *Der Maler Albrecht Altdorfer* (Vienna, 1938); Franz Winzinger, *Altdorfer Zeichnungen*, pp. 28–30; and Alfred Stange, *Malerei der Donauschule* (Munich, 1964).

32 – Eberle, *Individuum und Landschaft: Zur Entstehung und Entwicklung der Landschaftsmalerei*, Kunstwissenschaftliche Untersuchungen des Ulmer Vereins, Verband für Kunst und Kulturwissenschaften, 8 (Giessen, 1986), p. 48.

33 – Benesch, *Der Maler Albrecht Altdorfer*, pp. 32 and 8. Winzinger made a similar argument in *Altdorfer Zeichnungen*, 'Die Entstehung der Landschaft', pp. 28–30.

34 – Benesch, *Der Maler Albrecht Altdorfer*, p. 32; Winzinger, *Altdorfer Gemälde*, p. 14.

35 – Gombrich, 'The Renaissance Theory of Art and the Rise of Landscape', in *Norm and Form: Studies in the Art of the Renaissance I* (London, 1966), pp. 107–21, esp. 117–18 (originally published in *Gazette des Beaux-Arts*, n.s., 41, 1953, p. 334ff.); and *Art and Illusion: A Study in the Psychology of Pictorial Representation* (Princeton, NJ, 1960), pp. 315–20.

36 – In a letter to Alessandro Contarini of 1554/55; translated by Mark Roskill, *Dolce's 'Aretino' and Venetian Art Theory of the Cinquecento* (New York, 1968), pp. 216–7.

37 – De Piles, *Dialogue sur le coloris*, quoted in Gombrich, *Art and Illusion*, p. 315.

38 – See Berthe Widmer, *Enea Silvio Piccolomini in der sittlichen und politischen Entscheidung*, Basler Beiträge zur Geschichtswissenschaft, 88 (Basel and Stuttgart, 1963), pp. 30–32.

39 – Todorov, *The Conquest of America* (New York, 1984), pp. 23–5.

40 – Pächt, 'Early Italian Nature Studies and the Early Calendar Landscape', *Journal of the Warburg and Courtauld Institutes*, 13 (1950), pp. 13–47.

41 – Alpers, *The Art of Describing: Dutch Art in the Seventeenth Century* (Chicago, 1983).

42 – Baxandall, *The Limewood Sculptors of Renaissance Germany* (New Haven, 1980), esp. pp. 123–7.

43 – Hans-Christoph Buch, *Ut Pictura Poesis: Die Beschreibungsliteratur und ihre Kritiker von Lessing bis Lukács* (Munich, 1972), pp. 10–25.

44 – See Käte Hamburger, *Die Logik der Dichtung*, 3rd edn (Stuttgart, 1980), p. 60ff.

45 – Bryson, *Vision and Painting: The Logic of the Gaze* (New Haven, 1983), esp. p. 87ff.

46 – Belting, *Giovanni Bellini Pietà: Ikone und Bilderzählung in der venezianischen Malerei* (Frankfurt, 1985).

47 – Koerner, *The Moment of Self Portraiture in German Renaissance Art* (Chicago, 1993).

48 – Pliny, *Historia naturalis*, vol. 9, ed. and trans. H. Rackham, Loeb Classical Library (Cambridge, Mass., 1952), p. 35, ll.116–17. *Lorenzo Ghibertis Denkwürdigkeiten (I Commentari)*, ed. Julius von Schlosser (Berlin, 1912), I, p. 28 (*Commentari* I, 27): 'Dipigneua paesi marine pescatori navilij liti verdure'.

49 – Eugène Müntz, *Les Collections des Médicis au XVe siècle* (Paris, 1888), p. 59. Cited in Diane Wolfthal, *The Beginnings of Netherlandish Canvas Painting: 1400–1530* (Cambridge, 1989), p. 18.

50 – See, however, Eva Börsch-Supan, *Garten-, Landschafts- und Paradiesmotive im Innenraum* (Berlin, 1967).

51 – Enrico Castelnuovo, *Il ciclo dei Mesi di Torre Aquila a Trento* (Trent: Museo Provinciale d'Arte, 1987).

52 – In a manuscript of 1466. Julius von Schlosser, 'Giustos Fresken in Padua und die Vorläufer der Stanza della Segnatura', *Jahrbuch der kunsthistorischen Sammlungen*, 17 (1896), document III, p. 99; partially reprinted in Schlosser, *Quellenbuch zur Kunstgeschichte des abendländischen Mittelalters*, Quellenschriften für Kunstgeschichte und Kunsttechnik des Mittelalters und der Neuzeit, 7 (Vienna, 1896), p. 330.

53 – Betty Kurth, *Die deutschen Bildteppiche des Mittelalters*, 3 vols (Vienna, 1926), pls 44–6, 49, 55–66, 108–19, 171, 174; pp. 90, 92, 95–9, 124–5; see further references below, p. 153 and illus. 107.

54 – Giorgio Vasari, *Le Vite de' più eccellenti pittori, scultori ed architettori*, ed. Gaetano Milanesi (Florence, 1878–85), 3, p. 498. The frescoes survive, but in ruinous condition. See David R. Coffin, 'Pope Innocent VIII and the Villa Belvedere', *Festschrift Millard Meiss* (New York, 1977), pp. 92–3, illus. 3–4.

55 – Joseph Gantner, 'Les Fragments récemment découverts d'une fresque de Léonard de Vinci au Château de Milan', *Gazette des Beaux-Arts*, n.s., 53 (1959), pp. 27–34. Volker Hoffmann, however, in 'Leonardos Ausmalung der Salla delle Asse im Castello Sforzesco', *Mitteilungen des Kunsthistorischen Institutes in Florenz*, 16 (1972), pp. 51–62, does not see the cadaver.

56 – Belleville Breviary, Paris, Bibliothèque Nationale, MS. lat. 10483–84. Erwin Panofsky, *Early Netherlandish Painting* (Cambridge, Mass, 1953), pp. 33–4, illus. 13–14.

57 – Madrid, National Library, MS. E. XIV Tesoro (Vit. 25–5). Friedrich Winkler, *Die Flämische Buchmalerei des XV. und XVI. Jahrhunderts* (Leipzig, 1925), p. 183, pl. 56. Otto Pächt, *The Master of Mary of Burgundy* (London, 1948), p. 39, n. 36, cat. no. 15, illus. 26b, 27.

58 – London, British Museum, Add. MS. 25698. Winkler, *Flämische Buchmalerei*, p. 177.

59 – Vienna, Österreichische Nationalbibliothek, Cod. 1897. Winkler, *Flämische Buchmalerei*, pp. 119, 205, pl. 69; Hortulus Master. Dagmar Thoss, *Flämische Buchmalerei: Handschriftenschätze aus dem Burgunderreich* (Graz, 1987), no. 74; Maximilian Master.

60 – Pächt, 'Early Italian Nature Studies and the Early Calendar Landscape'.

61 – Bartholomeus Anglicus, *De proprietatibus rerum* (London, 1495), Book xiii. (Harvard University, Houghton Library). On some Dutch editions see James Snyder, 'The Bellaert Master and *De proprietatibus rerum*', in Sandra Hindman, ed., *The Early Illustrated Book: Essays in Honor of Lessing J. Rosenwald* (Washington DC, 1982), pp. 41–62.

62 – Luisa Cogliati Arano, *The Medieval Health Handbook: Tacuinum Sanitatis* (New York, 1976).

63 – See Elisabeth Rücker, *Die Schedelsche Weltchronik* (Munich, 1973).

64 – *Chronik von allen Königen und Kaisern* (Ulm, 1486), fol. fi r, 18.8 × 11.9 cm. (Yale University, Beinecke Library). See Charles Talbot, 'Topography as Landscape in Early Printed Books', in Hindman, ed., *The Early Illustrated Book*, p. 110, fig. 3. The book was widely known; the Franconian engraver LCz copied the goat on the cliff into his own *Temptation of Christ* around 1500. See Alan Shestack, *Master LCz and Master WB* (New York, 1971), p. 31.

65 – Munich, Bayerische Staatsbibliothek, Clm 189, fol. 55r, 109 × 78 mm. Béatrice Hernad, ed., *Die Graphiksammlung des Humanisten Hartmann Schedel* (Munich, 1990), p. 138, no. 2, pl. 1.

66 – London, British Museum, Cotton MS. Aug. A.V., fol. 345v, 16 × 22 cm. Pächt, 'La Terre de Flandres', *Pantheon*, 36 (1978), pp. 3–16. Georges Dogaer attributes the miniature to the Master of the St Bertin Altarpiece, who was probably the French painter Simon Marmion; *Flemish Miniature Painting in the Fifteenth and Sixteenth Centuries* (Amsterdam, 1987), pl. 4.

67 – Cahn, 'Medieval Landscape and the Encyclopedic Tradition', in Daniel Poirion and Nancy Freeman Regalado, eds, *Contexts: Style and Values in Medieval Art and Literature*, Yale French Studies special issue (1991), p. 13.

68 – Hugo von Trimberg, *Der Renner*, Heidelberg, University Library, Cod. Pal. Germ. 471, fol. 4*; size of page 40.8 × 28 cm. *Regensburger Buchmalerei* (Munich, 1987), no. 89, pl. 62.

69 – Pächt, *Master of Mary of Burgundy*, p. 39.

70 – Panofsky, *Early Netherlandish Painting*, p. 244.

71 – *Hours*, fol. 93v, Turin, Museo Civico. See the facsimile edition by Georges Hulin de Loo, *Les Heures de Milan* (Paris and Brussels, 1911). Albert Châtelet, *Early Dutch Painting* (Fribourg, 1980), no. 18, with bibliography on p. 194.

72 – Besançon, Bibliothèque Municipale; size of page 27.7 × 19.3 cm. W.72. A similar castle appears in a pen sketch in Vienna, W. 103. The Paris exhibition catalogue *Altdorfer and Fantastic Realism in German Art* (Paris, 1984) published excellent facsimiles of the Altdorfer and other infrequently reproduced pages, for example the castle in a landscape by Lucas Cranach, pl. XXXI.

73 – Erika Tietze-Conrat, 'Das erste moderne Landschaftsbild', *Pantheon*, 15 (1935), pp. 72–3.

74 – Gombrich, 'Renaissance Theory of Art and the Rise of Landscape', p. 108.

75 – Gianvittorio Dillon, 'La pala di Asolo', *Lorenzo Lotto a Treviso*, exhibition catalogue (Treviso, 1980), pp. 127–47. André Chastel already doubted that the predella was original to the Assumption altarpiece: 'Sur une predelle enigmatique', *Acta Historiae Artium*, 24 (1978), pp. 167–75.

76 – Van Mander, *Das Leben der niederländischen und deutschen Maler*, ed. and trans. Hanns Floerke, 2 vols (Munich and Leipzig, 1906), I, p. 66. James Snyder thought the scene must have belonged to the main altar painting: 'The Early Haarlem School of Painting', *Art Bulletin*, 42 (1965), pp. 45–6. A later Franconian panel of the *Separation of the Apostles* (Nuremberg, Germanisches Nationalmuseum) may reflect Ouwater's composition; Châtelet, *Early Dutch Painting*, no. 50.

77 – Elisabeth Dhanens, *Hubert and Jan van Eyck* (New York, 1980), p. 115 (predella). Lotte Brand Philip, *The Ghent Altarpiece and the Art of Jan van Eyck* (Princeton, NJ, 1971), pp. 32, 100–101 (cloth antependium). Panofsky, *Early Netherlandish Painting*, p. 214, n. 1 (panel antependium, but with doubts).

78 – Bernard Berenson, *Italian Pictures of the Renaissance*, vol. 1: *Venetian School* (London, 1957), pl. 295. Stefano Bottari, *La Pittura del Quattrocento in Sicilia* (Messina and Florence, 1954), fig. 155, attributes the altar to Jacobello, Antonello's teacher.

79 – Dürer, *Adoration of the Trinity*, Vienna, Kunsthistorisches Museum, inv. no. 838, A.118. Altdorfer, *Madonna and Child in Glory*, Munich, Alte Pinakothek, inv. no. 665, W.45.

80 – Boston, Museum of Fine Arts; 95 mm. in diameter, 149 mm. high. Dodgson 123. Meder, *Dürer-Katalog* (Vienna, 1932), no. 209, knew only six impressions that included both landscape and roundel, although he missed the Boston impression.

81 – Panofsky, *Albrecht Dürer*, no. 397.

82 – *Lorenzo Lotto: L'opera completa*, ed. Rodolfo Pallucchini (Milan, 1975), no. 13.

83 – Behling, *Die Pflanze in der mittelalterlichen Tafelmalerei*, pls LXXIV–LXXV.

84 – Vienna, Österreichische Galerie, inv. no. 4856. Elfriede Baum, *Katalog des Museums Mittelalterlicher Österreichischer Kunst* (Vienna, 1971), no. 171. For a German example of pure foliage see Davies, *Paintings and Drawings on the Backs of National Gallery Pictures* (London, 1946), pl. 36 (inv. no. 3662).

85 – London, National Gallery, inv. no. 747, 17.5 × 57 cm; Davies, *Paintings and Drawings on the Backs of National Gallery Pictures*, p. 19.

86 – Max J. Friedländer, *Early Netherlandish Painting*, 14 vols (Leiden, 1962–76), vol. 8, no. 2.

87 – Washington DC, National Gallery of Art, Kress Collection. The wings have been split apart, and the Adam and Eve joined together to make a new central

image. Winzinger attributed them to a follower of the 1530s: *Altdorfer Gemälde*, nos. 109–11. Angelica Dülberg, *Privatporträts: Geschichte und Ikonologie einer Gattung im 15. und 16. Jahrhundert* (Berlin, 1990), no. 349. Baldass, *Albrecht Altdorfer*, p. 174.

88 – The landscapes belong to the Rijksmuseum, Amsterdam, inv nos A3134 and A3135, but are on long-term loan to The Hague, Mauritshuis, inv. no. 843, 90 × 30.5 cm. The rest of the altar is in New York, Metropolitan Museum of Art, inv. no. L 44.23.20. Friedländer, *Early Netherlandish Painting*, vol. 6, no. 160. Hans J. van Miegroet, *Gerard David* (Antwerp, 1989), pp. 231–4, no. 30, dates them to 1510–15.

89 – Panofsky, *Early Netherlandish Painting*, p. 278, n. 1.

90 – Esther E. Cleven, 'Ach was ist der Wald schön grün: Gerard David, das "bosgezicht", und sein (Miss-) Verständnis', *Akt over kunst*, 14 (1990), pp. 2–14. For this reference and other information I am grateful to Edwin Buijsen at the Mauritshuis, who was involved in the restoration of the panels in 1986–7 and is preparing an iconographic study.

91 – Dülberg, *Privatporträts: Geschichte und Ikonologie einer Gattung im 15. und 16. Jahrhundert*.

92 – New York, Metropolitan Museum, inv. no. L 44.22.1. Rotterdam, Museum Boymans–van Beuningen. Friedländer, *Early Netherlandish Painting*, vol. 6, 1, no. 16A. Dülberg, *Privatporträts*, no. 176. Panofsky thought the two panels composed a diptych: *Early Netherlandish Painting*, p. 349, n. 7.

93 – An existing panel meeting this description is evidently a forgery by the seventeenth-century painter Peter Cordüer; the landscape is an exact copy of a scene from the Grimani Breviary, a Flemish manuscript of about 1510. A second forgery was inspired by another entry in an Imhoff inventory: a description of a lost Dürer – a miniature in an edition of Lucian? – with 'a landscape and four satyrs'. Private collections, 44 × 32 cm. and 45 × 32 cm. A. 41k–42k. Dülberg, *Privatporträts*, nos 339–40, with texts.

94 – Quoted in Michael Baxandall, *Painting and Experience in Fifteenth-century Italy* (Oxford, 1972), p. 17. This remains the standard usage of the word *paese* in sixteenth-century texts; see, for example, Pontormo's letter to Varchi of 1548.

95 – Snyder, 'The Early Haarlem School of Painting', p. 45, n. 32. The date 1490 that is usually given to this document is unreliable; according to A. W. Weissman, 'Gegevens omtrent Bouw en Inrichting van de Sint Bavokerk te Haarlem', *Oud-Holland*, 33 (1915), pp. 69–70, the document was merely found between the leaves of a book printed in 1490.

96 – Letters of 4 November 1508 and 26 August 1509; Rupprich, 1, pp. 68, 72.

97 – In a contract between the painter Engelhart Hofmann and the Franciscan convent, published in Hans Huth, *Künstler und Werkstatt der Spätgotik* (1925; Darmstadt, 1967), p. 135, col. 1.

98 – Richter, *The Notebooks of Leonardo da Vinci*, no. 461.

99 – Rupprich, 1, p. 126. Pirckheimer said that had he lived longer, Dürer would have produced many writings 'useful to the art of painting, landscape, colours,

and the like', as well as perspective.

100 – See the superb summary of texts and examples in Walter S. Gibson, *'Mirror of the Earth': The World Landscape in Sixteenth-century Flemish Painting* (Princeton, NJ, 1989), pp. 37–42.

101 – Quoted in Baxandall, *Giotto and the Orators* (Oxford, 1971), p. 108 n.

102 – Vasari, *Le Vite*, ed. Milanesi, 7, p. 429: 'e tenuto per ciò in casa alcuni Tedeschi, eccellenti pittori di paesi e verzure'.

103 – Günter Panhans, 'Florentiner Maler verarbeiten ein Eyckisches Bild', *Wiener Jahrbuch für Kunstgeschichte*, 27 (1974), pp. 188–98.

104 – Memling, *Madonna and Child with Two Angels*, Florence, Uffizi inv. no. 703, *c.*1480, 57 × 42 cm. Friedländer, *Early Netherlandish Painting*, vol. 6, 1, no. 61; Fra Bartolommeo, *Madonna and Child*, New York Metropolitan Museum, inv. no. 06.171, *c.*1495, 58.4 × 43.8 cm. Everett Fahy, 'The Earliest Works of Fra Bartolommeo', *Art Bulletin*, 51 (1969), pp. 142–54. Liana Castelfranchi Vegas, *Italie et Flandres dans la peinture du XVe siècle* (Milan, 1983), p. 226, illus 132, 140.

105 – *Zibaldone*, Florence, Biblioteca Nazionale, B.R. 5.1.13, formerly Magliabech. Cl. XVII, 7 cod. 2; fol. 75; *c.*1472–83. See Robert Corwegh, 'Der Verfasser des kleinen Kodex Ghiberti', *Mitteilungen des Kunsthistorischen Institutes in Florenz*, 1 (1908–11), pp. 156–67; and Bernhard Degenhart in *Münchner Jahrbuch bildenden Kunst*, 9 (1932), p. 9f.

106 – See the exhibition catalogue *Vorbild Dürer: Kupferstiche und Holzschnitte Albrecht Dürers im Spiegel der europäischen Druckgraphik des 16. Jahrhunderts* (Nuremberg: Germanisches Nationalmuseum, 1978).

107 – Vasari, *Le Vite*, ed. Milanesi, 5, p. 399.

108 – Madrid, Prado, inv. no. 1611, 121 × 177 cm.

109 – See Robert A. Koch, *Joachim Patenir* (Princeton, NJ, 1968), pp. 49–50; and Larry Silver, *The Paintings of Quentin Massys* (Oxford, 1984), no. 26, p. 209. The double attribution is attested by an inventory of 1574. Van Mander mentioned a Madonna by Joos van Cleve of Antwerp with 'a very beautiful landscape' painted by Patenir: *Das Leben der niederländischen und deutschen Maler*, vol. 1, p. 211.

On Patenir and the 'world-landscape' generally, see Gibson, *Mirror of the Earth*; and Detlef Zinke, *Patinirs 'Weltlandschaft': Studien und Materialien zur Landschaftsmalerei im 16. Jahrhundert* (Frankfurt, 1977), a little-known but highly original study and the best collection of primary textual evidence on Renaissance landscape.

110 – 5 May 1521. Rupprich, 1, p. 169: 'der gut landschafft mahler'.

111 – Theodor Frimmel, ed., *Der Anonimo Morelliano (Marcantonio Michiel's Notizia d'Opere del disegno)*, Quellenschriften für Kunstgeschichte und Kunsttechnik des Mittelalters und der Renaissance, 1 (Vienna, 1888), p. 102.

112 – Berlin, Gemäldegalerie, inv. no. 1631, 42 × 28 cm. Châtelet, *Early Dutch Painting*, no. 72.

113 – See Margaret Sullivan, 'Bruegel's Proverbs: Art and Audience in the Northern Renaissance', *Art Bulletin*, 73 (1991), p. 438.

114 – Friedländer, *Landscape, Portrait, Still-Life* (New York, 1963), p. 66 (original publication in German, 1947).

115 – Gibson, *Mirror of the Earth*, pp. 47–59, has assembled much important evidence for this relationship. See also Alpers, *Art of Describing*, ch. 4, esp. p. 138.

116 – London, British Museum. 77 mm. in diameter. G.F. Hill, *A Corpus of Italian Medals of the Renaissance* (London, 1930), no. 44, pl. 11.

117 – *Historie des Bijbels*, vol. 2, Brussels, Bibliothèque Royale, inv. no. 9018–19, fol. 7r. Camille Gaspar and Frédéric Lyna, *Les Principaux Manuscrits à peintures de la Bibliothèque royale de Belgique* (Brussels, 1984–9), vol. 2, no. 223, p. 70ff. The Bible was made in Utrecht. The text was quoted in Ludwig Kaemmerer, *Die Landschaft in der deutschen Kunst* (Leipzig, 1886), p. 47.

118 – Bernhard Degenhart and Annegrit Schmitt, 'Marino Sanudo und Paolino Veneto: Zwei Literaten des 14. Jahrhunderts in ihrer Wirkung auf Buchillustrierung und Kartographie in Venedig, Avignon und Neapel', *Römisches Jahrbuch für Kunstgeschichte*, 14 (1973), p. 7, n. 8.

119 – Fazio's text was edited by Baxandall, 'Bartholomaeus Facius on Painting', *Journal of the Warburg and Courtauld Institutes*, 27 (1964), pp. 102–3. See Charles Sterling, 'Jan van Eyck avant 1432', *Revue de l'Art*, 33 (1976), pp. 69–77.

120 – Nuremberg, Germanisches Nationalmuseum, inv. no. WI 1826. The globe was painted by Georg Glockendon.

121 – Rupprich, 2, pp. 131, 133: 'Dy messung des ertrichs, wasser und der stern ist verstentlich worden durch antzeigen der gemell . . .'.

122 – *Treatise on Painting*, ed. McMahon, no. 49: 'la pittura che in una piana superficie per forza di scientia dimostra le grandissime campagne con li lontani orizzonti.'

123 – Pass. 201; B.151–2. See Nuremberg 1971, nos 307–10 and 315.

124 – Dieter Wuttke discovered the model in the Neudörfer manuscripts, which had been irresponsibly transcribed by their nineteenth-century editor. The text should read: 'Er hat auch selbsten mich eine gantze Mappa sehen lassen, die Er von erhöchten Bergen und geniderten Wasserflüssen, samt den Stätten und Wäldern Erhölungen geschnitzt und gemahlet hat.': 'Das unbekannte Landschaftsmodell des Veit Stoss', *Artibus et historiae*, 6 (1982), pp. 89–96.

125 – Quoted in Dieter Koepplin, *Cranachs Ehebildnis des Johannes Cuspinian von 1502*, diss., Basel 1964 (1973), p. 103, n. 263: 'cognoscerentque quadam veluti brevi tabula et modica verborum sculptura, quo et per quem universus ille conflatus esset et consisteret . . .'.

126 – Quoted in Koepplin, *Cranachs Ehebildnis*, p. 116, n. 317: 'ut pictores solent, in parva tabella totum orbem describere'.

127 – Quoted in Koepplin, *Cranachs Ehebildnis*, p. 111: 'in parvae tabulae modum . . . depictam'.

128 – Celtis, *Quatuor libri amorum* (Nuremberg, 1502), fol. 25r, 22 × 15 cm. (Harvard University, Houghton Library). See the exhibition catalogue *Meister um Albrecht Dürer*, no. 226, where the woodcuts are attributed to Dürer's pupil Hans von Kulmbach; and Nuremberg 1971, no. 289.

129 – Heinrich Lausberg, *Handbuch der literarischen Rhetorik*, 2 vols (Munich, 1960), § 819, *Topographia*, here drawing on Quintilian.

130 – See, for instance, Vadian or Cuspinian, cited in Koepplin, *Cranachs Ehebildnis*, p. 100, n. 252, and pp. 110–11.

131 – See Dürer's drafts for the introduction to the treatise on painting (1512), Rupprich, 2, pp. 109, 111, 112; or Leonardo, *Notebooks*, ed. Richter, nos 653–4.

132 – Paracelsus, *De imaginibus*, in Karl Sudhoff, ed., *Sämtliche Werke* (Munich and Berlin, 1931), 1. Abteilung, 13, pp. 375–6: '. . . es seind der chiromantia noch mer, ein chiromantia der kreuter, ein chiromantia des laubs an den beumen, ein chiromantia des holz, ein chiromantia der felsen und bergwerken, ein chiromantia der lantschaften durch die straßen und wasserflüss.' The passage was memorably quoted, in this case with attention to the concept of chiromancy, by Baxandall, *Limewood Sculptors*, p. 32.

133 – The term *logos* is used in the first chapter of the *Poetics* and is sometimes translated as 'speech'. For the interpretation of *logos* as the first state of the text, prior to recitation or performance, see Gerald Else, *Aristotle's Poetics: The Argument* (Cambridge, Mass., 1957), pp. 17, 24–5.

134 – Lausberg, *Handbuch der literarischen Rhetorik*, § 46.

135 – Huth, *Künstler und Werkstatt der Spätgotik*, p. 115, col. 1, and p. 137, col. 1. See also the contract with Wolf Huber of 1515, p. 132, col. 2, and p. 133, col. 1. The word *historie* is used in a similar way, for example at p. 135, col. 2, and p. 139, col. 1.

136 – Rupprich, 2, p. 131, 133: 'Dan dy gemell werden geprawcht jm dinst der kÿrchen und dardurch angetzeigt das leÿden Crÿstÿ und vill andrer guter ebenpild.' The passage immediately precedes the remarks on painting and cartography quoted above, p. 46.

137 – 18 August 1506. Rupprich, 1, p. 53: 'Item der historien halben sy ich nix besunders, daz dy walhen machen, daz sunders lustig in ewer studiorum wer.'

138 – London, National Gallery, inv. no. 6307 (*c.*1505–10). Canvas, 73.3 × 91.5 cm.

139 – London, National Gallery, inv. no. 4884 (*c.*1505). Panels, each scene 19.7 × 18.4 cm.

140 – Washington DC, National Gallery of Art, inv. no. 1942.9.2 (*c.*1515). Canvas, transferred from panel, 39.5 × 81 cm.

141 – Washington DC, National Gallery of Art, inv. nos. 1939.1.147 (*c.*1505) and 1939.1.156 (dated 1505). Panels, 43 × 34 cm. and 56.5 × 42.2 cm.

142 – Paris, Louvre, inv. no. 71 (*c.*1510). Canvas, 109 × 137 cm.

143 – Edinburgh, National Gallery of Scotland (*c.*1512–15). Canvas, 90.2 × 151.2 cm.

144 – Paul Schubring, *Cassoni* (Leipzig, 1915), p. 176.

145 – Dülberg, *Privatporträts*, no. 187.

146 – Dülberg, *Privatporträts*, no. 329.

147 – Venice, Galleria dell' Accademia, inv. no. 915. Canvas, 68 × 59 cm.

148 – Venturi, *Giorgione e il giorgionismo* (Milan, 1913); Gilbert, 'On Subject and Not-Subject in Italian Renaissance Pictures', *Art Bulletin*, 34 (1952), pp. 202–16.

149 – Settis, *La 'Tempesta' interpretata* (Turin, 1978).

Translated as *Giorgione's 'Tempest': Interpreting the Hidden Subject* (Cambridge, 1990).

150 – Barthes, 'Introduction à l'analyse structurale des récits', *L'Analyse structurale du récit* (Paris, 1981), p. 13, nn. 1–2 (reprint of *Communications*, 8 [1966]).

151 – Vasari, *Le Vite*, ed. Milanesi, 4, p. 96.

152 – Quoted in Jakob Burckhardt, 'Die Sammler', *Beiträge zur Kunstgeschichte von Italien*, ed. Heinrich Wölfflin (Stuttgart, 1930), p. 387.

153 – Washington DC, National Gallery of Art, Samuel H. Kress Collection, *c.*1500. Panel, 56 × 44 cm.

154 – New York, Metropolitan Museum of Art, Lehman Collection. Dülberg, *Privatporträts*, no. 184.

155 – Frimmel, ed., *Der Anonimo Morelliano*, p. 88.

156 – Frimmel, ed., *Der Anonimo Morelliano*, pp. 88, 102.

157 – Frimmel, ed., *Der Anonimo Morelliano*, p. 106: 'el paesetto in tela cun la tempesta, cun la cingana et soldato'. Michiel also used the word *paesetto* to describe the landscape seen through the window in a picture of St Jerome in his study (pp. 98–100).

158 – Erika Tietze-Conrat, 'Titian as a Landscape Painter', *Gazette des Beaux-Arts*, n.s. 6, 45 (1955), pp. 15–19, fig. 4. See Harold Wethey, *The Paintings of Titian*, vol. 3: *The Mythological and Historical Paintings* (London, 1975), p. 213, no. X–18, as follower of Titian.

The word *paesaggio*, incidentally, imitated the French *paysage*. One of its first usages in a pictorial context was a letter of 1564 from Domenicus Lampsonius of Bruges to Vasari: '. . . a dipigner' cose piu incerte, che ricercano la mano piu esercitata e sicura, quali sono paesaggi, alberi, acque, splendori, fuochij ecc.' Karl Frey and Herman-Walther Frey, eds, *Der literarische Nachlass Giorgio Vasaris*, vol. 2 (Munich 1930), pp. 114–15, no. CDLXVII.

159 – Alberti, *Ten Books on Architecture*, Book IX, ch. 4. The passage is translated in Gombrich, 'Renaissance Theory of Art and the Rise of Landscape', p. 111.

160 – *Treatise on Painting*, ed. McMahon, no. 42; see also no. 22.

161 – Erasmus, *Christiani Instituto Matrimonii* (1526), *Opera omnia*, vol. 5 (London, 1704; reprinted London 1962), col. 697A.

162 – 'Doxi autem Ferrariensis urbanum probatur ingenium cum in justis operibus, tum maxime in illis, quae parerga vocantur. Amoena namque picturae diverticula voluptario labore consectatus, praeruptas cautes, viventia nemora, opacas perfluentium ripas, florentes rei rusticae apparatus, agricolarum laetos fervidosque labores, praeterea longissimos terrarum marisque prospectus, classes, aucupia, venationes et cuncta id genus spectatu oculis jucunda, luxurianti ac festiva manu exprimere consuevit.' The original text is quoted, but misleadingly translated, by Gombrich, 'Renaissance Theory of Art and the Rise of Landscape', pp. 113–14.

163 – *Treatise on Painting*, ed. McMahon, no. 93.

164 – *Francesco da Hollanda: Vier Gespräche über die Malerei*, ed. Joaquim de Vasconcellos, Quellenschriften für Kunstgeschichte und Kunsttechnik des Mittelalters und der Renaissance, 9 (Vienna, 1899), pp. 28–9.

165 – Koepplin, *Cranachs Ehebildnis*, pp. 188–91. See also Eugenio Battisti, 'Le origini religiose del paesaggio veneto', *Esistenza, Mito, Ermeneutica*, vol. 1, Archivio di

Filosofia (Padua, 1980), pp. 227–46; and the excellent summary of the sources in Lisa Vergara, *Rubens and the Poetics of Landscape* (New Haven, 1982), ch. 6.

166 – The book, the edition of Aldus Manutius of 1495 or 1496, is now in New York, Ian Woodner Family Collection. The miniature was painted on vellum, then cut out and pasted on the printed page. *Die Sammlung Ian Woodner* (Vienna: Graphische Sammlung Albertina, 1986), no. 48; *Woodner Collection: Master Drawings* (New York: Metropolitan Museum of Art, 1990), no. 58. Nuremberg 1971, no. 296. The miniature is closely related to a page in a Florentine manuscript of about 1490 with poems by Poliziano, Lorenzo de' Medici, and others.

167 – Myriam Billanovich recently called attention to inconsistencies between two early redactions of Feliciano's account; she actually doubts that the excursion ever took place: 'Intorno alla "Iubilatio" di Felice Feliciano', *Italia medioevale e umanistica*, 32 (1989), pp. 351–8. I owe this reference to Robert Williams, London.

168 – See the essay by Sandro de Maria in the exhibition catalogue *Humanismus in Bologna, 1490–1510* (Bologna, 1988), p. 22.

169 – *Poetics*, Book 5.

170 – Van Mander, *Das Leben der niederländischen und deutschen Maler*, ed. Floerke, vol. I, p. 256, in the translation of F. Grossmann, *Bruegel: The Paintings* (London, 1966), p. 7.

171 – Pliny, *Historia naturalis*, 35.101.

172 – *Hypnerotomachia Poliphili* (Venice: Aldus Manutius, 1499), p. d.iii: 'cum gli exquisiti parergi, Aque, fonti, monti, colli, boscheti, animali . . .'. Quoted in Gombrich, 'Renaissance Theory of Art and the Rise of Landscape', p. 114, n. 36.

173 – Friedrich Winkler, 'Simon Marmion als Miniaturmaler', *Jahrbuch der königlichen Preussischen Sammlungen*, 34 (1913), pp. 279–80.

174 – *Hortulus animae*, Vienna, Österreichische Nationalbibliothek, Cod. 2706, fol. 258v; before 1524. Winkler, *Flämische Buchmalerei*, pp. 119, 207, pl. 69, as the Hortulus Master (the same who painted the empty calendar landscapes in the Prayer Book of James IV; see p. 35 above). Dagmar Thoss, *Flämische Buchmalerei: Handschriftenschätze aus dem Burgunderreich*, exhibition catalogue, Vienna, Österreichische Nationalbibliothek (Graz, 1987), no. 78.

175 – Blount, *Glossographia* (London, 1656). See also his entry for 'Parergy, Parergon, or Parergum'.

176 – These examples are well-known, but were most recently and incisively analyzed by Norman Bryson, *Looking at the Overlooked: Four Essays on Still Life Painting* (London, 1990), ch. 4.

177 – Gilbert, 'On Subject and Not-Subject', pp. 204–5, and Felton Gibbons, *Dosso and Battista Dossi* (Princeton, NJ, 1968), pp. 108–12, both interpreted the passage this way.

178 – Gibbons, *Dosso and Battista Dossi*, nos 130, 5, 70.

179 – Canvas, 81 × 133 cm. Unpublished; auctioned at Sotheby's, New York, on 15 January 1993. I am grateful to Creighton Gilbert for alerting me in time to see the picture before it was sold.

180 – Philostratus, *Imagines*, ed. and trans. Arthur

Fairbanks, Loeb Classical Library (Cambridge, Mass., 1960). See Karl Lehmann-Hartleben, 'The "Imagines" of the Elder Philostratus', *Art Bulletin*, 23 (1941), pp. 16–44, on the question of the reality of Philostratus's images. Although the particular panels subjected to Philostratus's *ekphrases* may not have existed, others like them certainly did.

181 – Pliny, *Historia naturalis*, 35.118. On the other hand, panel painters were perhaps more famous only because their pictures could be rescued from fires and therefore survived longer.

182 – Derrida, *La Vérité en peinture* (Paris, 1978); *The Truth in Painting*, trans. Geoff Bennington and Ian McLeod (Chicago, 1987), ch. 1: 'Parergon'.

183 – Pliny, *Historia naturalis*, 35.101. This had been pointed out by Jean-Claude Lebensztejn in his essay 'L'art de la signature: Esquisse d'une typologie', *Revue de l'art*, 26 (1974), pp. 48–56.

184 – Strabo, *Geography*, vol. 6, ed. Horace Leonard Jones, Loeb Classical Library (Cambridge, Mass., 1929), Book XIV, 2, 5; quoted by Gilbert, 'On Subject and Not-Subject', p. 204, n. 8.

185 – Hans-Wolfgang Strätz, 'Notizen zu Stil und Recht', in *Stil: Geschichten und Funktionen eines kulturwissenschaftlichen Diskurselements*, ed. Hans Ulrich Gumbrecht and K. Ludwig Pfeiffer (Frankfurt, 1986), pp. 53–67.

186 – The paraph or the 'seing manuel' was applied to documents by scribes from the tenth century on, and was replaced by signatures only in the sixteenth century. The paraph survived in Germany into the eighteenth century in the form of small engraved emblems. See Daniel Eberhard Baring, *Clavis diplomatica* (Hannover, 1737); A. Giry, *Manuel de Diplomatique* (Paris, 1894), pp. 602–11; A. de Boüard, *Manuel de diplomatique française et pontificale* (Paris, 1929), pp. 330–33; Friedrich Leist, *Die Notariats-Signete* (Leipzig and Berlin, 1897).

187 – *The Merry Wives of Windsor*, II.ii. 272–3.

188 – 'Ja es wirt nyemandt dann der gleych wie du gar und gantz vorblendet ist urteylen, das das meyn stilus

oder gedicht sey . . .'. *Luther und Emser: Ihre Streitschriften aus dem Jahre 1521*, ed. Ludwig Enders, vol. 2, Flugschriften aus der Reformationszeit, 9 (Halle, 1891), pp. 6–7.

189 – Vasari, *Le Vite*, ed. Milanesi, 5, p. 398.

190 – *Treatise on Painting*, ed. McMahon, no. 76.

191 – Vasari, *Le Vite*, ed. Milanesi, 4, p. 134.

192 – London, British Museum, inv. no. 5218/162. 61 × 40 mm. Winkler 631, Strauss 1511/19.

193 – Alberti, *On Painting*, ed. and trans. John R. Spencer (New Haven, 1956), Book Two, pp. 72–85; *Della Pittura*, in Alberti, *Kleinere kunsttheoretischen Schriften*, ed. and trans. Hubert Janitschek, Quellenschriften für Kunstgeschichte und Kunsttechnik des Mittelalters und der Renaissance, 11 (Vienna, 1877), pp. 115–41.

194 – Hilliard, *Art of Limning* (c.1598–9), ed. Linda Bradley Salamon (Boston, 1983), p. 30.

195 – Peacham, *Graphice, or the most auncient and excellent art of drawing and limming* (1612), p. 45.

196 – Franciscus Junius, *The Painting of the Ancients* (1638), p. 354. See the critical edition of the English translation, ed. Keith Alldrich, Philipp Fehl and Raina Fehl (Berkeley, 1991), p. 311. Junius ends his entire book (at least in the Dutch and English translations) with the discussion of *parerga*.

197 – Hoogstraten, *Inleyding tot de hooge schoole der schilderkonst* (Rotterdam, 1678), p. 90; quoted by E. de Jongh, 'The Interpretation of Still-life Paintings: Possibilities and Limits', in *Dutch Still-Life Painting*, ed. de Jongh *et al.* (Auckland, 1983), p. 28, n. 6.

198 – Rupprich, 3, pp. 291, 293. See also below, p. 80. Raupp, *Bauernsatiren: Entstehung und Entwicklung des bäuerlichen Genres in der deutschen und niederländischen Kunst ca. 1470–1570* (Niederzier, 1986), pp. 37–9. Parshall, 'Reading the Renaissance Woodcut: The Odd Case of the Master N.H. and Hans Lützelburger', *Register of the Spencer Museum of Art*, 6 (1989), pp. 30–43, makes a similar point, adducing like Raupp the example of the *Battle of Naked Men and Peasants* by N.H. and its accompanying text.

2 Frame and work

1 – Friedländer, *Albrecht Altdorfer* (1891), ch. 3.

2 – Charles Garside, *Zwingli and the Arts* (New Haven, 1966), p. 76.

3 – Zwingli, 'Eine Antwort, Valentin Compar gegeben', *Sämtliche Werke*, 4, Corpus Reformatorum, 91 (Leipzig, 1927), p. 123.

4 – See especially Hans Huth, *Künstler und Werkstatt der Spätgotik* (1925; reprinted Darmstadt, 1967), pp. 51–4, 81–6.

5 – Aeneas Silvius (Enea Silvio Piccolomini), *Germania*, ed. Adolf Schmidt (Cologne, 1962), Book II, 10. Schmidt published a translation of the text in the same year. On the reception of the book in Germany, see below, p. 157.

6 – *Liber chronicarum* (Nuremberg, 1493), fol. 97v–98r, 192 × 533 mm. Yale University, Beinecke Library.

7 – The altar wings are preserved in the Stadtmuseum, Regensburg. The altar may originally have been painted for St Ulrich's and not for the cathedral. See

Stange, *Deutsche Malerei der Gotik* (who attributes them to Frueauf); Baldass, *Conrad Laib und die beiden Rueland Frueauf* (Vienna, 1946), nos 58–71 (Frueauf workshop); and Baum, *Katalog des Museums Mittelalterlicher Österreichischer Kunst*, p. 80 (follower of Conrad Laib).

8 – See Achim Hubel in *Regensburger Buchmalerei von frühkarolingischer Zeit bis zum Ausgang des Mittelalters* (Munich, 1987), pp. 111–18, nos 103–10.

9 – Karl Schottenloher, *Das Regensburger Buchgewerbe im 15. und 16. Jahrhundert* (Mainz, 1920), pp. 1–17.

10 – The documents are published in Winzinger, *Altdorfers Gemälde*, p. 145. The most comprehensive discussion is C. W. Neumann's article in the *Allgemeines Künstler-Lexikon*, ed. Julius Meyer, vol. 1 (Leipzig, 1872), p. 536ff.

11 – Berlin, Kupferstichkabinett, Hs. 78 B 5. *Regensburger Buchmalerei*, p. 117, with illustration.

12 – The attractive hypothesis of a lost local ornamental style predating Altdorfer, with rustic drolleries and

swirling vegetation, cannot be sustained by surviving manuscripts. See for example A. de Hevesy, *La Bibliothèque du roi Matthias Corvinus* (Paris, 1923), p. 27. When Hans Tietze published the so-called Strochner Prayer Book from Nonnberg, he thought he had found the missing link between Furtmeyr and Altdorfer. But his dating of the marginal illumination, which is indeed close to Altdorfer in ductus and tone of voice, to the first decade of the century was too early. Even if it is not too early, the work is still posterior or subordinate to Altdorfer. Vienna, Österreichische Nationalbibliothek, Cod. ser. nov. 3257. Tietze, 'Albrecht Altdorfers Anfänge', *Jahrbuch der K.-K. Zentral-Kommission*, 2 (1908), pp. 1–20; Kurt Holter and Karl Oettinger, 'Manuscrits allemands', in 'Les Principaux Manuscrits de la Bibliothèque Nationale de Vienne', *Bulletin de la Société Française pour la Reproduction de Mss. à peintures*, 21 (1938), 142–3, no. 57 (marginal illumination by the Kölderer shop); Linz 1965, no. 424.

13 – See Hubel in *Regensburger Buchmalerei*, p. 117.

14 – Vienna, Haus-, Hof-, und Staatsarchiv, Allgemeine Urkundenreihe, 1512.XII.19, fol. 1v and 2r. Benesch, *Historia Friderici et Maximiliani*, pp. 112–13, illus. 85–6, derived the illuminations from Kölderer.

15 – Heinz Jürgen Sauermost argued that the young Altdorfer was working in 1506 on the high altar in Schwabach, just south of Nuremberg, under Michael Wolgemut. The hypothesis has at least the merit of calling attention to Franconian painting as a source for Altdorfer: 'Ohne Stoss – mit Altdorfer: Planung und Ausführung des Schwabacher Altars', *Jahrbuch des Vereins für christliche Kunst*, 14 (1984), pp. 44–63.

16 – Sandrart, *Teutsche Academie*, vol. 1, pt 2, book 3, chap. IV, xxiv, p. 231.

17 – Quad von Kinckelbach, *Teutscher Nation Herligkeit* (Cologne, 1609), p. 430.

18 – Heller, *Das Leben und die Werke Albrecht Dürers*, vol. 2 (Leipzig, 1831), p. 68. The drawing apparently belonged to the Welser collection and came up for auction in 1793. In 1822 it was in the possession of the Nuremberg dealer Frauenholz. Moriz Thausing, *Dürer: Geschichte seines Lebens und seiner Kunst* (Leipzig, 1884), vol. 1, pp. 176–7, and Friedländer, *Albrecht Altdorfer: Der Maler von Regensburg* (Leipzig, 1891), p. 5, both discounted the inscription; neither saw the drawing, however.

19 – Berlin, Kupferstichkabinett, KdZ 24624; Winkler 46, Strauss 1494/2. Ian Woodner Family Collection; Winzinger, 'Eine unbekannte Zeichnung Albrecht Dürers aus seiner Wanderzeit', *Pantheon*, 40 (1982), pp. 229–32; *Die Sammlung Ian Woodner*, no. 51, and *Woodner Collection: Master Drawings*, no. 55.

20 – Walter Boll, 'Albrecht Altdorfers Nachlass', *Münchner Jahrbuch der bildenden Kunst*, 13 (1938–9), p. 100.

21 – W.108; B.31.

22 – Koepplin, 'Das Sonnengestirn der Donaumeister', in *Werden und Wandlung: Studien zur Kunst der Donauschule*, ed. Kurt Holter and Otto Wurzel (Linz, 1967), p. 114.

23 – Jakob Wimpheling (1505), Christoph Scheurl (1515), and Beatus Rhenanus (1531) all mentioned Schongauer in printed texts.

24 – In the 1530s, an anonymous Swabian chronicler attributed a local retable, evidently without justification, to 'Hüpsch Martin, dem bössten Mahler'. A. Schilling, 'Die religiösen und kirchlichen Zustände der ehemaligen Reichstadt Biberach unmittelbar vor der Reformation', *Freiburger Diözesan-Archiv*, 19 (1887), p. 24; earlier he refers to 'der guoth Maister Hüpsch Marte'.

25 – Wilhelm L. Schreiber, *Handbuch der Holz- und Metallschnitte des XV. Jahrhunderts* (Leipzig, 1926–30), vol. 7, p. 40–43. A.M. Hind discusses Venetian book illustrations signed with single initials and concludes that they always designate the cutter and not the designer. *Introduction to a History of Woodcut* (New York, 1963), vol. 2, pp. 467–9.

26 – Hind reviews many cases, *Introduction to a History of Woodcut*, vol. 1, pp. 92, 128–30, 320–25, 388–9, and *passim*. Some of the names are accompanied by the word 'maler'. Mair von Landshut signed three woodcuts 'Mair' (two are dated 1499). Meanwhile, a woodcut based on an engraving by Mair is signed by the cutter, Hans Wurm.

27 – See Johannes Jahn, *Lucas Cranach als Graphiker* (Leipzig, 1955), p. 10. Another pioneer was Erhard Reuwich, the Utrecht painter who illustrated and printed Bernhard von Breydenbach's *Sancta Peregrinationes* (Mainz, 1486). See Hind on the attribution of illustrations to the Housebook Master (who may yet be Erhard Reuwich!), *Introduction to a History of Woodcut*, vol. 1, pp. 354–6, and the excellent discussions by Jane Campbell Hutchison and J.P. Filedt Kok in *Livelier than Life: The Master of the Amsterdam Cabinet or the Housebook Master* (Amsterdam: Rijksprentenkabinet, 1985), pp. 41–64, 278–84. Hind argued that painters generally did design the very early woodcuts, *Introduction to a History of Woodcut*, vol. 1, p. 93; so did Flechsig, at greater length, in *Albrecht Dürer* (Berlin, 1931), vol. 1, p. 73ff.

28 – The first to refer to Dürer in print was Wimpheling in his *Epithoma rerum germanicum* of 1505. On this topic see, most recently, Bernhard Decker, 'Dürer – Konstruktion eines Vorbildes,' in *Dürers Verwandlung in der Skulptur* (Frankfurt, 1981), pp. 397–431; and Jan Białostocki, *Dürer and His Critics*, Saecula Spiritalia, 7 (Baden-Baden, 1986), pp. 15–35. On the humanists' 'fame-mechanism' in general see Martin Warnke, *Hofkünstler: Zur Vorgeschichte des modernen Künstlers* (Cologne, 1985), ch. 9; trans. as *The Court Artist: On the Ancestry of the Modern Artist* (Cambridge, 1993).

29 – Dieter Wuttke, 'Unbekannte Celtis-Epigramme zum Lobe Dürers', *Zeitschrift für Kunstgeschichte*, 30 (1967), pp. 321–5.

30 – Panofsky, 'Erasmus and the Visual Arts', *Journal of the Warburg and Courtauld Institutes*, 32 (1969), pp. 200–27; Rupprich, 1, pp. 296–7.

31 – Rupprich, 2, p. 93.

32 – H.A. Schmid credited him with ten woodcut initials used by the firm of Schöffer in Mainz from 1522 on: *Die Gemälde und Zeichnungen von Matthias Grünewald* (Strasbourg, 1911), p. 271. Maria Lanckoronska detected Grünewald working for Zainer in 1476, 'Der Zeichner der Illustrationen des Ulmer Aesop', *Gutenberg-Jahrbuch* (1966), pp. 275–83. There is, in fact, no reason to believe that Grünewald designed prints, nor any proof that he did not.

33 – The Cuspinian portraits are in the Reinhart collection in Winterthur; the other pair are in Nuremberg and Berlin. Max J. Friedländer and Jakob Rosenberg, *Die Gemälde von Lucas Cranach* (Berlin, 1932), nos 6–9. Basel 1974, p. 768, n. 147, and nos 88–89. See Koepplin's discussion in the Basel catalogue, p. 160ff., and his dissertation, *Cranachs Ehebildnis des Johannes Cuspinian von 1502*, where he discards the old identification of the Nuremberg portrait as Stephan Reuss, p. 266f.

34 – Private collection. Ernst Buchner, *Das deutsche Bildnis der Spätgotik und der frühen Dürerzeit* (Berlin, 1953), no. 167. Nuremberg 1971, no. 75. Basel 1974, no. 91. The continuous landscape behind the half-length portrait was introduced by Hans Memling, for example in the *Man with a Medal* in Antwerp. Memling adapted the device from his teacher, Rogier van der Weyden; see the Braque triptych in the Louvre.

35 – Koepplin, *Cranachs Ehebildnis des Johannes Cuspinian von 1502*, esp. pp. 195–218.

36 – Berlin, Gemäldegalerie, inv. no. 564 A, 70.7 × 53 cm. Friedländer and Rosenberg, *Die Gemälde von Cranach*, no. 10.

37 – *Crucifixion*, Vienna, Kunsthistorisches Museum, inv. no. 1825; Friedländer and Rosenberg, *Die Gemälde von Cranach*, no. 1. *St Jerome*, Vienna, Kunsthistorisches Museum, inv. no. 6739, dated 1502; Friedländer and Rosenberg, *Die Gemälde von Cranach*, no. 4. *Crucifixion*, Munich, Alte Pinakothek, inv. no. 1416, dated 1503, an iconic image converted to narrative by a simple rotation through 90 degrees; Friedländer and Rosenberg, *Die Gemälde von Cranach*, no. 5. The panels *St Francis* and *St Valentine* in the Akademie in Vienna (inv. nos 28–29) were wings of a small altar; Koepplin suggests that the middle panel was a wood relief (Basel 1974, p. 156, nos 85–6). See especially Koepplin's comments on Cranach's *agon* with Dürer's graphic work in the Vienna years, Basel 1974, p. 112ff.

38 – Scheurl's 1509 letter to Cranach is published in excerpts in Rupprich, 1, p. 292–3, and in German translation in Christian Schuchardt, *Lucas Cranach des Älteren Leben und Werke*, vol. 1 (Leipzig, 1851), pp. 27–35. Werner Schade, *Die Malerfamilie Cranach* (Vienna and Munich, 1977), pp. 26–7, interprets Cranach's trademark winged serpent as a deliberate play on this reputation and on the Latinization of his name as 'Chronus'.

39 – Rupprich, 1, p. 306.

40 – Lille, Musée des Beaux-Arts, inv. no. Pl. 914. Pen with white heightening on brown ground, 235 × 177 mm. Jakob Rosenberg, *Die Zeichnungen Lucas Cranachs der Älteren* (Berlin, 1960), no. 4. Basel 1974, no. 77. Berlin 1988, no. 216.

41 – Munich, Graphische Sammlung, inv. no. 36. Pen with grey-brown wash and white heightening on dark blue-green ground, 185 × 125 mm. Rosenberg, *Die Zeichnungen Cranachs*, no. 5. Basel 1974, no. 53. Berlin 1988, no. 217.

42 – There has never been an integral history of the technique. But see Joseph Meder, *Die Handzeichnung* (Vienna, 1923), pp. 46–51, 86–93, 150, and 162–3; and James Watrous, *The Craft of Old-Master Drawings* (Madison, Wisconsin, 1957), pp. 3–4, 12–16, 30–32, 34–40.

43 – Berlin, Kupferstichkabinett, KdZ 4256. Inscribed: 'Discite a me quia nequam sum et pessimo corde 1502.' See Tilman Falk, 'Baldungs jugendliches Selbstbildnis: Fragen zur Herkunft seines Stils', *Zeitschrift für Schweizerische Archäeologie und Kunstgeschichte*, 35 (1978), pp. 217–23, which sketches a local Swabian context for this drawing.

44 – Berlin, Kupferstichkabinett, KdZ 2671. Dated (1)504 and inscribed in a later hand: 'Lucas Cran . . .'. See Berlin 1988, no. 1, for a more complete review of the literature.

45 – New York, Metropolitan Museum of Art, inv. no. 06.1051.2. 170 × 120 mm. This drawing is dated 1506, with monogram (AA with a small D or O, as in the 1506 drawings in Berlin and Paris; these are the only instances of this peculiarity in Altdorfer's work). Winzinger, *Altdorfer Graphik*, Appx 2, p. 131. Berlin 1988, no. 2.

46 – Paris, Louvre, inv. no. 18.867. 180 × 125 mm. Demonts, 8. Dated 1506, with monogram as in the *Samson and Delilah* and the *Pax and Minerva*. w.2. Berlin 1988, no. 7.

47 – Berlin, Kupferstichkabinett, KdZ 1691. 172 × 123 mm. Dated 1506, with monogram as in the *Samson and Delilah* and the *Witches' Sabbath*. w.1. Berlin 1988, no. 5.

48 – Copenhagen, Statens Museum for Kunst, inv. no. TU 90, 1. Dated 1506 (not 1508 as has often been read), with monogram. w.7. Berlin 1988, no. 10.

49 – Also framed by pen borders are the *Lansquenet and Woman* in a Netherlandish private collection (Winzinger, *Altdorfer Graphik*, Appx 3, p. 131; Berlin 1988, no. 8); the *Martyrdom of St Ursula* in London; the *Adoration of the Shepherds* in Basel; the *Resurrection* in Erlangen, inv. no. II E 2, dated 1514 (Bock 808; w.138, as the Historia Master); the *Fantastic Figure* in Milan (Becker 160; reproduced in Dieter Kuhrmann, ed., *Dürer und seine Zeit* (Munich: Staatliche Graphische Sammlung, 1967), no. 6 as a copy of an Altdorfer original); and the *Couple* in a private collection (w.136, as the Historia Master; Berlin 1988, no. 47).

50 – Becker no. 151.

51 – Berlin 1988, p. 38, also p. 108; nos 55–6. Winzinger does not discuss the question of the drawn frames except to disagree with Becker on the Copenhagen drawing; he does refer to the border on the *Lansquenet and Woman* in a private collection as the 'original border'; Winzinger, *Graphik*, p. 131, Appx 3.

52 – Oxford, Ashmolean Museum, Parker, 268. w.5; Berlin 1988, no. 21.

53 – Berlin, Kupferstichkabinett, KdZ 111 and 4446. w.13 and 18.

54 – There are various inscriptions on fifteenth-century German drawings that are not necessarily signatures. See, for example, the *St George* on coloured ground, formerly Vienna, Liechtenstein Collection, inscribed 'Kirmer A Z 1481' on a scroll (Schönbrunner-Meder 614); or the *Four Apostles* in Basel, inv. no. U. xv. 57, inscribed 'Frichissen beißbrg. 1457 torckem'.

55 – See, for example, Franz Winzinger, *Die Zeichnungen Martin Schongauers* (Berlin, 1962), nos 2–4. Winzinger does not address the question directly; he does, however, refer to the monogram and date 1470

on the *Head of a High Priest* in London, British Museum, inv. no. 1946–7–13–130, as authentic (no. 6).

56 – Berlin, Kupferstichkabinett, KdZ 3877. Winkler 144. Strauss 1497/1.

57 – See Gustav Pauli, 'Dürers Monogramm', *Festschrift für Max J. Friedländer* (Leipzig, 1927), pp. 34–40, and the monumental critical survey of monograms and dates on the drawings in Flechsig, *Albrecht Dürer*, vol. 2, pp. 3–126.

58 – Other Dürer pupils used monograms but never on drawings, for example the Behams.

59 – But see the *Martyrdom of St Ursula* in the British Museum, with part of a date (?) inscribed on a stone, and the *Madonna and Child in the Forest* in Braunschweig with the empty scrap of paper pinned to a tree (p. 84 and illus. 47). See below (p. 190) on the monogram in the Berlin *Landscape with Woodcutter*.

60 – Rupprich, 3, pp. 291, 293. The passage has figured centrally in the debate about whether Dürer ever cut his own woodcut blocks. It seems more likely that Dürer is referring here to relief carving.

61 – Berlin, Kupferstichkabinett, KdZ 83, 213 × 156 mm. W.27, Berlin 1988, no. 41. The closest comparisons are the drawings *Christ in the Garden of Gesthemane* in Berlin, KdZ 111, W13, dated 1509, and *Wild Family*, Vienna, Albertina, inv. no. 17.548, W.24, dated 1510 (illus. 46).

62 – B.61, W.22. There is a preliminary sketch for the woodcut in Erlangen, University Library, Bock 806, W.99.

63 – See, however, line 104 of Ovid, where Thisbe flees into a cave; perhaps Altdorfer interpreted this as the tomb.

64 – No previous commentator, doubtless for good reasons, has discerned her here. But compare a figure in just this position in the Karlsruhe *Samson and Delilah* drawing, a copy after Altdorfer (Kunsthalle, inv. no. VIII 1645, W.122, dated 1513).

65 – Frankfurt, Städelsches Kunstinstitut, inv. no. 6922. 178 × 142 mm. Pen and white heightening on olive-brown and orange ground. W.142 (as the Historia Master). Mielke restored the drawing to Altdorfer and dated it late, after 1520 (Berlin 1988, no. 102).

66 – Genette, 'Frontières du récit', in *L'Analyse structurale du récit*, p. 164; reprinted in Genette, *Figures II* (Paris, 1969).

67 – Svetlana Alpers has offered various and wide-ranging accounts of a realistic tradition in Northern painting; but in this context see her 'Describe or Narrate? A Problem in Realistic Representation', *New Literary History*, 8 (1976), pp. 15–41, where she explicates the contrasting attitudes of Auerbach and Lukács toward the levelling force of description.

68 – Braunschweig, Herzog Anton Ulrich–Museum, inv. no. Z 5. Pen with white heightening on light-brown ground, 170 × 147 mm. w.3. Berlin 1988, no. 15. The scrap of paper pinned to a tree-trunk at the lower left must have borne the monogram; the copyist, presumably a student under Altdorfer's eye, left it blank.

69 – St Florian, Augustinian Abbey. 129.5 × 97 cm. W.10.

70 – St Florian, Augustinian Abbey. 128 × 93.7 cm. W.17.

71 – Munich, Alte Pinakothek, inv. no. 5358. 140.7 × 130 cm. W.44.

72 – Munich, Alte Pinakothek, inv. no. 698. 74.8 × 61.2 cm. W.49.

73 – Braunschweig, Herzog Anton Ulrich–Museum, inv. no. Z 2. Pen and white heightening on olive-brown ground, 195 × 144 mm. Dated 1512. W.31. Berlin 1988, no. 62.

74 – Haarlem, Museum Teyler, inv. no. 44. Dated 1520 with false Dürer monogram. Benesch, *Historia Friderici et Maximiliani*, p. 83, no. 21 (as Altdorfer). Winzinger, 'Der Meister der Anbetung Thyssen', *Festschrift für Karl Oettinger* (Erlangen, 1967), pp. 373–5 (as the Master of the Thyssen *Adoration*, from the Huber shop).

75 – Paul Durrieu, *Heures de Turin* (Paris, 1902), plate XII, 'December'. These pages were destroyed by fire in 1904. On the artist, see Winkler, *Flämische Buchmalerei*, p. 23.

76 – Perhaps the mood was as rich in the lost Altdorfer original behind a weak drawing of ruins in Budapest; Museum of Fine Arts, inv. no. 228. Berlin 1988, p. 52.

77 – The traditional attribution of the *Martyrdom of St Catherine* to Altdorfer is by no means secure. Vienna, Kunsthistorisches Museum, inv. no. 6426. W.1. The picture was previously owned by Stift Wilten in Innsbruck, and indeed its wheeling surface patterns and sharp foreshortening suggest Pacher, Reichlich and the Tyrol. The rough brushwork and glowing tones, on the other hand, are closer to Bavaria and the early Cranach.

78 – Bremen, Kunsthalle, inv. no. 6. W.2.

79 – Berlin, Gemäldegalerie, inv. no. 638 A. W.5.

80 – Vienna, Albertina, inv. no. 17548. Pen and white heightening on grey-brown ground, 193 × 140 cm. W.24. Berlin 1988, no. 40.

81 – Hind 19.

82 – G.F. Waagen, *Kunstwerke und Künstler in Deutschland*, Pt 2 (Leipzig, 1845), p. 129.

83 – Berlin, Gemäldegalerie, inv. no. 638. 23.5 × 20.5 cm. W.3–4.

84 – B.100. 21.8 × 14.5 cm. This is one of the woodcuts that Dürer himself called the 'schlechtes Holzwerk'; it dates from c.1504–5. See p. 175 below.

85 – Dürer's small *St Jerome* on panel may have contributed to Altdorfer's version. Private collection, on loan to the Fitzwilliam Museum in Cambridge. 23 × 17 cm. A.14; Nuremberg 1971, no. 569. The picture was discovered in 1957; cf. Edmund Schilling in *Zeitschrift für Kunstwissenschaft*, 11 (1957), pp. 175–84, who dated it 1498–1500. The panel was formerly attributed to the Veronese Caroto. Three old copies attest to the painting's notoriety. A larger version in Cologne (inv. no. 844) was given to Altdorfer by Buchner, 'Altdorfers "Büssender Hieronymus" im Wallraf–Richartz–Museum', *Wallraf–Richartz–Jahrbuch* (1930), pp. 161–9, and Munich 1938, no. 10. A copy on copper in a private collection in Munich (at least in 1957) is dated 1532 and signed by Cranach; Buchner assigned it nevertheless to the Dürer Renaissance. A relief in Solnhofener stone based on this composition, finally, has been attributed to Hans Ässlinger,

the court sculptor of Albrecht V of Bavaria, *c.*1550 (Munich, Bayerisches Nationalmuseum, inv. no. 571. A.I.15; Munich 1938, no. 781).

86 – Paris, Louvre, inv. no. M.I.164. Dülberg, *Privatporträts*, no. 330.

87 – Berlin, Gemäldegalerie, inv. no. 638B. 57 × 38 cm. W.7.

88 – Fritz Blaich, 'Wirtschaft und Gesellschaft in der Reichstadt Regensburg zur Zeit Albrecht Altdorfers', *Albrecht Altdorfer und seine Zeit*, Schriftenreihe der Universität Regensburg, 5, ed. Dieter Henrich (Regensburg, 1981), p. 88.

89 – Winzinger, *Gemälde*, p. 76.

90 – See Benesch and Auer, *Die Historia Friderici et Maximiliani*, for the old view. The attribution to Altdorfer, which had been proposed by Peter Halm and others, was revived by Hans Mielke; Berlin 1988, no. 30.

91 – Hegel's analysis is lucidly summarized and explicated by Wolfgang Kemp, *Der Anteil des Betrachters* (Munich, 1983), ch. 1.

92 – Winkler, 'Simon Marmion als Miniaturmaler', p. 280.

93 – *Hours* (Paris, Kerver: 1505), fol. k. viii v; 10 × 7.2 cm. Harvard University, Houghton Library.

94 – Battisti, 'Le origini religiose del paesaggio veneto', in *Esistenza, Mito, Ermeneutica*, vol. 1, Archivio di Filosofia (Padua, 1980), pp. 227–46.

95 – London, National Gallery, inv. no. 599. Canvas (transferred from panel), 67 × 86 cm.

96 – Fritz Koreny, *Albrecht Dürer und die Tier- und Pflanzenstudien der Renaissance*, exhibition catalogue, Vienna, Albertina (Munich, 1985). For the peonies, now in the Getty Museum, see Koreny, 'A Flower Study by Schongauer', *The Burlington Magazine*, 133 (1991), pp. 588–97, or *Le Beau Martin: Gravures et dessins de Martin Schongauer* (Colmar: Museé d'Unterlinden, 1991), pp. 107–12.

97 – Siena, Pinacoteca, inv. nos 70, 71. Each is approximately 22 × 33 cm. The substantial older literature is summarized by Feldges, *Landschaft als topographisches Porträt*, pp. 68–82, who considers them Trecento descriptions of Sienese territory.

98 – The eighteenth-century description of a lost altar that Federico Zeri relies on may not quite fit these panels, but he is surely correct to push them a century forward, into the orbit of Sassetta; 'Ricerche sul Sassetta: La Pala dell' Arte della Lana (1423–1426)', *Quaderni di Emblema*, 2 (1973), pp. 22–34. Keith Christiansen confirms Zeri's technical observations and considers his hypothesis plausible but inconclusive. And he says the landscapes are surely by Sassetta: *Painting in Renaissance Siena 1420–1500* (New York: Metropolitan Museum of Art, 1988), p. 65, with further bibliography.

99 – Madrid, Prado, inv. no. 2179.

100 – Venice, Accademia, inv. no. 734.

101 – Meersburg, Unterstadtkapelle. See Hans Rott, *Quellen und Forschungen zur südwestdeutschen und schweizerischen Kunstgeschichte*, vol. 1, *Bodenseegebiet*, text vol. (Stuttgart, 1933), pp. 36–8, fig. 14; and Gertrud Otto, 'Altarwerke von Ivo Strigel', *Zeitschrift für Schweizerische Archäologie und Kunstgeschichte*, 10 (1948), pp. 57–63, pl. 33. The sculpture dates from

about the 1480s. Otto places the landscape in the early sixteenth century and suggests Bernhard Strigel as the author.

102 – B.64, Hind 31. *Humanismus in Bologna*, no. 62.

103 – *De artificiali perspectiva*, 2nd ed. (1509), fol. 28v (C 8 v). L. Brion-Guerry, *Jean Pélerin Viator* (Paris, 1962), pp. 331–5, fig. 120.

104 – Washington DC, National Gallery of Art, Kress Collection. Dürer repeated the device in his *St Jerome* woodcut of 1512 (B.113).

105 – Pesaro, Museo Civico. Central panel, 106 × 84 cm.

106 – Creighton Gilbert believes that the view is meant to be understood as a landscape painted on the throne, analogous to an *intarsia* panel on domestic furniture; see also Gombrich's interpretation of the predella of Lotto's Asolo altarpiece, p. 38

107 – Milan, Biblioteca Ambrosiana, inv. no. F 261 inf. 13/1. Tietze, *Drawings of the Venetian Painters*, pp. 92–3, no. 347. Francis Ames-Lewis, 'Il disegno nella practica di bottega del Quattrocento', in *La Pittura nel Veneto: Il Quattrocento*, vol. 2, ed. Mauro Lucco (Milan, 1990), p. 669.

108 – See the remarkable discussion of these 'prefigured' landscapes in Joseph Gantner, *Leonardos Visionen von der Sintflut und vom Untergang der Welt* (Bern, 1958), pp. 88–90.

109 – Munich, Bayerische Staatsbibliothek, cod. icon. 420. Julius von Schlosser, 'Zur Kenntnis der künstlerischen Überlieferung im späten Mittelalter,' *Jahrbuch der kunsthistorischen Sammlungen der allerhöchsten Kaiserhauses*, 23 (1902), pp. 325–6, fig. 10.

110 – Two examples are the *Old Man* in Frankfurt by the Master WB and *Bishop Hugo van Landenberg* in Karlsruhe by a Lake Constance master, dated 1502. Buchner, *Das deutsche Bildnis der Spätgotik und der frühen Dürerzeit*, nos 34 and 53.

111 – Erlangen, University Library, inv. no. I C 1. 201 × 106 mm. Bock 748. The sheet usually carries the name of Bernhard Strigel on the basis of some tenuous comparisons with the backgrounds of panels; Gertrud Otto, *Bernhard Strigel* (Munich, 1964), p. 58, no. 102, accepted the attribution unquestioningly. Ludwig Baldass, 'Beiträge zur Hausbuchmeisterfrage', *Oberrheinische Kunst*, 2 (1926/7), pp. 185, compared it to the landscape in the mining scene on fol. 35a of the Housebook, which he then attributed to an assistant of the Housebook Master. See also Alan Shestack, 'A Drawing by Bernhard Strigel', *Master Drawings*, 4 (1966), n. 12, who invokes Baldass but then complicates the matter by introducing several panels by the Master LCz.

112 – Vienna, Albertina, inv. no. 3055. Pen, 225 × 316 mm. Winkler 57, Strauss 1493/21.

113 – Erlangen, University Library, inv. no. II A 28. Pen, 211 × 312 mm. Bock 140. Nuremberg 1971, no. 96.

114 – The most important publication is Walter Koschatzky, *Albrecht Dürer: Die Landschaftsaquarelle* (Vienna, 1971).

115 – Berlin, Kupferstichkabinett, Kdz 15388. Watercolour on paper, 214 × 168 mm. Winkler 111, Strauss 1495/40.

116 – London, British Museum, inv. no. 5218/167.

Watercolour and gouache on paper, 262 × 374 mm. Winkler 114, Strauss 1496/14.

117 – On the distinction between landscape as a motif and as a *Bildaufgabe*, a 'pictorial task', in Dürer but also in Pacher and Huber, see the remarkable essay by Günther Fiensch, 'Die Anfänge des deutschen Landschaftsbildes', in his *Studien zur Kunstform*, Münsterische Forschungen, 9 (Münster, 1955), pp. 71–121.

118 – Basel, Kupferstichkabinett, inv. no. K. 53. 212 × 158 mm. Major and Gradmann, *Urs Graf*, no. 72.

119 – Milan, Biblioteca Ambrosiana, inv. no. F. 264 inf. 16. 179 × 141 mm. Another early exercise in the Ambrosiana is a cubic patchwork in pure watercolour, gaudy and rough-hewn; inv. no. F. 264 inf. 15, *Dürer und seiner Zeit* (Munich: Staatliche Graphische Sammlung, 1967), no. 82, with colour reproduction. A *Cliff Landscape* in Paris, piled fabulously with wide-roofed fortifications and peaked turrets, in choppy pen and blue, green, mustard, pink, grey, and pale brown washes, belongs squarely to the next generation, perhaps as late as the 1530s. Louvre, inv. no. 18964, Demonts 423.

120 – Winzinger, *Huber*, 9. The older literature – Halm and Becker – associated it unhelpfully with Jörg Kölderer, on the basis of the fortification watercolours (see illus. 143): Peter Halm, 'Die Landschaftszeichnungen des Wolfgang Huber', *Münchner Jahrbuch der bildenden Kunst*, 7 (1930), p. 62, n. 41; Becker 159. This attribution was still accepted in the Munich exhibition *Dürer und seiner Zeit*, no. 68.

121 – Winzinger compared the crenellated buildings to early Huber landscapes (his nos 2 and 5) and the *St Sebastian* in Washington (no. 12). Still better comparisons are the buildings in Altdorfer's *Couple Under a Tree* in Weimar of 1508 (w.12) or *View of Sarmingstein* of 1511 (illus. 164). On the other hand, Huber's initials (in chalk and written in his usual manner) and his full name (in pen, in an old hand, and subsequently crossed out) appear on the verso of the sheet; see Winzinger, *Huber*, Appx, no. 5.

122 – See the compact visual anthology of dates assembled by Oettinger in *Datum und Signatur bei Wolf Huber und Albrecht Altdorfer*.

123 – Vienna, Albertina, inv. no. 3214. 200 × 140 mm.

124 – Friedländer and Baldass recognized Altdorfer's hand. Friedländer, *Albrecht Altdorfer* (1891), no. 29, p. 155. Baldass, *Albrecht Altdorfer: Studien über die Entwicklungsfaktoren im Werk des Künstlers* (Vienna, 1923), p. 43, illus. 28. Becker, no. 178, disagreed; Winzinger ignored it entirely. The Tietzes in the Albertina catalogue suggested that it is a partial copy.

125 – Although not obviously in a different ink from the rest of the drawing, as the Albertina catalogue claims; D.220.

126 – Paris, Louvre, inv. no. R.F. 5565r. See Chris Fischer, 'Fra Bartolommeo's Landscape Drawings', *Mitteilungen des Kunsthistorischen Institutes in Florenz*, 33 (1989), pp. 307–10, fig. 12.

127 – E. Ridolfi, 'Notizie sopra varie opere di Fra Bartolommeo da S. Marco', *Giornale Ligustico di Archeologia, Storia e Belle Arti*, 5 (1878), p. 125. The inventory also mentioned 'four canvas scrolls of coloured landscapes' (*paesi coloriti*), and landscape drawings (*charte di paesi*) attributed to Lorenzo di Credi.

128 – Vienna, Albertina, inv. no. 17577. 11.8 × 22.1 cm. Fischer, *Fra Bartolommeo: Master Draughtsman of the High Renaissance* (Rotterdam: Museum Boymans-van Beuningen, 1990), nos 108–9.

129 – Budapest, Museum of Fine Arts, inv. no. 26 (E 17–46a). Brush in white and grey on red-brown ground, 173 × 113 mm. *Kunst der Reformationszeit* (Berlin, 1983), no. D 54. The date is written feebly at the extreme upper margin, and is possibly a decapitated 1519. See also the *Forest Landscape* of 1519 in Budapest, inv. no. 25 (E 17–46), in pen and black ink with brushed white on grey-ochre ground, 219 × 162 mm.

130 – The two drawings have always been paired. They were once loosely associated with Altdorfer: Becker 119; Schönbrunner-Meder 862a; Benesch, *Österreichische Handzeichnungen des XV. und XVI. Jahrhunderts*, Die Meisterzeichnungen, 5 (Freiburg, 1936), p. 54. Winzinger placed them squarely in Huber's œuvre (w. 45 and 63) on the basis of comparison with paintings.

131 – Berlin, Kupferstichkabinett, KdZ 500. Brush and pen, black ink with white and grey heightening on brown ground, 110 × 154 mm. Becker 97; Winzinger, *Huber*, no. 62.

132 – Koepplin, 'Altdorfer und die Schweizer'.

133 – See Koepplin as well as Stange, *Malerei der Donauschule*, pp. 143–4.

134 – Dessau, Staatliche Galerie, inv. no. 1, 58 (BII/17). Brush with black and white on dark-red ground, 209 × 133 mm. Falsely monogrammed AA. Friedländer rather rashly gave it to Altdorfer: *Albrecht Altdorfer* (1891), no. 25. Benesch attributed it to Erhard Altdorfer (see below, n. 139).

135 – Copenhagen, Statens Museum for Kunst, inv. no. 6707. 306 × 195 mm.

136 – Dresden, Kupferstichkabinett, inv. no. 1900–74. 281 × 194 mm. Inscribed in a later hand 'Shebalt beheem'.

137 – Friedländer attributed the Copenhagen sheet to Albrecht Altdorfer. Benesch, following Bock (*Die Zeichnungen in der Universitätsbibliothek Erlangen*, pp. 200–1), argued for Erhard's authorship of both drawings: 'Erhard Altdorfer als Maler', *Jahrbuch der Preussischen Kunstsammlungen*, 57 (1936), pp. 157–68, reprinted in *Collected Writings*, vol. 3, *German and Austrian Art of the Fifteenth and Sixteenth Centuries*, pp. 326–35; and *Historia Friderici et Maximiliani*, nos. 4 and 7). Becker assented warily (nos 123 and 154). The Dresden sheet appeared in the exhibitions of 1938 (no. 352) and 1965 (no. 167) under Erhard's name; both drawings were given to Erhard in Winzinger's monograph (nos 150–51) and in Mielke's exhibition (Berlin 1988, no. 189 and under no. 188).

138 – Paris, Louvre, inv. no. 18519, 120 × 145 mm. Demonts, no. 14. Benesch, *Historia Friderici et Maximiliani*, no. 9. Berlin 1988, no. 188.

139 – There is an affinity between this group and three further drawings on coloured ground: *St Sebastian* (Braunschweig, Herzog Anton Ulrich–Museum, inv. no. 61; Linz 1965, no. 164; Berlin 1988, no. 182), *Madonna and Child* (Berlin, Kupferstichkabinett, KdZ 2026; Becker 98; Munich 1938, no. 122; w.149, as

Erhard Altdorfer; Berlin 1988, no. 186), and *St John on Patmos* (Frankfurt, Städel, inv. no. 15674; Becker 137; Berlin 1988, no. 183). But what do any of these drawings have in common with Erhard Altdorfer's early pen-and-ink drawings, the three engravings, and the landscape etching (illus. 180) (W.143, 145, 241–44)? The entire group of coloured-ground drawings is linked to Erhard Altdorfer by a mere thread: the relationship of the *St John on Patmos* drawing to a woodcut illustration for the Lübeck Bible of 1534. Erhard's monogram appears twice in that Lübeck Bible. See Walther Jürgens, *Erhard Altdorfer* (Lübeck, 1931); Benesch, *Historia Friderici et Maximiliani*; Berlin 1988, no. 190. A *St John on Patmos* panel from Stift Lambach, now in Kansas City, was also attributed by Benesch to Erhard. Benesch, 'Erhard Altdorfer als Maler', and *Historia Friderici et Maximiliani*, p.87ff. See also the discussion of Erhard's career below, pp. 254–5.

140 – Erlangen, University Library, inv. no. II B 11 (verso; on recto *St John on Patmos*). Bock 121. 295 × 201 mm.

141 – Bremen, Kunsthalle; missing since 1945. 292 × 224 mm. Winkler 108, Strauss 1495/51.

142 – Erlangen, University Library, inv. II B 12, Bock 815. 198 × 299 mm. Becker 130. Benesch, *Historia Friderici et Maximiliani*, no. 5. Linz 1965, no. 166. Berlin 1988, no. 184. The *Visitation* (B.84) dates from about 1504, although the entire series was not published until 1511. In Dürer's preparatory drawing in the Albertina the landscape background is still unformed (Winkler 293, Strauss 1504/1). Paper tinted with red dust was a convention in Nuremberg workshops.

143 – Paris, Louvre, inv. no. 18595. 109 × 134 mm.

Demonts 181. Lippmann 301. Panofsky, *Albrecht Dürer*, no. 1412. Reproduced in Koschatzky, *Albrecht Dürer: Die Landschaftsaquarelle*, p. 33, illus. 29. Panofsky suggested that the castle was modelled on Segonzano in the Cembra valley east of Trent, which in Dürer's watercolour in Berlin lacks a tower (KdZ 24622; Winkler 101, Strauss 1495/36). He properly stifled Antonino Rusconi's theory that the Louvre drawing was Dürer's synthesis of his own two life-studies of Segonzano (the Berlin sheet and the sheet in Bremen which probably represents Schloss Prünn in the Altmühl valley west of Regensburg; Winkler 98, Strauss 1495/35), and that it actually preceded the St Eustace engraving ('Per l'identificazione degli acquerelli tridentini di Alberto Durero', *Die Graphischen Künste*, N.F. 1, 1936, pp. 130–2). Rusconi's study is otherwise indispensable for its accurate topographical identifications of the Berlin *Castle of Segonzano*, the Oxford *Wehlsch Pirg* (Winkler 99, Strauss 1495/37), and the Escorial *Brenner Road* (Winkler 100, Strauss 1495/42).

144 – Frankfurt, Städelsches Kunstinstitut, inv. no. 651. 267 × 196 mm. Inscribed on recto and verso 'M.r L. Cronach'. Edmund Schilling, *Katalog der deutschen Zeichnungen: Alte Meister*, 2 vols (Munich, 1973), no. 80. The drawing is somewhat smaller than the woodcut, which measures about 35 × 23 cm. Schuchardt considered the drawing a study for the woodcut; *Lucas Cranach der Ältere: Leben und Werke*, pt 2 (Leipzig, 1851), p. 60, no. 299.

145 – Budapest, Museum of Fine Arts, inv. no. 359. 214 × 153 mm. The only publications are Linz 1965, no. 203, without commentary; and the exhibition catalogue *Kunst der Reformationszeit*, no. D 56.

3 The German forest

1 – Strabo, *Geography*, 7.1.3, ed. Jones, pp. 162–3.

2 – Caesar, *Gallic War*, ed. H.J. Edwards, Loeb Classical Library (Cambridge, Mass., 1917), Book 6, § 25, p. 351. Some scholars have considered this passage a later interpolation.

3 – Kaspar Zeuss, *Die Deutschen und die Nachbarstämme* (Göttingen, 1904), pp. 2–11.

4 – Pt 2, 'Montes et sylvae'. Also Gerald Strauss, *Sixteenth-century Germany: Its Topography and Topographers* (Madison, Wisconsin, 1959), pp. 39–40, the best survey of the geographical texts.

5 – Nuremberg, Germanisches Nationalmuseum, inv. no. S. P. 10419. Parchment, 60 × 69 cm. See Baxandall, *Limewood Sculptors*, p. 28, fig. 11.

6 – Baxandall, *Limewood Sculptors*, p. 28.

7 – Tacitus, *Germania*, § 2.

8 – Giovanni Antonio Campani, *Opera* (Leipzig, 1707), p. 356.

9 – *Dialogi di pittura* (1548), ed. Rodolfo and Anna Pallucchini (Venice, 1946), p. 145. Quoted in Gombrich, 'Renaissance Theory of Art and the Rise of Landscape', p. 116.

10 – Celtis, *Oratio in gymnasio Ingelstadio publice recitata*, text and translation in *Selections from Conrad Celtis 1459–1508*, ed. Leonard Forster (Cambridge, 1948), § 33, pp. 44–5.

11 – Pomponius Mela, *Libri de situ orbis tres*, ed. Vadian (Vienna, 1518).

12 – Tacitus, *Germania*, § 30. Simon Schama's account of the cultural meanings of the German forest, in his forthcoming book *Landscape and Memory*, is characteristically fervent and plenteous.

13 – Berlin, Kupferstichkabinett, KdZ 11828. 177 × 146 mm. W.4. Berlin 1988, no. 17.

14 – 'Est locus, inflexa colles ubi valle levantur, / Densa et utrumque tegit pinae silva latus; / In medio angusto spatio via limite trita est / Perque putres agros ducit aquosa lacus. / Ecce, duo a silvis dextra laevaque latrones / Prosiliunt gladiis cuspidibusque feris!'; *Amores*, Book 2, Elegy 12, 'Narrat se Calendis Martiis a latronibus duobus atrociter verberatum et spoliatum'. The modern edition is *Quatuor libri amorum*, ed. Felicitas Pindter (Leipzig, 1924).

15 – Oettinger, 'Laube, Garten und Wald: Zu einer Theorie der süddeutschen Sakralkunst 1470–1520', *Festschrift Hans Sedlmayr* (Munich, 1962), pp. 201–28.

16 – Braunschweig, Herzog Anton Ulrich-Museum. 35.6 × 25.9 cm. Geisberg 808–2 (as Hans Dürer). Dodgson, I, p. 362. The attribution to Altdorfer was ventured by Horst Appuhn and Christian von Heusinger, *Riesenholzschnitte und Papiertapeten der Renaissance* (Unterschneidheim, 1976), p. 22, illus. 16.

17 – Braunschweig, Herzog Anton Ulrich-Museum, 53.2 × 32.2 cm. Pass 206 (Dürer). Dodgson, I, p. 482, no. 155 (H.S. Beham). Appuhn and Heusinger, *Riesenholzschnitte und Papiertapeten*, p. 16, illus. 7.

18 – Munich, Alte Pinakothek, inv. no. WAF 29. W. 6. The monogram and date appear on the trunk of the second tree from the right. The panel passed from Kränner of Regensburg to L. Schorn in 1816, and then to the collection of the brothers Boisserée. See Eduard Firmenich-Richartz, *Die Brüder Boisserée*, vol. 1, p. 486, no. 211. That collection was purchased by Ludwig I of Bavaria in 1827.

19 – London, National Gallery, inv. no. 6320. W.39. Parchment on oak panel, 41.2 × 35.5 cm. From a private collection in Aschaffenburg to the Munich art market 1908/10. Munich 1938, no. 45. On the illegible date, see below, p. 161.

20 – Munich, Alte Pinakothek, inv. W.A.F. 30. W.46. Parchment on boxwood panel, 30.5 × 22.2 cm. Entered the collection of Prince Oettingen-Wallerstein in 1815 together with the collection of Count Josef von Rechberg. Waagen saw it in Nuremberg, in the Landauer Brüderhaus; *Kunstwerke und Künstler in Deutschland*, vol. 1 (Leipzig, 1843), p. 218. Munich 1938, no. 46.

21 – *Verzeichnis der Gemälde der kaiserlich-königlichen Bilder Gallerie in Wien* (Vienna, 1783), p. 257, no. 90. The picture measured 1 *fuss* 2 *zoll* by 10 *zoll*, or approximately 35 × 25 cm. J.D. Fiorillo also described it in his *Geschichte der zeichnenden Künste in Deutschland*, vol. 2 (Hannover, 1817), p. 407, although it is not clear that he actually saw the painting. A 'landscape with city' by Altdorfer was sold at auction in Vienna in 1870; *Repertorium für Kunstwissenschaft*, 14 (1891), p. 48; see Friedländer, *Albrecht Altdorfer* (1891), p. 129, no. I, 30.

22 – Rotterdam, Museum Boymans–van Beuningen, inv. D. 1. 266, lost since 1945. 204 × 138 mm. From the Savigny and Licht collections. Becker 43. Munich 1938, no. 120. Winzinger, *Altdorfer Zeichnungen*, no. 66.

23 – Erlangen, University Library, inv. II E 7, Bock 812. 202 × 133 mm. Becker 35. Munich 1938, no. 124. Winzinger, *Altdorfer Zeichnungen*, no. 68. Berlin 1988, no. 126. On the verso, a cursory pen sketch of a landscape (W.113), here illus. 190.

24 – Berlin, Kupferstichkabinett, KdZ 11651. 201 × 136 mm. Becker 18. Munich 1938, no. 125. Winzinger, *Altdorfer Zeichnungen*, no. 67. Berlin 1988, no. 125.

25 – Vienna, Albertina, inv. no. 24658. 272 × 192 mm. From the Grahl collection. Becker 177. Munich 1938, no. 121.

26 – See Friedländer, *Albrecht Altdorfer* (1891), pp. 139–40.

27 – Georges Hulin de Loo, 'La Vignette chez les enlumineurs gantois entre 1470 et 1500', *Académie Royale de Belgique: Bulletins de la Classe des Beaux-Arts*, 21 (1939), p. 168.

28 – London, National Gallery, inv. no. 2593.

29 – Washington DC, National Gallery of Art, inv. no. 1961.9.11.

30 – Seuse, *Deutsche Schriften*, ed. Karl Bihlmeyer (Stuttgart, 1907), p. 103.

31 – Berlin, Bode-Museum, inv. no. 78. See Barbara Daentler, *Die Buchmalerei Albrecht Glockendons und die Rahmengestaltung der Dürernachfolge* (Munich, 1984), p. 79.

32 – *Humanismus in Bologna*, nos 65–68.

33 – See Fritz Koreny, *Albrecht Dürer und die Tier- und Pflanzenstudien der Renaissance* (Munich, 1985), pp. 194–6; and Anzelewsky on Dürer's technique on parchment, p. 90.

34 – Munich, Alte Pinakothek, inv. no. 4772. A.130.

35 – A.7V, 8V, 81K. See also the portraits of the *Girl [?] with a Red Beret* in Berlin (A.102), *Michael Wolgemut* in a private collection, dated 1516 (A.131, perhaps the original version of the Nuremberg portrait on panel), and the *Cleric* in Washington, also dated 1516 (A.133).

36 – Berlin, Gemäldegalerie, inv. no. 618A, dated 1515. Friedländer and Rosenberg, *Cranachs Gemälde*, no. 56. This information was kindly communicated by Wilhelm Köhler, 29 April 1992. The picture was later transferred from panel to canvas.

37 – Paris, Louvre, inv. no. R.F. 2382. A.10; the paint layer was transferred to canvas in the 1840s.

38 – Paris, Louvre, inv. no. R.F. 1987–28, 28.7 × 19.3 cm. See *Revue du Louvre*, 38 (1988), p. 155.

39 – This and other Flemish examples are assembled by Torben Holck Colding, *Aspects of Miniature Painting* (Copenhagen, 1953), ch. 4.

40 – Bristol, City Art Gallery, 52.1 × 37.5 cm. See J. Byam Shaw, 'A Giovanni Bellini at Bristol', *The Burlington Magazine*, 94 (1952), pp. 157–9, 237. The composition follows a drawing by Mantegna or Bellini related to an engraving by the Mantegna school.

41 – Examination report by Marigene H. Butler, Head of Conservation, Philadelphia Museum of Art. The museum plans a publication on the work. The red border around the picture imitates a miniature frame. The report suggests that the Philadelphia painting is the original and the version in Turin the copy.

42 – Alfred Stange, 'Deutsche Romanische Tafelmalerei', *Münchner Jahrbuch*, N. F. 7 (1930), pp. 132–4, with examples and passages from Theophilus's treatise; Rolf E. Straub, 'Tafel- und Tüchleinmalerei des Mittelalters', *Reclams Handbuch der künstlerischen Techniken*, vol. 1, *Farbmittel, Buchmalerei, Tafel- und Leinwandmalerei* (Stuttgart, 1984), pp. 147–8. For a medieval Italian example of a parchment ground see the Crucifix in Pisa, Museo Civico, no. 20; *Catalogo della Mostra Giottesca* (Florence, 1937), no. 14.

43 – New York, Metropolitan Museum of Art, inv. no. 06.1038.

44 – This is the opinion of Gisela Goldberg of the Alte Pinakothek, Munich, offered in a conversation of 20 January 1988. I am grateful for the opinions of Maryan Ainsworth and, through her agency, Hubert von Sonnenburg, of the Metropolitan Museum of Art. They also believe – the report on the Philadelphia van Eyck notwithstanding – that parchment would not ordinarily be pasted down after being painted; the risk of damaging the paint layer is too great. They doubt, however, that parchment ground afforded any aesthetic advantage, such as finer detail.

45 – Eberhard Ruhmer, *Albrecht Altdorfer* (Munich, 1965), no. 21, and p. 26. The error about the ground repeats the error of the Munich exhibition catalogue (1938), no. 45. Otherwise this is a fascinating and original essay.

46 – See the excellent discussion by Anne van Buren, 'Thoughts, Old and New, on the Sources of Early Netherlandish Painting', *Simiolus*, 16 (1986), pp. 93–112.

47 – Winkler, *Flämische Buchmalerei*, p. 134. Hans J. van Miegroet, *Gerard David*, pp. 73–89, nos 84–88.

48 – See for example *Meister um Albrecht Dürer* (Nuremberg: Germanisches Nationalmuseum, 1961), nos 69, 70, 262.

49 – Winzinger, *Altdorfer Zeichnungen*, nos 8, 40; *Altdorfer Graphik*, nos 14, 130.

50 – On the *St George*, and in general on the forest landscapes and their relationship to contemporary folk and literary culture, see the wonderful essay of Larry Silver, 'Forest Primeval: Albrecht Altdorfer and the German Wilderness Landscape', *Simiolus*, 13 (1983), pp. 5–43.

51 – See, above all, Sixten Ringbom, *Icon to Narrative: The Rise of the Dramatic Close-up in Fifteenth-century Devotional Painting* (Åbo, 1965).

52 – Lugano, Thyssen-Bornemisza Collection, inv. no. 90. Oil on panel, 65 × 80 cm. A.98.

53 – See, for example, the Antwerp paintings of this subject and of the *Flight into Egypt* assembled by Gibson, *Mirror of the Earth*, p. 25. Van Eyck's composition is preserved in a copy in Budapest; see Châtelet, *Early Dutch Painting*, no. 22.

54 – Vienna, Albertina. 145 × 205 mm. B.414. Oberhuber, *Die Kunst der Graphik III: Renaissance in Italien, 16. Jahrhundert*, no. 146. *Vorbild Dürer*, exhibition catalogue, Nuremberg, Germanisches Nationalmuseum (1978), no. 99.

55 – Unicum, Munich, Graphische Sammlung, inv. no. 171506. 27.1 × 19.7 mm. Schreiber 1395. Dieter Kuhrmann, *Die Frühzeit des Holzschnitts* (Munich: Graphische Sammlung, 1970), no. 7.

56 – Quintilian, *Inst. Orat.* 8.3. See also Heinrich Lausberg's systematic anthology of classical and neoclassical rhetorical doctrine, *Handbuch der literarischen Rhetorik*, 2 vols, §§ 45 and 538 (*ornatus, delectatio*), §§ 1055–62 (*aptum*).

57 – Alberti, *On Painting*, Book Two, ed. Spencer, p. 78; *Della Pittura*, ed. Janitschek, p. 123: '... et cosi qualunque cosa fra loro o teco facciano i dipinti, tutto apartenga a hornare o a insegniarti la storia'.

58 – Alberti, *On Painting*, ed. Spencer, p. 85; *Della Pittura*, ed. Janitschek, p. 139.

59 – Erasmus, *Christiani Matrimonii Institutio*, col. 696E.

60 – Quoted in Christine Göttler, 'Die Disziplinierung des Heiligenbildes durch altgläubige Theologen nach der Reformation: Ein Beitrag zur Theorie des Sakralbildes im Übergang vom Mittelalter zur frühen Neuzeit', in Bob Scribner, ed, *Bilder und Bildersturm im Spätmittelalter und in der frühen Neuzeit*, Wolfenbütteler Forschungen, 46 (Wiesbaden, 1990), pp. 280, 288.

61 – Rupprich, 1, p. 297.

62 – Aventinus (Johann Turmair), *Deutsche Chronik* (1541), *Sämmtliche Werke*, vol. 1 (Munich, 1880), p. 320.

63 – Worringer, *Abstraktion und Einfühlung: Ein Beitrag zur Stilpsychologie* (1908).

64 – Friedländer, *Albrecht Altdorfer* (1923), p. 34.

65 – *The Shepheardes Calender*, Epistle; see *The Shorter Poems of Edmund Spenser* (New Haven, 1989), p. 15. The work was published in 1579. E.K. may have been Spenser himself, or at least a close friend. The passage partly contradicts itself, for hard by the confession of pleasure in disorderly order stands the argument that base and discordant ornament simply serves as an effective foil for beauty, which is not quite the same thing: 'Even so doe those rough and harsh termes enlumine and make more clearly to appeare the brightness of brave and glorious words'. On the possible dependency on Pino, see Lucy Gent, *Picture and Poetry 1560–1620: Relations between Literature and the Visual Arts in the English Renaissance* (Leamington Spa, 1981), pp. 25–6.

66 – Bernheimer, *Wild Men in the Middle Ages*, pp. 14–20.

67 – Wilhelm Mannhardt, *Wald- und Feldkulte*, 2 vols, 2nd edn (Berlin, 1904), vol. 1, pp. 72–154. Bernheimer, *Wild Men in the Middle Ages*. Timothy Husband, *The Wild Man: Medieval Myth and Symbolism* (New York: Metropolitan Museum of Art, 1980).

68 – See the reference to Betty Kurth's publication on p. 284, n. 53.

69 – The entire tapestry measures 82 × 890 cm. *Die Kunstdenkmäler der Oberpfalz*, 22, *Stadt Regensburg*, vol. 3, ed. Felix Mader (Munich, 1933), p. 108. Friedrich on der Leyen and Adolf Spamer, *Die altdeutschen Wandteppiche im Regensburger Rathause* (Regensburg, 1912), with a superb general discussion of Wild Man iconography, pp. 16–32. *Die Parler und der schöne Stil 1350–1400*, ed. Anton Legner (Cologne, 1978), vol. 3, pp. 111–12. It is not known how the tapestry got to Regensburg.

70 – See the outstanding essay by Dieter Blume, 'Beseelte Natur und ländliche Idylle', in *Natur und Antike in der Renaissance* (Frankfurt: Liebieghaus Museum alter Plastik, 1985), pp. 173–97.

71 – 164 × 117 mm. B.17. W.122. Berlin 1988, no. 79. The source is B.5, Hind 4; see Winzinger, *Graphik*, Appx 17.

72 – Vienna, Kunsthistorisches Museum, inv. no. 2636. 48 × 32.5 cm. Gert von der Osten, *Hans Baldung Grien: Gemälde und Dokumente* (Berlin, 1983), no. 10. The subject is also read as the *Three Ages and Death*.

73 – Matthias Mende, *Hans Baldung Grien: Das Graphische Werk* (Unterschneidheim, 1978), nos 77–9.

74 – Basel, Kupferstichkabinett, inv. no. 1823.3595. 15.4 × 29.5 cm. B.I. Geisberg 954.

75 – Parshall, 'Reading the Renaissance Woodcut: The Odd Case of the Master N.H. and Hans Lützelburger', *Register of the Spencer Museum of Art*, 6 (1989), pp. 30–43. See also above, p. 289, n. 198.

76 – London, British Museum, inv. no. 1910–6-11–1. Pen and white heightening on red ground, 216 × 149 mm. W.6.

77 – Mannhardt, *Wald- und Feldkulte*, pp. 97, 105, 334.

78 – See Dieter Wuttke, *Humanismus in den deutschsprachigen Ländern und Entdeckungsgeschichte, 1493–1534* (Bamberg, 1989).

79 – *Hans Burgkmair: Das graphische Werk* (Augsburg, 1973), nos 23–6.

80 – The edition illustrated dates from 1545. 26.2 × 39.5 cm. Dodgson, 2, p. 53, no. 237a. Geisberg 1106. Karl Heinz Schreyl, ed., *Hans Schäufelein: Das druck-*

graphische Werk, 2 vols (Nördlingen, 1990), nos 913–14. The figures are indeed based on Dürer's engraved Adam and Eve. See also Husband, *The Wild Man*, no. 33, with an illustration of a version in Berlin printed with a landscape background. The translation of Sachs is taken from Jeffrey Chipps Smith, *Nuremberg: A Renaissance City, 1500–1618* (Austin, Texas, 1983), no. 50.

81 – For an excellent summary of the problem see Ludwig Krapf, *Germanenmythus und Reichsideologie: Frühhumanistische Rezeptionsweisen der taciteischen 'Germania'* (Tübingen, 1979), pp. 11–42.

82 – Celtis, *Norimberga*. The modern edition is Albert Werminghoff, *Conrad Celtis und sein Buch über Nürnberg* (Freiberg, 1921).

83 – Bernheimer, *Wild Men in the Middle Ages*, p. 23.

84 – Ortelius, *Aurei saeculi imago, sive Germanorum veterum vita, mores, ritus, et religio* (Antwerp, 1596). But Margaret D. Carroll has argued persuasively that already in the first decades of the century contemporary peasant life and mores were starting to be re-evaluated in light of Tacitus: 'Peasant Festivity and Political Identity in the Sixteenth Century', *Art History*, 10 (1987), pp. 289–314.

85 – *Norimberga*, ed. Werminghoff, ch. 1, p. 104.

86 – See Paul Joachimsen, *Geschichtsauffassung und Geschichtsschreibung in Deutschland unter den Einfluss des Humanismus* (Leipzig, 1910), pp. 155–95; Gerald Strauss, *Sixteenth-century Germany: Its Topography and Topographers*; and Jacques Ridé, 'Un Grand Projet patriotique: Germania illustrata', in *L'Humanisme allemand*, pp. 99–111. Tacitus and many major modern geographical and historical texts, including Aeneas Silvius, Wimpheling, Celtis, Peutinger, Bebel and Münster, were assembled by Simon Schard in the *Schardius redivivus*, vol. 1 (Giessen, 1673).

87 – Vadian, 'Rudimentaria in Geographiam catechesis sequitur', introduction to Pomponius Mela, *Libri de situ orbis tres* (Vienna, 1518), fol. a4v.

88 – See Philip Jacks, *The Antiquarian and the Myth of Antiquity: The Origins of Rome in Renaissance Thought* (Cambridge, 1993), pp. 190–1.

89 – The Munich exhibition catalogue (no. 45) described the support as paper, not parchment; this error was repeated by Ruhmer, *Albrecht Altdorfer*, no. 21. See above, p. 145.

90 – Pfister's report is quoted directly by Winzinger, *Altdorfer Gemälde*, p. 92. Winzinger also reproduces an old photograph; Appx 53. The Munich exhibition catalogue (1938), no. 45, reported the monogram but not the date. See the reproduction in Baldass, *Albrecht Altdorfer* (Vienna, 1941), p. 300.

Winzinger rejected the monogram on the grounds that Altdorfer would not have written it on the border, and doubted the date because it was written, according to Pfister, in the same colour as the monogram. This monogram is visible in the upper right of the photograph reproduced in the Paris catalogue, *Albrecht Altdorfer and Fantastic Realism*, illus. 221. In any case, Winzinger preferred on stylistic grounds to read the date as 1516 rather than as 1526.

91 – Mannhardt, *Wald- und Feldkulte*, 1, p. 147, n. 2.

92 – Nora Watteck identified the town as Gölling bei Hallein: 'Hallein und seine Umgebung auf Werken von Albrecht Altdorfer', *Alte und Moderne Kunst*, 18 (1973), pp. 1–8. Her crusade on behalf of Hallein, a town south of Salzburg, persuades only in one instance: the buildings seen through the window behind the *Last Supper* in the Regensburg Minorite altar are clearly the Pfarrhof and Pfarrkirche at Hallein.

93 – Berlin, Gemäldegalerie, inv. no. 1883. W.40.

94 – Munich, Alte Pinakothek, inv. no. 5358. 140.7 × 130 cm. W.44.

95 – B.52. W.19.

96 – On the structure of Altdorfer's pictures see the comments by Panofsky, 'Perspektive als "Symbolische Form"' (1927), in *Aufsätze zu Grundfragen der Kunstwissenschaft*, ed. H. Oberer and E. Verheyen (Berlin, 1985), p. 124; or *Perspective as Symbolic Form*, trans. Christopher S. Wood (New York, 1991), p. 69; and by Otto Pächt, 'Zur deutschen Bildauffassung der Spätgotik und Renaissance', in *Methodisches zur kunsthistorischen Praxis* (Munich, 1977), pp. 107, 119–20. Two remarkable and under-appreciated essays: Carl Linfert, *Albrecht Altdorfer: Die Enthüllung der Landschaft* (Mainz, 1938), and Achim Hubel, 'Albrecht Altdorfers Tafel "Die Beiden Johannes": Studien zu Form und Farbe in Altdorfers Gemälden', *Verhandlungen des Historischen Vereins für Oberpfalz und Regensburg*, 113 (1973), pp. 161–75, esp. 167–70.

97 – Sandrart, *Teutsche Akademie* (1675), vol. 1, pt 2, book 3, p. 231.

98 – Berlin, Kupferstichkabinett, KdZ 2053. Pen in two different inks, 206 × 156 mm. W.46. Berlin 1988, no. 204.

99 – Budapest, Museum of Fine Arts, inv. no. E. 33–61c (205). Pen and ink, 149 × 150 mm. W.25.

100 – Feldges, *Landschaft als topographisches Porträt*, pp. 53–64, with bibliography.

101 – On early images of 'France' see Françoise Cachin, 'Le Paysage du peintre', in *Les Lieux de mémoire*, ed. Pierre Nora, pt 2, *La Nation*, vol. 1 (Paris, 1986), pp. 440–42.

102 – The pioneering monograph was Hermann Voss, *Die Ursprung des Donaustils* (Leipzig, 1907). See also the exhibition catalogue *Die Kunst der Donauschule 1490–1540* (Linz: Oberösterreichischer Landesverlag, 1965), and the accompanying volume of essays, *Werden und Wandlung: Studien zur Kunst der Donauschule* (Linz: Oberösterreichischer Landesverlag, 1967); Alfred Stange, *Malerei der Donauschule* (Munich, 1964); and the superb essays by Fedja Anzelewski, 'Albrecht Altdorfer and the Question of the "Danube School"', and Pierre Vaisse, 'Remarks on the Danube School', in *Altdorfer and Fantastic Realism in German Art*, exhibition catalogue, Paris, Centre Culturel du Marais (Paris, 1984), pp. 10–47 and 149–64.

103 – Otto Benesch took the notion of a regional school most seriously and tried to connect all the major artists too narrowly with Austria. He derived the entire *Donaustil* from an 'Austrian' tetrarchy of Marx Reichlich (a South Tyroler working in Salzburg), Cranach (a Franconian working in Vienna), Breu (a Swabian working in Lower Austria), and Frueauf (a Passauer working at Klosterneuburg). See 'Zur altösterreichischen Tafelmalerei', *Jahrbuch der Kunsthistorischen Sammlungen*, 2 (1928), pp. 63–118; 'Der Zwettler Altar und die Anfänge Jörg Breus', *Beiträge zur Geschichte der*

deutschen Kunst, 2 (1928); 'Die Tafelmalerei des ersten Drittels des 16. Jhs. in Österreich, *Die Bildende Kunst in Österreich*, 3 (1938), pp. 137–48; and the more informal summary, 'The Rise of Landscape in the Austrian School of Painting', *Konsthistorisk Tidskrift*, 28 (1959), pp. 34–58; reprinted in Benesch, *Collected Writings*, vol. 3, *German and Austrian Art of the Fifteenth and Sixteenth Centuries* (London, 1972), pp. 16–72, 248–76, 3–11, and 338–52 respectively. His championing of Reichlich and his analyses of early Cranach are persuasive; the cases of Breu and Frueauf, on the other hand, look more like special pleading.

104 – On the Master of Mariazell see Munich 1938, no. 683; Linz 1965, no. 412.

105 – On the Master I.P. see Linz 1965, p. 278ff.

106 – On the Pulkau altar see Linz 1965, p. 100ff.

107 – Munich, Bayerisches Nationalmuseum, inv. no. 88. Panel, 27.3 × 17.4 cm. *c*.1515(?). Munich 1938, no. 398. Stange, *Malerei der Donauschule*, pp. 110, 149, illus. 220.

108 – Nuremberg, Germanisches Nationalmuseum, inv. no. 101. 48.5 × 38.5 cm. Von der Osten, *Baldung*, no. 15. There is another version in Vienna.

109 – Cracow, St Mary. Franz Stadler, *Hans von Kulmbach* (Vienna, 1936), no. 109. *Meister um Albrecht Dürer*, no. 164a, illus. 22.

110 – Baxandall, *Limewood Sculptors*, pp. 135–42.

111 – On the dissemination of the Danube style, see Hermann Voss, 'Aus der Umgebung Albrecht Altdorfers und Wolf Hubers', *Mittheilungen der Gesellschaft für vervielfältigende Kunst*, 32 (1909), pp. 52–60, 73–7, Nicolò Rasmo, 'Donaustil und italienische Kunst der Renaissance', in *Werden und Wandlung*, pp. 115–36; Jaroslav Pešina, 'Böhmische Malerei am Anfang des 16. Jahrhunderts und Donauschule', *Alte und Moderne Kunst*, 11 (1966), pp. 2–5; and the sections on Hungary, Carinthia and Friuli in Linz 1965.

112 – Van Mander, *Das Leben der niederländischen und deutschen Künstler*, ed. Floerke, vol. 2, pp. 126–7.

113 – This phenomenon is wonderfully sketched by Gombrich, 'Renaissance Theory of Art and the Rise of Landscape', pp. 117–18.

114 – Schama, 'Dutch Landscapes: Culture as Foreground', in *Masters of Seventeenth-century Dutch Landscape Painting*, ed. Peter Sutton (Boston: Museum of Fine Arts, 1987), p. 69. The pioneering study is Wolfgang Stechow, 'Esaias van de Velde and the Beginnings of Dutch Landscape Painting', *Nederlands Kunsthistorisch Jaarboek*, 1 (1947), pp. 83–94.

115 – Van Mander, *Das Leben der niederländischen und deutschen Maler*, vol. I, pp. 66–7.

116 – The passage is quoted in Wolfgang Schöne, *Dieric Bouts und seine Schule* (Berlin and Leipzig, 1938), no. 34, doc. 86.

117 – Koepplin, *Cranachs Ehebildnis*, pp. 9–11.

118 – Caesar, *Gallic War*, § 14; Tacitus, *Germania*, § 3.

119 – *Norimberga*, ed. Werminghoff, ch. 3, p. 123.

120 – Quoted in Joachimsen, *Geschichtsauffassung*, p. 162.

121 – Rupprich, 2, pp. 130, 132; 1, pp. 125–6.

122 – Wimpheling, *Epithoma rerum Germanicarum* c. 68. Rupprich, I, p. 290.

123 – Rupprich, I, p. 296.

124 – Regensburg, St Kassian. Limewood, 95 cm. high.

125 – Regensburg, Niedermünster, south wall of choir, 170 cm. high. See *Die Kunstdenkmäler der Oberpfalz*, 22, *Stadt Regensburg*, II, ed. Felix Mader (Munich, 1933), p. 231.

On retrospective in sculpture generally, see Theodor Müller, *Frühe Beispiele der Retrospektive in der deutschen Plastik*, Bayerische Akademie der Wissenschaften, Phil.-Hist. Klasse, Sitzungsberichte, 1961, I; Baxandall, *Limewood Sculptors*, p. 142, and Decker, *Das Ende des mittelalterlichen Kultbildes und die Plastik Hans Leinbergers* (Bamberg, 1985).

126 – Winzinger, *Altdorfer Gemälde*, pp. 28–9.

127 – See the woodcut B.50, W.90. On the St Kassian Madonna, see Decker, *Das Ende des mittelalterlichen Kultbildes*, p. 274ff. On the connections between Altdorfer and Leinberger generally, see Alfred Stange, 'Albrecht Altdorfer, Hans Leinberger, und die bayerische Kunst ihrer Zeit', *Alte und Moderne Kunst*, 80 (1965), pp. 14–19.

128 – Washington DC, National Gallery of Art, inv. no. 1962.5.1. 340 × 245 mm. B.51. W.89. Berlin 1988, no. 115. This and one other early impression were printed from a single line-block and five tone-blocks. Others are printed in only four colours. Altdorfer also made a painted version of the icon, now in the Diocesan Museum St Ulrich in Regensburg, W.41. The icon itself is apparently a local, thirteenth-century copy of an older Byzantine panel.

See Achim Hubel, 'Die Schöne Maria von Regensburg: Wallfahrten, Gnadenbilder, Ikonographie', in P. Mai, ed., *850 Jahre Kollegialstift zu den Hl. Joh. Baptist und Joh. Evangelist in Regensburg 1127–1977* (Munich and Zurich, 1977); and Christopher S. Wood, 'Ritual and the Virgin on the Column: The Cult of the Schöne Maria in Regensburg', *Journal of Ritual Studies*, 6 (1992), pp. 87–107.

129 – Cited in Göttler, 'Die Disziplinierung des Heiligenbildes', p. 280.

130 – Krapf, *Germanenmythus und Reichsideologie*, pp. 68–72.

131 – Rupprich, 1, p. 289. See Donald B. Kuspit, 'Melanchthon and Dürer: The Search for the Simple Style', *Journal of Medieval and Renaissance Studies*, 3 (1973), pp. 177–202; and Jan Białostocki, *Dürer and His Critics*, Saecula Spiritalia, 7 (Baden-Baden, 1986), p. 34.

132 – Rupprich, I, p. 162. Flechsig's discussion of the problem is admirable: *Albrecht Dürer*, vol. I, pp. 283–5.

133 – Stange, *Deutscher Malerei der Gotik*, vol. 2 (Berlin, 1936), pp. 178–80, illus. 233–4.

134 – Budapest, Museum of Fine Arts, inv. no. 5892. W.39.

135 – Dresden, Kupferstichkabinett, inv. no. C 2203. 212 × 155 mm. W.66.

136 – Angelus Rumpler, *Historia inclyti monasterii sui* (1505), quoted in Göttler, 'Die Disziplinierung des Heiligenbildes', p. 288.

137 – Jane Campbell Hutchison sketches this episode wonderfully in *Albrecht Dürer: A Biography* (Princeton, NJ, 1990), ch. 12.

138 – Conrad Celtis, *Libri Odarum quatuor*, ed. F.

Pindter (Leipzig, 1937), I, 16. See, as well, the anti-clerical and nature-worshipping 'In Crispum Clogo-muram poetarum aemulum', I, 19. The Odes were published in 1513 (posthumously) by Schürer in Strasbourg.

139 – See, for example, Keith Thomas, *Man and the Natural World* (New York, 1983), p. 215, on some English Lollards and Protestants.

140 – Aeneas Silvius, *Historia Bohemica*, ch. 33, *Opera omnia* (Basel, 1551), p. 103. Euan Cameron, however, says that no real evidence of Waldensian iconophobia has ever been found: *The Reformation of the Heretics: The Waldenses of the Alps, 1480–1580* (Oxford, 1984) p. 100.

141 – See Basel 1974, no. 420, and the exhibition catalogue *Luther und die Folgen* (Hamburg, 1983), nos 96, 104.

142 – Peter Martyr (Pietro Martire d'Anghiera), *De orbe novo* (1530), First Decade, Book IX, trans. F. A. MacNutt (London, 1912), pp. 173–4.

143 – Aeneas Silvius, *Germania*, III, 7.

144 – In his manuscript *Miniatura*; quoted by Gombrich, 'Renaissance Theory of Art and the Rise of Landscape', p. 107.

145 – Raimond van Marle, *Iconographie de l'art profane au Moyen-Age et à la Renaissance: La vie quotidienne* (The Hague, 1931), pp. 434–8. The Wild Man, although he habitually wields a tree trunk, is decidedly not a woodcutter. He tears his trees up by the roots; see Altdorfer's *Wild Man* drawing in London (illus. 105), and the discussion above, p. 155.

146 – Hans Dünninger, 'Processio peregrinationis: Volkskundliche Untersuchungen zu einer Geschichte des Wallfahrtswesen im Gebiete der heutigen Diözese Würzburg', pt 2, *Würzburger Diözesangeschichtsblätter*, 24 (1962), pp. 55–6.

147 – See Ludwig Arntz, 'Wegekreuz und Wegebild', *Zeitschrift für christliche Kunst*, 25 (1912), p. 69ff.; *Handwörterbuch des deutschen Aberglaubens*, ed. Hanns Bächtold-Stäubli (Berlin and Leipzig, 1927), article on 'Bildstock', vol. 1, col. 1302ff.; and *Reallexikon der deutschen Kunst*, article on 'Bildstock', vol. 2, col. 695ff.; Dünninger, 'Processio peregrinationis', pp. 54–6, 74–6.

148 – Gerlinde Stahl, 'Die Wallfahrt zur Schönen Maria in Regensburg', *Beiträge zur Geschichte des Bistums Regensburg*, 2 (1968), p. 87.

149 – Dünninger, 'Processio peregrinationis', p. 76.

150 – Zwettl, Cistercian Abbey, 70 × 73 cm. Munich 1938, no. 367. On Breu, see also the publications of Benesch in ch. 3, note 103, above.

151 – Herzogenburg, Augustinian Abbey, inv. no. A 1. 110 × 84.5 cm. Munich 1938, no. 396. Linz 1965, no. 7.

152 – Annunciation altar, St Stephan, Mörlbach bei Icking.

153 – Unicum in Amsterdam, Rijksprentenkabinet. Lehrs 69. J.P. Filedt Kok, ed., *Livelier Than Life: The Master of the Amsterdam Cabinet or the Housebook Master* (Amsterdam: Rijksmuseum, 1985), no. 67, p. 165.

154 – *Narrenschiff* (Basel, 1484), ch. 21. Pen, 316 × 217 mm.

155 – Basel, Kupferstichkabinett, inv. no. K. 70. Major and Gradmann, *Urs Graf*, no. 17.

156 – Luther, *Werke* (Weimar, 1883–), 6, pp. 447–8.

157 – Zwingli, 'Antwort zu Valentin Compar', pp. 124–6.

158 – Lee Palmer Wandel, 'Iconoclasts in Zurich', in Scribner, ed., *Bilder und Bildersturm im Spätmittelalter und in der frühen Neuzeit*, pp. 125–41, esp. 132–7.

159 – Maastricht, Bonnefantenmuseum. Gibson, *Mirror of the Earth*, p. 17, fig. 2.6.

160 – Ascona, Collection Bentinck-Thyssen. Gibson, *Mirror of the Earth*, p. 26, fig. 2.37.

161 – Vordensteyn, De Pret-Roose Collection. The panel is signed Patenir. Koch, *Joachim Patenir*, no. 36, fig. 69 (as follower of Patenir; Koch wondered whether the panel illustrated an obscure local legend). H.G. Franz, *Niederländische Landschaftsmalerei im Zeitalter des Manierismus* (Graz, 1969), I, p. 46 (as follower of Patenir). Gibson, *Mirror of the Earth*, p. 17, fig. 2.1 (as Lucas Gassel).

162 – Berlin, Kupferstichkabinett, KdZ 99. 219 × 155 mm. Winzinger, *Wolf Huber*, no. 127. On these rotated Crucifixions, with a slightly different interpretation, see Warnke in the exhibition catalogue *Luther und die Folgen*, no. 91.

163 – Regensburg, Cathedral, tympanum, south portal, *c*.1320–30. *Die Kunstdenkmäler der Oberpfalz*, 22, *Stadt Regensburg*, I, ed. Felix Mader (Munich, 1933), p. 66.

164 – Miniature on parchment, 19.5 × 15.5 cm., from the Prayer Book of Johann of Saxony, Donaueschingen, Fürstlich Fürstenbergische Hofbibliothek, MS 355. See the exhibition catalogue *Martin Luther und die Reformation* (Nuremberg, 1983), no. 470.

165 – The *Urbild* of the programme was apparently the panel in Gotha, signed and dated on the tree-trunk; Schlossmuseum, inv. no. 722/676, Friedländer and Rosenberg, *Die Gemälde Lucas Cranachs*, no. 221. The most important woodcut is preserved in Weimar and London; Basel 1974, no. 353. See generally the discussions in Basel 1974, pp. 505–10, and in *Kunst der Reformationszeit*, pp. 357–60.

166 – Mannhardt, *Wald- und Feldkulte*, pp. 70–71, lists the main examples.

167 – Baxandall, *Limewood Sculptors*, p. 31.

168 – Werner Haftmann, *Das italienische Säulenmonument*, Beiträge zur Kulturgeschichte des Mittelalters und der Renaissance, 55 (Berlin, 1939), pp. 120–5.

169 – This was pointed out by Hans Belting, *Bild und Kult* (Munich, 1990), p. 505. That statue was not iconographically a Schöne Maria, but rather a standing Virgin carved by the cathedral architect Heydenreich in 1516 and moved to the square before the chapel in order to accommodate the pilgrims.

170 – See Stahl, 'Die Wallfahrt zur Schönen Maria in Regensburg', pp. 35–282, esp. 70–72, 77–9. Dürer's censure is recorded in his own hand on a copy of Michael Ostendorfer's *Pilgrimage of the Schöne Maria* woodcut, preserved at Veste Coburg; Rupprich, I, p. 210. The charge of idolatry is specifically explored in Wood, 'Ritual and the Virgin on the Column'.

171 – See the Albertina *Visitation* (Winkler 293, Strauss 1504/1); the *Centaur Family* in Washington DC, National Gallery of Art, Hammer Collection (Winkler 345, Strauss 1505/17); the Uffizi *Calvary* (Winkler 317, Strauss 1505/3); and the *Green Passion* in the

Albertina (Winkler 300, 302, 304, 306–8, 310–14; Strauss 1504/24, 26, 28, 31, 33, 36, 38, 40–41, 44, 46).

172 – See also the *Martyrdom of St Ursula* in the British Museum, inv. no. 1854-6-28-33, with part of a date (?) inscribed on a stone; the sheet is a copy after an early Altdorfer original. W.133 (as Historia Master).

173 – London, National Gallery. 141 × 111 cm. W.26.

174 – Vienna, Kunsthistorisches Museum, inv. no. 6427. W.21.

175 – *Libri Carolini*, IV, 16, ed. Julius von Schlosser, *Schriftquellen zur Geschichte der karolingischen Kunst* (Vienna, 1892), p. 307f., no. 887.

176 – Berlin, Kupferstichkabinett, KdZ 92. 207 × 152 mm. W.140. Berlin 1988, no. 174.

177 – Berlin, Kupferstichkabinett, KdZ 4174. Winkler 30, Strauss 1492/1. The resemblance between these two works was pointed out by Oskar Schürer, who even wondered whether Dürer might not have been in Haarlem in 1490 or 1491 after all, as van Mander had implied: 'Wohin ging Dürer's "ledige Wanderfahrt"?', *Zeitschrift für Kunstgeschichte*, 6 (1937), pp. 171–99. Karel van Mander reported in his life of Geertgen that Dürer actually visited Haarlem, and in the life of Dürer merely that he had seen the works of Geertgen: *Das Leben der niederländischen und deutschen Maler*, ed. Hanns Floerke, vol. I, pp. 70–1 and 94–5.

Panofsky invoked the comparison to make the point that Dürer had already mastered a 'modern' spatial schema, a space not constructed piecemeal out of clusters of objects, but conceived as a whole and then systematically (although not necessarily mathematically) accounted for on the picture surface; *Albrecht Dürer*, p. 23.

178 – Julius Böheim, *Das Landschaftsgefühl des ausgehenden Mittelalters* (Leipzig and Berlin, 1934), p. 66.

179 – Berlin, Kupferstichkabinett, KdZ 3369. Winkler 103, Strauss 1495/39.

180 – See the extended discussion of this pictorial and iconographical structure in Koerner, *The Moment of Self Portraiture in German Renaissance Art*, ch. 16.

181 – Friedländer, *Albrecht Altdorfer* (1891), p. 117.

182 – Munich 1938, no. 46. *Altdeutsche Malerei*, Alte Pinakothek München, Katalog II (Munich, 1963), pp. 32–3.

183 – See Henry-Russell Hitchcock, *German Renaissance Architecture* (Princeton, NJ, 1981), pp. 31–2. The new gatehouse at Wörth is inscribed 1525, although Hitchcock points out that it already appears in the Dresden drawing.

184 – Herbert Schindler, 'Die Entdeckung der Donaulandschaft: Wörth in den Bildern von Albrecht Altdorfer', *Wörth: Stadt zwischen Strom und Berg*, ed. Josef Fendl (Wörth a.d. Donau, 1979), pp. 83–7.

185 – On the German martial image see J. R. Hale, *Artists and Warfare in the Renaissance* (New Haven, 1990), esp. chs 1 and 2.

186 – Vienna, Albertina. W.56–79. 59 miniatures on parchment, each approximately 450 × 930 mm. For the woodcut *Procession*, see W.76–81.

187 – Vienna, Albertina, D.248 and 233. Winzinger, *Altdorfer Gemälde*, nos 66, 59, 60. Winzinger, *Die Miniaturen zum Triumphzug*, pls 21 and 6. See also the *Conquests of Burgundy and Artois* and the *Second Flemish Conquest* (D.236; Winzinger, *Die Miniaturen zum Triumphzug*, pl. 9), the *Swiss War* (D.244; W.62; Winzinger, *Die Miniaturen zum Triumphzug*, plate 17), and the *Bavarian War* (D.245; W.66; Winzinger, *Die Miniaturen zum Triumphzug*, plate 18).

188 – See the remarks by Karsten Harries, *The Meaning of Modern Art* (Evanston, 1968), pp. 41–2, on the structure of the *Battle of Alexander*.

189 – Carl Linfert said this in his hypnotic essay *Albrecht Altdorfer: Die Enthüllung der Landschaft* (Mainz, 1938), p. 35.

4 Topography and fiction

1 – *Italienische Reise*, 13 May 1787. *Werke*, Hamburger Ausgabe (Munich, 1981), vol. 11, pp. 313–14. As a sixteenth-century example Goethe named the Flemish painter Joos de Momper. See also his letter to Riemer, 27 March 1814: 'All those with imagination tend toward the heights, for example the early landscape painters of the sixteenth century', quoted by Kurt Gerstenberger, *Die ideale Landschaftsmalerei* (Halle, 1923), p. 19, n. 1.

2 – The core of the Huber literature is Peter Halm, 'Die Landschaftszeichnungen des Wolfgang Hubers', *Münchner Jahrbuch der bildenden Kunst*, 7 (1930), pp. 1–104; Oettinger, *Datum und Signatur bei Albrecht Altdorfer und Wolf Huber*, Erlanger Forschungen, Reihe A: Geisteswissenschaften, vol. 8 (Erlangen, 1957); Oettinger, 'Zu Wolf Hubers Frühzeit', *Jahrbuch der Kunsthistorischen Sammlungen*, 53 (1957), pp. 71–100; and Winzinger, *Huber*.

3 – See Winzinger, *Wolf Huber*, p. 50ff., document 1, and nos 278–87. Indeed, only two paintings predate the completion of the St Anna retable in 1521: the epitaph of Jakob Endl at Kremsmünster, dated 1517

(W.276), and the small panel of the *Christ Taking Leave of his Mother* in the Kunsthistorisches Museum, dated 1519 (W.277). Brigitte Heinzl tentatively identified Huber as the author of four remarkable Passion panels in Linz, signed 'H' and dated 1507: 'Der Monogrammist H und seine Beziehung zu Wolf Huber', *Jahrbuch des oberösterreichischen Musealvereines*, 113 (1968), pp. 135–40. The idea should by no means be dismissed.

4 – *Pyramus and Thisbe* in Budapest (W.6), *Nude in a Landscape* in Hamburg (W.7), *St Sebastian* from the Koenigs collection (W.10), and *St Francis* in the Albertina (W.11). Mielke is unfair to say that Huber only drew on coloured ground because his contemporaries demanded it (Berlin 1988, p. 315).

5 – W.12.

6 – Berlin, Kupferstichkabinett, KdZ 2061. 211 × 306 mm. Munich 1938, no. 474. W.69. Berlin 1988, no. 208.

7 – Koenigs Collection, owned by Museum Boymans-van Beuningen, Rotterdam. Watercolour and gouache, 309 × 207 mm. Munich 1938, no. 473. W.68. Halm

reported seeing two similar watercolour landscapes by Huber on the art market in Vienna in 1926: 'Die Landschaftszeichnungen des Wolf Huber', no. 22.

8 – Erlangen, University Library, inv. no. II E 31. Bock 822. 327 × 448 mm. Munich 1938, no. 475. W. 255. Given by Bock, Halm and Buchner to Huber but rejected by Winzinger.

9 – Peter Halm actually supposed that the space in the foreground was reserved for an Entombment scene. *Gedächtnisausstellung zum 400. Todestages Wolf Hubers* (Passau, 1953), no. 63.

10 – Florence, Uffizi, inv. no. V, 8 P. Pen and ink, 19 × 28.5 cm. A.E. Popham, *The Drawings of Leonardo da Vinci* (New York, 1945), illus. 253. Inscribed in Leonardo's hand: 'di di santa Maria della neve addi 5 daghossto 1473'.

11 – Gombrich, 'Light, Form and Texture in Fifteenth-century Painting North and South of the Alps', *The Heritage of Apelles* (London, 1976), pp. 33–4. Alexander Perrig considers the drawing a complete fiction: 'Die theoriebedingten Landschaftsformen in der italienischen Malerei des 14. und 15. Jahrhunderts', in *Die Kunst und das Studium der Natur vom 14. zum 16. Jahrhundert*, ed. Wolfram Prinz and Andreas Beyer (Weinheim, 1987), p. 52.

12 – For an early sixteenth-century French example, see *A History of Private Life*, vol. 2: *Revelations of the Medieval World*, ed. Georges Duby (Cambridge, Mass., 1988), p. 445. For a mid-fifteenth-century figurative map of the environs of Bruges, see Dhanens, *Hubert and Jan van Eyck*, p. 52, n. 29. An early sixteenth-century Bruges example, painted on canvas, was introduced by Ann Roberts, 'The Landscape as Legal Document: Jan de Hervy's "View of the Zwin"', *The Burlington Magazine*, 133 (1991), pp. 82–6. On documentary landscapes in Trecento Siena, finally, see Feldges, *Landschaft als topographisches Porträt*, esp. pp. 23–32.

13 – Bayerische Hauptstaatsarchiv, Plansammlung, inv. no. 11256. For this example I am indebted to Kristin Zapalac.

14 – Pen and black ink, watercolour and gouache with white heightening on parchment; four parts pasted on paper, 457 × 556 mm. See the exhibition catalogues *Die Sammlung Ian Woodner*, no. 47 and *Woodner Collection: Master Drawings*, no. 53.

15 – Translated in Smith, *Nuremberg: A Renaissance City*, p. 90. See Fritz Schnelbögl, 'The Life and Work of the Nuremberg Cartographer Erhard Etzlaub', *Imago Mundi*, 20 (1966), p. 11ff.; or 'Leben und Werk des Nürnberger Kartographen Erhard Etzlaub', *Mitteilungen des Vereins für Geschichte der Stadt Nürnberg*, 57 (1970), p. 216ff.

16 – Vienna, Österreichische Nationalbibliothek, cod. 2858. C. 1508. 24 fol., drawings in pen and ink with washes, some black chalk underdrawing. There is no text apart from the names of the forts. Halm, 'Die Landschaftszeichnungen des Wolfgang Huber', p. 62, n. 41, attributes the volume to the Kölderer circle and publishes documents regarding Imperial commissions for maps and plans. See also the exhibition catalogue of the Österreichische Nationalbibliothek, *Maximilian I.* (1959).

17 – Vienna, Österreichische Nationalbibliothek,

cod. 10815/16/24. The first two volumes begin with identical depictions of the Neuzeughaus in Vienna, spread over two pages and initialed I.K. Presumably they are preliminary versions, and belong alongside a further fragment in Munich initialled and dated 1502 (Cod. icon. 222), and a fragment in the possession of H.P. Kraus in New York and dated 1507. The third volume in the Nationalbibliothek, on parchment, is much larger and more sumptuously ornamented. But like the three volumes in the Waffensammlung of the Kunsthistorisches Museum in Vienna (inv. 50746), still more magnificent, they include only lists and illustrations of weapons. See Franz Unterkircher, *Maximilian I. Ein Kaiserlicher Auftraggeber illustrierter Handschriften* (Hamburg, 1983); Winzinger, *Altdorfer Gemälde*, pp. 52–3.

18 – *Fortifications*, fol. 4.

19 – Vienna, Österreichische Nationalbibliothek, cod. 7962. See the facsimile editions of the *Fischereibuch* and the *Jagdbuch* by Michael Mayr (Innsbruck, 1901), and the publication of Franz Unterkircher, *Das Tiroler Fischereibuch Maximilians I* (Graz, 1967).

20 – Dhanens, *The Ghent Altarpiece* (New York, 1973), pp. 64–5. On topographical portraiture generally in van Eyck and other Netherlandish painters, see Panofsky, *Early Netherlandish Painting*, pp. 137 and 225 n. 3, and Lotte Brand Philip, *The Ghent Altarpiece and the Art of Jan van Eyck* (Princeton, NJ, 1971), pp. 194–6, esp. n. 386.

21 – See Floridus Röhrig, ed., *Der Albrechtsaltar und sein Meister* (Vienna, 1981), pl. 1, p. 36.

22 – See Benesch, 'Der Meister des Krainburger Altars', *Wiener Jahrbuch für Kunstgeschichte*, 8 (1932); reprinted in *German and Austrian Art of the Fifteenth and Sixteenth Centuries*, p. 183, fig. 204.

23 – Benesch, 'Der Meister des Krainburger Altars', pp. 195–6, fig. 217.

24 – Straubing, St Jakob, c.1480–90, 222 × 147 cm. *Albrecht Dürer Ausstellung* (Nuremberg: Germanisches Nationalmuseum, 1928), no. 32. See also the city in the background of Wolgemut's Zwickau altar, no. 1.

25 – Hollstein 80. 228 × 158 mm. Basel 1974, no. 401, and p. 761, n. 31. Jahn, *Lucas Cranach als Graphiker*, pl. 23.

26 – Nuremberg, Germanisches Nationalmuseum, inv. no. St. Nbg. Norica 759 (747). Ochre, grey, red, vermilion and blue-green washes, 148 × 212 mm. Zink 106 (c.1520).

27 – London, British Museum. Pen with red wash (in roofs), 93 × 192 mm. Lippmann 438. Eduard Flechsig, *Albrecht Dürer* (Berlin, 1928), vol. 2, pp. 143–4, denied that the topographical inscriptions were in Dürer's hand. See Winkler, *Die Zeichnungen Albrecht Dürers*, vol. 2, p. 132, and Appx, plate XXIV.

28 – Berlin, Kupferstichkabinett, KdZ 15342–7. The basic publication is Max Müller and Friedrich Winkler, 'Bamberger Ansichten aus dem XV. Jh.', *Jahrbuch der Preussischen Kunstsammlungen*, 58 (1937), pp. 241–57. See also the exhibition catalogue *Dürer und seine Zeit* (Berlin: Kupferstichkabinett, 1967), nos 12–14; and Nuremberg 1971, no. 555.

29 – Berlin, Kupferstichkabinett, KdZ 15346, 190 × 472 mm.

30 – *The Ordeal by Fire of Empress Kunigunde*, Bamberg,

Staatsgalerie, inv. no. L 1031. See Alfred Stange, *Deutsche Malerei der Gotik* (Munich and Berlin, 1958), vol. 9, p. 219, or *Kritisches Verzeichnis der deutschen Tafelbilder vor Dürer* (Munich, 1978), vol. 3, no. 296. Katzheimer is actually better known through documents than by attested paintings. It should be pointed out that the association of the Berlin watercolours with Katzheimer rests entirely on the attribution of this panel.

31 – London, British Museum, inv. no. 1924-12-13-1; see Dodgson in *Old Master Drawings*, 1 (1926/27), illus. 30. Nils Bonsels, in *Wolfgang Katzheimer von Bamberg*, Studien zur deutschen Kunstgeschichte, no. 306 (Strasbourg, 1936), pp. 94–5, misunderstood the structure of the building in the London drawing and concluded on the basis of construction history that it was drawn before 1489, and by Katzheimer. Stange (*Deutsche Malerei der Gotik*, 9, pp. 103–4) also associated the sheet with Katzheimer.

32 – For the woodcut see Dodgson, 1, p. 511f. The clearest discussion of the entire problem is Fedja Anzelewsky, 'Eine spätmittelalterliche Malerwerkstatt: Studien über die Malerfamilie Katzheimer in Bamberg', *Zeitschrift des deutschen Vereins für Kunstwissenschaft*, 19 (1965), pp. 137–42. Anzelewsky helpfully moves the London drawing away from Katzheimer and instead gives it squarely to Traut. See also Michael Imhof, 'Die topographischen Ansichten des Domberges um 1470 bis 1480', in *Der Bußprediger Capestrano auf dem Domplatz in Bamberg*, exhibition catalogue, Historisches Museum, Bamberg (1989), pp. 69–86.

33 – Berlin, Kupferstichkabinett, KdZ 15344 and 15343.

34 – The engraver LCz, who was close to Cranach and Altdorfer, was possibly Lorenz Katzheimer, presumably a relative of Wolfgang. See Alan Shestack, *Master LCz and Master WB* (New York, 1971), pp. 45–7; and Basel 1974, pp. 760–61, n. 31. Hanswernfried Muth, in *Bericht des historischen Vereins Bamberg*, 96 (1959), p. 17ff., actually attributed the Berlin watercolours to LCz.

35 – Erlangen, University Library, inv. no. III D 53, Bock 139. Nuremberg 1971, no. 92.

36 – Leipzig, Museum der bildenden Künste, inv. no. NI.51. Watercolour and gouache over metalpoint, 178 × 277 mm., signed (later) MvS. *Meisterzeichnungen des Museum der bildenden Künste*, ed. Dieter Gleisburg (Leipzig, 1990).

37 – Malibu, J. Paul Getty Museum, inv. no. 89.GG.12. Pen with watercolour and gouache, 73 × 135 mm. See *European Drawings, 2: Catalogue of the Collections*, ed. George R. Goldner and Lee Hendrix (Malibu, J. Paul Getty Museum, 1992), no. 126, where the sheet is associated with the Katzheimer life-studies.

38 – Munich, Graphische Sammlung, inv. no. 118108. Schreiber 2760. Hernad, *Die Graphiksammlung des Humanisten Hartmann Schedel*, no. 85.

39 – On the city views see Rücker, *Die Schedelsche Weltchronik*; and V. de Loga, 'Die Städteansichten in Hartmann Schedels Chronik', *Jahrbuch der preussischen Kunstsammlungen*, 9 (1880), pp. 93–107, 184–96.

40 – This was demonstrated by Charles Talbot, 'Landscapes from Incunabula to Altdorfer', *Gesta*, 15 (1976), pp. 321–6. On late medieval and Renaissance city views generally, see Jürgen Schulz, 'Jacopo de' Barbari's View of Venice: Map Making, City Views, and Moralized Geography Before the Year 1500', *Art Bulletin*, 60 (1978), esp. pp. 456–67.

41 – Geneva, Musée d'Art et d'Histoire, 132 × 155 cm. See Joseph Gantner, *Konrad Witz* (Vienna, 1942).

42 – Rotterdam, Museum Boymans–van Beuningen, inv. no. 1958/T28. 343 × 267 mm. Winkler 63. Strauss 1494/5.

43 – Described by Dürer in his Family Chronicle; Rupprich, 1, p. 28.

44 – Berlin, Kupferstichkabinett, KdZ 4. Watercolour and gouache, 290 × 426 mm. Winkler 61. Strauss 1494/3.

45 – Vasari, *Le Vite*, ed. Milanesi, vol. 5, p. 399.

46 – Florence, Uffizi, inv. no. 1700 F. 202 × 273 mm. Inscribed 'Marco Basaiti' in a later hand. The Tietzes published the drawing as Dürer; *Old Master Drawings*, 11 (1936/7), pp. 34–5. But since Degenhart the Venetian solution has prevailed: 'Dürer oder Basaiti?', *Mitteilungen des Kunsthistorischen Institutes in Florenz*, 5 (1937–40), pp. 423–8. See Panofsky, *Albrecht Dürer*, no. 1418; Nuremberg 1971, no. 190.

47 – Neudörfer, *Nachrichten von Künstlern und Werkleuten*, ed. G.W.K. Lochner, Quellenschriften für Kunstgeschichte und Kunsttechnik des Mittelalters, 10 (Vienna, 1875), p. 132.

48 – Rotterdam, Boymans–van Beuningen Museum, missing since 1945. Silverpoint on vellum, 160 × 282 mm. Winkler 479, Strauss 1517/18. Winkler said that the drawing was so abraded that it was more legible in reproduction than in the original.

49 – See Carl Koch, *Die Handzeichnungen Hans Baldung Griens* (Berlin, 1941), nos 248–52; and Kurt Martin, ed., *Skizzenbuch des Hans Baldung Griens* (Basel, 1950).

50 – Nuremberg, Germanisches Nationalmuseum, inv. no. 3978, recto and verso. 90 × 141 mm.; inscribed 'Goldbach / 1.5.22 an. S. Michalstag', Zink 136. See also the silverpoint mountain panorama, Germanisches Nationalmuseum, inv. no. 3964, Zink 144 (Upper Rhine, c.1515).

51 – Berlin, Kupferstichkabinett, KdZ 17662. Pen with black ink on light reddish tinted paper, 199 × 265 mm. Monogrammed and dated 1505. W.8. Linz 1965, no. 274. Berlin 1988, no. 205.

52 – Many German examples were also heightened with white or red. See Meder, *Die Handzeichnung*, p. 46ff.

53 – Bock 117–37. These drawings do not use white heightening and do not particularly strive for plastic effects.

54 – One possible exception is the *View of Heroldsberg* (near Nuremberg) in Bayonne, Musée Bonnat, inv. no. 1299/1528, which is monogrammed and dated 1510. Flechsig, *Albrecht Dürer*, 2, p. 76, doubted both signature and date; Winkler (no. 481) accepted them. The dates on the *Quarry* watercolours in London (Winkler 110, Strauss 1494/19) and Berlin (Winkler 111, Strauss 1495/40, illus. 70) are specious.

55 – Oettinger judged both date and monogram autograph and contemporaneous with the drawing; *Datum und Signatur*, pp. 27–8. Winkler thought that Huber added both later; 'Die Sammlung Ehlers', *Jahrbuch der*

Preussischen Sammlungen, 60 (1939), pp. 30, 42, no. 26.

56 – Budapest, Museum of Fine Arts, inv. no. E. 33–23. Pen in brown ink, 133 × 148 mm. W.14. Winzinger wondered whether the drawing might not have originally extended further to the left and right.

57 – Nuremberg, Germanisches Nationalmuseum, inv. no. 18. Pen with dark brown ink, 127 × 206 mm. Zink 152. W.15. Munich 1938, no. 446. Linz 1965, no. 275.

58 – W.10, 11, 9. On the *Historia* illustrations, see p. 100 above. The *Venus and Cupid* is in Berlin, Kupferstichkabinett, KdZ 4184, 97 × 66 mm.

59 – On this hypothesis, see Oettinger, 'Zu Wolf Hubers Frühzeit', pp. 97–100.

60 – W.107, unicum in Paris, Bibliothèque Nationale. See Berlin 1988, nos 22–3.

61 – Budapest, Museum of Fine Arts, inv. no. 191 (E. 33–13a) and 190 (E. 33–15a) (illustrated). Pen, 153 × 208 mm., 152 × 207 mm. W.23–4.

62 – Oxford, Ashmolean Museum, Parker 301; pen, 176 × 134 mm.; W.2. Berlin, Kupferstichkabinett, KdZ 97; pen, 191 × 130 mm.; W.3. Winzinger dates these drawings to *c.*1503–5. But neither they nor two further landscapes in Oxford and Göttingen (W.4 and 5, 'before 1505'), equally fantastic and elaborate, are conceivable so early in Huber's career.

63 – Cleveland, Museum of Art, inv. no. 51.277. W.22.

64 – The views of Traunkirchen (Koenigs collection, dated 1519, W.64), Feldkirch (London, dated 1523, W.71), the Danube valley near Krems (Berlin, dated 1529, W.81), and the Danube whirlpool ('Donaustrudel') at Grein (Washington, dated 1531, W.87). The *Castle* in Basel (dated 1542, W.95) possibly represents Aggsbach on the Danube. See also the copies after Huber landscapes with views of Passau (W.186 and 188). The views of Vienna after the Turkish siege (Albertina, dated 1530, W.86) and of the Battle of Pavia (Munich, W.85) are not landscapes or topographies in this sense, but quasi-journalistic reports on events.

65 – *Annunciation to Joachim*, Washington, 1514 (W.38); *Pyramus and Thisbe*, formerly in Bremen, 1515 (W.40); *Crucifixion*, Berlin, 1517 (W.47); *St Hubert*, formerly Koenigs collection, and Kreuzenstein (a copy) (W.37, 175).

66 – The latest, and one of the greatest, is the *View out of a Gorge* of 1552, at University College, London (W.109).

67 – Zurich, Kunsthaus, Alter Bestand N I K. Pen, 220 × 158 mm. Winzinger, *Huber*, no. 228. Linz 1965, no. 348. Leu's *Landscape with Hunters* in Milan, in horizontal format, is dated 1516; Biblioteca Ambrosiana, inv. no. F 264, inf. 22. Winzinger, *Huber*, no. 226. The vertical *Large Castle Landscape* in Bremen is dated 1517.

Winzinger, *Huber*, no. 227. Linz 1965, no. 210.

68 – Berlin, Kupferstichkabinett, KdZ 14698. 260 × 198 mm. Walter Hugelshofer, *Schweizer Handzeichnungen des XV. und XVI. Jahrhunderts* (Freiburg, 1928), no. 13. *Niklaus Manuel Deutsch: Maler, Dichter, Staatsmann* (Bern: Kunstmuseum, 1979), no. 177.

69 – Koepplin, 'Altdorfer und die Schweizer', *Alte und Moderne Kunst*, 11 (1966), pp. 6–14.

70 – Budapest, Museum of Fine Arts, inv. no. E. 33–25. Pen and black ink, 148 × 208 mm. Dated 1511. W.28.

71 – Vienna, Akademie, inv. no. 2518. Pen and black ink on yellowed paper, 141 × 197 mm. Monogrammed by a later hand. W.29. Berlin 1988, no. 46.

72 – B.55, W.14, Berlin 1988, no. 51. This and three others dated 1511 are Altdorfer's earliest woodcuts, with the exception of the little Mondsee 'seals' that Winzinger considers autograph; see below, p. 259.

73 – The fact of the journey was established by Joseph Meder, 'Albrecht Altdorfers Donaureise im Jahre 1511', *Mittheilungen der Gesellschaft für vervielfältigende Kunst* (a supplement to *Die Graphischen Künste*), vol. 25 (1902), pp. 9–12, and vol. 30 (1907), pp. 29–34.

74 – Norbert Lieb suggested that Huber's *View of the Mondsee* was done this way: Winzinger, *Huber*, under no. 15.

75 – Vienna, Albertina, inv. no. 3000, D.216. Pen and white heightening on green ground, 179 × 144 mm. W.21. Berlin 1988, no. 29.

76 – The tower was demolished at the beginning of the nineteenth century. Meder, 'Albrecht Altdorfers Donaureise' (1902), p. 9f.

77 – W.12, 134. Benesch, *Historia Friderici et Maximiliani*, nos 6, 23.

78 – See Jürgens, *Erhard Altdorfer*, illus. 44.

79 – Goethe, 'Schema auf einem Blatt mit Notizen für die Zeitschrift "Über Kunst und Altertum"', *Werke*, Hamburger Ausgabe (Munich, 1981), 12, p. 217.

80 – See Koepplin, 'Das Sonnengestirn der Donaumeister'.

81 – New York, Metropolitan Museum of Art. B.58. 96 × 143 mm. For the landscape Dürer cannibalized his Pupila Augusta drawing; Windsor Castle, inv. no. 12175, Winkler 153, Strauss 1496/17. See Wölfflin, *Die Kunst Albrecht Dürers* (1905), 9th edn (Munich, 1984), pp. 223–4.

82 – Erlangen, University Library, Bock 807, 111 × 98 mm. W.97. Berlin 1988, no. 98.

83 – London, Guildhall Library. 144 × 110 mm. W.113. John Rowlands, *The Age of Dürer and Holbein: German Drawings 1400–1550* (Cambridge, 1988), no. 132.

5 The published landscape

1 – B.66–70, 72–74, Pass. 109. W.175–83. Max Friedländer published excellent facsimiles of the Albertina set of eight (with the colouring bleached out!), together with the Munich *Landscape with Watermill* (Pass. 109); *Albrecht Altdorfers Landschafts-radierungen*, Graphische Gesellschaft, no. 3 (Berlin, 1906).

2 – B.71 (as Albrecht). W.244.

3 – Erasmus, *Convivium religiosum*, from the *Colloquia familiaria* (1518), in *Ausgewählte Schriften*, ed. Werner Welzig, vol. 6 (Darmstadt, 1967), pp. 21–3; quoted in Zinke, *Patinirs 'Weltlandschaft'*.

4 – Tietze, *Albrecht Altdorfer*, p. 11.

5 – Cited in Tilman Falk, *Hans Burgkmair* (Munich, 1968), p. 84.

6 – W.42, 52. The subjects, a cleric and a woman, are

unidentified. Wertinger's portrait of Johann is now in Regensburg; Bayerische Staatsgemäldesammlung, inv. no. 1855: 1424, 70 × 47.5 cm.

7 – w.80–89.

8 – Heinrich Lutz, 'Die Sodalitäten im oberdeutschen Humanismus des späten 15. und frühen 16. Jahrhunderts', in *Humanismus im Bildungswesen des 15. und 16. Jahrhunderts*, Mitteilungen der Kommission für Humanismusforschung, 12 (Weinheim, 1984), pp. 45–60.

9 – Alois Schmid, 'Stadt und Humanismus: Die bayerische Haupt- und Residenzstadt München', in *Humanismus und höfisch-städtische Eliten im 16. Jahrhundert*, ed. Klaus Malettke and Jürgen Voss (Bonn, 1989), pp. 242–4.

10 – Warnke, *Hofkünstler*, esp. ch. 9.

11 – Gustav Künstler, 'Wolf Huber als Hofmaler des Bischofs von Passau, Graf Wolfgang von Salm', *Jahrbuch der kunsthistorischen Sammlungen in Wien*, 58 (1962), p. 73ff.

12 – Huth, *Künstler und Werkstatt*, pp. 8–9.

13 – Peter Parshall, 'The Print Collection of Ferdinand, Archduke of Tyrol', *Jahrbuch der Kunsthistorischen Sammlungen*, 78 (1982), pp. 139–84.

14 – Hernad, *Die Graphiksammlung des Humanisten Hartmann Schedel.*

15 – Anzelewsky, 'Dürers Stellung im Geistesleben seiner Zeit', in *Dürer-Studien: Untersuchungen zu den ikonographischen und geistesgeschichtlichen Grundlagen seiner Werke zwischen den beiden Italienreisen* (Berlin, 1983), pp. 179–216.

16 – See Stephen H. Goddard, ed., *The World in Miniature: Engravings by the German Little Masters, 1500–1550*, exhibition catalogue, Spencer Museum of Art, University of Kansas (1988).

17 – See Arnulf Wynen, *Michael Ostendorfer*, diss., Freiburg, 1961.

18 – Hermann von dem Busche, *Vallum humanitatis* (Cologne, 1518); quoted by Joël Lefebvre, 'Le Poète, la poésie et la poétique: Eléments pour une définition et pour une datation de l'humanisme allemand', in *L'Humanisme allemand (1480–1540)*, XVIIIe Colloque International de Tours: 1975 (Paris and Munich, 1979), pp. 285–301.

19 – See Julius von Schlosser, *La letteratura artistica* (Florence, 1977), pp. 276–80.

20 – Gerald Strauss, *Historian in an Age of Crisis: The Life and Work of Johannes Aventinus 1477–1534* (Cambridge, Mass., 1963).

21 – Bernhard Bischoff, 'Studien zur Geschichte des Klosters St Emmeram im Spätmittelalter (1324–1525)', in Bischoff, *Mittelalterliche Studien* (Stuttgart, 1967), vol. 2, pp. 115–55.

22 – Andreas Kraus, 'Die geistige Welt des Johann Aventinus – Bayern und der europäische Humanismus', in *Aventinus und seine Zeit, 1477–1534*, ed. Gerhard-Helmut Sitzmann (Abensberg, 1977), p. 47.

23 – A good summary of the circumstantial evidence is Pierre Vaisse, 'L'Ecole du Danube et Humanisme', *L'Humanisme allemand (1480–1540)*, XVIIIe Colloque International de Tours: 1975, pp. 551–65.

24 – Vienna, Kunsthistorisches Museum, inv. no. 1942. Winzinger, *Huber*, no. 303.

25 – Saran, 'Der Maler Albrecht Altdorfer als Humanist in seiner Reichsstädtischen Umwelt', in Otto Herding and Robert Stupperich, eds, *Die Humanisten in ihrer politischen und sozialen Umwelt* (Boppard, 1976), pp. 131–40.

26 – On intellectual circles in Vienna see Wilhelm Saliger, 'Die gelehrte Donaugesellschaft und die Anfänge des Humanismus in Wien', *Programm des deutschen Staats-Obergymnasiums in Olmütz* (Olmütz, 1876), pp. 3–35; Dieter Koepplin, *Cranachs Ehebildnis des Johannes Cuspinian von 1502*, esp. pp. 33–60; and Basel 1974, pp. 130–84.

27 – Hind, *Introduction to a History of Woodcut*, pp. 48–53; Walter L. Strauss, *Chiaroscuro: The Clair-Obscur Woodcuts by the German and Netherlandish Masters of the XVIth and XVIIth Centuries* (Greenwich, Conn., 1973); Basel 1974, pp. 644–5; Tilman Falk, 'Cranach und die Anfänge des farbigen Holzschnitts', *Akten des Kolloquiums zur Basler Cranach-Ausstellung 1974* (Basel: Kunstmuseum, 1977), pp. 17–18.

28 – Although some Italian woodcuts were so successful that they were mistaken by connoisseurs for drawings. See Oberhuber in *Die Kunst der Graphik III: Renaissance in Italien, 16. Jahrhundert* (Vienna: Graphische Sammlung Albertina, 1966), pp. 11, 20ff., 127ff.

29 – Frimmel, ed., *Der Anonimo Morelliano*, p. 30.

30 – See Lili Fröhlich-Bum, 'Die Landschaftszeichnungen des Domenico Campagnola', *Belvedere*, 8 (1929), pp. 258–61; Hans Tietze and Erika Tietze-Conrat, *The Drawings of the Venetian Painters in the Fifteenth and Sixteenth Centuries* (New York, 1944), pp. 122–32.

31 – London, British Museum, inv. no. 1881-7-9-80, 493 × 217 mm. B.20. Oberhuber, *Kunst der Graphik III: Renaissance in Italien*, no. 168 (Titian, cutter unknown); Peter Dreyer, *Tizian und sein Kreis* (Berlin: SMPK, 1971), no. 7 (Titian, cut by Ugo da Carpi); David Rosand and Michelangelo Muraro, *Titian and the Venetian Woodcut* (Washington DC, 1976), no. 25 (Domenico Campagnola).

32 – New York, Metropolitan Museum of Art, inv. no. 67.770, 330 × 444 mm. B.4. Signed DNIC. Oberhuber, *Kunst der Graphik III: Renaissance in Italien*, no. 181; Dreyer, *Tizian und sein Kreis*, no. 33; Rosand and Muraro, *Titian and the Venetian Woodcut*, no. 28.

33 – Washington, DC, National Gallery of Art, inv. no. 1943.3.372, 165 × 116 mm. W.24. Berlin 1988, no. 76.

34 – Vasari, *Le Vite*, ed. Milanesi, 6, p. 587.

35 – See the article on Hopfer in Thieme–Becker. The best general treatments of the problem are Gustav Pauli, *Inkunabeln der deutschen und niederländischen Radierung*, Graphische Gesellschaft, no. 8 (Berlin, 1908); and A.M. Hind, *History of Engraving and Etching* (Boston, 1923), p. 108.

36 – B.22, 191. The *Angel Displaying the Sudarium* (B.26) and the *Abduction of Proserpine* (B.72) are dated 1516.

37 – Washington DC, National Gallery of Art, inv. no. 1950.17.21, 217 × 322 mm. B.99.

38 – Hans Burgkmair made no engravings but one etching.

39 – Vasari, *Le Vite*, ed. Milanesi, 5, p. 423.

40 – See the excellent exhibition catalogue *Italian*

Etchers of the Renaissance and Baroque (Boston: Museum of Fine Arts, 1989).

41 – B.63–64; W.173–74; Berlin 1988, nos. 117, 116. 170 × 125 mm.; 160 × 116 mm.

42 – The events are most thoroughly recounted by Gerlinde Stahl, 'Die Wallfahrt zur Schönen Maria in Regensburg'.

43 – Josiah Gilbert, *Landscape in Art before Claude and Salvator* (London, 1885), p. 292.

44 – W.172. Munich 1938, no. 223.

45 – W.184–206, 207–8. Impressions are exceedingly rare; moreover, Winzinger estimates on the basis of watermarks that only two of the surviving impressions were actually made in Altdorfer's lifetime.

46 – B.VI, 416. Pass. IV, 40, 1. W.242.

47 – The engravings are a safe bet: *Vanitas* (B.60, as Albrecht) and *Man with Two Harlots* (Pass. IV, 285, 211). The attribution of the drawings is more hazardous. Certainly the *Courtly Company* in Berlin (KdZ 85; W.145) and the *Beheading of John the Baptist* in Regensburg (Stadtmuseum, inv. no. G 1935/107; W.143) are by the same hand; and that hand may also have drawn the *St George* on coloured ground at Windsor, as Oettinger argued. The densest discussions of the Erhard problem are Benesch, 'Erhard Altdorfer als Maler', and *Historia Friderici et Maximiliani*, pp. 85–97; and Oettinger, *Altdorfer-Studien*, pp. 82–107. See also Berlin 1988, nos 176–91. See also above, p. 115, n. 137.

48 – The documents are assembled and analyzed most thoroughly by Jürgens, *Erhard Altdorfer*, p. 11ff.

49 – Dresden, Kupferstichkabinett, inv. no. C 1884–2 (C 2142). Becker 27. Munich 1938, no. 126. W.69. The drawing was published by Ludwig Grote-Dessau, 'Zur Datierung der Landschaftsradierungen Albrecht Altdorfers', *Monatshefte für Bücherfreunde und Graphiksammler*, 1 (1925), pp. 229–30. Baldass, 'Albrecht Altdorfers künstlerische Herkunft und Wirkung', *Jahrbuch der Kunsthistorischen Sammlungen*, 12 (1938), p. 151, gave the sheet to Erhard. See also Christian Dittrich, *Vermißte Zeichnungen des Kupferstichkabinetts Dresden* (Dresden: Staatliche Kunstsammlungen, 1987), no. 18.

50 – Although the form of the date is not inconsistent with the 1522 of the Rotterdam watercolour or the 1526 of the *Susanna and the Elders*, Oettinger declined on paleographic grounds to assign it to Albrecht: *Datum und Signatur*, pp. 65–6. The strange flourish in the sky, as was noted earlier, may be standing in for a monogram; p. 229 above. The dots before and after the date also appear in the Rotterdam watercolour.

51 – Vienna, Albertina, inv. no. 17546. 206 × 312 mm. Schönbrunner-Meder 867. Becker 181, also p. 95. Munich 1938, no. 351. Benesch, *Historia Friderici et Maximiliani*, p. 132, no. 10. W.146. Winzinger in Linz 1965, no. 165, dates it 1512/15! Oettinger, *Altdorfer-Studien*, p. 94, also favours an early dating. Berlin 1988, no. 187. The drawing was originally catalogued as Hirschvogel. Joseph Meder was the first to name Erhard, and this judgement has subsequently been accepted by every commentator without exception. Koreny has doubted the connection of the *Coastal Landscape* to the other landscape drawings given to Erhard, but not the attribution; he also dates it *c.*1530; *Old Master Drawings from the Albertina* (Washington DC,

1984), no. 19, p. 201.

52 – B.67 at Veste Coburg and Pass. 109 in Plymouth (completing the Albertina's set of coloured etchings, perhaps). The Plymouth set (all but B.66) is a curiosity in the history of collecting. They were purchased by Charles Rogers (1711–84), presumably from one of his Nuremberg dealers. See Antony Griffiths, 'The Rogers Collection in the Cottonian Library, Plymouth', *Print Quarterly*, 10 (1993), pp. 19–36.

53 – Erlangen, University Library, 202 × 133 mm. Bock 812. W.113.

54 – Berlin, Kupferstichkabinett, KdZ 1692 (as Hirschvogel). Pen with green, blue, brown, and grey washes, 137 × 212 mm. Halm, 'Die Landschaftszeichnungen Hubers', p. 36, n. 18 (as Hirschvogel). W.65. The drawing was copied in a miniature dated 1522; it also served as the model for an etching by Hirschvogel dated 1546 (B.61).

55 – Vienna, Albertina, inv. no. 3066. Winkler 296. Strauss 1503/22.

56 – For the early hand-coloured woodcut, see Hind, *Introduction to a History of Woodcut*, pp. 167–70, or the exhibition catalogue *Die Frühzeit des Holzschnitts* (Munich: Staatliche Graphische Sammlung, 1970).

57 – These are a series of thirteen woodcuts in Vienna (Albertina and Österreichische Nationalbibliothek) that were dated by Winzinger to *c.*1500 (W.1–13). Two bear Altdorfer's monogram. They were once pasted in manuscript prayer-books from the abbey of Mondsee; three are still found in Cod. 4101 in the Nationalbibliothek. See also Linz 1965, no. 429. The monograms may be false; at any rate the woodcuts look more like a degradation of Altdorfer's mature manner than a harbinger. Mielke in Berlin 1988 ignores the woodcuts altogether.

58 – See Basel 1974, no. 67, and Berlin 1988, no. 212.

59 – Museum of Fine Arts, inv. no. 68.275. See *Albrecht Dürer: Master Printmaker*, exhibition catalogue (Boston: Museum of Fine Arts, 1971), no. 53.

60 – Christiane Andersson and Charles Talbot, *From a Mighty Fortress: Prints, Drawings, and Books in the Age of Luther 1483–1546* (Detroit: Institute of Arts, 1983), nos 134 (*Sea Monster*), 156 (*St Jerome in his Study*), and 123 (Cranach's *St John Chrysostom*).

61 – *Begegnungen: Meisterwerke der Zeichnung und Druckgraphik aus dem Rijksprentenkabinet in Amsterdam und der Albertina in Wien* (Maarssen, 1989), nos 27–31, especially p. 84.

62 – Peter Halm, 'Eine Altdorfer-Sammlung des 17. Jahrhunderts', *Münchner Jahrbuch der bildenden Kunst*, 11 (1960), p. 170, and Winzinger, *Altdorfer Graphik*, pp. 48–9.

63 – Five thousand prints are preserved in 34 volumes. See Parshall, 'The Print Collection of Ferdinand, Archduke of Tyrol'. Volume 22 also contains an impression of Dürer's etching *Landscape with Cannon*.

64 – Berlin 1988, p. 232.

65 – Frankfurt, Städel, inv. no. 7006. 111 × 159 mm. Schilling, *Katalog der deutschen Zeichnungen*, no. 18. Becker 135. Grote, 'Zur Datierung der Landschaftsradierungen', p. 230. The same etching was copied by Augustin Hirschvogel some years later in a drawing in the Bibliothèque Nationale.

66 – See Berlin 1988, no. 123; the drawing is in a German private collection.

67 – Georg Habich, 'Der Augsburger Geschlechtertanz von 1522', *Jahrbuch der Preussischen Sammlungen*, 32 (1911), pp. 213–35.

68 – Vienna, Österreichische Nationalbibliothek, cod. 4486, fol. 81v and 53v. See Peter Halm, 'Das Gebetbuch von Narziss Renner in der ÖNB', *Zeitschrift für Kunstwissenschaft*, 8 (1954), pp. 65–88; Linz 1965, no. 427; and above, illus 138.

69 – Winzinger dates the Altdorfer etchings variously to 1517/20 and to *c.*1520. He also raises the possibility, although for no clear reason, that Erhard's etching might have preceded Albrecht's. Mielke places them between 1517 and 1522.

70 – Lehrs 7. Copenhagen, Statens Museum for Kunst, inv. no. 6703. W.42. Berlin 1988, no. 63.

71 – Rossholm Lagerlöf, *Ideal Landscape: Annibale Carracci, Nicolas Poussin and Claude Lorrain* (New Haven, 1990), p. 2.

72 – Berlin, Gemäldegalerie, inv. no. 638C. 28.9 × 41 cm. W.53.

73 – Philadelphia Museum of Art, Johnson Collection, inv. no. 378. 62.2 × 59.1 cm. Koch, *Patenir*, no. 9.

74 – Vienna, Kunsthistorisches Museum, inv. no. 2923. 107.5 × 189 cm. W.55.

75 – Milan, private collection (?). Bernard Berenson, *Lorenzo Lotto* (Milan: Electa, 1955), pl. 2, p. 19.

76 – Nuremberg, Germanisches Nationalmuseum, inv. no. St. Nbg. 75Ie.28.2 × 40.4 cm. Geisberg 1361. The impression in Oxford is hand-coloured.

77 – Heinrich Röttinger, *Erhard Schön und Niklas Stör, der pseudo-Schön*, Studien zur deutschen Kunstgeschichte, 229 (Strasbourg, 1925), no. 23, pp. 220, 240. *The Illustrated Bartsch*, vol. 13 (Commentary), ed. Walter L. Strauss (New York, 1984), no. 1302.023.

78 – A later and more successful woodcut is *John on Patmos* by the Monogrammist HWG. Geisberg 1319 (as Virgil Solis). Pass. 1. 196 × 370 mm.

79 – H. van de Waal, 'Graphische Arbeiten des Monogrammisten P.S.', *Die graphischen Künste*, 4 (1939), pp. 47–61.

80 – B.97. Hollstein 258. 110 × 81 mm. See Gustav Pauli's article on Binck in Thieme–Becker. Binck's earliest prints date from 1525 and 1526. By the early 1530s he was a court painter in Copenhagen. On these lesser German landscapists, see also Hermann Voss, 'Aus der Umgebung Albrecht Altdorfers und Wolf Hubers'.

81 – Karl Schwarz, *Augustin Hirschvogel* (Berlin, 1917).

82 – B.77. 98 × 262 mm. Schwarz, *Hirschvogel*, no. 77. Oberhuber, *Die Kunst der Graphik IV: Zwischen Renaissance und Barock: Das Zeitalter von Bruegel und Bellange* (Vienna: Graphische Sammlung Albertina, 1967), no. 168.

83 – B.60, 61, 71.

84 – Annegrit Schmitt, *Hanns Lautensack* (Nuremberg, 1957).

85 – Washington DC, National Gallery of Art, inv. no. 1949.14.6, 166 × 118 mm. B.30, Schmitt, *Lautensack*, no. 66. For Hirschvogel and Lautensack see also *The Illustrated Bartsch*, vol. 18, ed. Jane S. Peters (New York, 1982); and Oberhuber, *Die Kunst der Graphik IV: Zwischen Renaissance und Barock*, p. 126ff., 132–9.

86 – London, British Museum, 244 × 497 mm. B.33. Henri Zerner, *The School of Fontainebleau* (New York, 1969), no. 36. Zerner, 'L'Eau-forte à Fontainebleau: Le rôle de Fantuzzi', *Art de France*, 4 (1964), pp. 70–84.

87 – Zerner 43.

88 – Gombrich, 'Renaissance Theory of Art and the Rise of Landscape'.

89 – Budapest, Museum of Fine Arts, inv. no. E. 33–25a. Pen with grey ink, 109 × 157 mm. W.1. Schönbrunner-Meder 384a.

90 – The date is definitely 1512, with an accidental pen stroke to the left of the second '1'. Inspection reveals a very slight difference in tone between the two downward strokes of the putative 'o'. There is no evidence of any damage or abrasion to the numeral. Whether the date was in fact written by Huber is another question. Indeed, Koepplin thinks the drawing is an excellent copy after a lost original; 'Das Sonnengestirn der Donaumeister', p. 106. Oettinger read the date unequivocally as 1512 but considered it a forgery; Huber never placed his date among clouds but rather in blank sky. In any case the drawing was for Oettinger inconceivable before 1515, and probably a pastiche. Oettinger, *Datum und Signatur*, pp. 32–3.

91 – On Cock, see Oberhuber, *Die Kunst der Graphik IV: Zwischen Renaissance und Barock*, p. 13ff., 31–51; and Timothy A. Riggs, *Hieronymus Cock (1510–1570): Printmaker and Publisher in Antwerp at the Sign of the Four Winds*, diss., Yale University, 1971.

92 – Oberhuber, 'Hieronymus Cock, Battista Pittoni und Paolo Veronese in Villa Maser', in *Munuscula Discipulorum*, Festschrift Hans Kauffmann (Berlin, 1968), pp. 207–24.

93 – On narrativity in van Eyck, see Hans Belting and Dagmar Eichberger, *Jan van Eyck als Erzähler* (Worms, 1983), esp. pp. 165–82.

94 – Reindert L. Falkenburg, *Joachim Patinir: Landscape as an Image of the Pilgrimage of Life* (Amsterdam and Philadelphia, 1988), where this basically sound hypothesis is overstated to the point of caricature.

95 – *June, or Harvest.* Nuremberg, Germanisches Nationalmuseum, inv. no. 1130. 32.5 × 39.8 cm. Nine of twelve panels are in Nuremberg; the other three are in St Petersburg and in private hands. Eberhard Lutze and Eberhard Wiegand, *Die Gemalde des 13. bis 16. Jahrhunderts* (Nuremberg: Germanisches Nationalmuseum, 1937), pp. 185–6, fig. 281. Munich 1938, nos 741–48. Linz 1965, no. 191. See the dissertation by Gloria Ehret, *Hans Wertinger*, Munich University, 1976, p. 28.

96 – Washington DC, National Gallery of Art, inv. no. 1972.16.1, 213 × 284 mm. Oberhuber, *Die Kunst der Graphik IV: Zwischen Renaissance und Barock*, no. 33. Christopher White, '"The Rabbit Hunters" by Pieter Bruegel the Elder', in *Pieter Bruegel und seine Welt*, ed. Otto von Simson and Matthias Winner (Berlin, 1979), pp. 187–91.

97 – *Das Lehrgedicht des Karel van Mander*, ed. R. Hoecker (The Hague, 1916). On van Mander's attempt to apply the principles of landscape composition to history painting, and thereby legitimate the Northern landscape tradition, see Walter S. Melion, *Shaping the Netherlandish Canon: Karel van Mander's*

Schilder–Boeck (Chicago, 1991), pp. 1–12.

98 – Berlin, Kupferstichkabinett, KdZ 13618. 147 × 197 mm. *Prag um 1600: Kunst und Kultur am Hofe Rudolf IIs.*, exhibition catalogue, Villa Hügel, Essen (Freren, 1988), no. 284, pl. 63. Teresz Gerszi, 'Les Attaches de Paulus van Vianen avec l'art allemand', *Bulletin du Musée Hongrois des Beaux-Arts*, 44 (1975), pp. 71–90, who emphasizes especially the link to Dürer. See also Thomas Da Costa Kaufmann on the co-existence of mannered and realistic modes within the School of Prague, 'The Eloquent Artist: Towards an Understanding of the Stylistics of Painting at the Court of Rudolf II', *Leids Kunsthistorisch Jaarboek*, 1 (1982), pp. 119–48.

99 – Keith Andrews, *Adam Elsheimer* (London, 1977).

For a painting heavily under the spell of Altdorfer, see the *Holy Family* in Berlin, inv. no. 2039, *c.*1599.

100 – Panofsky, 'Albrecht Dürer and Classical Antiquity' (1921/22), in *Meaning in the Visual Arts* (Garden City, 1955), pp. 269–70. Panofsky cites Riegl at exactly this point in the argument.

101 – Panofsky, *Die deutsche Plastik des 11. bis 13. Jahrhunderts* (Munich, 1924), p. 61.

102 – Derrida, '+R (Into the Bargain)', in *The Truth in Painting*, p. 175.

103 – W.171. Berlin 1988, no. 160.

104 – Winzinger, *Altdorfer Gemälde*, p. 11.

105 – Jauss, 'Theory of Genres and Medieval Literature', *Toward an Aesthetic of Reception* (Minneapolis, 1982), p. 109.

Bibliography

1 ABBREVIATIONS

A.
Fedja Anzelewsky, *Albrecht Dürer: Das malerische Werk*, Berlin, 1971; 2nd edn, 2 vols, 1991

B.
Adam von Bartsch, *Le Peintre-graveur*, 21 vols, Vienna, 1803–21

Basel 1974
Lucas Cranach, ed. Dieter Koepplin and Tilman Falk, 2 vols, Basel: Kunstmuseum, 1974

Becker
Hanna L. Becker, *Die Handzeichnungen Albrecht Altdorfers*, Munich, 1938

Berlin 1988
Albrecht Altdorfer, ed. Hans Mielke, Berlin: Staatliche Museen Preussischer Kulturbesitz, 1988

Bock
Elfried Bock, *Die Zeichnungen in der Universitätsbibliothek Erlangen*, Frankfurt-am-Main, 1929

D.
Hans Tietze and Erika Tietze-Conrat, *Beschreibender Katalog der Handzeichnungen in der Graphischen Sammlung Albertina*, vol. 4: *Die deutschen Schulen*, Vienna, 1933

Demonts
Louis Demonts, *Musée du Louvre, Inventaire générale des dessins des Ecoles du Nord: Ecoles Allemande et Suisse*, 2 vols, Paris, 1937

Dodgson
Campbell Dodgson, *Catalogue of Early German and Flemish Woodcuts preserved in the British Museum*, 2 vols, London, 1903, 1911

Geisberg
Max Geisberg, *The German Single-leaf Woodcut, 1500–1550*, 4 vols, rev. and ed. Walter L. Strauss, New York, 1974

Hind
Arthur M. Hind, *Early Italian Engraving*, 7 vols, London, 1938–48

Hollstein
F.W.H. Hollstein, *German Engravings, Etchings, and Woodcuts, c.1400–1700*, Amsterdam, 1954–

KdZ
Elfried Bock, *Die Zeichnungen alter Meister im Kupferstichkabinett: Die deutschen Meister*, Berlin,
 1921

Lehrs
Max Lehrs, *Geschichte und kritischer Katalog des deutschen, niederländischen und französischen
 Kupferstiches im XV. Jahrhundert*, 9 vols, Vienna, 1908–34

Linz 1965
Die Kunst der Donauschule 1490–1540, Linz: Land Oberösterreich, 1965

Lippmann
Friedrich Lippmann, *Zeichnungen von Albrecht Dürer in Nachbildungen*, 7 vols, Berlin, 1883–
 1929

Munich 1938
Albrecht Altdorfer und sein Kreis, Munich: Bayerisches Nationalmuseum, 1938

Nuremberg 1971
Albrecht Dürer 1471–1971, Nuremberg: Germanisches Nationalmuseum, 1971

Paris 1984
Albrecht Altdorfer and Fantastic Realism in German Art, ed. Jacqueline and Maurice Guillaud,
 Paris: Centre Culturel du Marais, 1984

Parker
K. T. Parker, *Catalogue of the Drawings in the Ashmolean Museum*, vol. 1, Oxford, 1938

Pass.
Johann David Passavant, *Le Peintre-graveur*, 6 vols, Leipzig, 1860–64

Rupprich
Hans Rupprich, *Dürers schriftlicher Nachlass*, 3 vols, Berlin, 1956–69

Schönbrunner-Meder
Joseph Schönbrunner and Joseph Meder, eds, *Handzeichnungen alter Meister aus der Albertina
 und anderen Sammlungen*, 12 vols, Vienna, 1896–1908

Schreiber
Wilhelm L. Schreiber, *Manuel de l'amateur de la gravure sur bois et sur métal au XVe siècle*, 8
 vols, Berlin, 1891–1911

Strauss
Walter L. Strauss, *The Complete Drawings of Albrecht Dürer*, 6 vols, New York, 1974

W.
Franz Winzinger, *Albrecht Altdorfer: Zeichnungen*, Munich, 1952

– Franz Winzinger, *Albrecht Altdorfer: Graphik*, Munich, 1963

– Franz Winzinger, *Albrecht Altdorfer: Die Gemälde*, Munich, 1975

– Franz Winzinger, *Wolf Huber: Das Gesamtwerk*, 2 vols, Munich and Zurich, 1979

Winkler
Friedrich Winkler, *Die Zeichnungen Albrecht Dürers*, 4 vols, Berlin, 1936–9

Zink
Fritz Zink. *Die Handzeichnungen bis zur Mitte des 16. Jhs*, Nuremberg: Germanisches National-
 museum, 1968

2 ADDITIONAL LITERATURE ON ALTDORFER'S LANDSCAPES

Ludwig Baldass, *Albrecht Altdorfer: Studien über die Entwicklungsfaktoren im Werk des Künstlers*, Vienna, 1923

– *Albrecht Altdorfer*, Vienna, 1941

Otto Benesch, *Der Maler Albrecht Altdorfer*, Vienna, 1938

– *The Art of the Renaissance in Northern Europe*, London, 1965

– 'Zur altösterreichische Tafelmalerei', *Jahrbuch der Kunsthistorischen Sammlungen*, 2 (1928), pp. 63–118; reprinted in *Collected Writings*, vol. 3: *German and Austrian Art of the Fifteenth and Sixteenth Centuries*, London, 1972, pp. 16–72

– 'Die Tafelmalerei des ersten Drittels des 16.Jhs. in Österreich'. *Die Bildende Kunst in Österreich*, 3 (1938), pp. 137–48; reprinted in *Collected Writings*, vol. 3, pp. 3–11

– 'The Rise of Landscape in the Austrian School of Painting at the Beginning of the Sixteenth Century', *Konsthistorisk Tidskrift*, 28 (1959), pp. 34–58; reprinted in *Collected Writings*, vol. 3, pp. 338–52

Otto Benesch & Erwin M. Auer, *Die Historia Friderici et Maximiliani*, Berlin: Deutscher Verein für Kunstwissenschaft, 1957

Max J. Friedländer, *Albrecht Altdorfer: Der Maler von Regensburg*, Leipzig, 1891

– *Albrecht Altdorfers Landschaftsradierungen*, Graphische Gesellschaft, no. 3, Berlin, 1906

– *Albrecht Altdorfer*, Berlin, 1923

Ludwig Grote-Dessau, 'Zur Datierung der Landschaftsradierungen Albrecht Altdorfers', *Monatshefte für Bücherfreunde und Graphiksammler*, 1 (1925), pp. 229–30

Peter Halm, 'Die Landschaftszeichnungen des Wolfgang Hubers', *Münchner Jahrbuch der bildenden Kunst*, 7 (1930), pp. 1–104

Dieter Koepplin, 'Altdorfer und die Schweizer', *Alte und Moderne Kunst*, 11 (1966), pp. 6–14

Carl Linfert, *Albrecht Altdorfer: Die Enthüllung der Landschaft*, Mainz: Werkstatt für Buchdruck, 1938

Joseph Meder, 'Albrecht Altdorfers Donaureise', *Mittheilungen der Gesellschaft für vervielfältigende Kunst*, 25 (1902), pp. 9–12, and 30 (1907), pp. 29–34

Karl Oettinger, *Datum und Signatur bei Albrecht Altdorfer und Wolf Huber*, Erlanger Forschungen, Reihe A: Geisteswissenschaften, vol. 8, Erlangen: Universitätsbund Erlangen, 1957

– *Altdorfer–Studien*, Nuremberg, 1959

Eberhard Ruhmer, *Albrecht Altdorfer*, Munich, 1965

Herbert Schindler, 'Die Entdeckung der Donaulandschaft: Wörth in den Bildern von Albrecht Altdorfer', *Wörth: Stadt zwischen Strom und Berg*, ed. Josef Fendl, 1979, pp. 83–7

Larry Silver, 'Forest Primeval: Albrecht Altdorfer and the German Wilderness Landscape', *Simiolus*, 13 (1983), pp. 5–43

Alfred Stange, *Malerei der Donauschule*, Munich, 1964

Charles Talbot, 'Landscapes from Incunabula to Altdorfer', *Gesta*, 15 (1976), pp. 321–6

Hans Tietze, *Albrecht Altdorfer*, Leipzig, 1923

Hermann Voss, *Der Ursprung des Donaustiles*, Leipzig, 1907

Nora Watteck, 'Hallein und seine Umgebung auf Werken von Albrecht Altdorfer', *Alte und Moderne Kunst*, 18 (1973), pp. 1–8

Werden und Wandlung: Studien zur Kunst der Donauschule, Linz: Oberösterreichischer Landesverlag, 1967

Checklist of Landscapes
by Albrecht Altdorfer

1 PAINTINGS ON PANEL

1.1 – *Landscape with Footbridge*. London, National Gallery, inv. no. 6320. Oil on parchment attached to oak panel, 41.2 × 35.5 cm. Signed AA and formerly dated 15–6; both possibly false. w.39. *Illus. 99*.

1.2 – *Landscape with Castle*. Munich, Alte Pinakothek, inv. no. W.A.F. 30. Oil on parchment attached to boxwood panel, 30.5 × 22.2 cm. Signed AA. w.46. *Illus. 100*.

1.3 – Landscape with 'a tall fir tree in the middle of a wild mountainous landscape, with a lake, a city on the banks of the lake, and a castle on a mountain visible in the distance'. Formerly Vienna; described by Christian von Mechel, *Verzeichnis der Gemälde der kaiserlich-königlichen Bilder Gallerie in Wien*, 1783, p. 257, no. 90. Oil(?) on parchment attached to panel, approximately 35 × 25 cm. Signed AA and dated 1532.

2 WATERCOLOUR AND GOUACHE PAINTINGS ON PAPER

2.1 – *Landscape with Church*. Rotterdam, Museum Boymans–van Beuningen (Koenigs Collection), inv. no. D.I.255, lost since 1945. Black ink, watercolour and gouache on paper, 20.4 × 13.8 cm. Signed AA and dated 1522. w.66. *Illus. 101*.

2.2 – *Landscape with Sunset*. Erlangen, University Library, inv. no. II E 7, Bock 812. Black ink, watercolour and gouache on paper, 20.2 × 13.3 cm. Signed AA. w.68. *Illus. 102*.

2.3 – *Landscape with Woodcutter*. Berlin, Kupferstichkabinett, KdZ 11651. Black ink, watercolour and gouache on paper, 20.1 × 13.6 cm. Signed AA. w.67. *Illus. 1*.

3 DRAWINGS

3.1 – *Cliff with Castle*. Milan, Biblioteca Ambrosiana, inv. no. F. 264 inf. 16. Grey-black ink, watercolour and gouache on paper, 17.9 × 14.1 cm. Dated 1509. Winzinger, *Wolf Huber*, no. 9. *Illus. 72*.

3.2 – *View of Sarmingstein*. Budapest, Museum of Fine Arts, inv. no. E. 33–25. Black ink on paper, 14.8 × 20.8 cm. Dated 1511. w.28. *Illus. 164*.

3.3 – *Willow Landscape*. Vienna, Akademie der bildenden Künste, inv. no. 2518. Black ink on yellowed paper, 14.1 × 19.7 cm. Signed AA by a later hand. w.29. *Illus. 165*.

3.4 – *Coastal Landscape*. Vienna, Albertina, inv. no. 17546, D.221. Grey-black ink on paper, 20.6 × 31.2 cm. w.146 (as Erhard Altdorfer). *Illus. 188*.

3.5 – *View of Schloss Wörth*. Dresden, Kupferstichkabinett, inv. no. c 1884–2 (c 2142); lost since 1945. Brown ink and watercolour on paper, 21.2 × 30.5 cm. Dated 1524. w.69. *Illus. 187.*

4 ETCHINGS (dimensions after Winzinger)

4.1 – *Small Fir*. B.66. Etching, 15.5 × 11.5 cm. Signed AA. w.181. *Illus. 171.*

4.2 – *Large Fir*. B.67. Etching, 22.5 × 17.0 cm. Signed AA. w.182. *Illus. 173.*

4.3 – *Landscape with Large Castle*. B.68. Etching, 10.8 × 14.9 cm. Signed AA. w.175. *Illus. 174.*

4.4 – *Landscape with Cliff*. B.69. Etching, 11.5 × 15.5 cm. Signed AA. w.176. *Illus. 178.*

4.5 – *Landscape with Double Fir*. B.70. Etching, 11.0 × 16.0 cm. Signed AA. w.179. *Illus. 177.*

4.6 – *City on a Coast*. B.72. Etching, 11.5 × 15.5 cm. Signed AA. w.180. *Illus. 172.*

4.7 – *Landscape with Fir and Willows*. B.73. Etching, 11.5 × 15.5 cm. Signed AA. w.177. *Illus. 175.*

4.8 – *Landscape with Two Firs*. B.74. Etching, 11.0 × 15.5 cm. Signed AA. w.178. *Illus. 176.*

4.9 – *Landscape with Watermill*. Pass.109. Etching, 17.4 × 23.0 cm. Signed AA. w.183. *Illus. 179.*

List of Illustrations

All dimensions are given in centimetres.

1 – Albrecht Altdorfer, *Landscape with Woodcutter*, *c.*1522, pen, watercolour and gouache on paper, 20.1 x 13.6. Kupferstichkabinett, Berlin. Photo: Bildarchiv Preussischer Kulturbesitz/Jörg P. Anders.

2 – Hercules Segers, *Mossy Tree*, *c.*1620–30, etching on coloured paper, 16.9 x 9.8. Rijksprentenkabinet, Amsterdam.

3 – Albrecht Dürer, *Fir*, *c.*1495, watercolour and gouache on paper, 29.5 x 19.6. British Museum, London.

4 – Leonardo da Vinci, *Tree Study*, *c.*1498, red chalk on paper, 19.1 x 15.3. Royal Library, Windsor Castle.

5 – Fragment of the tomb of Albrecht Altdorfer, 1538, marble. Stadtmuseum, Regensburg.

6 – Hans Mielich, *Presentation of the 'Freiheitsbuch' before the Assembly of the Inner Council*, 1536, miniature, from the *Freiheitsbuch*, 41 x 27.5. Stadtmuseum, Regensburg.

7 – Philipp Kilian, *Portrait of Albrecht Altdorfer*, engraving after a drawing by Joachim von Sandrart, in Sandrart's *Teutsche Academie* (Nuremberg, 1675). Houghton Library, Harvard University, Cambridge, Mass.

8 – Albrecht Altdorfer, *The Battle of Alexander and Darius at Issus in 334 BC*, 1529, oil on panel, 158 x 120. Alte Pinakothek, Munich. Photo: Artothek.

9, 10 – Details from illus. 8.

11 – Albrecht Altdorfer, *Crucifixion with Virgin and St John*, *c.*1515, oil on panel, 102 x 116.5. Gemäldegalerie, Kassel. Photo: Artothek.

12 – Albrecht Altdorfer, *The Two St Johns*, *c.*1515, oil on panel, 173.2 x 233.6. Stadtmuseum, Regensburg.

13 – Albrecht Altdorfer, *Christ Taking Leave of His Mother*, 1520(?), oil on panel, 141 x 111. National Gallery, London.

14 – Albrecht Altdorfer, *Castle Landscape*, *c.*1515, pen and pale red ink on parchment, from *The Prayer Book of the Emperor Maximilian*, size of printed page 27.7 x 19.3. Bibliothéque Municipale, Besançon. Photo: Yves Petit.

15 – Albrecht Dürer, *Shepherds Making Music*, miniature on parchment, pasted on printed page in an edition of Theocritus, Venice, *c.*1495–6, size of printed page 31.1 x 20.2. Ian Woodner Family Collection, New York. Photo: Jim Strong.

16 – Bohemian master(?), *July*, *c.*1400, fresco, Torre Aquila, Castello del Buonconsiglio, Trent. Photo: Alinari/Art Resource, New York.

17 – English master, *On Water and its Ornaments*, woodcut, 15 x 15, from Bartholomeus Anglicus, *Die proprietatibus rerum*, London, 1495. Houghton Library, Harvard University, Cambridge, Mass.

18 – German master, *Castle Langenargen*, woodcut, 18.8 x 11.9, from Thomas Lirer, *Chronik von allen Königen und Kaisern*, Ulm, 1486. Beinecke Rare Book Library, Yale University, New Haven.

19 – German master, *Mounts Horeb and Sinai*, before 1508–9, miniature from a manuscript copy of Felix Fabri's *Evagatorium*, vol. 2, owned by Hartmann Schedel, 10.9 x 7.8. Bayerische Staatsbibliothek, Munich.

20 – Flemish master, *Flemish Countryside*, *c.*1470, 16 x 22, miniature from Cotton MS Aug. A. V. British Library, London.

21 – German master (Regensburg school), *Landscape with Larks*, *c.*1430, miniature from manuscript of Hugo von Trimberg, *Die Renner*, size of page 40.8 x 28. University Library, Heidelberg.

22 – Lorenzo Lotto(?), Predella from *Assumption* altarpiece, 1506(?), oil on panel, 25 x 146. Cathedral, Asolo. Photo: Alinari/Art Resource, New York.

23 – Albrecht Dürer, *Madonna and Child Above a Rocky Landscape*, *c.*1515, woodcut, diameter 9.5, height 14.9. Museum of Fine Arts, Boston.

24 – Gerard David, exterior wings of *Nativity* altarpiece, 1510s, oil on panel, 90 x 30.5. Rijksmuseum, Amsterdam, on loan to the Mauritshuis, The Hague. Photo: Rijksmuseum, Amsterdam.

25 – Hans Memling, *Madonna and Child with Two Angels*, *c.*1480s(?), oil on panel, 57 x 42. Uffizi, Florence. Photo: Alinari/Art Resource, New York.

26 – Italian master, *Casting of Bells*, *c.*1472–83, miniature, from the *zibaldone* of Buonaccorsi Ghiberti. Biblioteca Nazionale, Florence.

27 – Geertgen tot Sint Jans, *St John the Baptist in the Wilderness*, *c.*1475, oil on panel, 42 x 28. Gemäldegalerie, Berlin. Photo: Bildarchiv Preussischer Kulturbesitz/Jörg P. Anders.

28 – Joachim Patenir, *Rest on the Flight into Egypt*, *c.*1520, oil on panel, 121 x 177. Museo del Prado, Madrid.

29 – Antonio Pisanello, Portrait medal of Don Iñigo d'Avalos, verso with 'world map', *c.*1448–9, bronze, diameter 7.7. British Museum, London.

30 – Dutch master, *Tomb of Darius*, miniature from a

manuscript *Historie des Bijbels*, Utrecht, 1431. Bibliothèque Royale, Brussels.

31 – Workshop of Albrecht Dürer, *Elsula Alpina*, woodcut, from Conrad Celtis's *Quatuor Libri Amorum* Nuremberg, 1502. Houghton Library, Harvard University, Cambridge, Mass.

32 – Lorenzo Lotto, *A Maiden's Dream*, c.1505, oil on panel, 43 x 34. Samuel H. Kress Collection, National Gallery of Art, Washington DC.

33 – Giorgione, *The Tempest*, c.1507, oil on canvas, 68 x 59. Galleria dell'Accademia, Venice. Photo: Alinari/Art Resource, New York.

34 – Flemish master (the Hortulus Master, or Simon Bening?) *St Christopher*, c.1524, miniature, from *Hortulus animae*. Österreichische Nationalbibliothek, Vienna. Photo: Lichtbildwerkstätte Alpenland.

35 – Albrecht Dürer, *Quarry*, c.1510, pen on paper, 6.1 x 4. British Museum, London.

36 – Workshop of Michael Wolgemut, *View of Regensburg*, woodcut, from the *Liber chronicarum*, 1493, 19.2 x 53.5. Beinecke Rare Book Library, Yale University, New Haven.

37 – Lucas Cranach, *Portrait of Anna Putsch*, c.1502, oil on panel, 59 x 45. Collection Oskar Reinhart, Winterthur, Switzerland.

38 – Lucas Cranach, *Rest on the Flight into Egypt*, 1504, oil on panel, 70.7 x 53. Gemäldegalerie, Berlin. Photo: Bildarchiv Preussischer Kulturbesitz/Jörg P. Anders.

39 – Lucas Cranach, *St John the Baptist in the Wilderness*, c.1503, pen with white heightening on brown grounded paper, 23.5 x 17.7. Musée des Beaux-Arts, Lille.

40 – Albrecht Altdorfer, *Couple*, 1504, pen on paper, 28.3 x 20.5. Kupferstichkabinett, Berlin. Photo: Bildarchiv Preussischer Kulturbesitz/Jörg P. Anders.

41 – Albrecht Altdorfer, *Two Lansquenets and a Couple*, 1506, pen and white heightening on red-brown grounded paper, 17.6 x 13.7. Statens Museum for Kunst, Copenhagen.

42 – Albrecht Altdorfer, *Dead Pyramus*, c.1510, pen and white heightening on blue grounded paper, 21.3 x 15.6. Kupferstichkabinett, Berlin. Photo: Bildarchiv Preussischer Kulturbesitz/Jörg P. Anders.

43 – Detail from *Dead Pyramus*.

44 – Albrecht Altdorfer, *Dead Man*, c.1515, pen and white heightening on olive-brown and orange grounded paper, 17.8 x 14.2. Städelsches Kunstinstitut, Frankfurt. Photo: Ursula Edelmann.

45 – Albrecht Altdorfer, *Satyr Family*, 1507, oil on panel, 23 x 20.5. Gemäldegalerie, Berlin. Photo: Bildarchiv Preussischer Kulturbesitz/Jörg P. Anders.

46 – Albrecht Altdorfer, *Wild Family*, c.1510, pen and white heightening on grey-brown grounded paper, 19.3 x 14. Graphische Sammlung Albertina, Vienna. Photo: Lichtbildwerkstätte Alpenland.

47 – After Albrecht Altdorfer, *Madonna and Child in a Forest*, c.1510(?), pen and white heightening on light-brown grounded paper, 17 x 14.7. Herzog Anton Ulrich-Museum, Braunschweig. Photo: B.P. Keiser.

48 – Albrecht Altdorfer, *St Francis*, 1507, oil on panel, 23.5 x 20.5. Gemäldegalerie, Berlin. Photo: Bildarchiv Preussischer Kulturbesitz/Jörg P. Anders.

49 – Albrecht Altdorfer, *St Jerome*, 1507, oil on panel, 23.5 x 20.4. Gemäldegalerie, Berlin. Photo: Bildarchiv Preussischer Kulturbesitz/Jörg P. Anders.

50 – Albrecht Altdorfer, *Arrest of Christ*, from the St Sebastian altarpiece, c.1515, oil on panel, 129.5 x 97. Augustiner-Chorherrenstift, St Florian, Austria. Photo: Foto Marburg/Art Resource, New York.

51 – Albrecht Altdorfer, *Trial of St Sebastian*, from the St Sebastian altarpiece, c.1515, oil on panel, 128 x 93.7. Augustiner-Chorherrenstift, St Florian, Austria. Photo: Foto Marburg/Art Resource, New York.

52 – Albrecht Altdorfer, *Birth of the Virgin*, c.1520, oil on panel, 140.7 x 130. Alte Pinakothek, Munich. Photo: Foto Marburg/Art Resource, New York.

53 – Albrecht Altdorfer, *Marcus Curtius*, 1512, pen and white heightening on olive-green grounded paper, 19.5 x 14.4. Herzog Anton Ulrich-Museum, Braunschweig. Photo: B. P. Keiser.

54 – Albrecht Altdorfer, *Rest on the Flight into Egypt*, 1510, oil on panel, 57 x 38. Gemäldegalerie, Berlin. Photo: Bildarchiv Preussischer Kulturbesitz/Jörg P. Anders.

55 – Albrecht Altdorfer, *Susanna and the Elders*, 1526, oil on panel, 74.8 x 61.2. Alte Pinakothek, Munich. Photo: Artothek.

56 – Albrecht Altdorfer, *A Church on a City Street*, 1520, pen and white heightening on dark brick-red grounded paper, 17 x 14.7. Teylers Museum, Haarlem.

57 – Albrecht Dürer, *St Francis*, c.1500-05, woodcut, 21.8 x 14.5. British Museum, London.

58 – Lorenzo Lotto, *St Jerome in the Wilderness*, 1506, oil on panel, 48 x 40. Musée du Louvre, Paris. Photo: Service Photographique de la Réunion des Musées Nationaux.

59 – French master, *Emblems of the Virgin*, 1505, woodcut, from a Book of Hours published in Paris, 10 x 7.2. Houghton Library, Harvard University, Cambridge, Mass.

60 – Giovanni Bellini, *Madonna of the Meadow*, c.1505, oil on canvas (transferred from panel), 67.3 x 86.4. National Gallery, London.

61 – Sienese master, *Landscape Fragment*, 15th century, tempera on panel, 22 x 33. Pinacoteca, Siena. Photo: Alinari/Art Resource, New York.

62 – German masters, Annunciation altar with landscape painted on inside wall of shrine, c.1480s (sculpture), c.1500-10 (painting). Unterstadtkapelle, Meersburg am Bodensee. Photo: Art Resource, New York/Foto Marburg.

63 – Nicoletto da Modena, *Marcus Aurelius*, c.1507, engraving, 21.2 x 14.4. Graphische Sammlung Albertina, Vienna.

64 – Jean Pelérin-Viator, *La Sainte Baume*, from his *De artificiali perspectiva*, published in Paris in 1509 (2nd edition), woodcut. Houghton Library, Harvard University, Cambridge, Mass.

65 – Giovanni Bellini, *Coronation of the Virgin*, early 1470s, oil on panel, central panel 106 x 84. Museo Civico, Pesaro. Photo: Alinari/Art Resource, New York.

66 – Stephan von Urach, *Landscape Study*, from his Modelbook, late 15th century, pen and watercolour. Bayerische Staatsbibliothek, Munich.

67 – German master, *Cliff Landscape with River*, late 15th century, watercolour and gouache on paper. 20.1 X 10.6. University Library, Erlangen.

68 – Albrecht Dürer, *Cliff Landscape with Wanderer*, *c*.1490, pen on paper, 22.5 X 31.6. Graphische Sammlung Albertina, Vienna.

69 – Nuremberg master, *Cliff Landscape with Wanderer*, *c*.1490, pen on paper, 21.1 X 31.2. University Library, Erlangen.

70 – Albrecht Dürer, *Quarry*, *c*.1495, watercolour on paper, later dated 1510, 21.4 X 16.8. Kupferstichkabinett, Berlin. Photo: Bildarchiv Preussischer Kulturbesitz/Jörg P. Anders.

71 – Urs Graf, *Cliff*, 1514, pen with watercolour and gouache on paper, 21.2 X 15.8. Kupferstichkabinett, Basel.

72 – Albrecht Altdorfer, *Cliff with Castle*, 1509, pen with watercolour and gouache on paper, 17.9 X 14.1. Biblioteca Ambrosiana, Milan.

73 – Follower of Albrecht Altdorfer(?), *Group of Trees*, *c*.1510–20, pen on paper, 20 X 14. Graphische Sammlung Albertina, Vienna.

74 – Albrecht Dürer, *A Pond in the Woods*, *c*.1495, watercolour and gouache on paper, 26.2 X 37.4. British Museum, London.

75 – Fra Bartolommeo, *Landscape with Five Farm Buildings*, pen on paper, 11.8 X 22.1. Graphische Sammlung Albertina, Vienna.

76 – German master, *Foliage Study*, 1519, brush and pen with opaque white and grey on brown grounded paper, 11 X 15.4. Kupferstichkabinett, Berlin. Photo: Bildarchiv Preussischer Kulturbesitz/Jörg P. Anders.

77 – German master, *Landscape with Village*, 1517, brush with opaque white and grey on red-brown grounded paper, 17.3 X 11.3. Museum of Fine Arts, Budapest.

78 – Hans Leu the younger, *Tree*, early 1510s, pen and brush with opaque white on red-brown grounded paper, 21.1 X 13.2. Staatliche Galerie, Dessau.

79 – Follower of Albrecht Altdorfer, *Landscape with Tree*, *c*.1525–30, pen on red-tinted paper, 28.1 X 19.4. Kupferstichkabinett, Staatliche Kunstsammlungen, Dresden.

80 – Follower of Albrecht Altdorfer, *Mountain Landscape*, *c*.1525–30, pen on red-tinted paper, 12 X 14.5. Musée du Louvre, Paris. Photo: Service Photographique de la Réunion des Musées Nationaux.

81 – Follower of Albrecht Altdorfer, *Landscape with Tree*, *c*.1525–30, pen with white heightening on grey-green grounded paper, 30.6 X 19.5. Statens Museum for Kunst, Copenhagen.

82 – Nuremberg master, *Cliff Study*, after *c*.1496, pen on red-tinted paper, 29.5 X 20.1. University Library, Erlangen.

83 – Albrecht Dürer, *St Jerome*, *c*.1496, engraving, 32.4 X 22.8. Mr & Mrs Isaac D. Fletcher Fund, Metropolitan Museum of Art, New York.

84 – Albrecht Dürer, *Quarry*, *c*.1495–6, watercolour on paper, 29.2 X 22.4. Formerly Kunsthalle, Bremen (missing since 1945).

85 – German master, *Mountain Landscape*, *c*.1510–15, pen on light red-tinted paper, 19.8 X 29.9. University Library, Erlangen.

86 – Albrecht Dürer, *Visitation*, *c*.1504–5, woodcut, 30 X 21.

87 – Follower of Albrecht Altdorfer, *Foliage Study*, after 1507, gouache on paper, 21.4 X 15.3. Museum of Fine Arts, Budapest.

88 – German master, *Mountain with Castle*, early 16th century, watercolour and gouache on paper, 10.9 X 13.4. Musée du Louvre, Paris. Photo: Réunion des Musées Nationaux.

89 – Albrecht Dürer, *St Eustace*, *c*.1510, engraving, 35.3 X 25.9. Fletcher Fund, 1919, Metropolitan Museum of Art, New York.

90 – German master, *Landscape*, *c*.1510s, pen on paper, 26.7 X 19.6. Städelsches Kunstinstitut, Frankfurt.

91 – Lucas Cranach, *St Jerome*, 1509, woodcut, 35.5 X 22.6. British Museum, London.

92 – Erhard Etzlaub, *Imperial Forests around Nuremberg*, 1516, parchment, 60 X 69. Germanisches Nationalmuseum, Nuremberg.

93 – Albrecht Altdorfer, *Forest Robbery*, *c*.1508, pen on paper, 17.7 X 14.6. Kupferstichkabinett, Berlin. Photo: Bildarchiv Preussischer Kulturbesitz/Jörg P. Anders.

94 – Albrecht Altdorfer, *Foliate ornament*, woodcut, 31.1 X 25.8. Herzog Anton Ulrich-Museum, Braunschweig. Photo: B.P. Keiser.

95 – Albrecht Altdorfer, *St George and the Dragon*, 1510, oil on parchment attached to panel, 28.2 X 22.5. Alte Pinakothek, Munich. Photo: Artothek.

96 – Detail from *St George and the Dragon*.

97 – Albrecht Dürer or follower, *Satyrs*, woodcuts, each 53.5 X 32.5. Herzog Anton Ulrich-Museum, Braunschweig. Photo: B.P. Keiser.

98 – Albrecht Dürer, *Satyr Family*, 1505, engraving, 11.5 X 7. National Gallery of Art, Washington DC, Rosenwald Collection.

99 – Albrecht Altdorfer, *Landscape with Footbridge*, 1516(?), oil on parchment attached to panel, 41.2 X 35.1. National Gallery, London.

100 – Albrecht Altdorfer, *Landscape with Castle*, *c*.1522–25, oil on parchment attached to panel, 30.5 X 22.2. Alte Pinakothek, Munich. Photo: Artothek.

101 – Albrecht Altdorfer, *Landscape with Church*, 1522, pen, watercolour and gouache on paper, 20.4 X 13.8. Missing since 1945. Photo: Museum Boymans-van Beuningen, Rotterdam (Koenigs Collection).

102 – Albrecht Altdorfer, *Landscape with Sunset*, *c*.1522, pen, watercolour and gouache on paper, 20.2 X 13.3. University Library, Erlangen.

103 – Detail from *Landscape with Sunset*.

104 – Follower of Albrecht Altdorfer, *Landscape with Tree and Town*, 1525, pen and light watercolour on paper, 27.2 X 19.2. Graphische Sammlung Albertina, Vienna.

105 – Albrecht Altdorfer, *Wild Man*, 1508, pen and white heightening on red grounded paper, 21.6 X 14.9. British Museum, London.

106 – Albrecht Dürer, *Christ Among the Doctors*, 1506, oil on panel, 65 X 80. Thyssen-Bornemisza Collection, Lugano-Castagnola.

107 – German master, *St Dorothy*, *c*.1400, woodcut,

27.1 X 19.7. Staatliche Graphische Sammlung, Munich.

108 – Agostino Veneziano, *Animals in Forest*, 1510s, engraving, 14.5 X 20. Graphische Sammlung Albertina, Vienna.

109 – German tapestry, *Scenes from the Life of the Wild Men*, c.1400, height 82. Stadtmuseum, Regensburg. Photo: Art Resource, New York/Foto Marburg.

110 – Albrecht Altdorfer, *Madonna with Blessing Christ Child*, c.1515, engraving, 16.4 X 11.7. National Gallery of Art, Washington DC, Rosenwald Collection.

111 – Hans Baldung, *Allegory of Vanity*, c.1509–10, oil on panel, 48.0 X 32.5. Kunsthistorisches Museum, Vienna.

112 – Master N.H., *Battle of the Naked Men and the Peasants*, 1522, woodcut, 14.8 X 24. Kupferstichkabinett, Öffentliche Kunstsammlung Basel.

113 – Hans Schäufelein, *Klag der wilden Holzleüt*, c.1530, woodcut, 26.2 X 39.5. British Museum, London.

114 – Wolf Huber, *Willow Landscape*, c.1515, pen in two different inks on paper, 20.6 X 15.6. Kupferstichkabinett, Berlin. Photo: Bildarchiv Preussischer Kulturbesitz/Jörg P. Anders.

115 – Wolf Huber, *Mill with Footbridge*, c.1515, pen on paper, 14.9 X 15. Museum of Fine Arts, Budapest.

116 – Bavarian Master of the Munich John on Patmos, *St John on Patmos*, c.1515, oil on panel, 27.3 X 17.4. Bayerisches Nationalmuseum, Munich. Photo: Foto Marburg/Art Resource, New York.

117 – Hans Baldung, *Holy Family*, c.1511–14, oil on panel, 48.5 X 38.5. Germanisches Nationalmuseum, Nuremberg.

118 – Hans Leinberger, *Madonna and Child*, c.1520, limewood with modern paint layer, height 90. St Kassian, Regensburg. Photo: Foto Marburg/Art Resource, New York.

119 – German master, *Madonna and Child*, mid-14th century, stone, height 170, from the choir in Niedermünster, Regensburg. Photo: Foto Marburg/Art Resource, New York.

120 – German master(?), *Madonna and Child*, 13th century, tempera on panel. Alte Kapelle, Regensburg. Photo: Foto Marburg/Art Resource, New York.

121 – Albrecht Altdorfer, *Schöne Maria of Regensburg*, c.1519–20, woodcut with five tone-blocks, 34 X 24.5. National Gallery of Art, Washington, DC, Rosenwald Collection.

122 – Bavarian master, *Crucifixion with Virgin and St John*, c.1400, oil on panel, 177.5 X 136.5. Bayerisches Nationalmuseum, Munich.

123 – Wolf Huber, *Landscape with Church*, c.1518–20, pen on paper, 21.2 X 15.5. Kupferstichkabinett, Staatliche Kunstsammlungen Dresden.

124, 125 – Details from *Landscape with Woodcutter* (illus. 1).

126 – Jörg Breu the elder, *St Bernard in a Cornfield*, 1500, oil on panel, 70 X 73. Cistercian Abbey, Zwettl, Austria.

127 – Urs Graf, *Banner Carrier and Bildstock*, 1516, pen on paper, 31.6 X 21.7. Kupferstichkabinett, Öffentliche Kunstsammlung Basel.

128 – Hieronymus Bosch, *Vagabond*, outside wings of the *Haywain Triptych*, c.1490–95, oil on panel, 135 X 100. Museo del Prado, Madrid.

129 – Master I.S., *Crucifixion*, 1511, pen and grey wash on paper, 21.9 X 15.5. Kupferstichkabinett, Berlin. Photo: Bildarchiv Preussischer Kulturbesitz/Jörg P. Anders.

130 – German master, *Crucifixion*, first half of 14th century, from tympanum of the south portal of the Cathedral, Regensburg. Photo: Foto Marburg/Art Resource, New York.

131 – Follower of Lucas Cranach, *Man of Sorrows Beneath a Tree*, c.1525–30, miniature in a Lutheran Prayer Book of Johann of Saxony, 19.5 X 15.5. Fürstlich Fürstenbergische Hofbibliothek, Donaueschingen. Photo: Georg Goerlipp.

132 – Erhard Altdorfer, Title-page woodcut from Low German Bible, published in Lübeck in 1533, size of page c. 31 X 23. Houghton Library, Harvard University, Cambridge, Mass.

133 – Michael Ostendorfer, *Pilgrimage to the Schöne Maria in Regensburg*, c.1520, woodcut, 55 X 38. Kupferstichkabinett, Berlin. Photo: Bildarchiv Preussischer Kulturbesitz/Jörg P. Anders.

134 – Follower of Albrecht Altdorfer, *Landscape with Mill*, 1520s, pen with grey wash and white heightening on red-brown grounded paper, 20.7 X 15.2. Kupferstichkabinett, Berlin. Photo: Bildarchiv Preussischer Kulturbesitz/Jörg P. Anders.

135 – Albrecht Altdorfer, *Crucifixion*, 1526(?), oil on panel, 40.5 X 33.1. Germanisches Nationalmuseum, Nuremberg. Photo: Artothek.

136 – Albrecht Altdorfer, 'End of the Procession' from *Triumphal Procession*, c.1516–18, two woodcuts, each 39 X 39. Graphische Sammlung Albertina, Vienna.

137 – Albrecht Altdorfer, 'The Great Venetian War' from *Triumphal Procession*, c.1512–14, pen, watercolour and gouache on parchment, size of page 45.3 X 90.6. Graphische Sammlung Albertina, Vienna. Photo: Lichtbildwerkstätte Alpenland.

138 – Narziss Renner, *John the Baptist Preaching*, 1523, 22 X 16.2, miniature from a Prayer Book. Österreichische Nationalbibliothek, Vienna. Photo: Lichtbildwerkstätte Alpenland.

139 – Wolf Huber, *Alpine Landscape*, 1522 (later altered to 1532), pen with watercolour and gouache on paper, 21.1 X 30.6. Kupferstichkabinett, Berlin. Photo: Bildarchiv Preussischer Kulturbesitz/Jörg P. Anders.

140 – Wolf Huber, *Landscape with Golgotha*, c.1525–30, pen with watercolour and gouache on paper, 32.7 X 44.8. University Library, Erlangen.

141 – Leonardo da Vinci, *Arno Valley Landscape*, 1473, pen on paper, 19 X 28.5. Uffizi, Florence.

142 – German master, *A Farm in a Wood*, c.1500, pen with watercolour and gouache with white heightening on parchment; four sheets pasted on paper, 45.7 X 55.6. Ian Woodner Family Collection, New York. Photo: Eric Pollitzer.

143 – Jörg Kölderer, *Peitenstein*, c.1508, watercolour over black chalk, from manuscript *Fortifications in South Tyrol and Friuli*, size of page approx. 30 X 40. Österreichische Nationalbibliothek, Vienna. Photo: Lichtbildwerkstätte Alpenland.

144 – Jörg Kölderer, *Achensee*, miniature from manuscript *Fischereibuch*, 1504, 32 X 22. Österreichische Nationalbibliothek, Vienna. Photo: Lichtbildwerkstätte Alpenland.

145 – Michael Wolgemut, *Presentation of Christ in the Temple*, c.1480–90, oil on panel, 222 X 147. St Jakob, Straubing (Lower Bavaria). Photo: Foto Marburg/Art Resource, New York.

146 – Lucas Cranach, *Martyrdom of St Erasmus*, 1506, woodcut, 22.4 X 15.8. Private collection.

147 – German master, *View of Nuremberg Castle*, early 16th century, watercolour on paper, 14.8 X 21.2. Germanisches Nationalmuseum, Nuremberg.

148 – Bamberg master, *View of Imperial and Episcopal Palace in Bamberg*, before 1487, pen and watercolour on paper, 19 X 47.2. Kupferstichkabinett, Berlin. Photo: Bildarchiv Preussischer Kulturbesitz/Jörg P. Anders.

149 – German master, *View of a Walled City in a Coastal Landscape*, late 15th century, pen with watercolour and gouache, 7.3 X 13.5. J. Paul Getty Museum, Malibu.

150 – Konrad Witz, *Miraculous Draught of Fishes*, 1444, oil on panel, 132 X 155. Musée d'Art et d'Histoire, Geneva.

151 – Albrecht Dürer, *Lime Tree*, c.1493–4, watercolour and gouache on parchment, 34.3 X 26.7. Museum Boymans–van Beuningen, Rotterdam.

152 – Albrecht Dürer, *Wire-drawing Mill*, c.1494, watercolour and gouache on paper, 29 X 42.6. Kupferstichkabinett, Berlin. Photo: Jörg P. Anders.

153 – Northern Italian master, *Cliff*, late 1490s, watercolour, 20.2 X 27.3. Uffizi, Florence.

154 – Albrecht Dürer, *View of Reuth*, c.1517, silverpoint on parchment, 16 X 28.2. Photo: Museum Boymans[-]van Beuningen; missing since 1945.

155 – German master, *River Bank*, 1522, pen on paper, 9 X 14.1. Germanisches Nationalmuseum, Nuremberg.

156 – Wolf Huber, *Bridge at the City Wall*, 1505, pen on red-tinted paper, 19.9 X 26.5. Kupferstichkabinett, Berlin. Photo: Bildarchiv Preussischer Kulturbesitz/Jörg P. Anders.

157 – Wolf Huber, *View of Urfahr*, c.1510, pen on paper, 13.3 X 14.8. Museum of Fine Arts, Budapest.

158 – Wolf Huber, *View of the Mondsee*, 1510, pen on paper, 12.7 X 20.6. Germanisches Nationalmuseum, Nuremberg.

159 – Albrecht Altdorfer, *Venus and Cupid*, 1508, pen on paper, 9.7 X 6.6. Kupferstichkabinett, Berlin. Photo: Bildarchiv Preussischer Kulturbesitz/Jörg P. Anders.

160 – Wolf Huber, *Willow Landscape*, 1514, pen on paper, 15.3 X 20.8. Museum of Fine Arts, Budapest.

161 – Wolf Huber, *Castle Landscape*, 1510s, pen on paper, 19.1 X 13. Kupferstichkabinett, Berlin. Photo: Jörg P. Anders.

162 – Hans Leu the younger, *Landscape with Cliff*, 1513, pen on paper, 22 X 15.8. Kunsthaus, Zürich.

163 – Niklaus Manuel Deutsch, *Mountainous Island*, pen on paper, 26 X 19.8. Kupferstichkabinett, Berlin. Photo: Bildarchiv Preussischer Kulturbesitz/Jörg P. Anders.

164 – Albrecht Altdorfer, *View of Sarmingstein*, 1511,

pen on paper, 14.8 X 20.8. Museum of Fine Arts, Budapest.

165 – Albrecht Altdorfer, *Willow Landscape*, c.1511, pen on paper, 14.1 X 19.7. Akademie der Bildenden Künste, Vienna.

166 – Albrecht Altdorfer, *St Christopher*, c.1510, pen and white heightening on green grounded paper, 17.9 X 14.4. Graphische Sammlung Albertina, Vienna.

167 – Albrecht Altdorfer, *Saint*, c.1517–18, pen on paper, 11.1 X 9.8. University Library, Erlangen.

168 – Albrecht Dürer, *St Anthony*, 1519, engraving, 9.6 X 14.3. Mr and Mrs Isaac D. Fletcher Fund, 1917, Metropolitan Museum of Art, New York.

169 – Wolf Huber, *Portrait of a Man*, 1517, pen on paper, 14.4 X 11. Guildhall Library, Corporation of London. Willshire Collection. Photo: Godfrey New Photographics.

170 – Hans Wertinger, *Portrait of Johann III von der Pfalz*, 1520s, oil on panel, 70 X 47.5. Bayerische Staatsgemäldesammlung, Munich.

171 – Albrecht Altdorfer, *Small Fir*, c.1521–2, etching with watercolour, 15.5 X 11.5. Graphische Sammlung Albertina, Vienna. Photo: Lichtbildwerkstätte Alpenland.

172 – Albrecht Altdorfer, *City on a Coast*, c.1521–2, etching with watercolour, 11.5 X 15.5. Graphische Sammlung Albertina, Vienna. Photo: Lichtbildwerkstätte Alpenland.

173 – Albrecht Altdorfer, *Large Fir*, c.1521–2, etching with watercolour, 22.5 X 17. Graphische Sammlung Albertina, Vienna. Photo: Lichtbildwerkstätte Alpenland.

174 – Albrecht Altdorfer, *Landscape with Large Castle*, c.1521–2, etching, 10.8 X 14.9. Kupferstichkabinett, Berlin. Photo: Bildarchiv Preussischer Kulturbesitz/Jörg P. Anders.

175 – Albrecht Altdorfer, *Landscape with Fir and Willows*, c.1521–2, etching, 11.5 X 15.5. City Museum and Art Gallery, Plymouth, Cottonian Collection. Photo: Robert Chapman.

176 – Albrecht Altdorfer, *Landscape with Two Firs*, c.1521–2, etching, 11 X 15.5. Kupferstichkabinett, Berlin. Photo: Bildarchiv Preussischer Kulturbesitz/Jörg P. Anders.

177 – Albrecht Altdorfer, *Landscape with Double Fir*, c.1521–2, etching, 11 X 16. Kupferstichkabinett, Berlin. Photo: Bildarchiv Preussischer Kulturbesitz/Jörg P. Anders.

178 – Albrecht Altdorfer, *Landscape with Cliff*, c.1521–2, etching, 11.5 X 15.5. Kupferstichkabinett, Berlin. Bildarchiv Preussischer Kulturbesitz/Jörg P. Anders.

179 – Albrecht Altdorfer, *Landscape with Watermill*, c.1521–2, etching, 17.6 X 23.6. Ailsa Mellon Bruce Fund, National Gallery of Art, Washington D C.

180 – Erhard Altdorfer, *Landscape with Fir*, c.1521–2, etching, 11.7 X 16.2. National Gallery of Art, Washington D C, Pepita Milmore Memorial Fund.

181 – Titian, *Two Goats at the Foot of a Tree*, c.1530–5, chiaroscuro woodcut, 49.3 X 21.7. British Museum, London.

182 – Domenico Campagnola, *Landscape with Travellers*, late 1530s, woodcut, 33 X 44.4. Harris

Brisbane Dick Fund and Rogers Fund, by exchange, 1967, Metropolitan Museum of Art, New York.

183 – Albrecht Altdorfer, *St Christopher*, 1513, woodcut, 16.5 x 11.6. National Gallery of Art, Washington DC, Rosenwald Collection.

184 – Albrecht Dürer, *Landscape with Cannon*, 1518, etching, 21.7 x 32.2. National Gallery of Art, Washington DC, Rosenwald Collection, Gift of W. G. Russell Allen.

185 – Albrecht Altdorfer, *Regensburg Synagogue*, 1519, etching, 16.4 x 11.7. Kupferstichkabinett, Berlin. Photo: Bildarchiv Preussischer Kulturbesitz/Jörg P. Anders.

186 – Albrecht Altdorfer, *Regensburg Synagogue*, 1519, etching, 17 x 12.5. Kupferstichkabinett, Berlin. Photo: Bildarchiv Preussischer Kulturbesitz/Jörg P. Anders.

187 – Albrecht Altdorfer, *View of Schloss Wörth*, 1524, pen and watercolour on paper, 21.2 x 30.5. Missing since 1945. Photo: Sächsische Landesbibliothek, Dresden: Abteilung Deutsche Fotothek.

188 – Albrecht Altdorfer, *Coastal Landscape*, *c.*1521–2, pen on paper, 20.6 x 31.2. Graphische Sammlung Albertina, Vienna. Photo: Lichtbildwerkstätte Alpenland.

189 – Wolf Huber, *Landscape with Footbridge*, *c.*1521–2, pen with watercolour on paper, 13.7 x 21.2. Kupferstichkabinett, Berlin. Photo: Bildarchiv Preussischer Kulturbesitz/Jörg P. Anders.

190 – Albrecht Altdorfer, *Landscape*, *c.*1522, pen on paper, 20.2 x 13.3, verso of illus. 102. University Library, Erlangen.

191 – Narziss Renner, *Visitation*, 1523, miniature from a Prayer Book, 22 x 16.2. Österreichische Nationalbibliothek, Vienna. Photo: Lichtbildwerkstätte Alpenland.

192 – Albrecht Altdorfer, *Allegory*, 1531, oil on panel, 28.9 x 41. Gemäldegalerie, Berlin. Photo: Bildarchiv Preussischer Kulturbesitz/Jörg P. Anders.

193 – Albrecht Altdorfer, *Lot and His Daughters*, 1537, oil on panel, 107.5 x 189, Kunsthistorisches Museum, Vienna.

194 – Northern Italian master, *Nude in Landscape*, *c.*1500–10, oil on panel. Whereabouts unknown.

195 – Niklas Stoer, *Landscape*, *c.*1530s, woodcut, 28.2 x 40.4, Germanisches Nationalmuseum, Nuremberg.

196 – Jakob Binck, *Landscape with Castle*, *c.*1530, etching, 11 x 8.1. British Museum, London.

197 – Augustin Hirschvogel, *Landscape with the Conversion of St Paul*, 1545, etching, 9.8 x 26.2. British Museum, London.

198 – Hanns Lautensack, *Landscape with Natural Arch*, 1554, etching, 16.6 x 11.8. National Gallery of Art, Washington DC, Rosenwald Collection.

199 – Antonio Fantuzzi, *Decorated Cartouche with Landscape*, *c.*1543, etching, 24.4 x 49.7. British Museum, London.

200 – Wolf Huber, *Golgotha*, 1512, pen on paper, 10.9 x 15.7. Museum of Fine Arts, Budapest.

201 – Hans Wertinger, *June, or Harvest*, *c.*1520s, oil on panel, 32.5 x 39.8. Germanisches Nationalmuseum, Nuremberg.

202 – Pieter Breugel the elder, *The Rabbit Hunters*, 1560, etching, 21.3 x 28.4. National Gallery of Art, Washington DC, Ailsa Mellon Bruce Fund.

203 – Paulus van Vianen, *Willows on a Bank*, *c.*1600, pen on paper, 14.7 x 19.7. Kupferstichkabinett, Berlin. Photo: Bildarchiv Preussischer Kulturbesitz/Jörg P. Anders.

Index

Numerals in brackets preceded by 'B.' refer to reference numbers in Bartsch's listing (*see* Bibliography).
Numerals in *italics* are illustration numbers.

Aertsen, Pieter 58
Alberti, Leon Battista 54, 56, 57, 64, 147, 149, 151, 176, 280
Albertus Magnus 67, 244
Aldegrever, Heinrich 70, 243
Altdorfer, Albrecht 26–7, 29, 31, 33, 45, 47, 49, 50, 56, 57, 59, 62, 66, 79, 135, 149, 160, 164–5, 171, 275, 277–82
 Life 17–19, 30, 68–70, 72, 100, 234–5, 241–5, 266–7, 280–1
 School and followers 73, 76–7, 79–81, 87, *104*, 109, 113, 115, 121, *134*, *243*, 165–6, 187, 193, 206, 267
 WORKS
 Paintings
 Adam and Eve, Washington 40
 Allegory, Berlin *192*, 261, 267
 Battle of Alexander and Darius at Issus, Munich *8–10*, 19, 22–3, 201–2, 230, 264, 266–7
 Birth of the Virgin, Munich *52*, 93, 162, 254
 Christ Taking Leave of His Mother, London *13*, 23, 162, 191, 195, 244
 Crucifixion, Budapest 175–6
 Crucifixion, Kassel *11*, 23, 175–6
 Crucifixion, Nuremberg *135*, 198
 Landscape with Castle, Munich *100*, 138, 141, 145, 161, 194, 195, 198–9, 261, 262
 Landscape with Footbridge, London *99*, 138, 141, 145, 161–2, 198, 262
 Lot and His Daughters, Vienna *193*, 267
 Madonna and Child, Munich 39
 Nativity, Bremen 97, 162, 190
 Rest on the Flight into Egypt, Berlin *54*, 100, 245
 St Francis, Berlin *48*, 97–9, 138, 153, 175, 190
 St George and the Dragon, Munich 22, *95–6*, 138, 141, 145, 150–3, 161, 190, 192, 195, 243, 263
 St Jerome, Berlin *49*, 97–9, 138, 153, 190
 St Sebastian altarpiece, St Florian 19, 23, *50–1*, 70, 93, 100, 191, 195, 235
 Satyr Family, Berlin *45*, 97–9, 121, 145–6, 153, 162
 Separation of the Apostles, Berlin 162
 Susanna and the Elders, Munich *55*, 93, 162, 190, 229
 Triumphal Procession, Vienna 69, 100, *137*, 145, 171, 199–201, 208, 267
 Two St Johns, Regensburg *12*, 23, 244
 Drawings and watercolours
 Christ in the Garden at Gethsemane, Berlin 78
 Church on a City Street, Haarlem *56*, 96–7, 254
 Cliff with Castle, Milan *72*, 109, 259

Coastal Landscape, Vienna *188*, 203–4, 255–6, 264
Couple in a Cornfield, Basel 219, 227
Dead Man, Frankfurt *44*, 84
Dead Pyramus, Berlin *42–3*, 80–8, 162, 177, 191, 199
Death of Marcus Curtius, Braunschweig *53*, 93, 97
Forest Robbery, Berlin *93*, 130–1, 194
Historia Friderici et Maximiliani 100, 109, 191, 219–20, 227, 229
Landscape, Erlangen (verso of *Landscape with Sunset*) *190*, 258
Landscape with Church, formerly Koenigs Collection *101*, 138, 177, 180, 193–4, 258, 263
Landscape with Sunset, Erlangen *102–3*, 138, 180, 190, 193–4, 200, 258, 260
Landscape with Woodcutter, Berlin *1*, 9, 12, 22, 138, 180–93, 258, 261, 263, 281
Loving Couple, Berlin 40, 77
Madonna and Child in Forest, Braunschweig *47*, 89, 97, 99
Pax and Minerva, Berlin 77, 100, 190
Prayer Book of Maximilian, Besançon *14*, 37
Saint, Erlangen *167*, 233
St Christopher, Vienna *166*, 227
St Nicholas Calming the Storm, Oxford 78, 88
Samson and Delilah, New York 77, 109, 190, 227
Samson and the Lion, Berlin 78
Two Lansquenets and a Couple, Copenhagen *41*, 77, 80, 88, 199
Venus and Cupid, Berlin 109, *159*, 219, 227
View of Sarmingstein, Budapest, *164*, 203–4, 224–30, 255
View of Schloss Wörth, formerly Dresden *187*, 203, 229, 235, 255, 259–60
Wild Family, Vienna *46*, 98, 145, 153
Wild Man, London 78, *105*, 155, 157, 158–9, 229
Willow Landscape, Vienna *165*, 203, 224–5, 255, 263
Witches' Sabbath, Paris 77, 88, 190
Prints
Foliate Ornament, woodcut *94*, 134
landscape etchings 110, 121, *171–9*, 203, 234, 246, 250–1, 254–66, 270
Madonna with Blessing Christ Child (B. 17) *110*, 153
Regensburg Synagogue, etchings (B. 63–4) *185–6*, 251, 254
St Christopher, woodcut *183*, 249–50
St George, woodcut (B. 55) 225

Schöne Maria of Regensburg, woodcut (B. 51) *121*, 171–2, 259
Triumphal Procession, woodcuts *136*, 199
Altdorfer, Erhard 68–9, 115, *132*, *180*, 196, 195, 203, 217, 229, 234, 254–6, 260, 262
Altdorfer, Ulrich 68–9
Anglicus, Bartholomeus 17, *36*
Annius of Viterbo 170
Antonello da Saliba 39
Aretino, Pietro 168
Aristotle 47, 56
Augsburg 67, 72, 200, 241–2, 246, 250, 267, 275
Aventinus, Johann 22, 149, 159, 170, 244–5

Baldung Grien, Hans 62, 72, 77, 79, *111*, 115, *117*, 153–4, 166, 171, 213, 242, 251
Bamberg 42, 68, *148*, 209, 211, 213, 259, 270
Barbari, Jacopo de' 50, 72, 98, 267
Bartolommeo, Fra 42, 54, *75*, 110, 206
Bebel, Heinrich 157
Beck, Leonhard 72
Behaim, Martin 46
Beham, Sebald 70, 145, 243, 251
Bellini, Giovanni 29, 50, 53, *60*, *65*, 101–4, 143, 146
Bellini, Jacopo 93, 104
Bening, Alexander 35, 141, 143
Bening, Simon *34*, 57, 143, 145
Beresteyn, Claes van 278
Binck, Jacob 70, *196*, 270
Biondo, Flavio 159
Blount, Thomas 57
Bol, Hans 278
Bosch, Hieronymus 45, 128, 183, 185, 194, 275
Botticelli, Sandro 42, 55, 63, 277
Bouts, Dirk 169, 212
Brant, Sebastian 183
Brescia, Giovanni Antonio da 43, 153
Breu, Jörg, the elder 72, *126*, 182, 275
Breydenbach, Bernard von 36, 212
Bruegel, Jan, the elder 12
Bruegel, Pieter, the elder 12, 33, 49, 56, 147, 168, 177, 183, 194–5, *202*, 234, 264–5, 267, 274–7
Brunswick Monogrammist, the 184
Burgkmair, Hans 19, 62, 72, 100, 143, 155, 157, 235, 244, 246, 275
Busche, Hermann von dem 243

Caesar, Julius 128, 170, 180
Campagnola, Domenico 51, *182*, 194, 223, 247, 249, 270
Campagnola, Giulio 43, 51, 147, 249
Campani, Giovanni Antonio 128
Caravaggio, Michelangelo Merisi da 278
Celtis, Conrad 26, *31*, 47, 56, 71, 128–31, 157–9, 169–70, 173, 176, 177–80, 194, 241, 244–5
Cennini, Cennino 217
Charles V, Emperor 100, 179
Christus, Petrus 143
Ciriaco d'Ancona 42
Claude *see* Lorrain
Cock, Hieronymus 168, 234, 270, 274–5
Colonna, Francesco 57
Columbus, Christopher 27
Compar, Valentin 184
Coninxloo, Gillis van 12, 168, 267
Constable, John 23
Cranach, Lucas 19, *37–9*, 62, 72–3, 76–7, 88, *91*, 93, 97, 98–9, 115, 121, 143, *146*, 161–2, 166, 171, 173, 186, 209, 241, 244–5, 246, 251, 255, 259, 281
Cuspinian, Johann 47, 73, 76, 241, 244–5

Daum, Erasmus (*called* Australis) 244
David, Gerard *24*, 40, 145, 166
Dolce, Lodovico 27, 53–4, 64
Dossi, Dosso 55, 59
druids 130, 170, 180
Dürer, Albrecht 19, 22, 29, 40, 42, 62, 67, 69–73, 77, 80, 88, 97, 100, 115, 128, 145, 149, 151–2, 155, 162, 166, 171, 173, 178, 190, 204, 206, 211, 212–13, 229, 234–5, 241–4, 246–51, 261, 264, 267, 278, 279–80
WORKS
 Paintings
 Christ Among the Doctors, Lugano *106*, 146–7
 Self-Portrait, Madrid 103, *194*
 Self-Portrait, Munich 30
 Self-Portrait, Paris 143
 Shepherds Making Music, Woodner Collection *15*, 56
 Trinity (Landauer altarpiece), Vienna 39
 Drawings and watercolours
 Chestnut Tree 17
 Cliff Landscape with Wanderer and a Distant Castle, Vienna 68, 105, 107
 Fir 3, 17
 Holy Family, Berlin 193
 Lime Tree, Rotterdam 143, *151*, 183, 212
 Lute-Playing Angel, Berlin 79
 plant watercolours 102
 Madonna of the Many Animals, Vienna 259
 Pond in the Woods 17, *74*, 107
 Quarry, Berlin *70*, 107, 152
 Quarry, Bremen *84*, 119, 152
 Quarry, London *35*, 63–4, 109–10, 229
 View of Reuth, lost *152*, 213
 Wire-drawing Mill, Berlin *152*, 165, 212–13
 Prints
 Apocalypse, woodcuts 97
 Hercules at the Crossroads, engraving (B. 73) 98, 195
 Holy Family with Three Hares, woodcut (B. 102) 76
 Landscape with Cannon, etching (B. 99) *184*, 251
 Madonna and Child Above a Rocky Landscape, woodcut *23*, 39
 Prodigal Son, engraving 43, 213
 St Anthony, engraving (B. 58) *168*, 230–2
 St Eustace, engraving (B. 57) *89*, 119
 St Francis, woodcut (B. 100) 98–9, 175
 St Jerome, engraving (B. 61) *83*, 119, 177, 217
 Satyr Family, engraving (B. 69) 58, 98, *98*, 135, 153
 Satyrs, woodcuts 97, *134*
 Virgin with the Dragonfly, engraving (B. 44) 71
 Visitation (from the *Life of the Virgin*), woodcut (B. 84) *86*, 119
 Writings 13, 42, 45, 46, 47, 49, 50, 65, 71, 80, 88, 160, 170, 175
Duetecum, Jan and Lukas 274–5

Elsheimer, Adam 278
Emser, Hieronymus 62, 149, 172–3
Erasmus, Desiderius 54, 71, 149–50, 171, 172, 234
Etzlaub, Erhard *92*, 128, 206
Eyck, Jan van 30, 37, 38, 42, 46, 143, 145, 147, 208, 274

Fantuzzi, Antonio *199*, 270, 273
Fazio, Bartolommeo 46
Feliciano, Felice 56
Ferdinand I of Austria, King of Bohemia and Hungary (later Emperor) 18, 270, 281
Ferdinand of Tyrol, Archduke 242, 260, 270

Francia, Francesco 143
Francisco da Hollanda 55, 277
Franco, Giovanni Battista 250
Frederick the Wise, Elector of Saxony 72, 76
Frueauf, Rueland, the elder 67, 68
Fuchsmagen, Johann 245
Furtmeyr, Berthold 68-9

Gassel, Lucas 184
Geertgen tot Sint Jans 27, 45, 193
George of Lichtenstein, Bishop 33
Gheyn, Jacques de 12
Ghiberti, Lorenzo 33, 42, 59
Giorgione 33, 50-3, 56, 64, 100, 168, 247
Giotto 46
Giovio, Paolo 55-6, 59
Glockendon, Albert 143
Goethe, Johann Wolfgang von 203, 221-3, 229-30, 255
Goltzius, Hendrick 12
Gonzaga, Federigo 53
Gossaert, Jan 40
Graf, Urs 63, 71, 77, 109, 115, 127, 183, 199, 224, 250
Grünewald, Matthias 62, 72, 76, 173, 175, 230
Grünpeck, Joseph 100, 219, 244
Guicciardini, Francesco 169

Hegel, Georg Wilhelm Friedrich 101
Heinrich of Mecklenburg, Duke 255
Heller, Jakob 42
Hilliard, Nicholas 64
Hirschvogel, Augustin 197, 234, 259, 270, 277-8
Historia Friderici et Maximiliani 100, 109, 219-20, 227, 229, 244-5
Historia Master see Master of the Historia Friderici et Maximiliani
Hobbema, Meindert 198
Hoefnagel, Georg 278
Hoffmann, Christophorus (called Ostofrancus) 244
Hoffmann, Hans 278
Holbein, Hans, the elder 67, 115
Holbein, Hans, the younger 19, 143, 145, 171, 183
Hoogstraten, Samuel van 64
Hopfer, Daniel 250
Horace 47, 56, 155
Housebook Master see Master of the Housebook
Hrosvitha of Gandersheim 170, 244
Huber, Wolf 12, 33, 62, 77, 78, 109, 113, 115, 115, 123, 139-40, 155-8, 160-1, 160-1, 164, 166, 169, 177, 184, 189, 200, 203, 206, 212, 217-34, 242, 245, 246-7, 250, 259-61, 267, 270, 273-4, 278
Hutten, Ulrich von 170
Hypnerotomachia Poliphili 57

Iñigo d'Avalos, Don 29, 45
Innocent VIII, Pope 35
Irenicus, Franciscus 159

Johann III von der Pfalz, Bishop-Administrator of Regensburg 69, 170, 198, 235, 242, 255
Junius, Franciscus 64

Kant, Immanuel 25, 59-61, 263
Karlstadt, Andreas 187
Katzheimer, Wolfgang, the elder 148, 209, 211, 259
Kölderer, Jörg 67, 143-4, 183, 206, 208
Koninck, Philips de 198
Kulmbach, Hans von 72, 79, 166

Lautensack, Hanns 198, 234, 270, 278
Leinberger, Hans 118, 171, 242
Lemberger, Georg 171
Leonardo da Vinci 4, 13, 17, 35, 47, 54, 55, 63, 141, 204, 206, 217, 277
Leu, Hans, the younger 77, 78, 79, 109, 115, 162, 224
Limbourg brothers 165
Lirer, Thomas 18, 36, 105
Locher, Jacob (called Philomusus) 244
Lomazzo, Gian Paolo 64
Lorenzetti, Ambrogio 165
Lorrain, Claude Gelée, called 22, 273
Lotto, Lorenzo 22, 32, 38-9, 40, 50, 53, 58, 99, 267
Lützelburger, hans 112, 155
Luther, Martin 31, 62, 149, 169-70, 173, 178, 183-4, 186-7, 199, 244, 254, 280

Magnasco, Alessandro 273
Mair von Landshut 63
Mander, Karel van 38, 56, 168-9, 277-8
Mantegna, Andrea 29, 56, 100, 146, 176, 199
Manuel, called Deutsch, Niklaus 77, 109, 115, 163, 199, 224
Marcanova, Giovanni 56
Marcantonio Raimondi 43, 81, 147, 250-1
Mariette, Pierre-Jean 110
Marmion, Simon 57, 101
Marvell, Andrew 151
Massys, Cornelis 270
Massys, Quentin 45
Master E. S. 134
Master H. L. 171
Master I. P. 166, 242
Master I. S. 129, 184
Master N. H. 112, 155
Master P. S. 270
Master of the Historia Friderici et Maximiliani 115
Master of the Housebook 88, 183, 249, 262, 263
Master of Mary of Burgundy 35
Matsys see Massys
Maximilian I, Emperor 37, 67, 69-70, 72, 100, 115, 155, 170, 199, 206, 208, 235, 242, 244-5, 251, 267
Meckenem, Israel van 134, 170
Mela, Pomponius 129, 160, 245
Melanchthon, Philipp 76, 173
Meldemann, Niklas 195, 267
Memling, Hans 25, 40, 42, 143
Merian, Matthaeus 227
Michelangelo 55, 101, 266, 277
Michiel, Marcantonio 45, 53, 247
Mielich, Hans 6, 18, 145
Milton, John 49
Molijn, Pieter 168-9
Mosauer, Johannes 100
Multscher, Hans 66
Münzer, Erasmus 244

Napoleon Bonaparte 22
Negker, Jost de 246
Neudörfer, Johann 47, 206, 213
Nicoletto da Modena 43, 63, 104
Norgate, Edward 180
Nuremberg 42, 46, 47, 67, 72, 73, 115, 128, 131, 147, 157, 159, 166, 209, 211-13, 224, 241-2, 244-5, 260, 267, 270
Nuremberg Chronicle 33, 36, 36, 67, 159-60, 183, 211, 242, 262

Ortelius, Abraham 159
Ostendorfer, Michael 133, 187, 243, 245, 254

Ouwater, Albert van 38, 45, 53, 169
Ovid 50, 52, 81

Pacher, Michael 40, 49, 66
Paracelsus (Theophrastus Bombastus von
 Hohenheim, *called*) 26, 47
Parmigianino 251
Patenir, Joachim *28*, 43, 45, 47, 49, 184, 234, 267,
 270, 274–5
Peacham, Henry 64
Pélerin-Viator, Jean *64*, 104
Pencz, Georg 70, 145, 243
Peter Martyr (Pietro Martire d'Anghiera, *called*) 179,
 185
Petrarch (Francesco Petrarca, *called*) 56, 155
Peutinger, Konrad 159, 241–2
Piccolomini, Aeneas Silvius; wrote as Aeneas Silvius
 (*which see*); later Pope Pius II
Piero di Cosimo 53, 63
Piles, Roger de 27
Pino, Paolo 128, 152, 168
Pinturicchio, Bernardino 35, 42
Pirckheimer, Willibald 13, 42, 50, 128, 159, 178,
 241, 244
Pisanello, Antonio *29*, 45, 104, 267
Pius II, Pope *see* Silvius, Aeneas
Pliny 33, 57, 59, 61, 171, 243–4, 273
Poggio Bracciolini, Gian Francesco 157
Polack, Jan 67
Pollaiuolo, Antonio 155
Pomponius Mela *see* Mela, Pomponius
Poussin, Nicolas 22, 273
Previtali, Andrea 50
Pucelle, Jean 35
Putsch, Anna *37*, 73, 76, 245

Quad von Kinckelbach, Matthias 70, 267
Quiccheberg, Samuel von 235

Raimondi *see* Marcantonio
Raphael 46, 160, 266
Reformation 29, 30–1, 58, 64, 145, 169, 172,
 178–80, 183–4, 186–7, 241, 243, 280–1
Regensburg 17, 18–19, 22, *31*, *36*, 37, 47, 67–70,
 98, 100, 128, 131, 149, 153, 166, 171, 183, 198,
 206, 211, 234–5, 242–5, 255
 Augustinian Monastery and Church 17, 281
 Cathedral 67, 68, 100, 186
 St Emmeram 19, 67, 170, 244
 Schöne Maria, pilgrimage 30–1, 96, *133*, 171–2,
 181, 187, 234, 244, 251, 254, 263–4, 280
 Synagogue *185*, *186*, 251, 254
Rem, Lucas 267
Rembrandt van Rijn 64
Renner, Narziss *138*, *191*, 200, 260
Reuwich, Erhard 212
Rhenanus, Beatus 159, 170, 245
Riemenschneider, Tilman 173
Robetta, Cristofano 43
Rogier *see* Weyden, Rogier van der
Rosa, Salvator 273
Rosso Fiorentino 270, 273
Rubens, Peter Paul 22, 49, 278
Rudolf II, Emperor 278
Ruisdael, Jacob van 23, 198, 278
Ruisdael, Salomon van (*also called* Ruysdael) 168,
 198

Rumpler, Angelus 177
Ruskin, John 150

Sachs, Hans 157
Sandrart, Joachim von 7, 18, 70, 162, 260, 267
Sannazaro, Jacopo 54, 160
Savery, Jacques 12
Savery, Roelandt 12, 278
Schaffner, Martin 72
Schäufelein, Hans 72, 79, *113*, 157
Schedel, Hartmann 19, 33, 36, 159, 211, 242, 244,
 259
Scheurl, Christoph 76
Schiavone, Andrea 251
Schiller, Friedrich 13, 25–6
Schlegel, Friedrich 22–3, 98
Schongauer, Martin 71, 79–80, 102, 134, 171, 235, 244
Sebastiano del Piombo 53
Segers, Hercules *2*, 12, 278
Seuse, Heinrich 143
Silvius, Aeneas (pseud. of A. S. Piccolomini; later
 Pope Pius II) 27, 67, 157, 159, 179–80
Somer, Mathias van 18–19
Spenser, Edmund 49, 152
Springinklee, Hans 72, 79
Stabius, Johann 46, 69, 100, 244–5
Staupitz, Johann von 178
Stephan von Urach *66*, 105
Stoer, Niklas *195*, 267
Stoss, Veit 46, 49, 66
Strigel, Bernhard 72, 76

Tacitus 128–30, 157–8, 170, 173, 177
Theocritus 56, 160
Titian 27, 42, 50–1, 53–4, 168, *181*, 194, 206, 223,
 234, 247, 270
Tolhopf, Johannes 170, 244–5
Traut, Wolf 72, 211
Trithemius, Johannes 170
Tröster, Johannes 244

Vadian, Joachim 159–60, 245
Valckenborch, Lucas van 12
Van Eyck *see* Eyck, Jan van
Vasari, Giorgio 35, 42, 43, 53, 63, 213, 250–1
Velde, Esaias van de 168–9, 198
Veneto, Bartolommeo 104
Veneziano, Agostino *108*, 147
Venice 45, 50–4, 57, 64, 100, 101, 103, 146–7, 160,
 168, 213, 223, 234, 243–4, 247, 270
Vianen, Paulus van *203*, 278
Viator *see* Pélerin-Viator
Vinci, Leonardo da *see* Leonardo da Vinci
Virgil 52, 56, 155, 160, 245

Wertinger, Hans *170*, *201*, 235, 275
Weyden, Rogier van der 42
Wilhelm IV, Duke of Bavaria 19
Wimpheling, Jakob 157, 159, 171
Witz, Konrad *150*, 212
Wolfgang von Salm, Bishop of Passau 242
Wolgemut, Michael 40, 67, *69*, 71, 105, *145*, 160,
 194, 209, 211–12, 217

Zeitblom, Bartholomäus 67
Ziegler, Jakob 245
Zoan Andrea 43, 100
Zwingli, Huldreich 31, 66, 172, 184